EVOLUTION

Text and Photographs © 2007 Éditions Xavier Barral
Originally published in France June 2007 by Éditions Xavier Barral,
42, rue Sedaine 75011 Paris, www.exb.fr

English translation © 2007 Seven Stories Press
First North American edition October 2007

Published by
Seven Stories Press
140 Watts Street
New York, NY 10013
www.sevenstories.com

Distributed in Canada by
Publishers Group Canada, 559 College Street, Suite 402, Toronto, ON M6G 1A9

Library of Congress Cataloging-in-Publication Data

Panafieu, Jean-Baptiste de.
 Evolution / by Jean-Baptiste de Panafieu ; photographs by Patrick Gries ; translated by Linda Asher. -- 1st ed.
 p. cm.
 Simultaneously published: Evolution. [Paris] : Éditions Xavier Barral, 2007.
 ISBN 978-1-58322-784-8 (hardcover)
 1. Evolutionary paleobiology. 2. Fossils. 3. Mammals--Evolution. 4. Natural selection. 5. Paleontology. I. Title.

QE721.2.E85.P36 2007
576.8--dc22
 2007021154

Printed in France

9 8 7 6 5 4 3 2 1

EVOLUTION

TEXT BY JEAN-BAPTISTE DE PANAFIEU
PHOTOGRAPHS BY PATRICK GRIES

Translated from the French by Linda Asher

7 SEVEN STORIES PRESS
NEW YORK

EDITOR'S NOTE

I must have begun this project in drawing class during my student days. Observing the animal model, I found it difficult to work out a number of deductions as to its mechanics. In an effort to understand some posture, or a probable movement, I would draw the hypothetical skeleton I imagined for the subject, and then I would lay muscles around it. Later these missing elements brought me to consider the history of such anatomies, histories whose memory lived on in the bones, and observation called up other answers.

This volume was made possible only because it was nurtured by passionate partners— friends and curators—for whom the sense of curiosity means to take care and to understand.

All the individuals shown here are our contemporaries. We saw them as driven by life. So that they might offer up their essential selves, most have been restored, sometimes mounted or remounted, and then freed of their metal supports. We chose the photographic views that would bring them to tell us most in answer to our queries.

Every animal has been a particular encounter—in its complexity, its beauty, the grace that still emanates from it. Most of them are from the collections of the Muséum National d'Histoire Naturelle in Paris, which was the first to support our project and open its doors to us, but many are from other collections: Monaco's Oceanographic Museum, the Musée Fragonard, the veterinary school at Maisons-Alfort, the Natural History Museums of Marseilles and of Toulouse, and from the collector-osteologist at Neung-sur-Beuvron.

The choice of black-and-white photography also derives from the art of drawing, for the timelessness of its representation. It indicates by volume a thing resistant to the light, the darkness suggesting an enveloping space. It makes an abstraction of time.

Xavier Barral

PREFACE
JEAN-PIERRE GASC

It is the essence of science to build a body of knowledge that is ordered and illuminated by one or several theories. The life and nature sciences, in which knowledge has grown enormously since the early nineteenth century through many disciplines that have shared in studying every topic, at every level, and through every available mechanism, have found their unified theory on the bases of Charles Darwin's ideas. Like any theory, what today is called the theory of evolution has its fundamental elements and a body of analysis applied to data gathered from various materially accessible areas of observation. Of course, technological advances have made possible a deeper investigation of the theory by opening the way to new areas of observation and experiment. It is also the essence of science to reopen constantly the question of the accuracy of previous knowledge and its pertinence to newly observed phenomena, and to test the explications given for them. In science, there is no absolute truth or definitive certainty. Science advances through debate and a to-and-fro between hypotheses and observed facts. This last point is often ill understood by laymen, who may tend to confuse theory and dogma, knowledge and faith. Yet these are two entirely different perspectives, leading to irreconcilable actions—often dramatic ones, as history teaches us. It is also why the history of ideas and scientific theories cannot be dissociated from the history of society, the "larger history," with all its political and economic components and its dominant ideologies. In this regard, the theory of evolution is as exemplary as the heliocentric theory of Copernicus; one might even say that it has taken over that same role in history, in being faced with condemnation by the churches for the same reasons: these theories contradict the sacred texts considered to be God's revealed truth. But the fate of the theory of evolution has been further complicated by its implications not only for the earth's position in a cosmological hierarchy, but for the position of human beings, supposedly created in the image of divinity. Rejection of Darwin's formulation on the transformation of species over time arises not only from its opposition to religious dogmas, but more generally from the repugnance of any man at seeing himself brought back to the rank of an ordinary animal whose origin is the result of a general process in which random chance plays a prime role. This is the reason that, since Darwin's time, scholars convinced of the idea of evolution have nonetheless pruned Darwinian theory of the element that is its essence: the absence of a priori direction and thus of purpose; the continual reshuffling of "chances" over the course of time.

Darwin used the term "evolution" very little, describing his theory by the summary phrase "descent with modification." The fundamental concept of hereditary transmission was brought to the fore when we did not yet possess the theoretical formulation of the rules of hereditary transmission—which would establish the science of genetics shortly after Darwin's death—and when all we had were the elementary rules articulated by Karl von Baer for understanding the development of each individual. It might even be said that the word "evolution" got off to a very bad start, for, manipulated as it was by Herbert Spencer to support his conception of human societies, the term was associated with the notion of ineluctable progress, on one hand, and on the other with a single plank of the concept of natural selection: that concerning the triumph of the fittest. In this context, Darwinism was cited as grounds for ideologies that were alien to the scientific approach, and in complete contradiction to the thinking of Darwin himself. Victorian England, and more generally the society of the industrial era, was clearly susceptible to such ideas. Alas, that confusion still persists in the media.

The two fundamental pillars of Darwinian theory—continuous variation within species, and natural and sexual selection—have gained increasing influence with the discovery of means for experimental approaches. It took the whole first half of the twentieth century to throw some light on the conditions of variation and its material basis, and extending genetic science into populations has brought the study of selection back onto the roster. The rise of ecology has made known the tools for approaching environmental factors that affect selective sorting, and revealed some of the rules that provide a precarious stability among the diverse species present in any single ecosystem. Fossils, those miracles of history, have rather randomly opened some small windows onto the past of life. With the use of physico-chemical techniques like isotope analysis, paleontology has become a science that can incorporate data that reconstruct fauna and flora, components of the species' environment and their way of life. In the second half of the century, the juncture between genetics and developmental biology, aided by work at the molecular level, has opened the way to understanding the construction of an organism, the issue of a cascade of events during which small disruptions can produce large effects. All these discoveries illuminate one another mutually, as they integrate into the general framework Darwin projected in his time—with some audacity, it must be acknowledged, for many of the demonstrations were only to come as long as a century after his death.

The volume presented here by Xavier Barral and Jean-Baptiste de Panafieu, with its splendid illustrations by Patrick Gries, fulfills that mission of communicating a whole body of information without which there can be neither judgment nor the exercise of reason—the essence of the human being. The project is clear: begin with concrete objects—handsomely mounted skeletons, the riches of several natural history museums, in particular the Gallery of Comparative Anatomy at the Museum of National History in Paris—given their due by photography and stimulating observation and reflection. The text unfolds in a counterpoint of little stories, each bringing a pebble to the educational edifice, and moving beyond the objects illustrated to broaden the demonstration to the whole universe of living beings. For such is the purpose: to not leave our fellow humans ignorant of the twenty-first century's knowledge on the evolution of living beings.

Jean-Pierre Gasc, professor emeritus
Muséum National d'Histoire Naturelle, Paris

CONTENTS

Animal measurements:
The size mentioned is that of the animal photographed, except when only its head is visible, in which case it is an average size.
The length (l.) is that of the entire skeleton, including the tail.
The height (h.) or the shoulder height (s.h.) is that of the skeleton in the position shown.
Other measurements: wingspan (w.span), diameter (diam.), maximum length (max. l.).

GENERAL INTRODUCTION
JEAN-BAPTISTE DE PANAFIEU

Since man first sought to understand the laws of the universe, he has come up with several significant, unambiguous answers: the earth is round; it circles the sun; worms and microbes are not generated spontaneously from organic matter. Similarly, the reality of evolution is no longer in doubt these days. Every species—animal, plant, or microorganism—changes over time. All creatures alive today are descended from a population of single-cell organisms that lived some billions of years ago. Since the first animals appeared, millions of species have been born (the majority of which are now extinct) including our own, *Homo sapiens*.

Even when the life sciences make no explicit reference to these principles, all of them work within the framework of evolution. When a livestock farmer chooses a bull to impregnate his cows, he sets in action a process similar to natural selection. When a doctor investigates the reason for a bacteria's resistance to antibiotics, he is analyzing mechanisms that are identical to those involved in the evolution of animals. When a geneticist decodes the human genome in order to fight cancer and hereditary disorders, he will also be comparing our genes to the chimpanzee's so as to better understand what underlies our own genetic originality. When an ecologist wants to evaluate the biodiversity of a natural environment, he employs concepts of population genetics.

The theory of evolution is the sole explanation that unifies a vast accumulation of data from various scientific disciplines: zoology, paleontology, embryology, ethology, ecology, medicine. In this sense, it is not just a "theory," an idea that might be swept aside by an isolated observation that seems to contradict it. Like history, it describes events in the past and is therefore not susceptible to observation, but it draws support from a multitude of proofs that are independent of one another, such as from genes and fossils. As in other experimental sciences, investigators put forth hypotheses and verify them by further observations or experiments. Evolution

has also been observed in real form, in the laboratory and in nature. The history of living beings is still little known, however, even though the discovery of fossil species is slowly filling in the enormous gaps that persist in our knowledge of vanished fauna. The exact mechanisms of evolution are far from being fully elucidated. The nature of the transformations of species, their rhythms, and the chemical reactions involved are the subject of innumerable debates, which testifies to the vitality of this area of research.

The theory of evolution has a long history, beginning in Europe. Early questions about the origins of animal and plant species were posed in the eighteenth century, largely in France and England, but were swiftly stifled by the Churches. Indeed, any idea of transformation in species contradicts the text of Genesis, which states that man and the animals arose from a creative act of God. Permitting the idea that animals had died off or changed implies that Creation was not perfect and, worse yet, that man might be descended from lesser forms of life. In France, the count de Buffon envisaged that possibility but rejected it immediately; in England, Erasmus Darwin (Charles's grandfather) also put forward the hypothesis of species transformation. The first naturalist to actually develop the transformation idea was Jean-Baptiste Lamarck, who in 1809 published his *Zoological Philosophy*. Lamarck, a professor of zoology at Paris's Natural History Museum, declared that animals change in order to adapt to their environment. When environmental conditions change, they modify their behavior and use their organs differently. This "use" or "non-use" may lead to anatomical modifications that are thereafter passed on to their offspring. For Lamarck, then, evolution is directed by the needs of individuals. This mechanism is appealing in that it presumes that animals find within themselves the responses to their new needs. But the internal forces that Lamarck invoked to explain these changes lacked evidence, and he failed to convince his colleagues. Eventually, the theory of the inheritance of acquired characteristics was definitively abandoned,

when it was proved that the modifications that an animal develops over its lifetime are not hereditary.

With the accumulating discoveries of the fossils of vanished animals, and with the progress of zoology and embryology, the idea of evolution gained ground among naturalists, but it still lacked a theory that could link together all the observed data. In 1859 Charles Darwin published *The Origin of Species*, a book aimed at other naturalists but also at the wider public, in which he presented a broad tapestry of evidence for evolution and, above all, proposed a plausible mechanism for that transformation of living creatures. The book was devoted to the birth of new species by means of natural selection: "If under changing conditions of life organic beings present individual differences in almost every part of their structure, it would be a most extraordinary fact if no variations had ever occurred useful to each being's own welfare; assuredly individuals thus characterised will have the best chance of being preserved in the struggle for life; and from the strong principle of inheritance, these will tend to produce offspring similarly characterised. This principle of preservation, or the survival of the fittest, I have called natural selection." For Darwin, animals do not change "for the purpose of" adapting but are naturally variable, and the process of selection retains the variations that confer an immediate advantage to the individual, not for the sake of future needs or "with a view to" some predetermined "plan." His book immediately gained great success in England, France, and Germany. Darwin's ideas found ardent defenders, such as Thomas Huxley in England and Ernst Haeckel in Germany. By the end of the nineteenth century, Darwinism was quite broadly accepted by the scientific community.

The major difficulty Darwin faced was the nature of the variations he was observing in animals. He believed that these variations were appearing randomly and were thereafter transmitted to their descendants, but their

biological basis remained unclear to him. The elements acting as support to hereditary features—the genes—had been described by Gregor Mendel in 1866, but his findings had gone unnoted and were "rediscovered" only at the start of the twentieth century. Because they were mainly focused on understanding how features were transmitted unchanged from one generation to the next, they did not seem useful in supporting evolutionist ideas. It was advances in the field of population genetics that made it possible to link gene work to the theory of evolution. In the 1940s, under the influence of the biologist Ernst Mayr, the geneticist Theodosius Dobzhansky, and the paleontologist George G. Simpson, work in these three disciplines combined to make up the "synthetic theory of evolution," or neo-Darwinism: that variations in animals are caused by mutations in the genes; that these mutations occur by chance; and that the mutated genes can, under certain conditions, be transmitted from one generation to the next—all of which corresponds exactly to the variations that Darwin described.

The theory of evolution has been enriched by many studies that have brought to light the variety of mechanisms involved. The schema favored in the 1950s was one of gradual, continuous evolution deriving from small mutations, with no qualitative leap. Investigators demonstrated that species could appear or change abruptly, as a result of mutations affecting structural genes, for instance, or the timing of embryonic development. These days, molecular biology plays a very important role. The sequencing of the genomes not only of man, the chimpanzee, and the mouse, but also of flies, worms, and bacteria, enables us to reconstruct the genetic events that occurred back when certain lines first began to diverge. Advances in computer technology enable us to compare the genomes of species to evaluate their genetic distance from one another and thereby outline "phylogenetic" trees showing the relationships among species. These trees are similar to those that were constructed over the past century

illustrating animal anatomy. And comparative anatomy remains an important area of research, for evolution concerns very real living beings, which must be understood in detail in order to retrace their history. In vertebrates the skull, made up of a great number of bones that must rearrange themselves to fit together over the course of development, is one of the most complex organs. The skeleton is of particular interest as well: it makes possible the connection between the zoology and biology of present day species with paleontology, the study of fossil species of which we often know only the hard bits—the shells or skeletons.

The development of molecular biology has led some biologists toward a vision of evolution centered upon the genes, metaphorically describing the genes' strategy for enhancing propagation and thus leaving more copies of themselves. This approach helps us understand certain puzzling phenomena, such as the sterility of worker bees in a hive. How did natural selection wind up suppressing any possibility of reproduction here, when it usually favors the reproductive capacity of individuals? The explanation lies in the fact that the bees of a hive are related genetically: the queen and a worker bee share half their genes, so a worker bee's activity promotes the propagation of its own genes through the queen, who is the sole female capable of reproducing.

The power of genes has sometimes been overrated, however. In considering every anatomical and behavioral characteristic to be genetically determined, some biologists have sought (and sometimes believed they found) genes for homosexuality, for religious belief, or for adultery. They have gone on to argue the adaptive value of these characteristics by ad hoc accounts. Applying an "adaptionism" argument to every last characteristic of animals (or plants) has come under criticism, for it often deals with some single element and disregards the other organs, or behavior, or the animal's actual environment. Selection acts not on an isolated element but on the animal as a whole. Moreover, an

organ's evolution depends on many factors other than its own specific adaptation, such as the overall genetic heritage of the species, or the effect of the selection process on other features of the animal—and not necessarily in the same direction. In matters of evolution, there are no perfect solutions, only more or less effective compromises.

Aside from possible medical applications, the detailed study of the human genome provides information about the advent of man and about the spread of early populations of modern man over the whole globe. We can interpret certain human characteristics in the framework of evolutionary theory from their adaptive value. Thus, for instance, the dark skin color of peoples who originated in tropical regions comes from their high levels of the pigment melanin, which protects against the sun's ultraviolet rays. Similarly, certain disorders, like diabetes, seem linked to genetic factors that provided for the formation of fat reserves; such genes were useful when sources of nourishment were variable, but in times of lasting abundance they become harmful, for they constitute an important factor in obesity. All these characteristics, though, are highly dependent on migration and population exchanges over tens of thousands of years.

Darwin did not broach the evolution of man in *The Origin of Species*, but it was evident to all his readers that the mechanisms of natural selection must also apply to our own species. The idea that man could descend from a monkey aroused the indignation of some of the public, especially in religious circles. The Anglican Church immediately rejected Darwinian theory, primarily because it contradicted the text of the Bible, but also because of its description of Nature as indifferent and because of the importance assigned to chance in evolution. The mechanism of Darwinian evolution does in fact rest on the randomness of mutations, but a randomness capable of producing complexity, at the price of a harsh natural process of selection that

eliminates most individuals at birth or before they have reproduced. That theory was contrary to the vision of a "providential" Nature, one governed by divine laws. The debate was swiftly obscured by arguments of a religious bent, whereas Darwinism subscribes to scientific procedure and not a doctrine. The two realms of thought are quite distinct: science seeks to explain biological or physical phenomena by material mechanisms that can be identified and reproduced; religion rests on beliefs that require no verification apart from sacred writ. A debate that starts from irreducibly different modes of argumentation cannot be fruitful, if it is even possible. Still, unless Genesis is seen as the account of events that actually took place, the theory of evolution does not at all oppose religious dogmas. As science, it keeps to a concrete description of the world we live in. Even though its philosophical implications are important, it does not seek to justify man's existence but merely to explain his origins.

Yet Darwinism and then neo-Darwinism were considered anti-religious, materialist philosophies, and they were attacked throughout the twentieth century by fundamentalists, especially Christian and Muslim. In 1996, though, the Catholic Church did acknowledge that evolution was "more than a theory." Official state education systems incorporated evolution into their curricula in most European countries, without much opposition. In contrast, teaching evolutionary theory is prohibited in countries where Islam is a state religion. In the United States, the situation is quite different: biologists, here as everywhere, work within the neo-Darwinian context, but teaching it arouses strong opposition from Christian fundamentalists, who are especially interested in having creationist ideas taught as an alternative to Darwinian theory. Given the prestige attached to science, these opponents have tried to promote "creationist science," which adheres strictly to the text of the Bible and therefore postulates a universe six thousand years old, in which all animals and man are today exactly as they were created at the start. Fossils

are said to be the remains of animals drowned in the Bible's Flood. This is a religious discourse that cannot claim any scientific validity, as it deliberately ignores the discoveries made in biology over the past two centuries. In recent years, many creationists have chosen to recast their argument in the form of "Intelligent Design." Somewhat subtler, they do not reject the idea of evolution but claim that it follows a plan set out beforehand by a superior intelligence. There again, the "theory" seems to lack a scientific basis, since one of the principal arguments against Darwinism consists in declaring that the world is too complex to be understood.

Beyond these adversarial positions, the theory of natural selection does raise some important questions. First of all, it assigns man a new place: he is no longer situated in opposition to the animals but as a "human animal" he belongs to the whole array of contemporary species. He is no longer at the top of the ladder but at the tip of one of the countless branches of the tree of living beings. Nor can man be considered the ultimate goal of evolution. In fact, his arrival on the scene is not in itself proof that the event was inevitable. Moreover, the evolution of a species is an adaptation to new conditions, not necessarily an improvement. The history of living creatures cannot be reduced to a simple race toward progress. The fauna that lived three million years ago are not qualitatively different from the fauna of our time. The human species has taken on disproportionate ecological importance, but on the anatomical level our organism is nothing exceptional, even if the human brain is an especially complex organ. Whether fishes, lizards, or scorpions, many animals are constituted along lines similar to the most ancient known species. Parasites often even have a very simplified anatomy compared with that of their ancestors. Nothing in the history of the earth indicates that some particular lineage would one day give rise to the human species. So many contingent events seem to have contributed to our history that it is justifiable to say that we emerged by chance. In this, Darwinism remains as scandalous now as it was one

hundred fifty years ago—more because of our "dominant-species" pride than for truly religious reasons. For many people, if mankind was not intended from the beginning of time, then our existence would have no meaning. In reality, neither Nature nor science can provide answers to the great existential questions fundamental to human beings. Nature is indifferent to our interrogations, and science would be abandoning its role if it tried to answer them. Through its description of a Nature emptied of any purpose, the theory of evolution has not merely brought man down from his pedestal; it has also freed us of the burden of a future laid out by our past. With or without the aid of religion, we are free to give meaning, ourselves, to our future.

"Take the skeleton of a man. Tilt the pelvis, shorten the femur, legs, and arms, elongate the feet and hands, fuse the phalanges, elongate the jaws while shortening the frontal bone, and finally elongate the spine, and the skeleton will cease to represent the remains of a man and will be the skeleton of a horse..."
Buffon, 1753

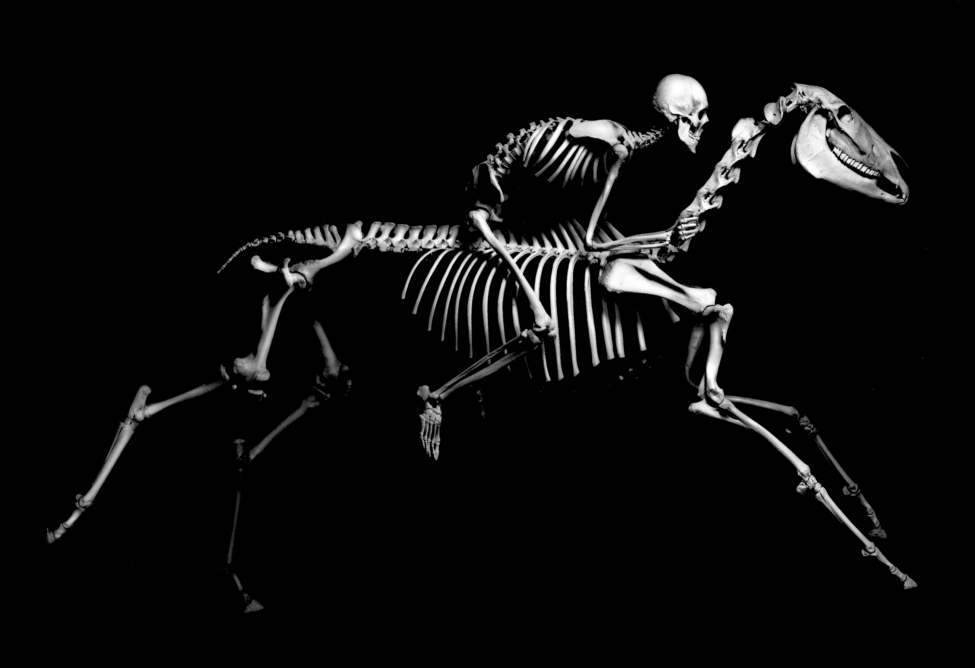

ARCHITECTURE

In 1555, in his *History of the Nature of Birds,* Pierre Belon published an engraving showing a human skeleton beside a bird skeleton, the latter suspended by the head and drawn larger to emphasize the skeletons' resemblance. The author also labeled the bones of the two skeletons by the same names, so as to "make clear how great is the affinity of the one to the other." To a naturalist accustomed to dissections, the similarities were obvious, but the author drew no conclusions about the history of the vertebrates or their relationship to other species. At the time, zoological classification was not based on precise anatomical criteria but rather—depending on the case—on such things as the animal's habitat, its way of life, or its form. Thus, Belon grouped bats among the birds, as flying animals. Without a theoretical model, registering anatomical resemblances could not evoke any biological relationship.

When, in 1735, Buffon compared the skeletons of humans and horses, he showed that the resemblances were sufficient to place them in the same family. This regrouping was based on detailed zoological observations, and the term "family" of course evoked a possible kinship, which Buffon himself emphasized. In the same text, however, he refuted the demonstration, citing as his primary argument the authority of sacred texts, with a view to heading off a foreseeable condemnation of his writings by the Catholic Church. Beyond the zoological viewpoint, the question did touch directly on religion. If two different species were related—that is to say, if they descended from a common ancestral species—that would be questioning Genesis, since, according to the Bible, God had created all the animal species at the same time. For Christians, the resemblances between species was simply the expression of the plan of divine creation.

In the early nineteenth century, naturalists discovered a great many fossils of extinct animals. The French naturalist Georges Cuvier, who did not accept the idea of evolution, concluded from the fossils that there had been several successive creations, and that entire fauna

had been swept off the surface of the earth by catastrophes of planetary proportions, the last of them being the biblical Flood. A founder of the new discipline of comparative anatomy, Cuvier sought a better way to classify animals, trying to understand the organization of Nature but without linking those resemblances to any possible relation among species. Other naturalists at France's Natural History Museum, however, including Lamarck and Geoffroy Saint-Hilaire, did view these fossils as vestiges of the ancestors of present day species. In their view, comparative anatomy should contribute to clarifying the true filiations at the heart of the animal kingdom. In 1859 Darwin published his work *On the Origin of Species,* which proposed a theoretical framework for this research. Drawing on many zoological and botanical observations, he was proposing a mechanism—natural selection—that was to give the idea of evolution a decisive momentum in the scientific community. Darwin declared, notably, that classification should faithfully reflect evolution, and that the zoological groups should be constructed according to the resemblances inherited from a common ancestor.

The study of phylogenies—the kin relationships among zoologic species or groups—at first drew on comparative anatomy, paleontology, and embryology. It is actually the embryo that provides the clearest view of the animal's organizational plan, before it is masked by its own development, the legacy of the species' evolution. Embryology permits comparisons at a more fundamental level than is possible from the adult. Vertebrates also have another organ that offers insight into the animal's deep structure: the internal bony skeleton [see page 16]. Despite the extraordinary diversity among vertebrates, from the goldfish to the whale, the pink flamingo to the crocodile, their common origin is still legible on their skeletons [see page 20]. Bone, the very material that makes up a vertebrate's skeleton, also gives us information about the history of that group [see page 28]. In the course of evolution, the organs of animals change. New anatomical features appear, which

are then passed along from generation to generation and which mark those animals' membership in the same group [see page 34]. The size factor, essential in the construction of the skeleton over the course of development, plays a very important role in the animal's life and also contributes to the course of evolution [see pages 38 and 42].

In the 1960s, zoological classification underwent a profound renewal. The German entomologist Willi Hennig proposed abandoning the use of ancestral features that had been the classic mode for defining groups, and instead looking only at evolutionary innovations. Each zoological group includes animals that exhibit some new feature or derived trait that appears in all the species in the group (even if some species have lost it in the course of evolution). Ancestral features may not be used for classification, since they are also present in a large number of species outside this group. Thus, among the terrestrial vertebrates, the fact of having five digits is not proof of any particular relationship and does not permit the construction of a category that would include all animals with five digits—for instance, lizards and monkeys. So it is no longer the resemblances that make for the classification but the differences among species, with their history being taken into account as well. This method, called "cladistics," overthrew traditional classification and made it possible to decide certain issues. For instance, the old grouping of fishes can no longer be considered a "natural" group, for it included animals that resemble one another by reason of their primitive characteristics and not of their evolution [see page 46]. The new classification led to a very different view of the broadest designations (taxons) and in particular brought an end to the five traditional classes of vertebrates [see page 56]. This conceptual revolution was based on the development of molecular biology and of computer science, which made possible the comparison of animals' genes, a comparison that is indispensable when anatomical data do not suffice.

The vertebrates represent only a small portion of the world's fauna. Is it possible to compare all the species? What do a jellyfish and a rabbit, a ladybug and a pigeon have in common? At the microscopic level, the similarities are obvious: all animals are made up of cells that function the same way, insofar as energy processes or the mechanisms of cellular division, for instance. The resemblances are greater still at the molecular level— that is, in the form and composition of molecules such as the proteins and DNA. In the most diverse species, similar proteins are responsible for maintaining the cellular membranes, for oxygen transport or for sugar metabolism. The genes that encode for these proteins—in other words, that permit their synthesis—are comparable, on the same principles as in the comparative anatomy of the organs. In fact, the resemblances between genes are proportional to the degree of relation between the species. The comparison of the DNA sequences also allows for the construction of phylogenetic trees similar to the trees based on anatomy.

The complex machinery for reading and translating genes into proteins is identical in all living beings, which today is interpreted as evidence of their common origin. But beyond that molecular relationship, certain animals seem to defy all comparison, as if, aside from having basic cellular material in common, animals were constructed along radically different pathways [see page 62]. For instance, many animals, especially among those most familiar to us, possess a bilateral symmetry: they present two halves that mirror each other. One can almost always make out a front and a rear, a back and a belly, a head and a tail. The architecture of these animals presents another common feature, the repetition of certain elements: a series of ribs and of vertebrae in vertebrates, and a segmented abdomen in insects [see page 16]. But although a mouse and a fly both have bilateral symmetry, it is very difficult to find other similarities: their skeletons, their respiratory systems, their nervous systems, their sensory organs— all differ radically. Still more distant, many species have

a "radial" symmetry: their body is arranged in star form around an axis. Thus, starfish have five arms, and sea urchins are built on the same symmetry based on five— a fundamental characteristic of their zoologic group, the echinoderms. This structure is profoundly different from that of insects or vertebrates.

The existence of bilateral symmetry and of segmentation in groups as different as the vertebrates and the arthropods is no mere coincidence. Biologists have identified in insects and in mammals similar genes responsible for the orientation and for the primitive division of the embryo, as well as genes responsible for the differentiation of segments. These genes, known as homeotic genes, play an essential role in expressing the organizational plan of animals. They are present in all contemporary zoological groups. Although their function in sponges and jellyfish is somewhat different, they have even been found there, allowing links between these groups to other animals. Similarly, while the eyes of insects and of mammals are different in structure, the genes responsible for their construction are alike. They are so important for the animals' development that they have been preserved since the common ancestor of both vertebrates and insects.

If molecular biology and comparative anatomy give us information on that hypothetical ancestor, only paleontology can provide us with a concrete image of it. In the case of the vertebrates, that distant ancestor had no mineralized skeleton, a characteristic unfavorable for fossilization. Yet some fossil species have been found that can claim the title of "ancestor to the vertebrates" or that, more plausibly, are near relatives to that ancestor. *Haikouichthys* is the oldest known vertebrate. This fish, two or three centimeters long, was found in China, in rocks dating from about five hundred thirty million years ago. On each flank the fish shows a series of muscles in a chevron pattern, which is typical of vertebrates. It also appears to have had a separate cranium and gills. Already quite different from the other

species of its period, it testifies to a rather advanced evolution over the first vertebrate. Another animal, *Pikaia*, dating from the same period and found in the Burgess schist layers in the Canadian Rockies, also possesses chevron-style muscles, but no head. This half-worm, half-fish creature may give us some idea of the look of the ancestor of the vertebrates.

Even if this creature should remain unknown, we can begin to figure out its appearance, thanks to data from paleontology, genetics, and comparative anatomy. Similarly, a comparison with skeletons of present day species allows us to retrace the history of its descendants over five hundred million years.

CHAPTER 1
THE ART OF REPETITION

Ceremonial mask? Warrior's ornament? Terrifying totem? The mandrill's skull looks like something imagined by a sculptor or a sorcerer. The striking effect of its appearance may come from the disturbing juxtaposition of seemingly contradictory elements: the eye sockets look almost human, whereas the outsized fangs recall the wolf more than the primate. That skull is unique; it distinguishes the mandrill from all other animals and could even serve to identify a particular individual among his fellows. The other bones seem more familiar. It is easy to make out the various bones of the limbs as well as the successive ribs and vertebrae. As a whole, the skeleton constitutes an organ common to all vertebrates—its structure reveals the mechanisms of its embryonic development as well as those of its evolutionary beginnings, several hundred million years back.

Detailed examination of the skull gives us information on the animal's way of life. The spectacular canine teeth are associated with large molars with rounded crowns, typical for an omnivore's diet: the mandrill feeds on insects as well as seeds and hard nuts, which he crushes with his powerful jaws. His fangs are thus not meant for killing large prey but rather for keeping predators at a distance, and above all for confirming his position within the hierarchy of his group [see page 120]. The lightness of his skeleton reveals the mandrill's ability to move swiftly over the forest floor. The contours of the humerus demonstrate the power of his arm muscles.

The skeleton calls to mind a roof-frame, except that unlike the beams of a house, the bones here cannot by themselves make for a stable structure. In the living animal, they are bound together by ligaments formed of elastic fibers. The bones also serve to anchor the muscles, which even at rest remain in a state of tension adequate to hold the skeleton upright. Not just a support structure, the skeleton also provides protection for the nervous system. Entirely contained within the cranial shell, the brain is shielded against shocks by its wall of bone. This nerve center stretches into the spinal cord, extending the length of the back, sheltered within the open-work vertebral canal. This articulated structure provides for the back's flexible movement and for the branching of the nerves out from the spinal column to carry signals throughout the whole organism. The protection of the central nervous system by the skeleton is a signature feature of the vertebrates. Among other

animals, only a few cephalopods, like the octopus or the squid, possess a cartilaginous skull that provides an equivalent function.

Certain bones can be viewed as pairs, such as the bones of the limbs, whose shapes mirror one another left and right. Likewise, the ribs and the vertebrae can be grouped in "families" of similar bones: the mandrill's thirty-seven vertebrae are built along a unique model, as are its twelve pairs of ribs. This repetitive structure is the consequence of an event early in the animal's embryonic development: at the back of the head, the embryo divides into successive segments that will be the beginnings of the vertebrae and certain muscles. Soon these segments differentiate, and the vertebrae gradually acquire their definitive shapes. Thus, in the mandrill we can see the cervical vertebrae supporting the neck, the thoracic vertebrae anchoring the ribs, the lumbar vertebrae with no attachments, the sacral vertebrae fused to the bones of the pelvis, and finally the caudal vertebrae, which form a short tail.

This specialization of the vertebrae is controlled by the "blueprint" set out by the individual's genes. From the earliest moments of embryo formation, certain genes determine the front and rear of the animal, as well as the positions of the back and the belly. Other genes control the division of the embryo into segments, and then what each segment will become. In this process of differentiation, the relative position in the body of each element probably also directly adds information to the action of the genes. This type of development, by segmentation and differentiation, saves on the volume of information to be transmitted for the construction of the skeleton and of the other organs: once the basic form is determined from a common set of data, the only further information needed to execute the program concerns the differences from one bone to the next, with no need to specify the whole construction process for each element.

In the mandrill, as in all four-footed animals, there is another repeated structure, one that is less immediately apparent—the two legs are effectively built on the same model as the two arms. The bony frame of each limb always displays the same arrangement: a flat bone (the scapula or the pelvis) bound to the vertebral spine and extended by a long bone (the humerus or the femur),

then by two long parallel bones (the radius and the ulna, or the tibia and the fibula), and finally by the bones of the hands or the feet (carpus-metacarpus-phalanges or tarsus-metatarsus-phalanges). As in the case of the vertebrae, the formation of the members is controlled by an initial common program adapted for the position of the limb: left or right, anterior or posterior. Thus it happens that the same genetic anomaly—the presence of a sixth finger, for instance—affects not only one limb but all four at once. It is highly unlikely that the same mutation would have occurred four different times, so this means that the same genetic information is used to construct the four limbs.

This mode of development of the organism, by an element's repetition and differentiation, is not peculiar to vertebrates. It is seen in centipedes and earthworms as well. It also occurs, though somewhat less obviously, in insects and mollusks. We can also see it in fossils of some of the oldest known vertebrates, fish-shaped aquatic animals. Most vertebrates at the time were almost identical to one another. Their later specialization into different anatomical types accompanied the enormous diversification of vertebrates over the course of evolution. The "blueprints" of the mandrill are no isolated invention, but rather a stage in a long process of complexification from a more rudimentary primitive program. The repetition of some skeletal elements allows us to see how an apparently very sophisticated structure could emerge from simple and fairly unspecialized elements. It also lets us conceive of how slight modifications to a primitive animal's basic structure could lead to the highly diverse forms of the whole array of present day vertebrates.

—
Mandrill, *Papio sphinx*. Sub-Saharan Africa (l. 80 cm)

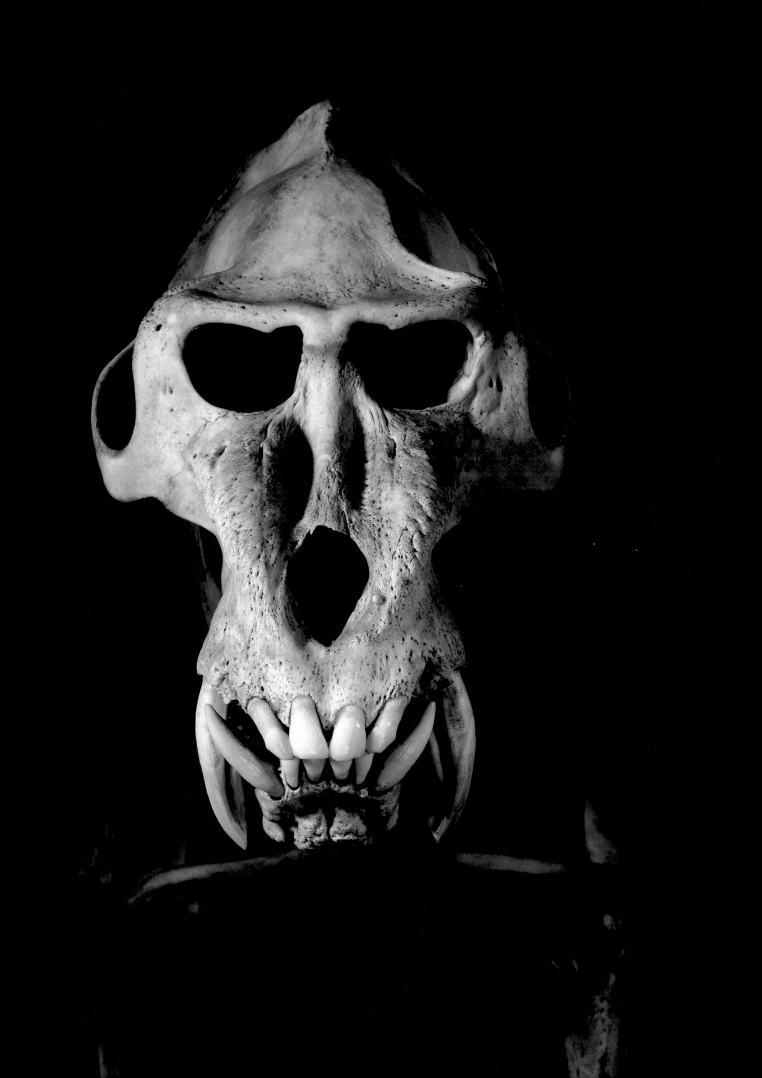

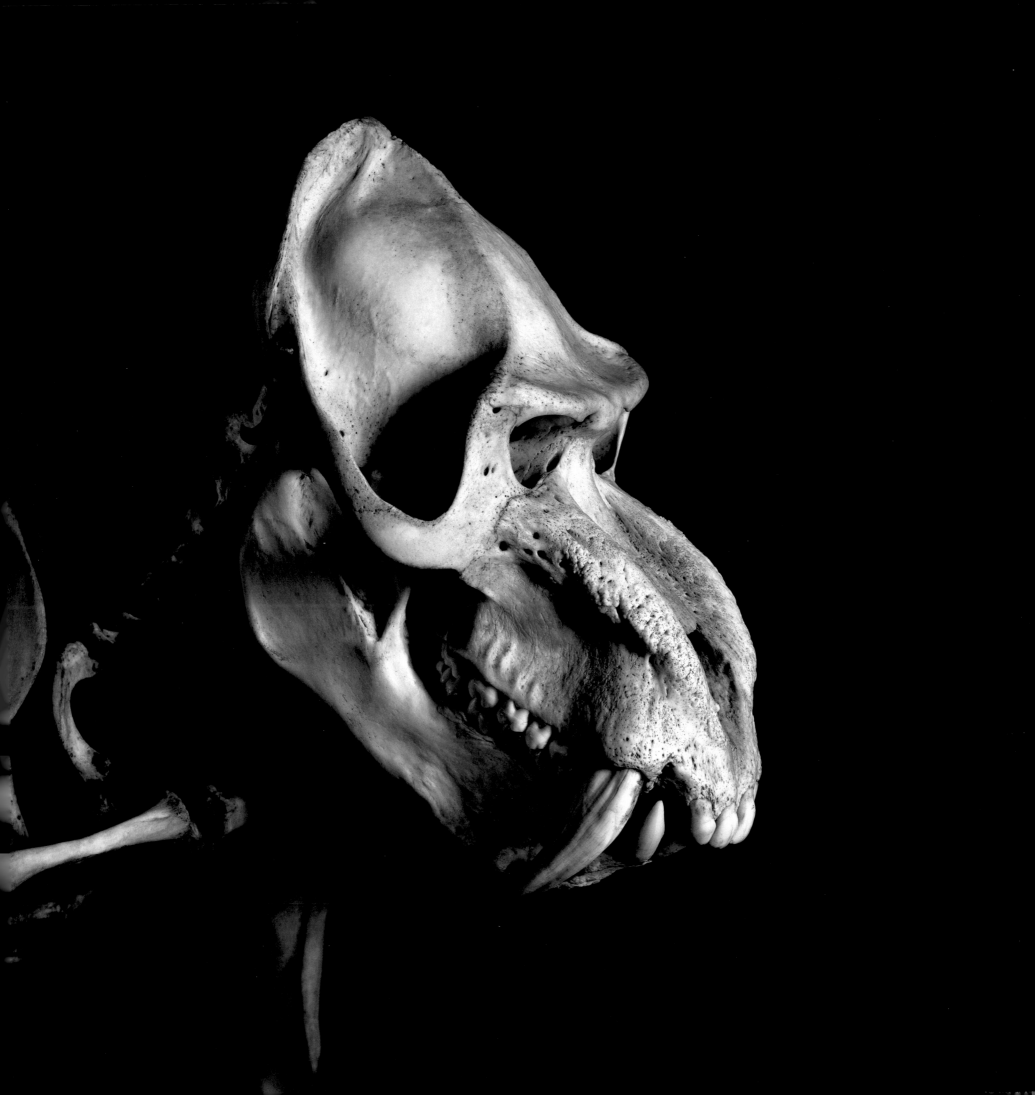

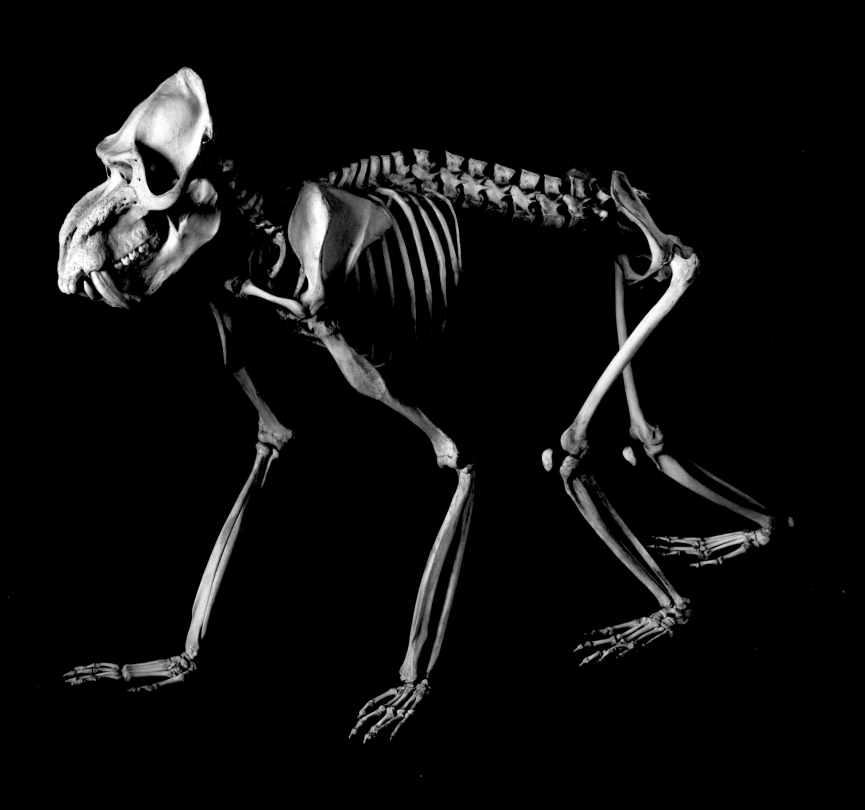

Mandrill, *Papio sphinx*. Sub-Saharan Africa (l. 80 cm)

CHAPTER 2
A DEEP UNITY

A chimpanzee called Washoe was the subject of a number of behavioral studies in the 1970s. Asked to classify photographs of animals, he separated them into two piles, one containing humans and the other animals. He placed himself among the humans. This deliberate choice demonstrated that classifying is not an activity that belongs exclusively to humans, and that any classification is strongly dependent on chosen criteria. Such criteria vary according to circumstances, but it is important for many animals to be able to identify other species: potential prey, predators to avoid, or neutral neighbors. Similarly, whether it be animals, plants, or mushrooms, it was indispensable and sometimes vital for the prehistoric hunter, as later for the peasant, to distinguish dangerous species from inoffensive ones, useful from harmful.

Today for a zoologist, comparing the anatomy of animals makes it possible to classify them and especially to establish their genetic connections. However different among themselves they may be, modern species share features that they have inherited from a common ancestor species. The skeleton, which expresses the animal's deep structure, is an essential element for constructing phylogenetic trees that trace their evolutionary history. The elements studied differ for animals that are nearly identical and for those that are markedly distinct, but the analysis always relies on a comparative evaluation of the anatomical similarities and differences. In the case of similar species, like two rodents, the zoologist looks for precise details that would include them in one group, and then within the group those details that would distinguish among them. With more distant species—for instance, two very different birds—he will look at more fundamental elements of the skeletal structure. Even in two species as distant as an antelope and a salamander, one might disregard the obvious differences and use similarities to retrace their history and recognize their kinship.

Although the capybara is a hundred times as heavy as the guinea pig, the two species have a number of points in common. Alive, the two animals have very nearly the same shape, as confirmed by observation of the skeletons. Their crania are slightly different, but the spinal columns and the bones of their limbs look much alike. The two species share certain characteristics, such as very special, beveled incisors, which place them in the rodent group. Other features, like the presence of premolars, the absence of clavicles, and a strongly developed crest on the jawbone, would put them in a same family, the caviides. These similarities are the sign of a joint ancestor that is rather recent, going back only a few million years.

The pink flamingo and the Northern gannet do not look at all alike. The two birds belong to separate zoological groups. The flamingo is a phoenicopterid, a family reduced to only five very similar species. With its outsize neck and its long stilt legs, it is the largest European bird, capable of flying thousands of kilometers. The Northern gannet belongs to the suidae family. It too flies and soars very well, but it can also swim underwater. When it spots prey from the air, it dives on it from twenty to thirty meters up, with its wings half-folded. Underwater, it is propelled by its webbed feet and perhaps its wings.

The similarities between the two birds are many, though less evident than those between the two rodents. The birds have the same bones, with roughly the same shape: the sternum stretches into a bony blade, the breastbone, which anchors the powerful flying muscles. The two clavicles are fused at the front, forming the wishbone, which also aids in flight.

At first glance, everything about the salamander and the antelope is unlike. The former has a naked, glandular skin, the other a shaggy coat; the one is flat against the ground while the other stands upright. But they both have a head and four feet. This observation may seem banal, but such a combination is rather rare in the animal world. Actually, from the jellyfish to the sea urchin, a great number of animals have no head at all. As to feet, insects, which make up the great majority of species on our planet, have six of them. Crustaceans have ten or more and centipedes up to seven hundred fifty. Snails and worms have none at all. The only animals to possess both a head and four feet are the tetrapods: amphibians, reptiles, birds, and mammals. Altogether they amount to no more than twenty-six thousand species—that is, according to estimates, between 0.1 and 1 percent of present day animals.

In fact, an examination of the skeletons of the antelope and the salamander reveals some fundamental resemblances. For instance, the leg bones correspond exactly, segment by segment, despite the differences in size and shape. Variations are discernible in the number and shape of the vertebrae, but the skeletal structure is the same. In the nineteenth century, detailed comparison of skeletons led naturalist Étienne Geoffroy Saint-Hilaire to develop the notion of "homology." To his mind, two organs are homologous if they have the same position in the skeleton. By contrast, he said, shape and size matter little, no more than their function. Biologists since that time have observed that homologous organs had the same embryonic origin. A man's arm and a bat's wing are constructed from the same still-undifferentiated areas of the embryo. The bat's wing is homologous to the monkey's arm [see page 198] but not to the insect's wing.

For Geoffroy Saint-Hilaire, homology was the sign of a family relationship, thus the result of evolution. This view was not shared by all naturalists. For instance, the English anatomist Richard Owen also used the concept, but only as a means for classifying animals more precisely, since he rejected the idea of evolution. After the publication of *The Origin of Species*, homology became an important element in helping to identify phylogenetic relationships among species. A guinea pig and a capybara, a pink flamingo and a Northern Gannet, a salamander and an antelope are all tetrapod vertebrates, characterized by a spinal column, a cranium, and four feet. The structure of these six species proves that they have a common ancestor, even if we cannot identify that species exactly.

—
Greater flamingo, *Phoenicopterus ruber*. Africa, America, Eurasia (h. 1.20m)

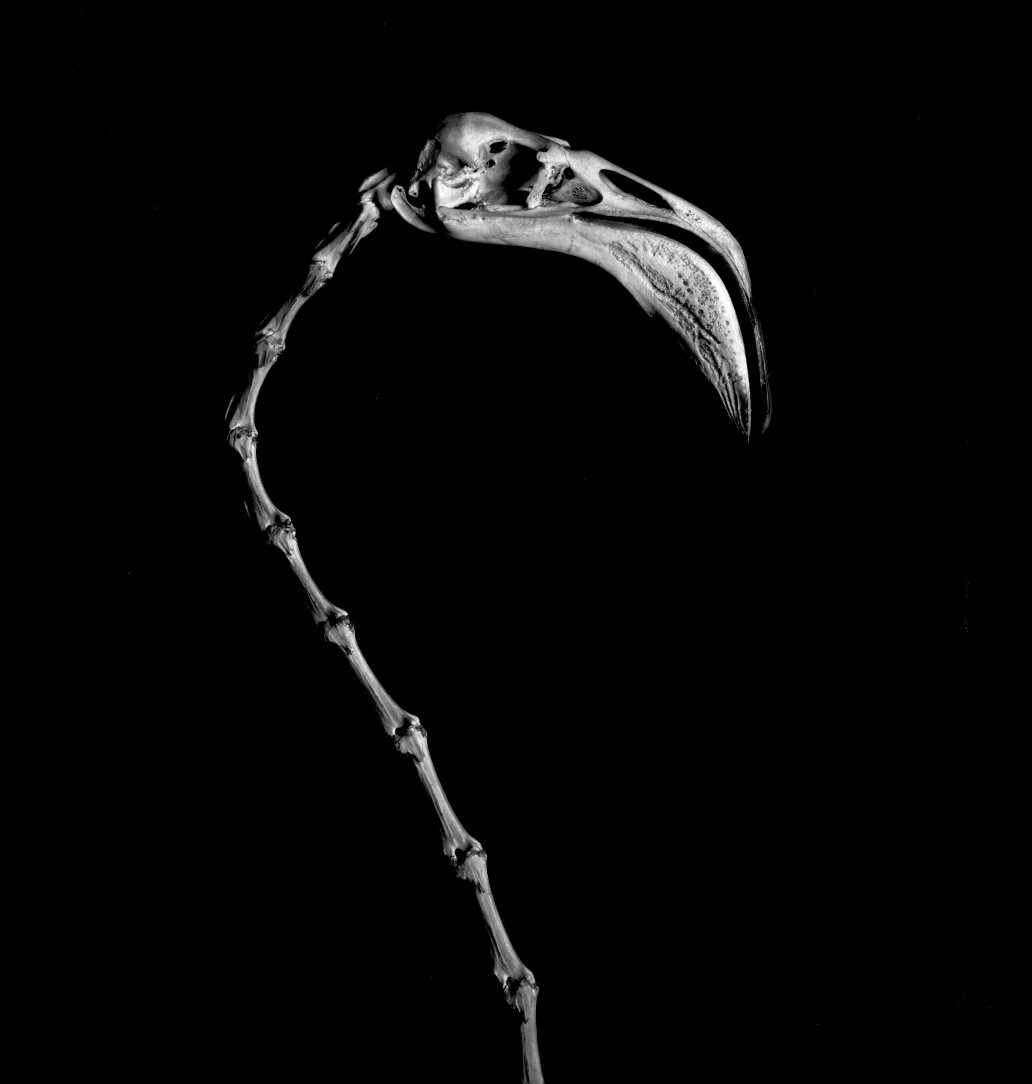

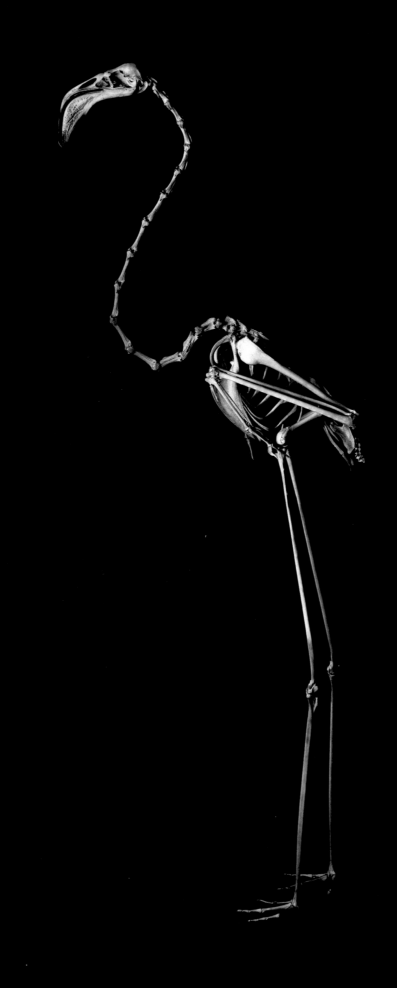

Greater flamingo, *Phoenicopterus ruber*. Africa, America, Eurasia (h. 1.20m)

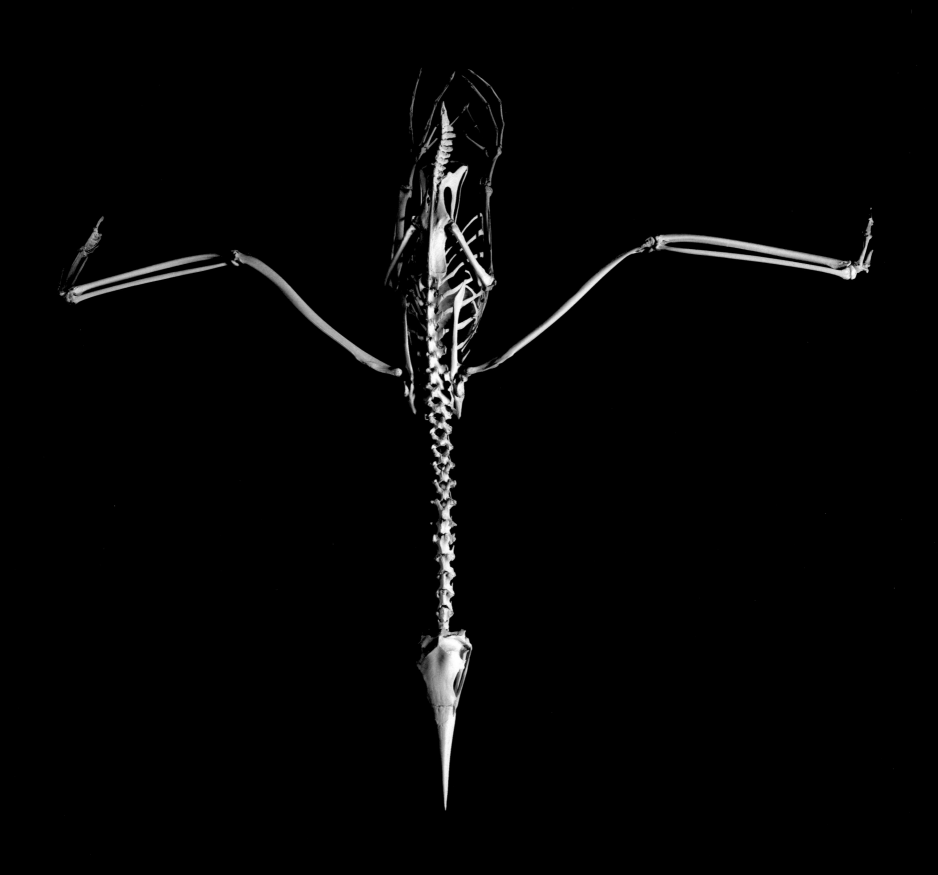

Northern gannet, *Morus bassanus*. North Atlantic Ocean (w. span 1.35 m)

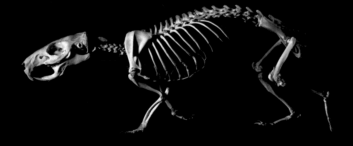

Guinea pig, *Cavia porcellus*. Domesticated. Originally from South America (l. 30 cm)

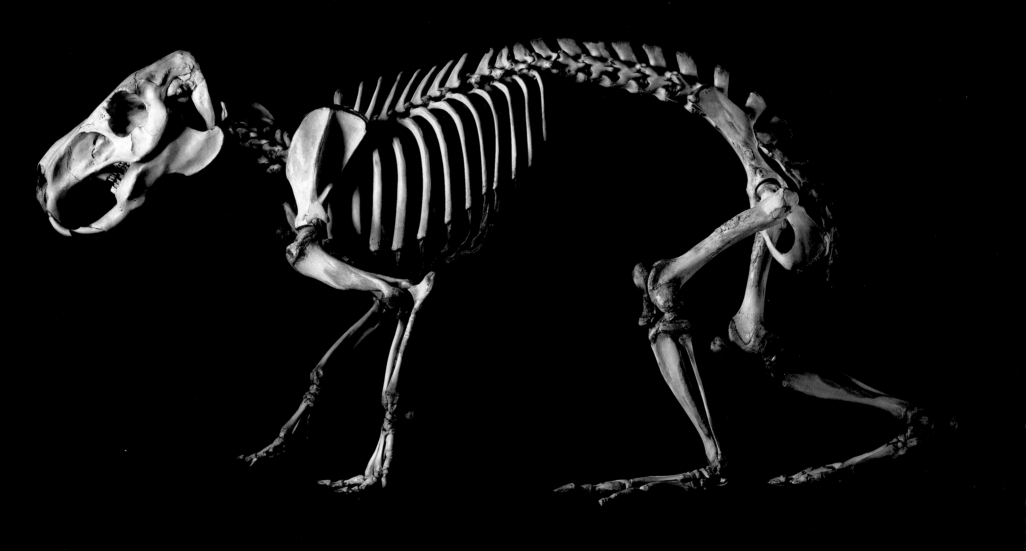

Capybara, *Hydrochoerus hydrochaeris*. South America (l. 85 cm)

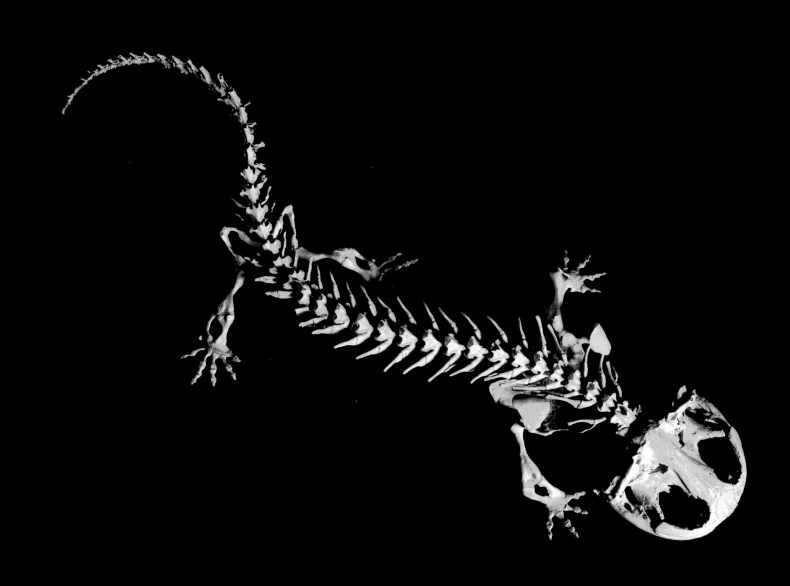

Japanese giant salamander, *Andrias Japonicus*. Japan (l. 95 cm)

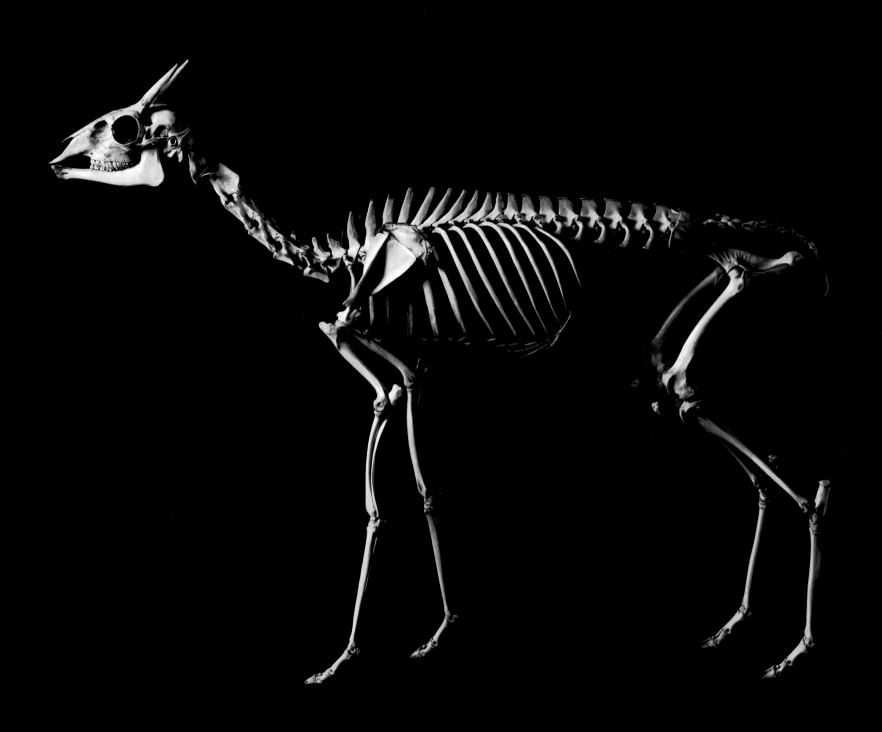

Oribi, *Ourebia ourebi*. Sub-Saharan Africa (s.h. 55 cm)

CHAPTER 3
BONY ARMOR

One of the Galapagos tortoises Darwin brought back to England at the end of his voyage around the world died in 2006, at the supposed age of 176. The longevity of tortoises, their slowness and their protective shell have given rise to countless myths, making these peaceable reptiles into symbols of wisdom and immortality. That shell may have inspired the idea that the animal bore the world on its back, but the tortoise's special ability is for protecting itself from that world, by withdrawing inside the shell and thus escaping possible predators. This heavy, rigid protective structure is no simple inert box, but rather a living construction that keeps growing throughout the animal's life and offers a striking example of the potential of bony tissue. Bone is actually a plastic material, which responds to the requirements of the organism's development as well as to the stunning inventiveness of evolution.

The tortoise group is very homogeneous. Despite the differences in size and their quite distinct ways of life, one recognizes instantly the bond of kinship between the tiny European freshwater turtle and the gigantic terrestrial tortoise of the Galapagos. Their shell consists of two shields over the animal's back and belly. The upper shell, or carapace, is made up of several bony plates joined to the vertebrae and the ribs. The lower shell, or plastron, also consists of several plates. In the land tortoise, the two shields are continuous; they are joined at the animal's sides but leave two openings, one for the head and the forelegs, the other for the tail and the hind legs. Along the margins of the shells are curved ridges that stiffen the whole structure. Like all reptiles, tortoises continue to grow throughout their lives, although their growth slows sharply after a few years. The shell plates therefore continually change at the edges, the bone being constantly destroyed and rebuilt by specialized cells. The bones of tortoises and of many reptiles exhibit successive lines corresponding to the years, like the rings in a tree trunk.

The ribs and most of the spinal column are not visible on the external part of the shell. They are joined to the inner side of the carapace. In the land tortoises, the pectoral girdle—the group of bones that supports the front legs—is located inside the thoracic cage, not outside as in some other reptiles. This "girdle" is made up of three bones on either side—the shoulder blade, the clavicle, and the coracoid—arranged as a triangular support structure reinforcing the carapace. The four legs are jointed inside the shell, which allows them to retract in case of danger but which also reduces their mobility.

In water turtles, the shells are smaller, with separate bony plates, which are not attached to the internal skeleton either. In the soft-shell turtle, for instance, the plastron is composed almost entirely of cartilage. With less protection, freshwater turtles compensate for their vulnerability by being more aggressive than land tortoises. The girdles in soft-shell turtles are highly developed: the three bones of the pectoral girdle and the pelvic bone are mostly flattened, and they cover almost the entire ventral surface of the animal. The limbs are far more mobile than in the land tortoises, which permits powerful swimming strokes.

A tortoise's cranium looks big in comparison to the body, but it is actually made up of two structures boxed one inside the other, the internal case holding the brain. Between the walls of the two cases, the jaw muscles are attached. Despite this hyperproduction of bone, tortoises lack the elements that are usually the most highly mineralized: teeth. Their jaws form a beak covered with horn, a hard material that gives them a cutting edge like shears. The carapace itself is also usually covered in horn. Incidentally, the pattern of its great outer scales, or scutes, does not correspond to the shape of the bony plates underneath.

This heavy protective structure is not unique among vertebrates. It was even the rule in some of the most ancient representatives of the group, the armored fish of the Paleozoic, which appeared more than four hundred million years ago. They were enclosed in an exoskeleton, a rigid external armor formed of large bony plates fused into a big shield protecting the head and the forepart of the body. Only the tail could move, to provide for swimming. Except for the head, this armor has nearly disappeared in most vertebrates, but some of them still have the ability to produce bone matter in the skin and to form supplemental bones. For instance, the skin of crocodiles is encrusted with bony plates called osteoderms. Among mammals, bone matter also produces the bony cores that hold up the horns of bovines, the antlers of ruminants, and sometimes an actual bony carapace, as in the armadillo. Horn also plays an important role among vertebrates: it forms rhinoceroses' horns, birds' beaks, cats' claws, and ungulates' hooves. And it produces our own hair, our nails, and the outer layer of our epidermis.

Bone is made of a flexible protein material called ossein that is hardened by impregnation with mineral salts, mainly calcium phosphates. Calcium is implicated in many important chemical and biochemical reactions in the organism, from the conduction of nerve impulses to muscle contraction. Phosphorus contributes to all the organism's energy transfers in the form of adenosine triphosphate (ATP). Bone acts as a storehouse for these essential mineral elements. It can release them into the blood if their levels are too low, or remove them if the levels become too high, thus providing for a very finely calibrated, continuous regulation of calcium and phosphorus. Horn is made of a different protein, keratin.

Despite their importance, bone and horn cannot be used as the decisive criteria for defining a vertebrate. Indeed, certain species do not produce either bone or keratin. The skeletons of sharks, for instance, are made of cartilage, a tissue very different in nature from bone but which can also be mineralized by calcium phosphate. Only the osteichthyans make true bone. This group includes all the descendants of the primitive bony fishes (the meaning of their name), which is to say, "modern" fishes with bony skeletons (those with spines), as well as all the tetrapods—the reptiles, birds, and mammals [see page 281]. Vertebrates cannot be defined by the presence of bone, as some of them have none. Neither bone nor horn make a tortoise a vertebrate; what does that is its spinal column, hidden within its shell.

—
Narrow-headed soft-shelled turtle, *Chitra indica*. India, Pakistan, Nepal (l. 43 cm)

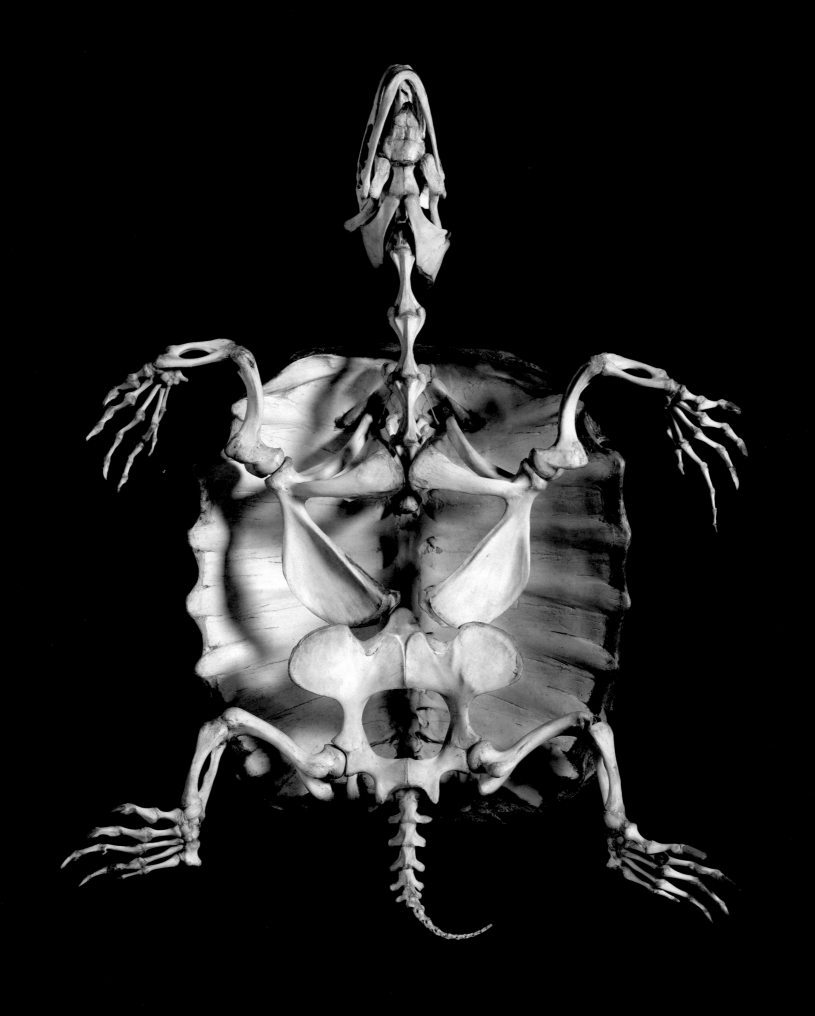

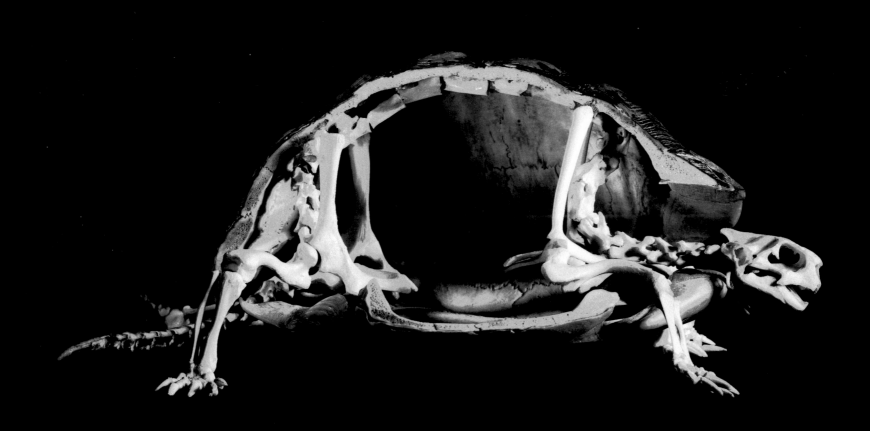

Hermann's tortoise, *Testudo hermanni*. France (l. 25 cm)

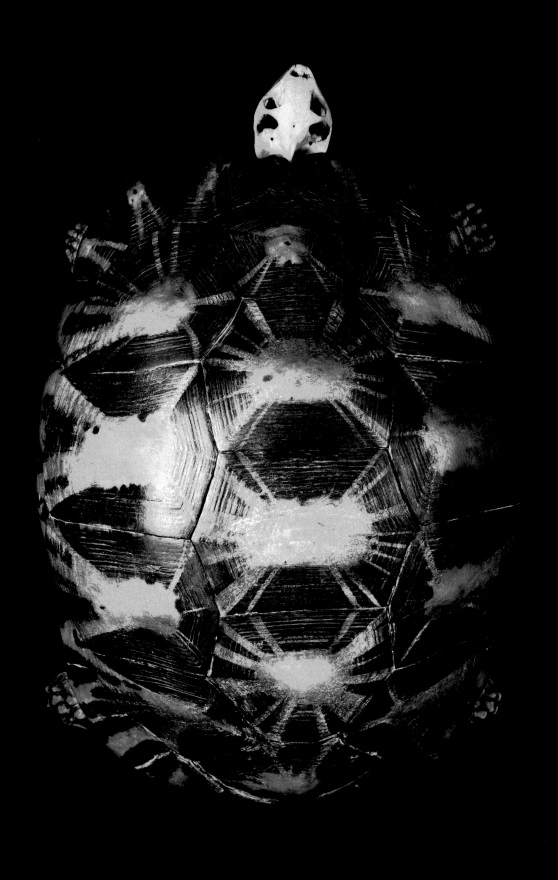

Red-footed tortoise, *Chelonoidis carbonaria*. South America, Antilles (l. 55 cm)

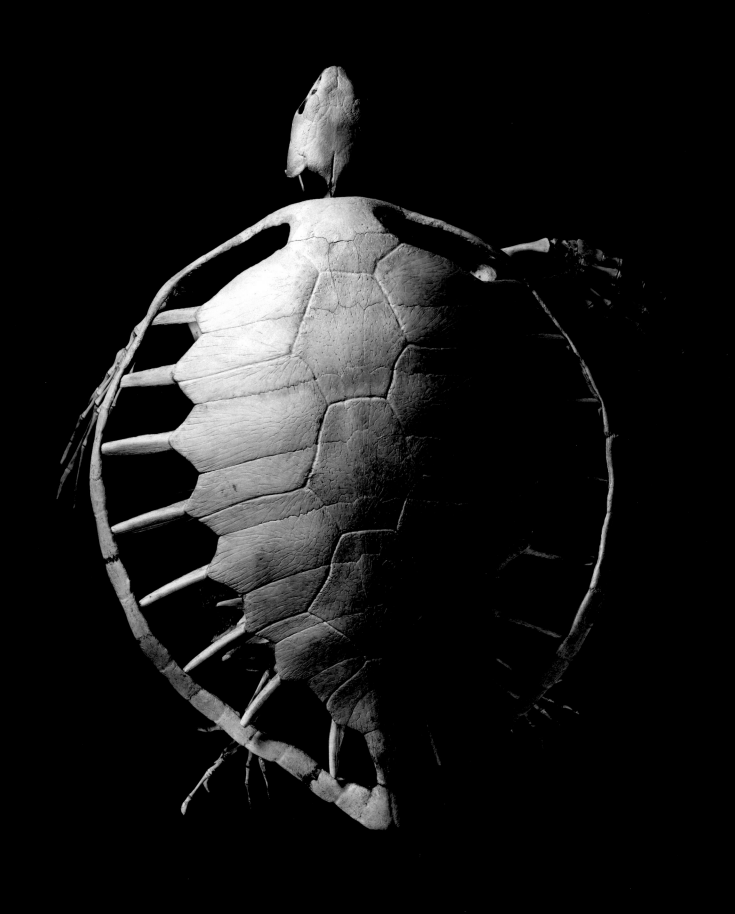

Green turtle, *Chelonia mydas*. Global oceans (l. 68 cm)

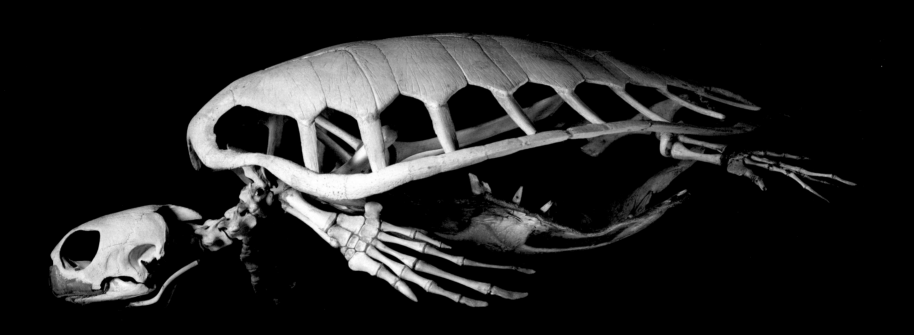

CHAPTER 4
FIVE FINGERS

Like the bipedal walk and a large brain, the hand has long been considered one of the most important characteristics of human beings. It is an indispensable tool for the expression of the brain's capacities, from writing to tinkering, from the athlete's movements to those of the artist. In the nineteenth century, the hand was one of the symbols of the perfection of the human body, such as God had conceived it on the sixth day of Genesis. Although the theory of evolution finally prevailed, acknowledging man's simian lineage, some naturalists retained their view of the human being, merely shifting him from the status of the masterwork of Creation to that of the summit of evolution, its natural culmination. This conception of the history of life rests upon the idea that evolution necessarily means progress, with the species becoming ever better adapted and thus more complex. For instance, for some, the little monkeys of the Tertiary era would necessarily develop into biped humans with capable hands and big brains. But in reality, evolution does not follow a neatly marked path, and the history of hands (and of feet) is not one of constant progress.

The earliest fossil hands appear in the first tetrapods—that is to say, the first four-footed vertebrates, able to move about on dry land. They were descended from "fish" which resembled them strongly but whose fins ended in spines or rays, not fingers [see page 46]. These primitive tetrapods, which looked like big stocky salamanders, did not all have five digits. *Ichthyostega*, dating from three hundred sixty million years ago, had feet with seven toes, and his contemporary *Acantostega* had eight-fingered hands. Some species had five digits, but they were not automatically dominant.

Among fossils a few million years more recent, all we see now are just two lineages: the one that gave rise to the amphibians, who since that time have had hands with four digits and feet with five; and the rest of the tetrapods, with five digits on each extremity. The other lines seem to have disappeared without leaving descendants. Having four or five digits may have been an advantage compared with having six or seven, but it is also possible that the selective extinction occurred merely by chance. The question has not been decided. It is difficult to evaluate the advantage of one element without considering an animal's overall anatomy. Furthermore, the exact history of that evolution is still little known, for there are not many tetrapod fossils extant. The primitive tetrapods that are the ancestors of present day reptiles, birds, and mammals had five digits. The pentadactyl (five-fingered) limb remained the rule in certain groups, for instance, monitors and lizards. Some mammals—bats and many carnivores—also kept their five digits, but others have lost them. This is the case in today's equids, who have only a single digit left, and bovids who have two [see page 178]. As these particularities appear only later and only in certain groups, biologists call them "derived" features, which means they result from the transformation of an organ that previously existed in some other form, which would be described as "primitive." The pentadactyl limb is a derived feature in comparison to the fin it comes from, but it is also a primitive feature, dating from about three hundred fifty million years ago, compared with the one- and two-digit limbs that appeared much later.

Primates are all pentadactyls like their distant ancestors, but they present a derived feature: an opposable thumb on each limb. This evolutionary novelty appeared in the first primates, who lived sixty million years ago, shortly after the extinction of the dinosaurs, and who were the ancestors of all the lemurs and monkeys of today. That evolution hinged on inherited modifications in the shape of bones, joints, and muscles, which were transmitted to all the species in that line. So the opposable thumb is one of the markers that allows the regrouping of the primates into a homogeneous zoological category. A few species, however, have a foot without an opposable thumb, like the jumping tarsiers or walking man. These exceptions are due to losses that occurred later in the course of evolution. Other derived features, like eye placement, do set those species squarely alongside the other primates.

Almost all the primates kept their opposable thumbs, but other organs have undergone a marked evolution over this time. Thus the tail became a prehensile organ in the monkeys of South America, whereas it disappeared completely among the African monkeys, the ancestors of chimpanzees and of man. In some primates, especially man, the brain has developed greatly and the teeth are significantly diminished. Some organs can undergo a radical transformation and even change function, while others keep the same form and go on playing the same role in the organism. This phenomenon is called "mosaic evolution."

For biologists, the word "evolved" does not carry exactly the same meaning as in ordinary language. Evolution is not necessarily an improvement but simply a transformation. The hand is a vestige dating from the origins of the terrestrial vertebrates, at once extraordinarily skillful and astonishingly primitive. When our ancestors became bipedal, several million years ago, the big toe evolved rapidly and lost its original mobility. The loss of its opposability is a derived characteristic that appeared late, linked together with the acquisition of bipedalism. Among other characteristics, it distinguishes man from his closest relative, the chimpanzee. Our most evolved finger is not our marvelous, archaic, opposable thumb, but our clumsy, recent big toe.

—
Water monitor, *Varanus salvator*.
South-east Asia (l. 90 cm)

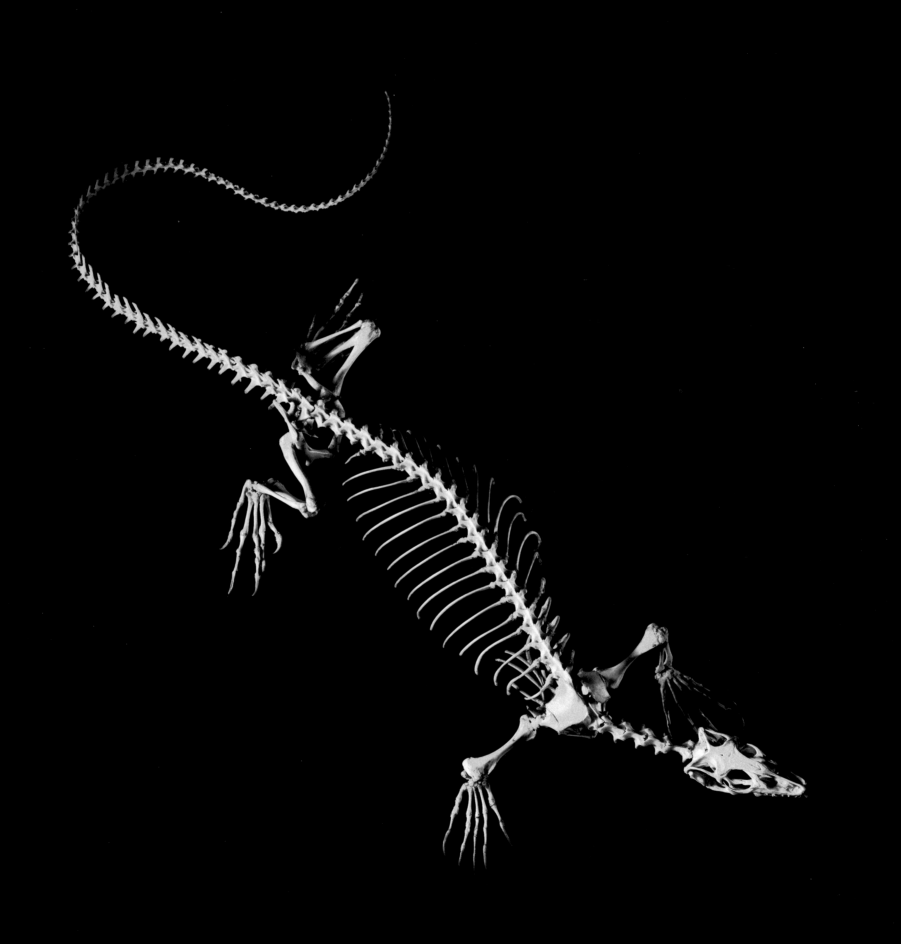

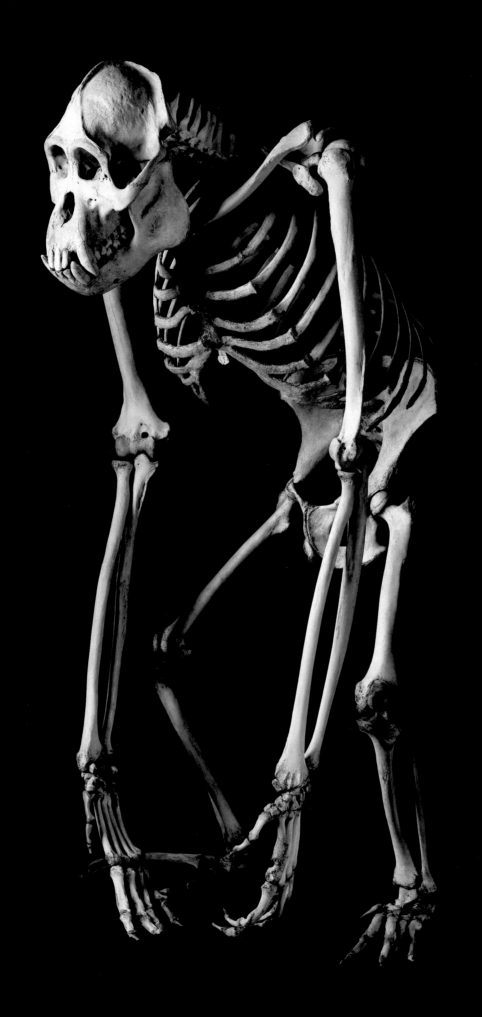

Orangutan, *Pongo pygmaeus*, Sumatra, Bornéo (h. 1 m)

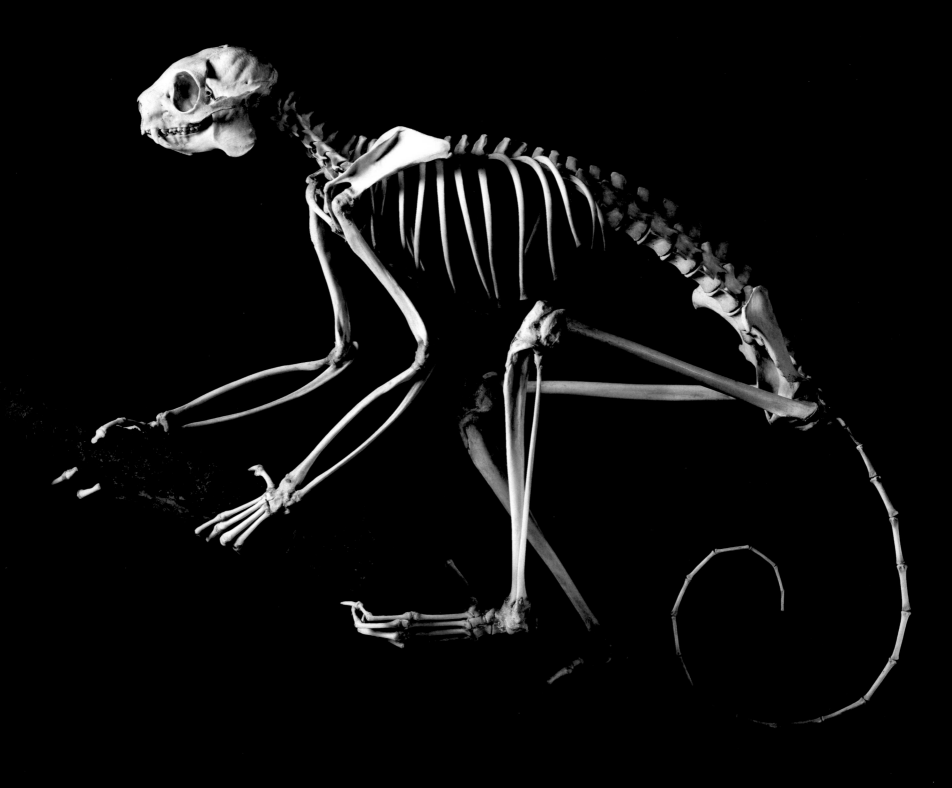

Diademed sifaka, *Propithecus diadema*. Madagascar (l. 92 cm)

CHAPTER 5
THE PROBLEMS OF GIANTS

For centuries, huge bones found in the earth were considered evidence for the existence of the giants in the fabulous stories of antiquity. Strange skulls with great single holes in the forehead, discovered in Mediterranean islands, may be the source of the Cyclops myth. With the development of comparative anatomy, mythological explanations had to be abandoned. Those bones could not have belonged to human beings, even very large ones. The cyclopean skulls were ultimately identified as belonging to elephants; that central "eye socket" was actually the nasal opening, corresponding to the location of the trunk. (The true eye sockets of elephants are barely marked.) The skulls were too small for normal-size elephants, however.

Other bones were similarly identified and ascribed to mammals or to giant reptiles that were even more astonishing than the legendary Titans, for they showed that unknown animals had lived on our planet and had become extinct. These species were still more fascinating for being larger than all living animals. After two centuries of paleontological discoveries, it is thought that the largest terrestrial animals of all time were herbivorous dinosaurs: *Argentinosaurus*, a cousin of *Diplodocus*, reached perhaps forty meters in length, with a weight of fifty to seventy tons. Among the mammals, one of the largest animals in prehistory is *Baluchitherium*, related to the rhinoceros but without a horn. It could lift its head to higher than eight meters, and must have weighed nearly fifteen tons. Today it is the elephant of the African savannah that holds the record for size among terrestrial animals, with a maximal height of four meters at the withers and a weight of about seven tons. The largest animal of all time is probably the blue whale, which grows to thirty-three meters long and more than one hundred ninety tons.

These spectacular species are few in number, for a large size presents not only advantages but also inconveniences. An adult elephant, for instance, runs little risk of being devoured by a predator. It can journey long distances to find food, and manages to reach leaves that are inaccessible to other herbivores. When the external temperature varies, the elephant's mass gives him an important thermal inertia. It grows cold or hot less rapidly than a small animal would, and therefore spends proportionally less energy regulating its internal temperature at around 97°F [see page 42]. In absolute terms, however, his feeding needs are great. Large animals live longer than small ones, but their reproduction is slower, and they generally have fewer descendants. They need broader territories, over which they are spread thinner, which complicates the search for a mate. It is therefore believed that a large sized species has a higher risk of extinction.

Large animals must also face structural problems. Indeed, their weight increases proportionally faster than their frame (as they double in height, their weight multiplies by an estimated factor of eight—that is, as a leg bone grows from half a meter to a meter long, it must bear eight times the weight it did, assuming the animal's overall form does not change). Independent of its height, a large animal's skeleton almost always looks more massive than a small animal's, for the bones are proportionally thicker. And as bone is denser than other organs, their thickness raises the animal's weight even more. Certain special adaptations do lessen the effects of this change in scale. For instance, an elephant's skull has many air-filled cavities, and they reduce its weight without lessening its sturdiness. (This was also true of the dinosaurs' vertebrae and leg bones.) The elephant's muscles must also be more powerful, in line with the animal's mass rather than its length. On the other hand, as the leg bones stand vertical, like columns, the demand on the muscles is less. Taking these adaptations into account, we can calculate that the maximal weight a land vertebrate could attain would lie between fifty and one hundred tons, which corresponds to the largest dinosaurs.

The extraordinary appendage that is the elephant's trunk is directly linked to the animal's great size. True, its enormous skull, made heavier by the tusks, represents as much as a quarter of the skeleton's weight. Such a mass would not permit a long neck; and in fact, the elephant's seven cervical vertebrae are flattened and shortened. In its quest for food, then, without a trunk it could only prospect a limited terrain. The organ did not appear suddenly in the course of evolution. Fossils of archaic elephants, much smaller, show that the trunk took form gradually, beginning with the joining of part of the nose and the upper lip. The shape of the skull shows us the location of the trunk muscles. Primitive elephants—living about thirty million years ago—had tusks and an elongated face. Initially they probably had a protruding upper lip, like a tapir's; then the lower jaw receded and the trunk was freed up, as in present day elephants with their very short faces. The history of elephants could be retraced from the many fossils of closely related species discovered by paleontologists. In this regard, the giant animals are especially interesting: less numerous than the small species but endowed with large bones that are more readily preserved, they are ultimately overrepresented among fossils.

Species that grew gigantic in the course of evolution can also diminish in size if their environment changes. This is what happened with some prehistoric elephants whose territories were cut off when sea levels rose some hundreds of thousands of years ago (they may also have swum to those islands). Out of reach of predators and with limited access to food supplies, it was the smaller individuals who were favored by natural selection. While their cousins left on the continent stayed large, these island animals became dwarf elephants. Still, in the course of that evolution, they did retain their general shape and their trunk. They disappeared some thousands of years ago, perhaps hunted by the first men to reach the shores of Sicily or Malta. All that remained of them were a few bones —and the Cyclops skulls that mystified the Greek seafarers.

—
African elephant, *Loxodonta africana*. Africa (s.h. 2.20 m)

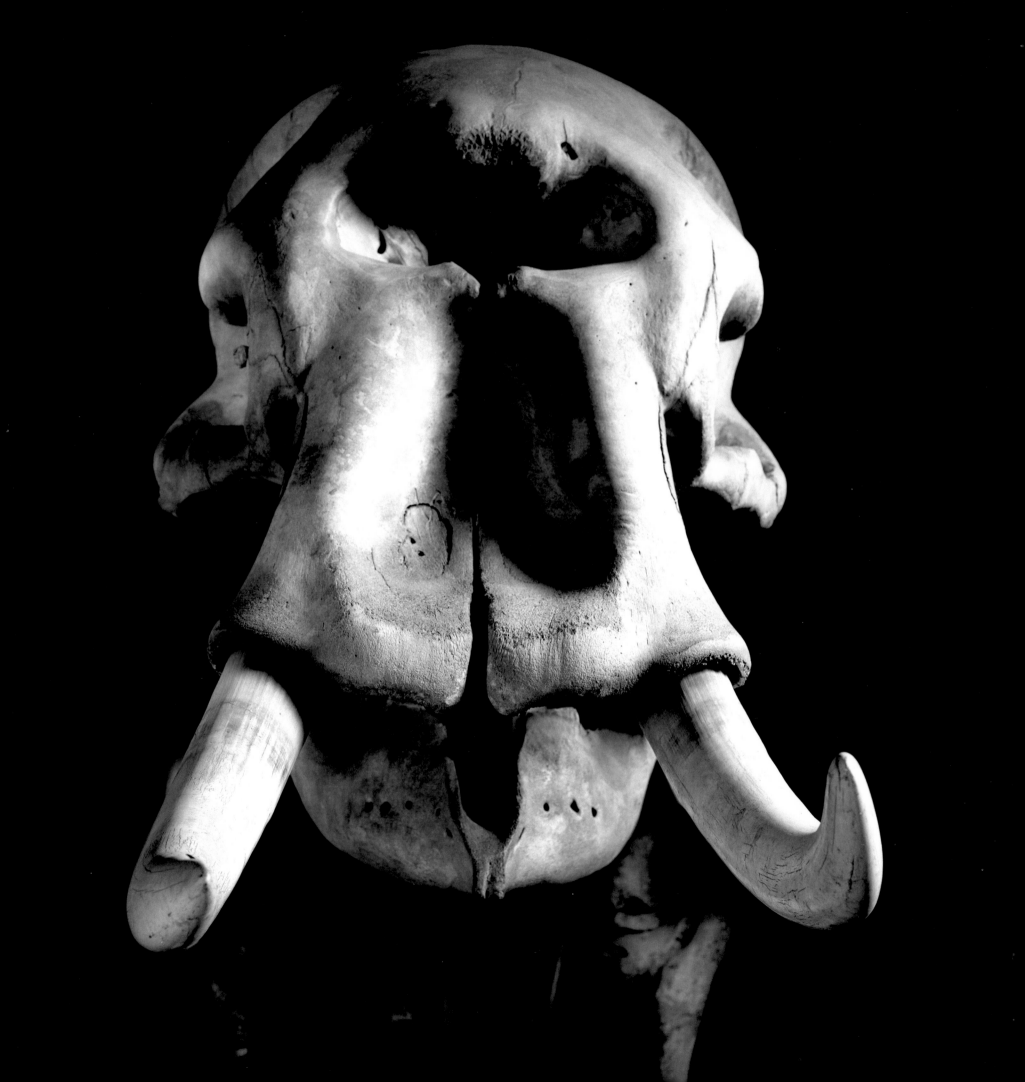

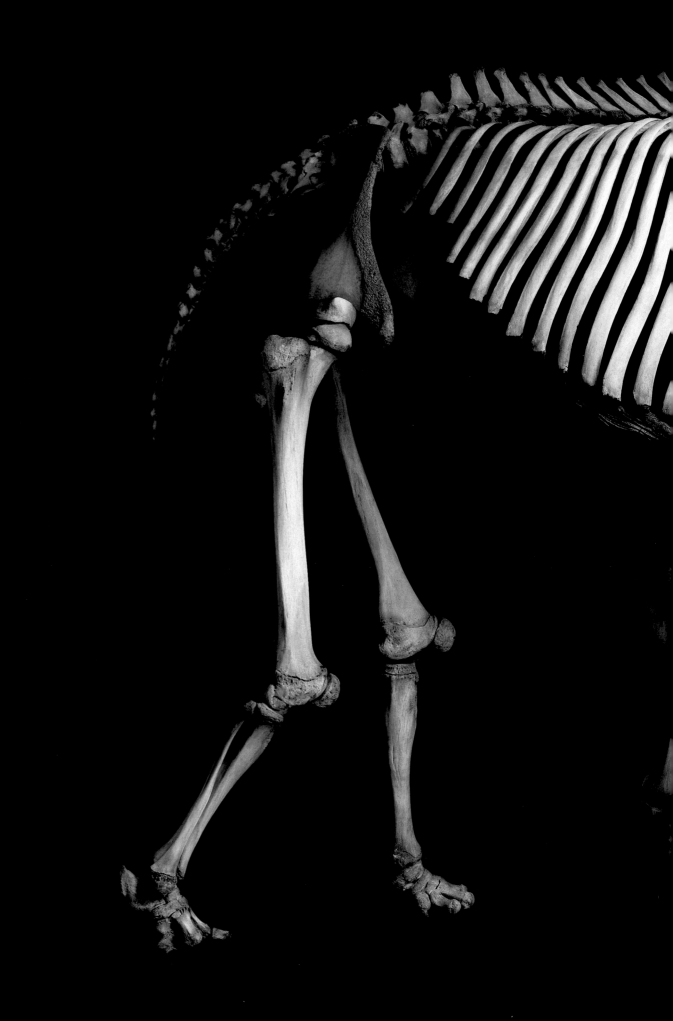

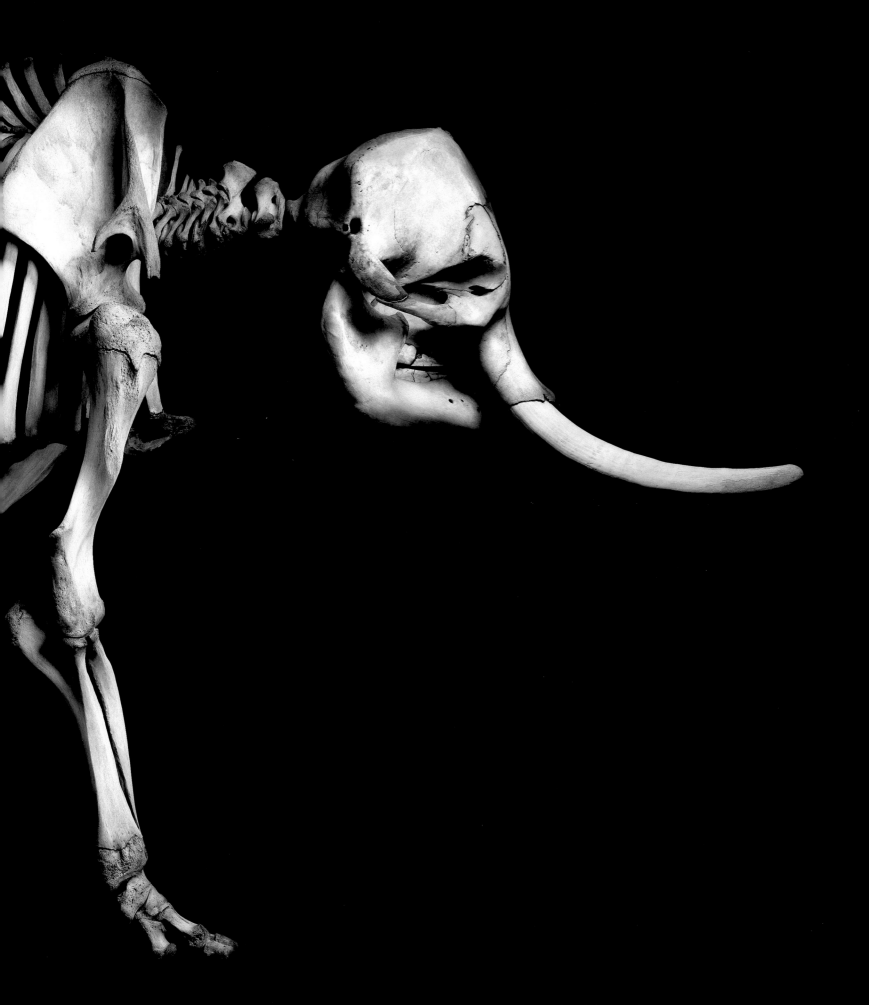

African elephant, *Loxodonta africana*. Africa (s.h. 2.20 m)

CHAPTER 6
SMALL ANIMALS AND LARGE

Islands have long been considered "laboratories of evolution." Animals live there far from the species they belong to, and they undergo different transformations from those that occur on the continents. Thus, fossils of dwarf elephants and hippopotamuses have been discovered on the Mediterranean islands. The Balearic Islands used to harbor a wild goat that stood less than forty centimeters tall. But it should not be concluded from this that island animals are always smaller than others. Large animals may shrink, but very small ones grow bigger as well. In Sicily there lived a rodent related to the dormouse but four times as large. Similarly, mice, field mice, and shrews are often larger on islands, in comparison to the nearest continental populations. To understand these seemingly contradictory trajectories of evolution, it is important to examine how animals' sizes are distributed in the ecosystems, and evaluate the respective advantages for small and large forms.

The hippopotamus is a hundred million times as heavy as the mouse; the blue whale is a hundred billion times as big as the smallest known fish. Vertebrates exhibit a range of dimensions more vast than any other zoological group. They are on average larger than the other species, and include almost all the giants of the animal world. While the large species are more familiar to us, however (probably because we are in the same group), they are relatively rare, whereas the small-size species are very numerous. This diversity of sizes is explained by the animals' ecology. Indeed, a range of varying species makes better use of the range of resources in a territory than would a group of species that were all the same size. In the course of evolution, the tiny vertebrates that appeared six hundred million years ago have given rise to species that are much larger. According to a "law" that has long figured in zoology manuals, the history of animals is said to show a general trend to increase in size. But the idea that evolution might follow some given direction stands counter to the Darwinian view of a totally unforeseeable story. The question of animal size is one element in a vaster debate about there being any possible "meaning" to evolution.

Insects and worms are incomparably more abundant than large animals, and their overall mass is much higher. Among the vertebrates, certain species are scarcely bigger than insects. The sunbird is a small bird that feeds on nectar, like the American hummingbird. Some of them are the size of a butterfly. Among mammals, the smallest known species are the Etruscan shrew and the bumblebee bat, which weighs barely two grams. There are geckos and frogs just a centimeter or two long. The smallest fish ever observed is related to the goldfish; it lives in the Indonesian marshes and is seven or eight millimeters long.

These minuscule species are no more endangered than others, for they easily go unnoticed by the great predators. Except for fishes, the major risk for these species is drying out. Very small reptiles and amphibians rapidly lose the water from their bodies and must keep absolutely to a humid atmosphere. The birds and mammals face a further problem: they tend to chill or heat up very rapidly from the temperature of their surroundings. The regulation of their internal temperature consumes so much energy that they spend their lives feeding. Their longevity is very much less, for in each zoologic category we see a strong correlation between size and life span. There is probably some bottom limit to the size of a vertebrate animal. Such a limit would be different for a fish and a mammal, for they have different energy needs. So a very small size presents disadvantages, but there are advantages as well: Small animals are often prolific, and their populations are great; it is very easy for them to hide and to find food.

The "arms race" between predators and prey is probably an important factor in increasing size of certain species over the course of evolution. If an ecosystem contains only small species, then being larger is an advantage for the predators, for that broadens the range of potential prey for them to capture. But then the prey also have an interest in growing larger. From one generation to the next, a change in size comes through simple mutation. The probability of such mutations appearing is greater when generations come in rapid succession and the descendants are many, which is more often the case for smaller species. One can envision a simple, efficacious selection mechanism— say, a preference among females for larger males—that would soon bring about an increase in the average size of the species. Significant size variations can thus occur in just a few hundred or thousand years. For island animals, in the absence of predators, the very small species have an advantage in becoming larger, for they then expend proportionally less energy.

Edward Drinker Cope, an American paleontologist from the late nineteenth century, believed he had discerned an evolutionary tendency toward increased size, which could be explained by the advantages it would afford to species. He based his idea mainly upon fossils of the ancestors of horses, of which the oldest examples were the size of a fox. This theory, which came to be called Cope's law, prevailed in biology for a long while, but more systematic observations showed that evolution also moves in the opposite direction. In the horse family some species appeared that were smaller than their ancestors. The same thing happened in the island species that became dwarf forms. We also see that the largest land animals of our day are markedly smaller than the largest animals in the past.

As to very small species, evolution toward still lesser sizes is necessarily limited. Rather, there develop larger species, which translates statistically into an average increase in fauna size, even though minuscule species are still present. Later on, random mutations will bring species that are larger, the same size, or smaller, depending on circumstances. Since the ecological niche for the small species is generally already filled, however, natural selection is more likely to favor larger species. Animals' tendency to increasing size is actually just the effect of a random testing of all their evolutionary possibilities according to the constraints of their environment. The countless throng of insects beneath our feet, and of mice in the fields, is daily proof of the advantage of being small—and staying that way.

—
Hippopotamus, *Hippopotamus amphibius*. Africa (s.h. 1.35 m)

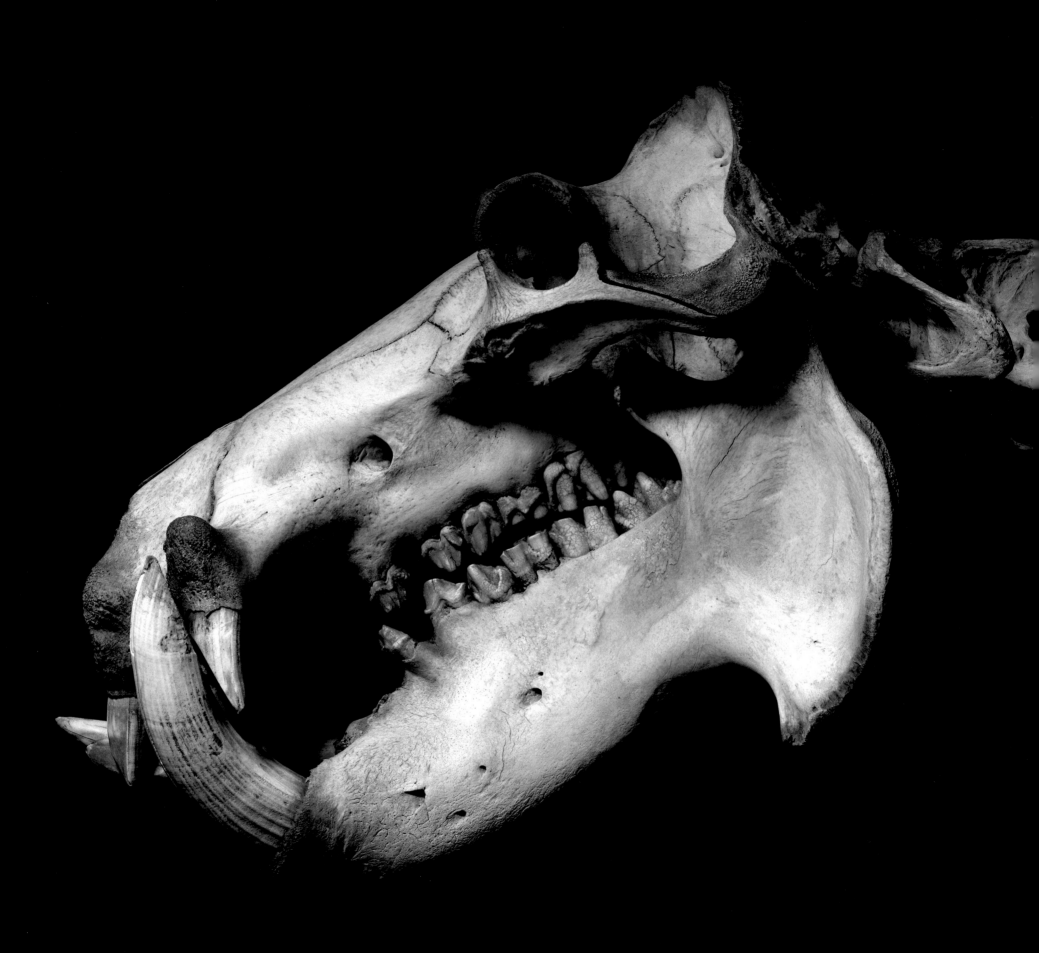

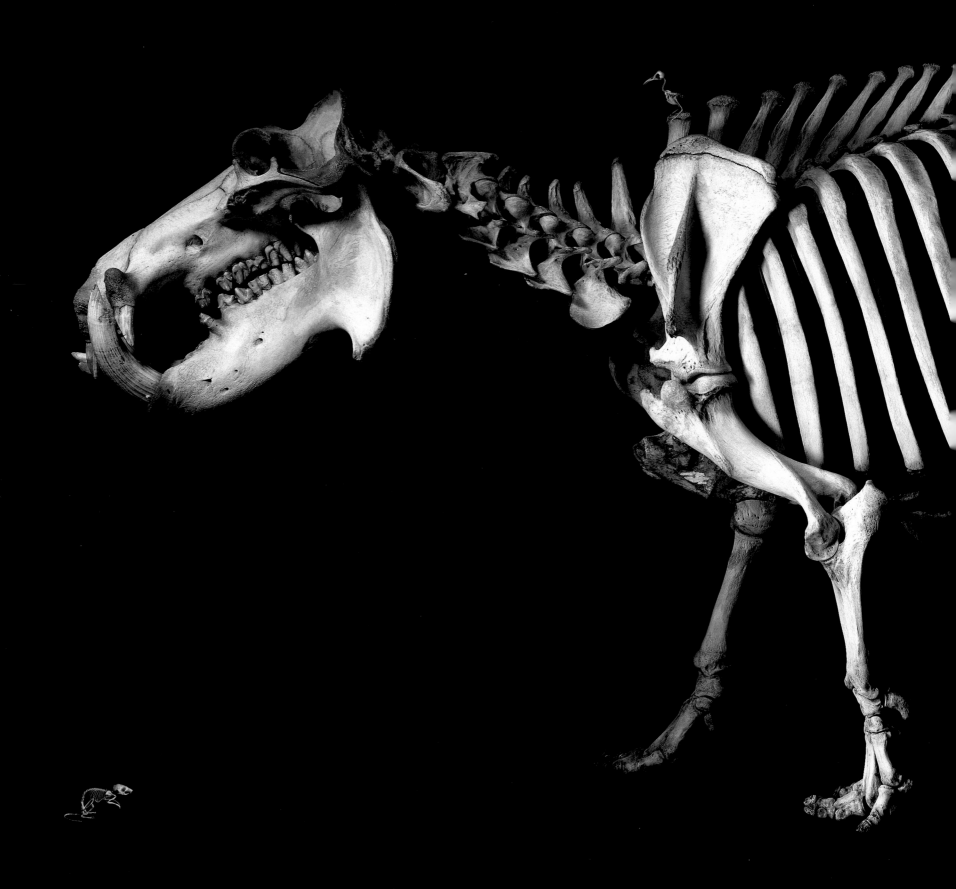

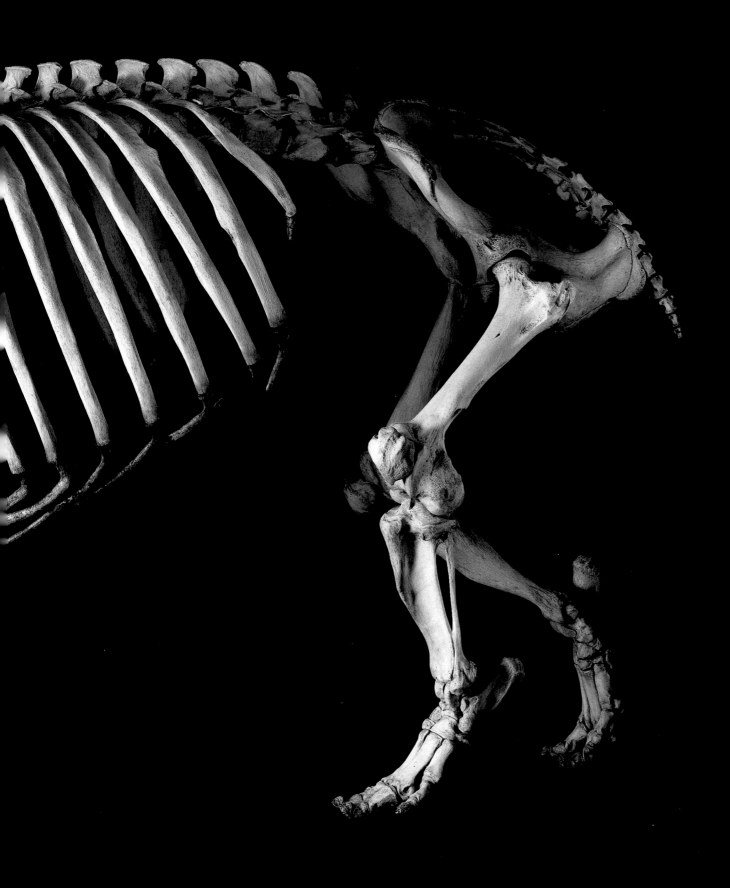

Wood mouse, *Apodemus sylvaticus*. Eurasia, North Africa (l. 18 cm)
Hippopotamus, *Hippopotamus amphibius*. Africa (s.h. 1.35 m)
Souimanga sunbird, *Nectarinia souimanga*. Madagascar (h. 6 cm)

CHAPTER 7
THE FALSE FISHES

Fishermen, fishmongers, and zoologists today recognize more than twenty-five thousand species of fish, a number that amounts to nearly half the world's vertebrates. Although their distribution is limited to the aquatic regions (no terrestrial fish exists) they are extremely diverse but easy to identify: the fish is an animal living in water, equipped with fins and an internal spine. For the zoologist, that definition does not reflect their evolutionary history. The most numerous fishes are the teleosteans, such as salmon and barracuda, which are characterized by a bony skeleton. There exist other species that resemble fishes and live like fishes but are very distant from the teleosteans in structure and history. Researchers have had to abandon the term "fish," which no longer exists as a zoological category in current classification.

To understand this disappearance, we must look back to the origin of the different lines of vertebrates, at the start of the Primary (or Paleozoic) era. The first vertebrates, which looked like fish, are the ancestors of two distinct groups, the chondrichthyans and the osteichthyans. These days, the first includes the sharks and the rays. They differ from other fish by their cartilaginous, rather than bony, skeletons. Their scales are made of dentine and covered in enamel, like teeth. The gill slits open directly to the exterior, without the covering of an operculum.

The other group, the osteichthyans, soon split into two branches, the actinopterygians ("ray-finned") and the sarcopterygians ("fleshy-finned"). The actinopterygians include the teleosteans (the most usual fishes) and a few smaller groups, like the chondrosteans (sturgeons). The primitive sarcopterygians with the look of fishes gave rise to the tetrapods but have preserved their archaic form in at least one present day species, the coelacanth, which does not have a true vertebral column but rather a cord, a cartilaginous tube filled with a liquid that gives it some elasticity. Its fins are supported by bones and muscles, and are therefore very different from the supple ray fins of the actinopterygians. Oceanographers have succeeded in filming this animal in its environment, in deep rocky areas of the Indian Ocean. Its swimming movements do not resemble the usual movements of fishes but look like the walk of a four-footed creature. It puts forward alternately the front right and rear left fins, then the front left and rear right.

The coelacanth family was very diverse in the Devonian period, about four hundred million years ago. Some of them were adapted to a shallow marsh environment. They were probably able to emerge from the water to escape their predators or to seek new prey themselves. Indeed, these "fishes" had a rudimentary lung that allowed them to breathe out of water. Their feet were not powerful enough to carry them, but they could crawl over the muddy ground by a paddling action. Some of them effected a further adaptation in the terrestrial setting, their fins becoming paws. That is the evidence from a fossil recently discovered in northern Canada and described in 2006 under the name *Tiktaalik*, whose limbs were intermediate forms between fins and feet. It had no digits, but the wrist joint was mobile, with the potential to evolve toward the limb of the tetrapods. *Tiktaalik* gives us a good picture of the ancestors of the earliest tetrapods—big salamanders still very much bound to the aquatic environment. This line is the origin of all the terrestrial vertebrates, from lizards to elephants and to monkeys.

Today classification conforms to the evolutionary history of the species and to their real genetic relationships. The archaic sarcopterygians are the ancestors of both the coelacanths and the four-footed terrestrial vertebrates, but their group constitutes a very different line from that of the actinopterygians, the spiny-finned or ray-finned fish. Consequently, the coelacanth is not a fish. Like the *Tiktaalik*, it is more closely related to the cow than to the salmon.

The lamprey is another strange "false fish." Its body looks like an eel's, but it lacks certain essential features. The lamprey indeed has neither teeth nor jaws. It does have a mouth, but it is a simple circular orifice armed with horny points. It uses them like a suction cup, to attach to a fish, lacerating its flesh and feeding on its blood. The lamprey gives us a picture of the first vertebrates which, like it, lacked jaws. As with the coelacanth, zoologically speaking it is artificial to place it in the same group as the salmons or the sturgeons.

The fact of possessing an elongated body and fins, of living in the water and of breathing with gills, is only a collection of primitive characteristics common to all the earliest vertebrates. Now half their descendants retain these features and therefore have the look of fishes, but

present day zoology looks at evolution's innovations (the derived features) and not the ancestral ones. The presence of a jaw relates the shark closer to the cow than to the lamprey; the coelacanth's fleshy fins make it a much closer relative of the four-footed terrestrial vertebrates than of the ray-finned fishes.

Contrary to his contemporaries, Aristotle very properly considered dolphins to be mammals and not fishes. Today it's the turn of the coelacanth, the lamprey, and the sharks to quit that group. Ecologically, the coelacanth and the shark are unquestionably fishes; zoologically, they are not among the Fishes.

—
Opah, *Lampris guttatus*. Western Atlantic Ocean (l. 1.10 m)

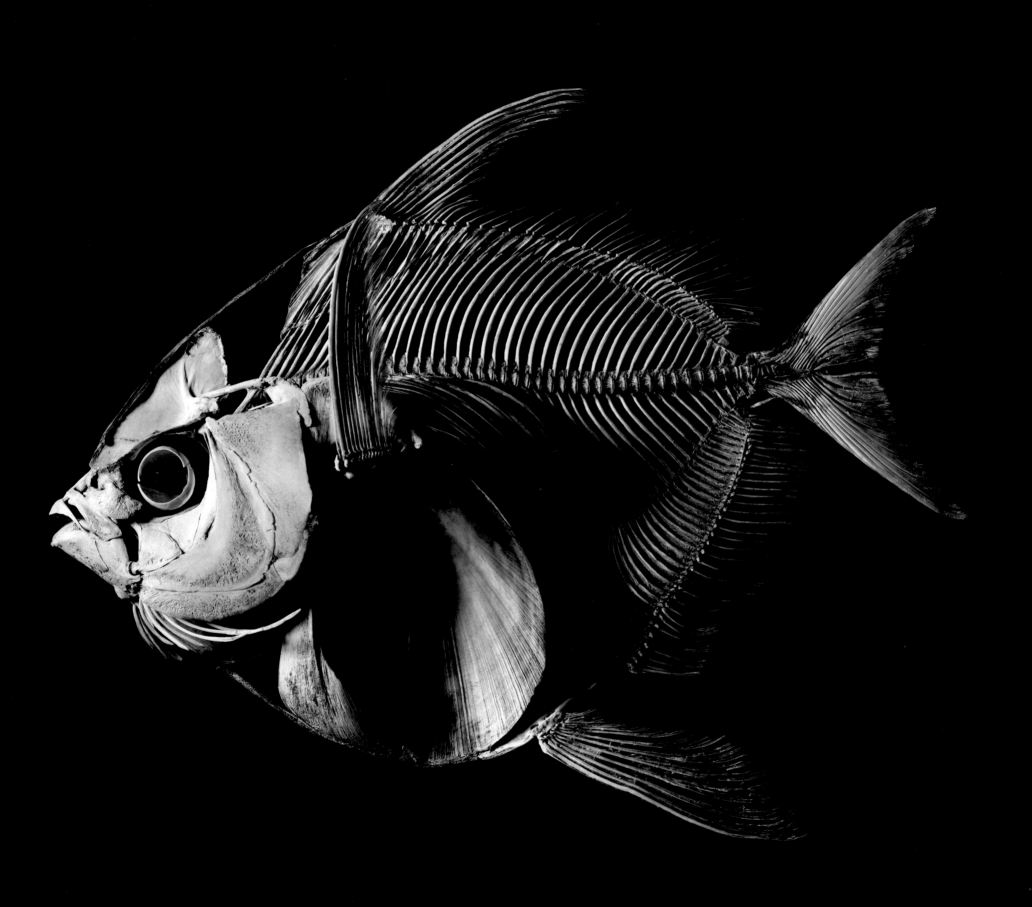

Sailfish, *Istiophorus sp.* Tropical and temperate seas (l. 2.35 m)

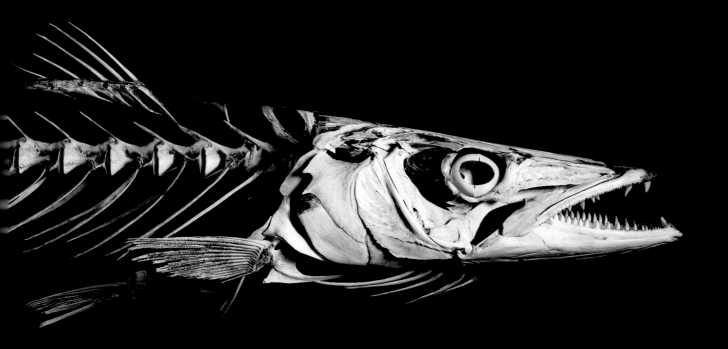

Great barracuda, *Sphyraena barracuda*. Tropical and temperate seas (l. 1 m)

Nurse shark, *Nebrius ferrugineus*. Pacific Ocean, Indian Ocean (l. 1.80 m)

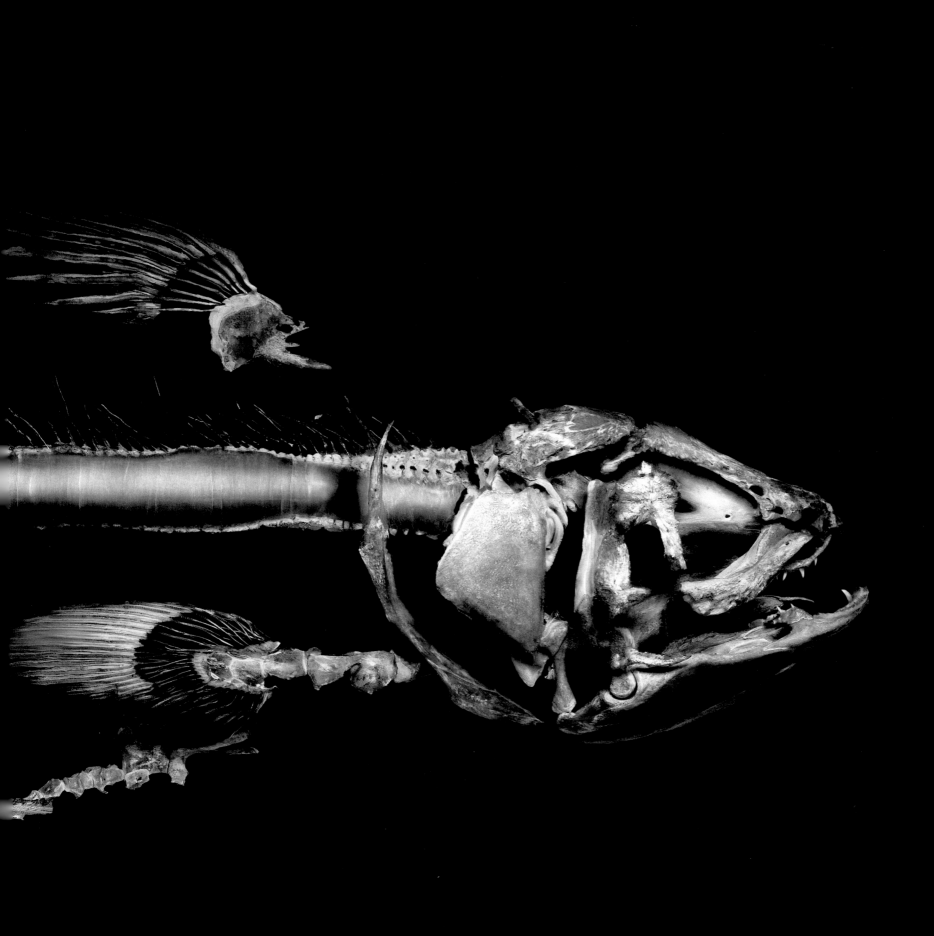

Coelacanth, *Latimeria chalumnae*. Indian Ocean (l. 1.15 m)

CHAPTER 8
THE EXPLOSION OF THE FIVE CLASSES

Naturalists have long tried to make some sense of the extraordinary diversity of the living world. In the beginning, one of the objectives of classifying plants and animals was to understand the Creator's intentions through an inventory and analysis of His work. When natural history succeeded in freeing itself from the corset of religion, the systematizers pursued their labors within the framework of evolutionary theory. They were faced with several difficulties. Comparing animals that were very like one another, they would have to untangle the complex skein of the relationships among species, subspecies, and varieties—very difficult to define and the topic of endless discussion. Conversely, the relationships among animals belonging to different branches seemed to defy the imagination, with any comparison seeming impossible. Between these two extremes of zoological pictures, the grouping into families, orders, and classes could be managed on the basis of fairly simple anatomical criteria, even though certain animals, like the platypus, seemed to elude any classification [see page 266].

In the fourth century B.C., Aristotle had already defined four groups among the "sanguines" (a category corresponding to the vertebrates): the hairy quadrupeds, which give birth to living young (the mammals), the hairless quadrupeds, which lay eggs (reptiles and amphibians), the birds, and the fishes. These four groups were taken up by the classifiers, who simply added a further distinction between amphibians and reptiles, thereby arriving at the five classes accepted until the twentieth century.

These five classes differ in the skeleton, the body covering, and the mode of reproduction. Thus, the fishes have no feet, are covered in bony scales, and lay eggs in the water, an environment from which they almost never emerge. The skin of amphibians is naked and glandular; most of them pass through an aquatic larval stage and then metamorphose and breathe in air, returning to the water to lay eggs. The reptiles have skin covered in horny "scutes," and they lay eggs protected by a shell that renders them independent of the watery environment. The birds are characterized by their plumage, their wings, their toothless beak, and their eggs protected by a calcareous shell. The mammals have fur (sometimes very minimal) and give birth directly to young, which they nurse with milk from their mammary glands; other characteristics also separate them from the rest of the vertebrates, like the jointed jaw and molars with several roots.

Originally, this classification assumed nothing about the evolutionary relationships among the species, but it was easily incorporated into the theory of evolution, which located the arrival of each of the five classes in the history of life. Fossils did indeed show that these different groups made their appearance in succession: first came the fishes (in the broad definition), followed by the amphibians, then by the reptiles, and finally the birds and the mammals. These classes seemed to correspond to a certain hierarchy, with the fishes located at the bottom and the mammals at the summit. Some naturalists had thus theorized a "ladder of organized beings." They considered that the fact of bearing young was more complex, more "evolved," than laying eggs, and that producing one's own body heat (the endothermy of birds and mammals) was an advance in comparison to the variable temperature (or ectothermy) of the fishes, the amphibians, and the reptiles. They could then interpret the order of arrival of the five classes in the history of the world as an example of evolutionary progress, with the fish at the very bottom of the ladder and man perched at the top. But to other naturalists, that ladder could not reflect the real complexity of the living world. Thus Lamarck, for instance, felt that birds were not intermediate forms between reptiles and mammals, but constituted a line parallel to that of mammals. The ladder of the creatures must therefore be divided into two lineages, that of mammals and that of the birds. The ever-finer description of the different zoological groups then led naturalists to abandon the "ladder" idea, in favor of another image shaped by the model of the genealogical tree. The initial tree, with two branches, became a bushy shrub whose many ramifications included the whole range of the animal species. In 1867, Ernst Haeckel proposed a "genealogical tree" of the vertebrates, which would be utilized until our own time, with a few modifications allowing for the integration of new species, fossil or living (the coelacanth, for example).

Current classification reflects the history of the zoological groups. The phylogenetic tree has, of course, been somewhat modified in view of paleontological and zoological discoveries, but its transformations are mainly the result of the new approach to classification mentioned above—the "cladistic"—which assigns animals to a group by the new, "derived" characteristics shared by them and only by them, without regard to resemblances due to archaic features. If a classification relies on the history of species, it becomes very difficult to define the hierarchic levels of the groups because they all emerge at different times, out of groups that themselves descend from one another. Thus, because birds descend from certain dinosaurs, their group should be included among the reptiles. So putting the bird and reptile classes on the same plane is meaningless as regards evolution. And these days, the reptile class is considered to be an artificial grouping. The fishes class has disappeared for the same reason [see page 46]. The five traditional classes have therefore been replaced by a number of groups that do not branch off at the same levels in the phylogenetic trees [see page 281].

Cladistics does not change much in our daily life; to our eyes, the shark is still a fish, and the serpent a reptile. The only really visible differences are located in the museums of natural history, which have profoundly remodeled their presentation of the world of vertebrates. In the old phylogenetic trees, the mammal class was often represented higher up than the other classes, with man dominating the animals. Today our species is no longer set at the top of the ladder, but among all the others, at a point that corresponds only to its evolutionary history. All the species are equal, even though, through its effect on the global ecosystem of our planet, one among them is more equal than the others.

Carp, *Cyprinus carpio*. Eurasia (l. 35 cm)

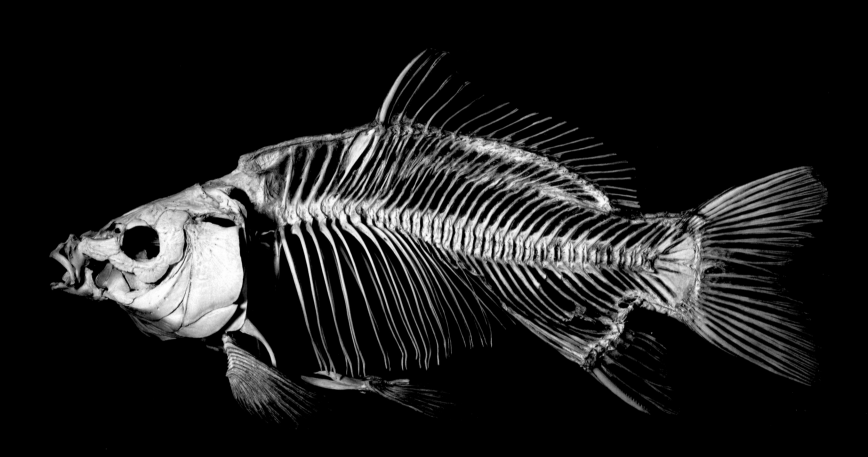

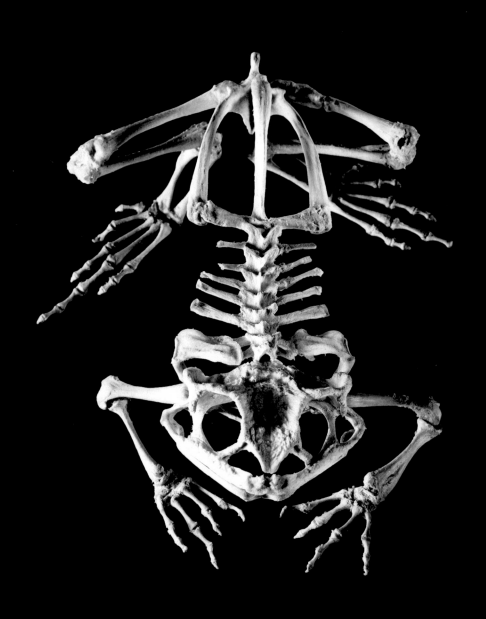

Cane toad, *Bufo marinus*. Tropical America (l. 15 cm)

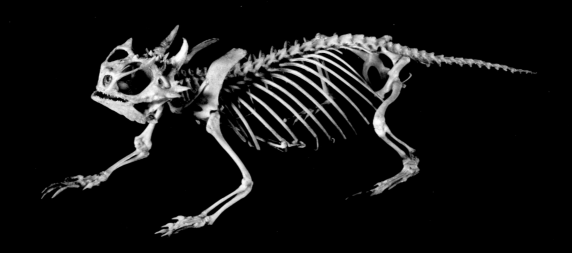

Horned lizard, *Phrynosoma cornutum*. North America (l. 11 cm)

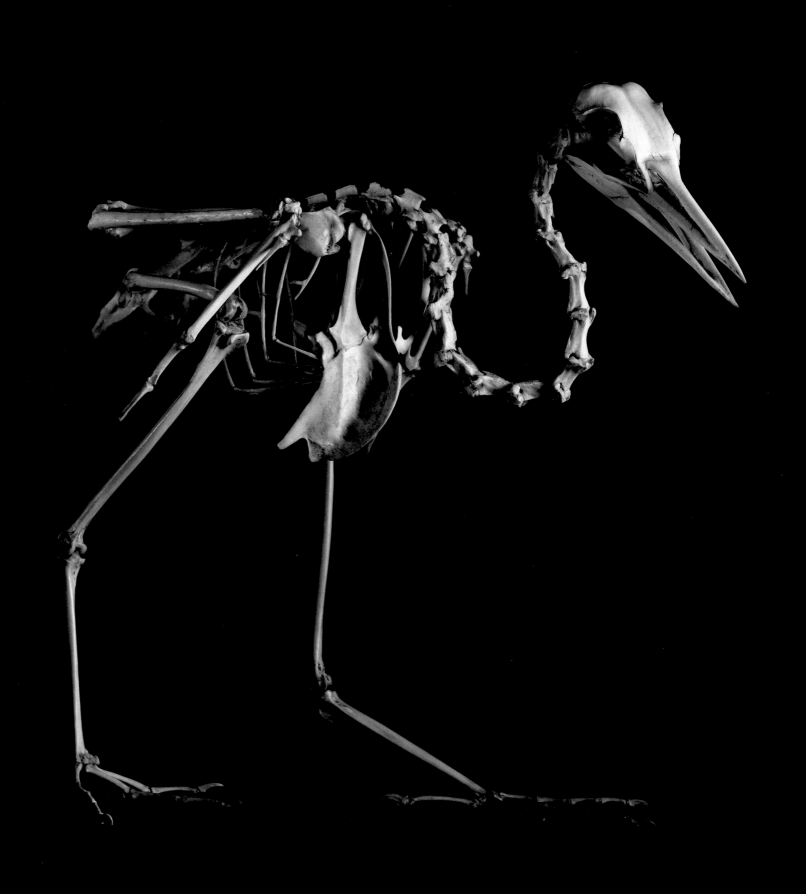

Black-crowned night heron, *Nycticorax nycticorax*. Africa, America, Eurasia (h. 32 cm)

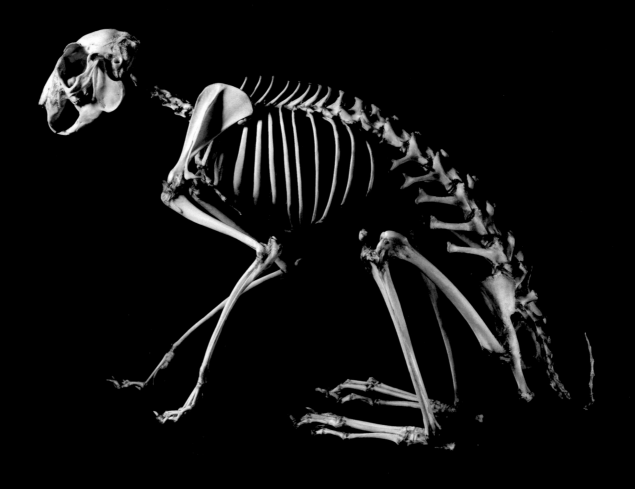

Mountain hare, *Lepus timidus*. North America, Eurasia (l. 42 cm)

CHAPTER 9
ANIMAL STRUCTURES

Even though for us they are the most familiar animals, the vertebrates make up only a small proportion of animal biodiversity: there are about fifty thousand species of them (fishes, amphibians, birds, reptiles, and mammals), whereas by most estimates there are between five million and twenty million animal species in the world. (These figures are extrapolated from various kinds of observations, which explains their vagueness.) The earliest classifications simply set out vertebrates as against invertebrates, but the existence of forms that were extremely different from one another in the second category forced naturalists to subdivide it. A crab's structure is so far distant from that of an octopus that the two creatures might just as well come from two different planets. In the nineteenth century, one question seriously divided naturalists: Is it imaginable that these animals could have a common ancestor, or must they be considered representatives of irreducible divisions in the animal kingdom?

Of course, this question was linked to the question of evolution itself. For instance, Cuvier recognized four large categories of animal, called phyla: Vertebrata, Arthropoda, Mollusca and Radiata. For him, these branches had no phylogenetic relationship, since the species were "fixed" and therefore could not have descended from some common ancestral species. Conversely, as he sought to establish the common origin for vertebrates and mollusks, Geoffroy Saint-Hilaire had provoked Cuvier's jeers by arguing that it could take a mere twist to move from an cuttlefish's anatomy to a vertebrate's. With no proof, though, he did not manage to convince his colleagues. Today biologists count nearly forty phyla that are distinct from one another by the animals' deep structure.

For instance, vertebrates are associated with two small groups of marine animals, the cephalocords and the tuniciers, in the Chordates phylum. All the members of that phylum possess, at least in the larval stage, the sketch of a spinal column: the "chord." Another phylum, the echinoderms (sea urchins and starfish) are characterized by a five-fold radial symmetry. The mollusks include bivalves (such as oysters and clams), gastropods (snails), and cephalopods (octopus and squid). Despite their differences, these animals have a strong resemblance at the larval stage, and in adulthood display a similar arrangement of the soft organs. The cnidaria include the corals, the jellyfishes, and the sea anemones. These animals present a radial symmetry on the order of four, six, or eight, according to the groups. Some of them, like the corals, build a calcareous skeleton. Sponges are aquatic animals that make up the "spongiaires" branch. This group is divided into three very distinct entities according to the nature of their skeleton: for example, *Euplectella* is a hexactinellid, the siliceous-sponge phylum.

The arthropods constitute another branch, characterized by an exoskeleton of chitin (a material different from both bone and horn) and appendages made up of articulated tubes. Among them, crabs and sea spiders are easily recognized by their rigid shell, their five pairs of legs (one pair is pincers), and the abdomen pulled in beneath the belly. Furthermore, crabs, like vertebrates, have a bilateral symmetry, with their right and left halves mirroring one another. In a crab, front and rear, belly and back, are easily recognized, but it has no distinct head, for that part is fused to a large body-section into a cephalothorax. Crustaceans share a number of features with insects, which are distinguished from them by their three pairs of legs and two pairs of wings (sometimes lost). Crustaceans, insects, spiders, and centipedes have the same structure, although their appendages have neither the same number nor the same form. On the other hand, these arthropods differ from the vertebrates not only in form and size but also in the deep structure of their anatomy. Their carapace is a support structure to which the animal's muscles attach, but it is not homologous to the internal skeleton of vertebrates. An arthropod's exoskeleton is mainly made of chitin and not of ossein. Moreover, the chitinous matrix is impregnated with calcium carbonate rather than with calcium phosphate, as in vertebrates. The soft organs also exhibit the differences between the two phyla: in vertebrates, the spinal cord lies between the digestive tract and the back; in a crab or an insect, the nerve cord (the equivalent in function to the spinal cord) is situated beneath the digestive tract. Thus, their anatomy seems to set up a fundamental contrast between chordates and arthropods.

The differences between phyla are so profound that it is very difficult to discover how they are related. These groups diverged more than six hundred million years ago, at a time when most animals did not produce a skeleton and therefore did not leave fossils. But today's anatomical research is enriched by the contributions of molecular biology. All present day animals (as well as plants and bacteria) share fundamental molecular characteristics, such as DNA, which constitutes one of the most convincing proofs of their common origin. Certain genes that play an essential role in expressing the animal's organizing scheme are common to the different phyla, with small modifications from one group to the next. Because they act at the very start of embryonic life, it is understandable that minute differences in their expression should lead to structures that are very diverse.

Similarly, the genes that in the embryo organize the development proper to each anatomical realm have points in common. They all show a homologous sequence, called "homeobox." For instance, biologists have discovered that the gene that governs the formation of the belly in an insect is homologous to the gene that produces the back in a vertebrate. This permits us to understand the inverse positioning of the nervous system and digestive tract in those two phyla. It also helps settle the debate between Cuvier and Geoffroy Saint-Hilaire: though he was wrong about the details, Geoffroy Saint Hilaire was right about his basic conclusion, the common origin of these animals. The crab's skeleton is not homologous to the fish's skeleton, but the crab's back is homologous to the fish's belly.

—
Sea spider, *Cyrtomaia cornuta*.
Southwestern Pacific Ocean (l. 20 cm)

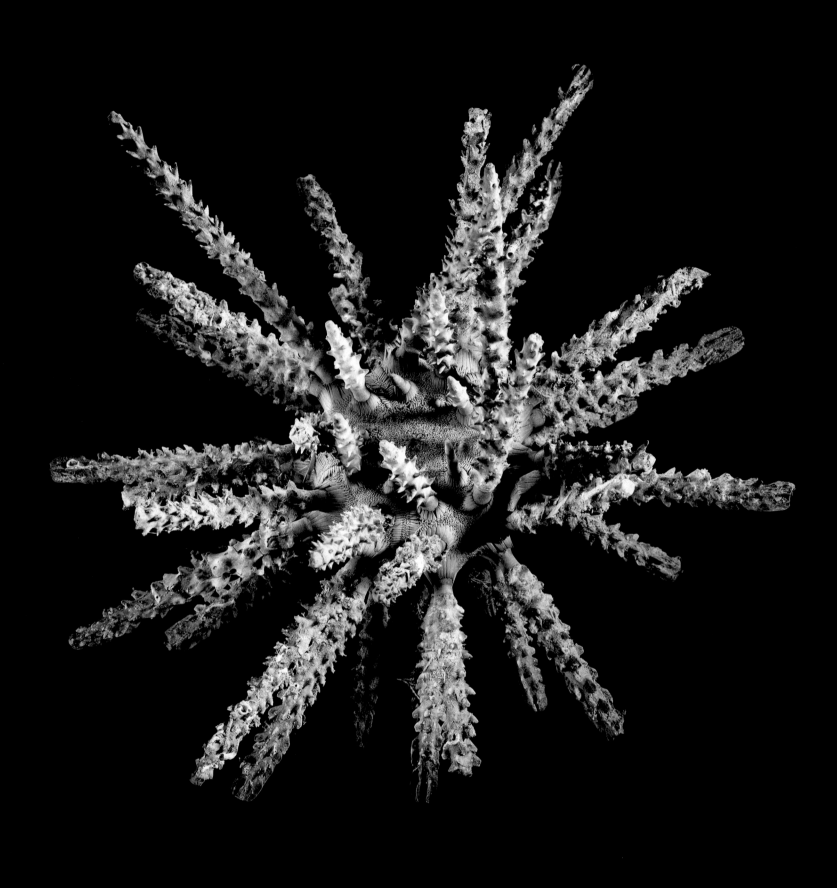

Rough-spined urchin, *Chondrocidaris gigantea*. Pacific Ocean (diam. 17 cm)

Rose-branch murex, *Chicoreus sp.* Indo-Pacific Ocean (l. 9 cm)

Pocillopora, *Pocillopora sp.* Indo-Pacific Ocean (diam. 23 cm)

Glass sponge, *Euplectella aspergillum*. Western Pacific Ocean (l. 26 cm)

PART II
THE BIRTH OF SPECIES

The animal kingdom has not always been as diverse as it is today. Seven or eight hundred million years back, the first animals to appear in the oceans—after their one-celled ancestors—were minute, and probably fairly similar, at least in their morphology. About five hundred forty million years ago, their diversity abruptly exploded. Hundreds of thousands of species appeared, more and more varied in size and structure. Fossils show that the earth then underwent several episodes of mass extinctions, which brought a collapse in biodiversity. Each time, the survivors rebuilt the rich array of fauna, their descendants moving into the ecological niches left vacant by the extinctions. All through the history of the Earth, the evolution of living things has combined two complementary phenomena: a transformation of species over time, and an increase in the overall number of species through division of a mother species into two different daughter species. Darwin's first book, *The Origin of Species*, did not use the word "evolution," and his principal subject was indeed the emergence of species, or "speciation." To bring other naturalists and the larger public to acknowledge the idea of evolution, Darwin explained through many examples how animal transformations could lead to the birth of new species.

The first obstacle Darwin encountered was the "typological" notion of species, which predominated at the time in the field of natural history. According to that concept, the living animal is merely the imperfect materialization of an ideal type. Each species is described by an individual embodying the type, and any variations do not matter. As these types are considered perfect, and immutable, the species have no reason to evolve, and they remain "fixed." This concept was the basis of the "fixism" advocated by some naturalists, including Cuvier in France and Richard Owen in England, who rejected any notion of evolution. Darwin, in contrast, insisted on the importance of the variations within

species. Today this anatomical or genetic diversity in species is called "polymorphism." Biometrics now lets us evaluate the nature and extent of the variability: the length of the body and of various bones, the number of vertebrae, and so on.

The differences between individuals result from their life conditions but also their genetic makeup. Each individual possesses its own genetic patrimony, different from that of its congeners. The genetic diversity of a population also increases as a result of sexual reproduction, which brings about a random redistribution of the parental genes in each generation, but also as a result of mutations. These DNA modifications constitute the main source of innovation in the anatomy, physiology, and behavior of animals [see page 74]. Because of this polymorphism, not all the individuals of a population are equal in the face of environmental constraints: the climate, diseases, availability of food, presence of predators, access to reproduction. Some among them will have a better capacity for survival than others and, most important, will produce more descendants. Their own genetic characteristics, transmissible from generation to generation, therefore tend to spread throughout the population. "Neutral" mutations—that is, those with no significance for the animals' adaptation to their environment—may also spread by mere chance.

In its natural environment, every species is subjected to a great number of constraints. The climate may change, and modify the vegetation the species feeds on, or on which its prey feeds. Its own predators are also evolving, and new species may invade its environment. Parasites weaken it, and diminish its capacity to survive and reproduce. The species will thus be constantly evolving, according to mutations that create new abilities and to pressures exercised by the selection process. The result of natural selection will not be a species ever more

powerful and prolific, but rather a continual adaptation to the changing conditions of life. If its environment is fairly constant—for instance, in the depths of the ocean—the species will evolve only slowly. On the other hand, if the climate changes rapidly, as in ice ages, the fauna undergo accelerated changes.

Most species are made up of several populations that are geographically separated. Each of these populations is characterized by a genetic structure peculiar to it as the effect of mutations, since such mutations occur randomly and affect genes by chance as well. When the anatomical differences are significant, and concern two populations of the same species completely separated geographically, zoologists speak of geographic varieties, or subspecies. The individuals are able to reproduce together, so they can be considered as all belonging to the same species [see page 70]. But when two populations of a species are separated by an obstacle that the animals cannot circumvent, exchanges between the populations diminish and often cease completely. Each population will evolve on its own, and acquire new characteristics in response to its own environment and its own genetic legacy. The divergence may then reach a point of rupture: individuals of the two populations no longer recognize each other as belonging to the same species, and they can no longer reproduce together, even if the obstacle that separated them is removed and they can again take up contact. That reproductive barrier is not always total; two species, as they evolve, may keep some of their capacity to breed, as is illustrated by mules, the hybrid offspring of a donkey and a mare [see page 76]. When the two sister species diverge again, any reproduction becomes completely impossible.

A speciation scenario favored by biologists is one that is based on individuals who are few in number, geographically isolated from the main population, and

representing only a fraction of the original diversity of their species. In such conditions, a favorable mutation can spread rapidly and bring about a divergence of this marginal population from the original species. This may have been the kind of phenomenon that occurred in a brown-bear population and led to the emergence of the polar bear [see page 82]. The advent of a new species is easy to understand when an ocean or a mountain range separates the two populations, but in some cases speciation can arise at the very heart of a population—for instance, through chromosomal mechanisms, as witness the current evolution of the house mouse in Europe [see page 88]. If the daughter species develops parallel to the original species, the overall number of species grows gradually. Because this process requires time, often several thousand years, it is impossible to study it as it goes on. Still, we can observe its effects in the case of such "ring species" as the seagull [see page 86], whose populations show us in space a picture of what has happened over time.

In the course of evolution, the daughter species themselves give rise to new species, the whole set bringing about a great number of related species. We can outline a group's evolution as a rather thickly branched shrub. Some groups are quite poor—for instance, if they are reduced to a few species that are very specialized—and isolated over restricted territory. Others, like rodents and sparrows, are rich, with several thousand species which molecular biology has proved all descend from a single ancestral species [see page 90]. That type of evolution leads to an intensive exploitation of environmental resources, with each species specializing as to the available foods, the local climate, and the predators it faces. Researchers have thus studied in detail particular zoological groups that are especially interesting because they clearly reveal certain mechanisms of speciation. This is the case with bears, with sparrows, and with cuckoos, which specialize in "nest" or "brood" parasitism [see page 92]. Other examples are harder to study but especially important for us—like the event that caused the appearance of a new line of bipedal monkeys with big brains, the ones we descend from [see page 94].

The mechanisms of species transformation and speciation are an important focus of research for biologists. The general principle, through differentiation and selection, is almost universally acknowledged, but a good many points still remain unclear. The respective roles of chance and selection in the birth of new species are not always easy to calculate. For instance, mutations might be eliminated randomly, quite apart from any direct activity of natural selection, merely because the individual carrying the gene did not produce descendants. Studying changes in the genetic legacy of populations does have concrete applications that are sometimes significant, like the spread of a mutation that raises resistance to insecticides in a population of mosquitoes. Another much discussed point is whether the birth of species helps us understand the divergence among higher level taxons such as classes and phyla. In other words, does macroevolution follow the same mechanisms as microevolution? There is no difference in nature between variability within a species (among individuals) and variability among species within the same genus. Anatomical changes are minor, like their genetic basis. These simple mutations have long seemed insufficient to cause profound transformations in the structure of individuals. Conversely, more important changes in DNA were considered a priori to be not viable, and quickly eliminated by natural selection. Today biologists explore trails that might explain how zoological phyla came to be—for example, through mutations affecting the homeotic genes, the ones that determine animals' very structure [see page 62].

CHAPTER 10
ATHENE NOCTUA

There is no such thing as an Owl, except in myths and fairy tales. The capital initial makes a symbol of it, but that ideal creature is a simplification of reality. For the zoologist, there exist several species of owls, quite different in size, plumage, and behavior. Each of them is designated by a scientific name made up of two parts. The little owl is called *Athene noctua*: *Athene* is the genus to which it belongs, a collection of species that resemble one another and are listed in the same zoological category; the second part of the name, *noctua,* designates that owl as belonging to a particular species within the genus. It is distinct from, say, the spotted owlet, *Athena brama*, which accupies its place in India and Southeast Asia and differs by a few details of plumage. Meanwhile, the snowy owl is genetically closer to the Eurasian eagle owl than to any other. These two species are both part of a different genus and are respectively named *Bubo scandiacus* and *Bubo bubo*.

It was the Swedish naturalist Carl Linnaeus who in the eighteenth century organized this way of designating living species. Since that time, naturalists have described more than 1.2 million different animals, among them over fifty thousand vertebrates. The Latin double name lets zoologists avoid the confusions arising from the common names, which vary from region to region and might designate several different species. However, while this denomination system aids scientific communication, it is no help at all for defining what a species is biologically. Yet the notion would seem obvious: we distinguish immediately between a cow and a horse, a scops owl and an eagle owl, the little owl and the snowy owl. But more exacting observation of animals (and plants) immediately raises a number of questions. Are the visual resemblances between two individuals enough to put them in the same species? How much difference could be tolerated? And why not consider that the scops owl, the long-eared owl, and the Eurasian eagle are all just different-size individuals in a single species of night raptor? Size is only a secondary characteristic, but the three species also differ in behavior and anatomy. Moreover, they cannot breed together, whereas males and female of the same species are theoretically "interfertile" without regard to the individuals' particularities. This reproductive criterion is basic to the classic definition of species. According to Ernst Mayr, species are "groups of actually or potentially inter-breeding natural populations that are reproductively isolated from other such groups." In practice, interfertility is often impossible to verify—for instance, when two populations are physically distant. To observe whether they reproduce, the animals would have to be kept in captivity—but their behaviors would then be different, which would compromise the experiment.

Therefore we must often be satisfied with criteria of resemblance, which are themselves also hard to evaluate. In a single species, the male sometimes differs from the female, or the young from the adult. The head of the male elephant seal is very different from the female's, and he weighs three to four times as much. A boxer and a cocker spaniel are both members of the species "dog," *Canis lupus*, despite their quite different shapes. Zoologists can also consider an animal's genes, which may differ all the more between two individuals if they belong to groups that are geographically distant. So it must be determined what degree of (morphological or genetic) difference will lead to seeing them as two distinct species rather than two populations of the same species. But although comparing the DNA of two populations may give precise indications as to their degree of genetic differentiation, that does not always tell us whether there is gene flow between them and thus whether they can reproduce together.

It does happen that reproduction becomes impossible between two populations even though in theory they are interfecund—for example, when they are separated by a natural barrier such as a mountain range or a desert. The two populations then gradually diverge, and certain characteristics (coloration, song, behavior, and so on) make it easy to distinguish them with certainty. The zoologist can then consider them two subspecies. As time passes, if the differences grow more marked, these geographic varieties are no longer able to bear young together, and they are two distinct species. A species also includes all the individuals descending from one another—but to take account of that temporal dimension further complicates the definition. For instance, if a species is undergoing transformation, at what point—or rather, after how many changes—does it become a new species? The criterion of reproduction cannot be called upon to decide here, because these are individuals separated in time. It is nonetheless possible to compare the DNA of scraps of skin or bone that date several tens or hundreds of thousands of years apart.

Beyond that, we can only do the morphological comparison of fossils.

The notion of species, which is for practical reasons indispensable to anyone working in the field of living things, is usually fairly clear cut. This question may have important consequences, notably in the realm of protection for endangered species. In one instance, there were two populations of the Amsterdam rockhopper penguin, little penguins of the Southern Hemisphere, living in two far-separate archipelagos. DNA sequencing showed that the two populations are in fact two different species, since there is no genetic exchange between them. One of the species is abundant, while the other numbers only a few thousand birds that are seriously endangered by the local tradition of collecting their freshly laid eggs. Putting that population under the endangered species statute has enabled far more effective protection for them.

In *The Origin of Species*, despite its title, Darwin did not actually make explicit the notion of species as such, since he considered that doing so was to "define the indefinable." In our time, some evolutionary biologists are even proposing to abandon it, at least within their field of research, for they believe it more important to try to understand the mechanisms involved in the emergence of new species than to lock into a rigid framework something that is really a continuous process. It is because species keep evolving that they are so difficult to define.

—
Snowy owl, *Bubo niva*. Arctic regions (h. 26 cm)

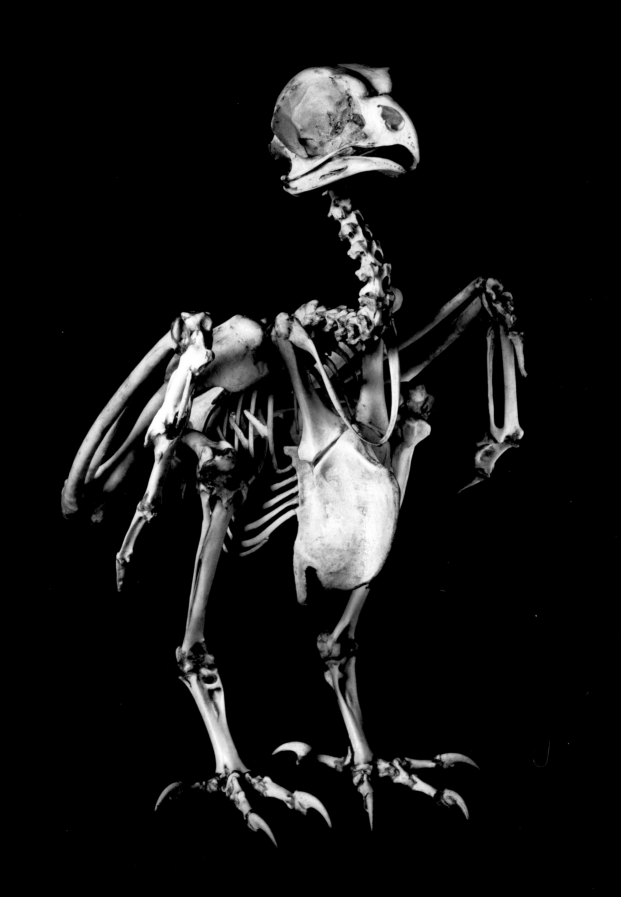

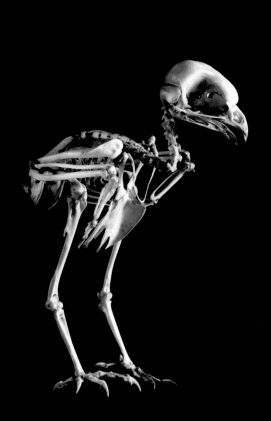

Little owl, *Athene noctua*. North Africa, Eurasia (h. 15 cm)
Common Scops owl, *Otus scops*. Africa, Eurasia (h. 11 cm)
Long-eared owl, *Asio otus*. Northern hemisphere (h. 16 cm)
Eagle owl, *Bubo bubo*. North Africa, Eurasia (h. 41 cm)

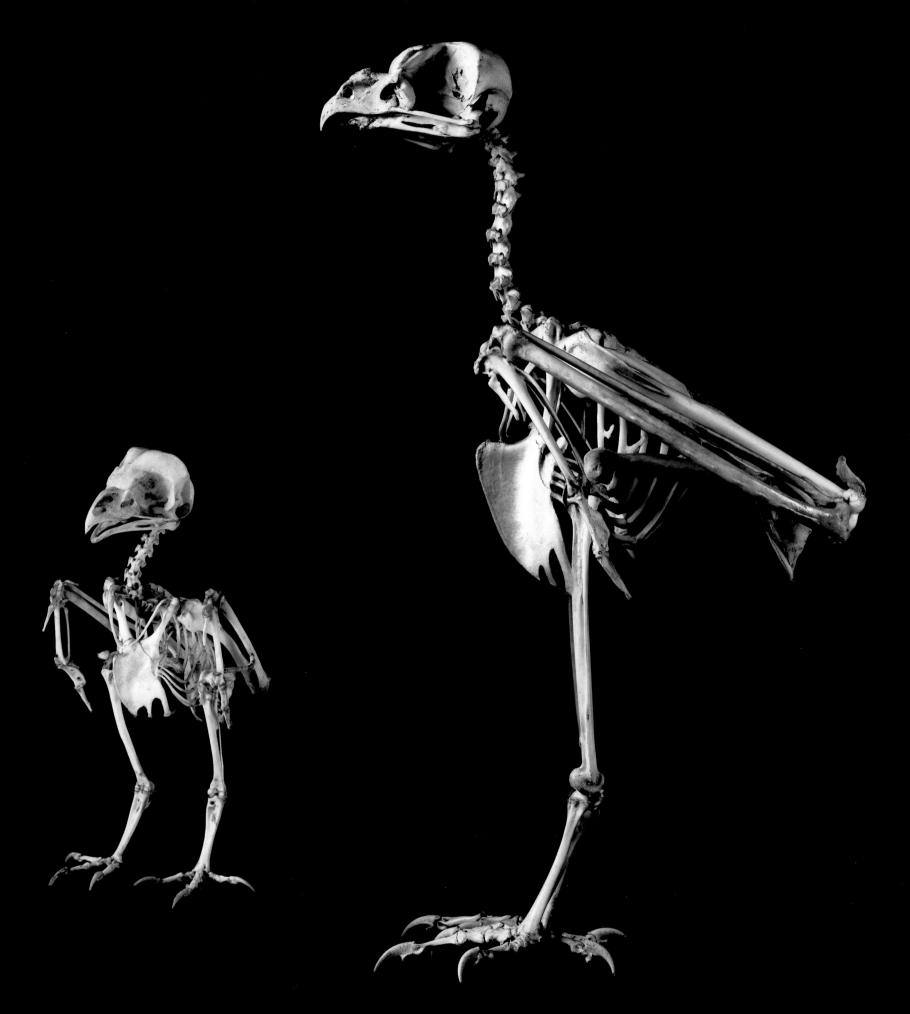

CHAPTER 11
ALL DIFFERENT

The more familiar a species is, the more easily we distinguish the individuals in it. We have no difficulty recognizing a particular human in a crowd of several thousand. With a little training, we manage rather easily to identify each cow in a herd or each dog in a pack. But all flies are the same to us, like all sardines or all hedgehogs. Yet it takes observing only a few individuals to quickly make out a number of small differences, from the length of a muzzle to the tint of the quills or the shape of the ears. These individual characteristics affect the skeleton as well, with a slimmer humerus, a broader shoulder blade, or an elongated skull. With a more detailed inventory, it is possible to note the most variable elements from one individual to another. And although we are more aware of diversity in humans, there is actually less of it in us than in most animal species, as is shown by detailed study of proteins and DNA.

Since Darwin, variation within a species has been considered a key element in evolution. It is important to distinguish between two types of variations, however. One kind comes from the individual's genetic heritage, and it can be transmitted to his descendants. These characteristics are "fixed," at least for several generations (since evolution may enter the picture and possibly change them). The second kind appears in the course of the animal's own life: climate, disease, or accidents that modify his behavior or his appearance. These changes are strictly individual and are not transmitted to offspring. The two types of variation correspond to what are traditionally called "innate" and "acquired." In the nineteenth century, it seemed obvious to most evolutionists that at least some of the "acquired" characteristics were hereditary. This was an important point in Lamarck's transformist theory, but Darwin also conceded that the phenomenon could contribute to evolution, even if the effect were only secondary. Later biologists demonstrated that characteristics acquired in the course of an animal's lifetime were not transmitted to descendants and therefore played no role in evolution. But hereditary differences—that is, genetic characteristics of the species—are essential.

These innate characteristics are determined by the genes, but still they are not immutable, because several mechanisms contribute to polymorphism—genetic diversity—in populations. The first mechanism is sexual reproduction. Every individual is the product of a random mix of the characteristics of each of its two parents. Each cell contains two strains of chromosomes, one coming from the father and one from the mother. Within its own sex cells, the chromosomes undergo exchanges that randomly redistribute the genes from the two parents. New combinations of genes appear, in the offspring and in each succeeding generation, among which natural selection will retain the most effective. This means that some of these combinations will turn up more frequently in the population because they confer on their carriers a better ability to survive and to reproduce.

The second source of innovation is mutations, also random, that affect the DNA. These modifications occur continually, in all the cells of the organism, under the influence of factors both natural and artificial. The sun's ultraviolet rays, radioactivity from rocks, and cosmic radiation can modify the DNA sequence, as can certain viruses and the "free radicals" produced by cellular metabolism. To these natural sources of mutation are added the effects of x-rays, of artificial radioactivity, and of many chemical substances. Larger changes also occur, like rearrangements within chromosomes or duplications of certain DNA fragments. Our cells are nearly all able to repair damaged DNA, but some mutations set in for good. Those that affect such organs as our skin, muscles, and brain remain limited to the cell where the change has taken place, and thus their incidence is not observable (though in some cases, the mutation causes a proliferation of the cell, which can lead to the occurrence of a tumor). When a mutation affects a sex cell, egg, or sperm, that later contributes to reproduction, the egg that develops from the fertilization will carry that mutation. Each cell of the new individual will also be a carrier, including some of its own sex cells. Thus, that mutation can be transmitted from one generation to the next. Occurring by chance, these genetic variations will be retained or eliminated by natural selection, according to their impact on the individuals' life.

The innate and the acquired are not always easy to distinguish, for the factors are sometimes inextricably bound together. For instance, in each species, the size of an animal depends on both genetic and environmental factors. The genes at least partly control the production of growth hormones and an animal's ability to locate food and to obtain it. Similarly, the environment creates factors that are more or less favorable, such as climatic conditions and the richness of dietary resources. Repeated situations of stress can also influence an animal's size. And depending on the conditions within which an animal develops and reproduces, the genes do not always express themselves the same way—that is, they do not produce the same effects. Except in certain pathologic cases, a given combination of genes is neither good nor bad in absolute terms, but it can be more or less efficacious depending on conditions. A mutation in a growth hormone, therefore, constitutes an innovation that will be retained or rejected according to whether it benefits the individuals. Natural selection does not act with a view to possible future changes in the environment but rather according to animals' real, immediate living conditions.

Certain factors can modify the expression of the genes starting at fertilization, from the very beginning of the individual's development. For instance, scientists have noted the occasional occurrence of a "parental imprint": the gene is expressed differently depending on whether it comes from the mother or the father. The position of the genes on the chromosomes and in the nuclei of the cells can also influence their expression, even though the DNA sequence is identical. Such not-directly-genetic factors are called "epigenetic." Mutations have been closely studied for a century now, yet this area is still little explored. It appears to be more and more important, however, since these mechanisms act directly on the diversity of populations and therefore affect their evolution.

—
European hedgehog, *Erinaceus europaeus*. Europe (l. 19 cm)

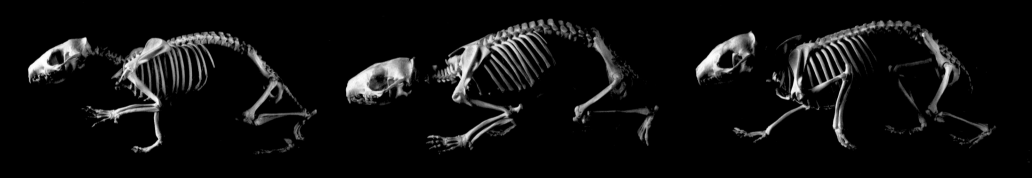

CHAPTER 12
HYBRIDIZATION

In his description of the donkey, published in 1753, Buffon raises the question of its resemblance to the horse: the donkey seems to be "only a degenerated horse." The relation between the two animals is for him the occasion for developing the notion of family, a subject of bitter debate among naturalists in his time. For Buffon, if several species are grouped into a single family, there is an implicit assumption that those species are related, and thus descend from a common ancestral species. Buffon rejects the idea of any possibility of profound transformation of species over time, but he does wonder about a transformation of lesser dimension; for instance, he describes how, under the influence of a difficult climate and scarce food, small wild horses might have become donkeys. The donkey's "degeneration" would thus be the expression of a relation to the horse. But the impossibility of breeding the two species—of obtaining a stable species through successive crossings between the two—led him to conclude that they had always been different.

The choice of the donkey and the horse for that demonstration was not fortuitous, for the two species are extremely similar, at least in their internal anatomy. When archaeozoologists find animal bones at an archaeological site, they can easily separate out the remains of equids from those of other species, whether cows, goats, or dogs. But among the equids, it is difficult for them to distinguish an ass from a horse, so alike are their bones. Size is not always a useful indication, for wild horses and ancient domesticated horses are not much larger than donkeys. If the skulls are complete, the angles of the bones to each other can be measured. The cannon bones, above the hooves, are equally significant for making the distinction, and they are often better preserved than the skulls. But the other limb bones and the vertebrae are not different enough to distinguish the donkey from the horse. Alive, the two species are impossible to confuse. Their coats, their tails, their ears are enough to identify them at a glance, and so are their cries and their behaviors. They themselves have no problem recognizing their difference, and they do not spontaneously seek to approach each other. Nor did their geographic origins predispose them to meet. Before they were domesticated, donkeys lived in the arid regions of East Africa, and horses on the Central Asian steppes.

The resemblances between their skeletons are the sign of a slim bond of relaltionship, a link confirmed by the possibilities of crossing a male donkey and mare, or male horse and female donkey; the hybrid offspring are called mule and hinny. There also exist horse-zebra hybrids and hybrids of horse and onager (a kind of great wild ass of Asia). The criterion normally used to distinguish species—the reproductive barrier—thus does not seem to apply exactly in the case of the equids. These hybrids are most often themselves sterile, however, which forbids any possibility of complete fusion of the two species. Moreover, hybridization does not occur in nature because these species do not live in the same regions and they have different behaviors. Only domestication permits breaching the barrier, through the use of special techniques. (For instance, the donkey is incited to couple with a mare by stimulating him beforehand with a visit from a female donkey in heat.)

Apart from behavior and geography, the reproductive barrier results from a difference in the number of chromosomes in the two species. A horse's cells contain sixty-four chromosomes, and a donkey's sixty-two. The egg from the fusion between an ovum and a spermatozoid from the two species contains sixty-three chromosomes. In the adult hybrids, this odd number seriously disrupts the production of the sex cells (ova and sperm), which explains why they are almost always sterile.

Hybridization, even incomplete, illustrates the limits of the definition of a species. The donkey and the horse descend from a common ancestral species, which lived in North America four million years ago. About two million years ago, that species crossed the Bering Strait, which was dry land at the time, and spread through Eurasia and into Africa. Each population adapted to a different new environment and evolved in its own direction. The donkey, for instance, acquired a greater resistance to the scarcity of water, but that evolution did not much affect the skeleton itself. The equids diversified, giving rise to horses and onagers in Asia; to asses in East Africa and the Middle East; and to the three species of zebras in Africa. Meanwhile, the ancestral species disappeared from America. The fact that hybridization can occur between these species is evidence that this history is very recent.

Buffon grasped perfectly the implications of the deep resemblances between the donkey and the horse: "If it is once admitted that there are families of plants and animals, that the donkey is of the horse family, and that it differs only because it has degenerated, then one could equally say say that the monkey is of the family of man: that it is a degenerated man; that man and the monkey had a common origin like the horse and the ass . . . If it is once proved that in animals and even in vegetables there be—I do not say several species, but even one single species—produced by degeneration from another species; if it were true that the ass is merely a degenerated horse, there would be no further limits to nature's power, and we would not be wrong to suppose that over time she has succeeded in drawing from a single being all the other organized beings." In its day, that evolutionist hypothesis was very bold, for it directly counters the biblical story of Genesis. This is probably the reason Buffon immediately rejected it, citing the Bible text as his principal argument against it: "But no, it is certain from Revelation that all the animals shared equally in the grace of Creation."

His equivocation may simply have been meant to fend off the blasts of censure. But today there is no longer any doubt: hybridization is the sign that a species is in the process of dividing into two, and that the process is not yet finished. The existence of hybrids constitutes a proof that evolution transforms species and brings about new ones.

—
Donkey, *Equus africanus*. Domesticated. Originally from Africa (s.h. 1.07 m)
—
Horse, *Equus caballus*. Domesticated. Originally from Asia (s.h. 1.50 m)

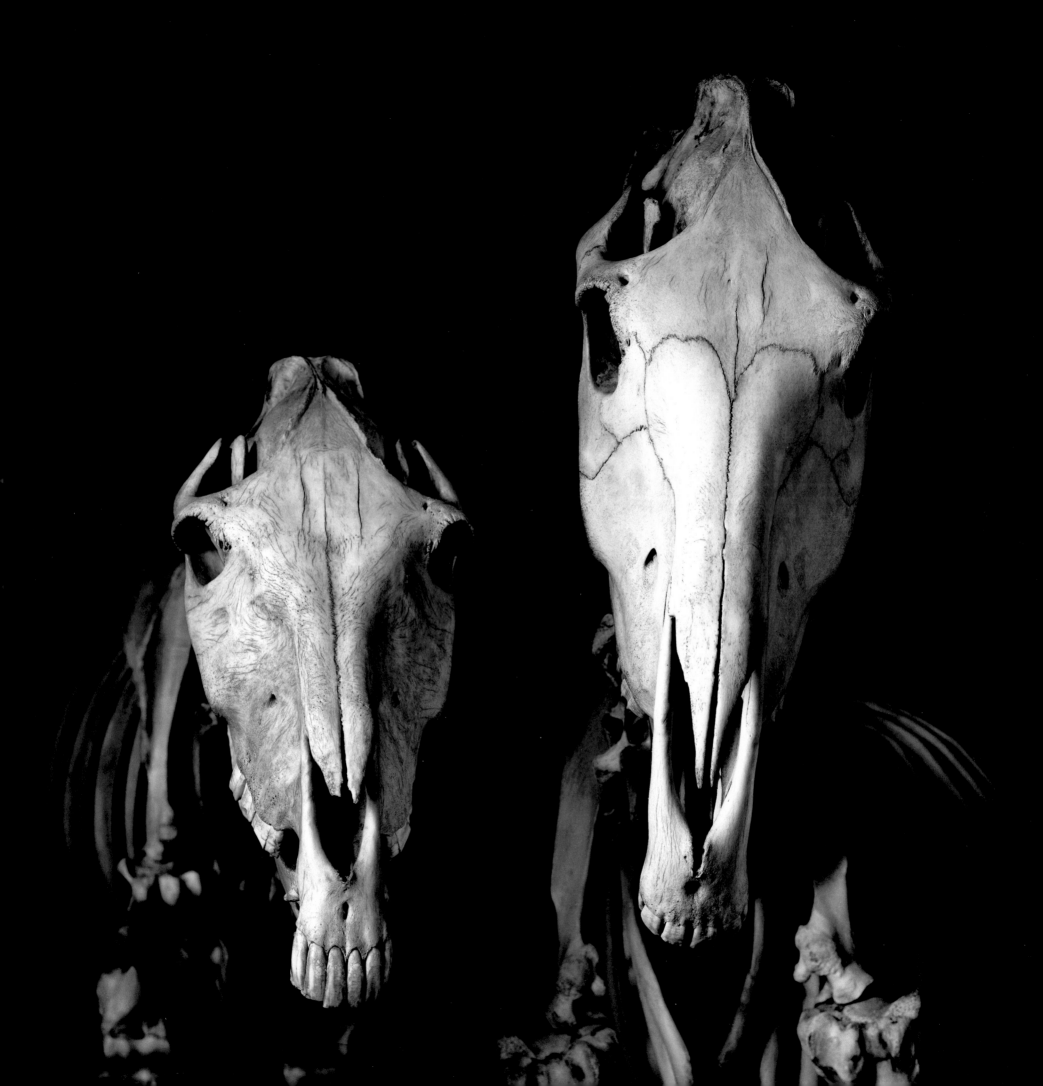

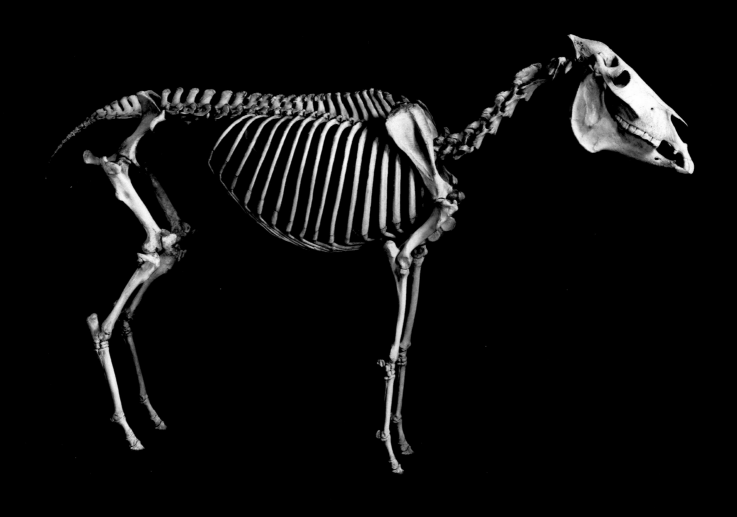

Donkey, *Equus africanus*. Domesticated. Originally from Africa. (s.h. 1.07 m)

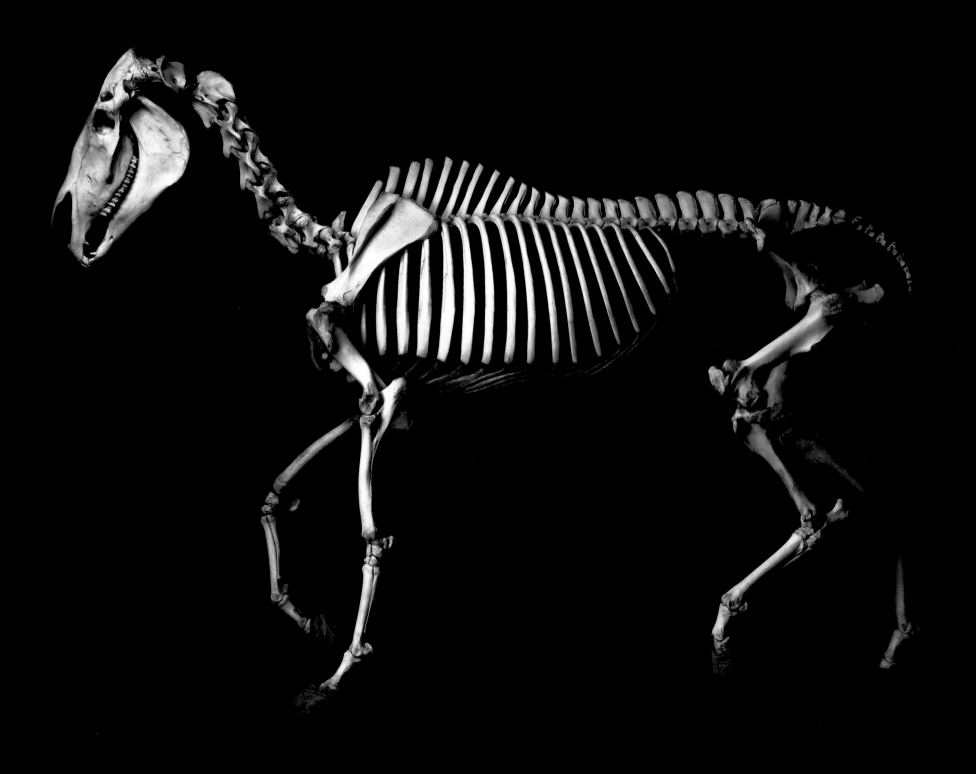

Horse, *Equus caballus*. Domesticated. Originally from Asia (s.h. 1.50 m)

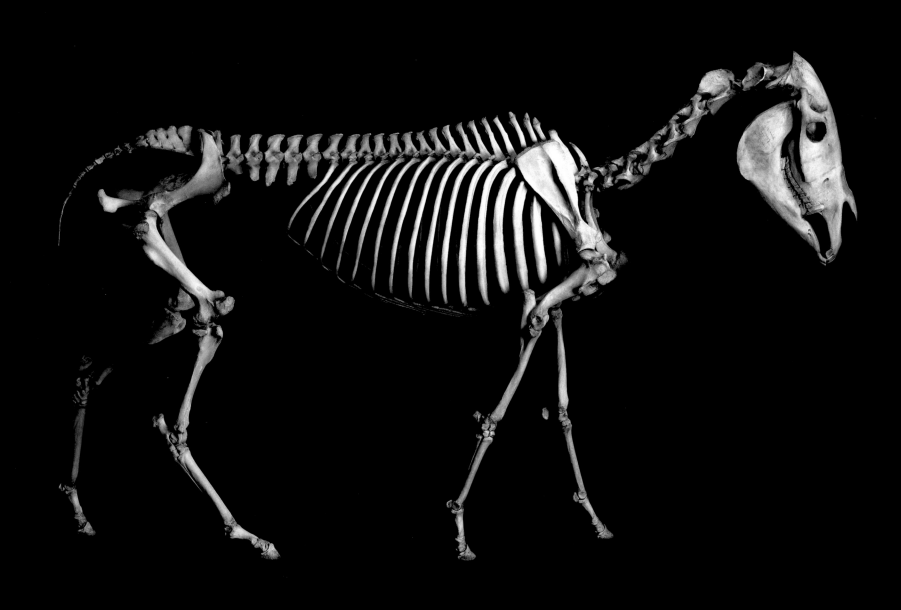

Common zebra, *Equus burchellii*. Sub-Saharan Africa (s.h. 1.10 m)

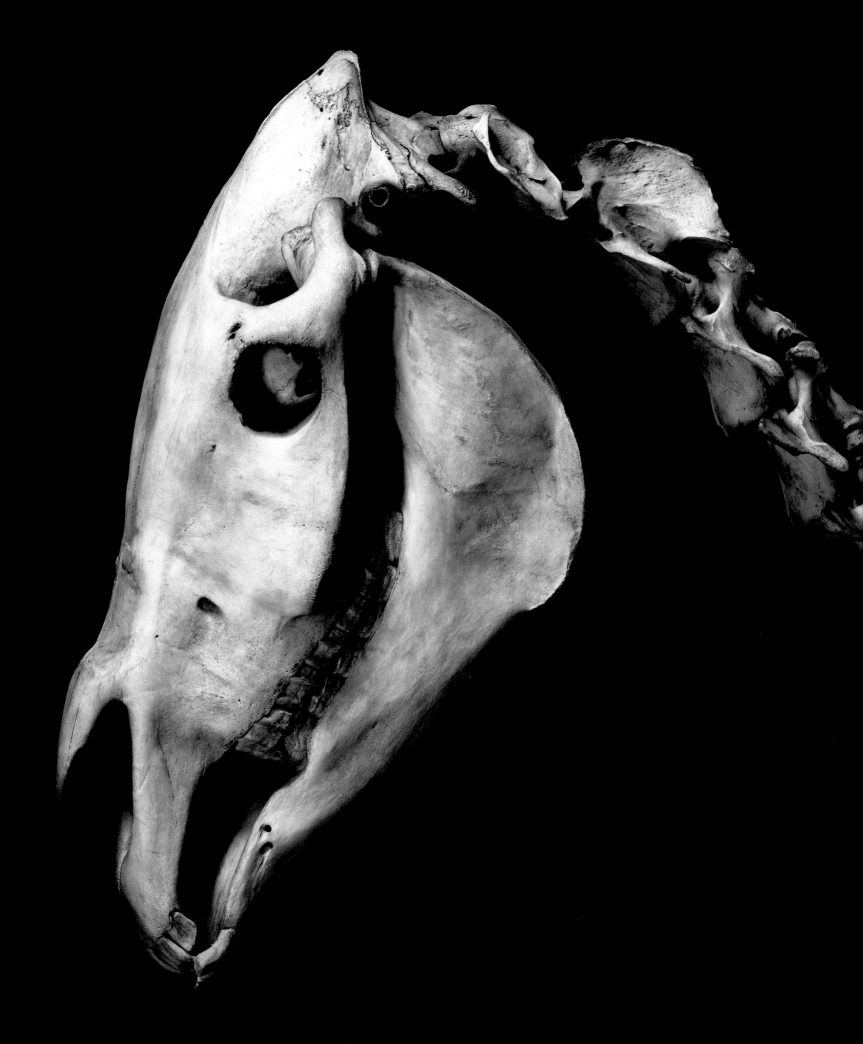

CHAPTER 13
THE THREE BEARS

The overall warming of the earth due to human activities will bring upheaval to the lives of its inhabitants, men and animals both. Certain species risk being unable to bear the size and speed of the climatic changes. Animals adapted to extreme environments, like the polar bears, are particularly threatened, for even a small rise in temperature could profoundly transform their surroundings. These bears live in the arctic regions. With an estimated population of 20,000, they are not yet considered to be a gravely endangered species. Hunting is not an immediate peril, for it is strictly controlled, at least in Canada and Alaska. However, their population could decline rapidly from the combined effects of pollution and the greenhouse effect. These predators are actually positioned at the top of the food chain: they feed on seals, who themselves consume fishes; the latter have accumulated the pesticides produced by the industrialized countries; the level of toxins increases in the seals' tissues and are further concentrated in the bears who eat them. These substances affect their immune system, their hormone production, their growth and reproduction. The other danger weighing on the polar bears is the warming of the atmosphere, which is causing a gradual melting of the ice. As they can only capture seals from the banks of the ice fields, this upheaval in their environment will disrupt their migrations and deprive them of a part of their hunting territory. And finally, the polar bears risk coming into confrontation with newcomers—the brown bears—in a face-to-face struggle that could prove fatal.

With his thick white fur, which covers even the underside of the paws, the polar bear is both camouflaged and protected against the cold. Other features show his adaptation to an environment that is especially harsh: for instance, he is capable of transforming fat into water, which avoids the energy loss involved in consuming snow or ice and expending body heat to melt them. His life cycle is different from that of the brown bears: the latter must hibernate because they would not find enough food during winter; conversely, polar bears can hunt seals all year round. Only their females hibernate, while still nursing their winter-birth infants.

The polar bear feeds mainly on seals, but also eats fishes, eggs, birds, and the cadavers of cetaceans stranded on the sea ice. Even though, in summer, he will sometimes fill out his diet with bayberries or mushrooms, his diet is essentially carnivorous, therefore much more specialized than that of the brown bear. The form of his teeth reflects that difference in diet. The brown bear's molars, broad and relatively flat, are adapted to a varied diet, richer in hard vegetable matter, which must be ground up for easier digestion. The polar bear's teeth, narrower and sharper, are typical of an animal that is strictly carnivorous. As he is more selective in choosing his food, it is a priori less easy for him to adapt to an abrupt change in his surroundings. The brown bear's skull is concave at the forehead, whereas that of the polar bear is nearly rectilinear. That difference is due to the large size of his nasal passages, an adaptation that allows him to better warm the air he inhales before it reaches his lungs. He also seems to have a finer sense of smell than the brown bear. Otherwise, their skeletons are fairly similar, any differences in silhouette having to do largely with the distribution of body fat and with the fur pelt. This general resemblance is explained by the close relation of the two species, which have a very recent common ancestor. Their history has been reconstructed by biologists from fossil skeletons found in America and in Eurasia, and especially by genetic analysis of the different populations.

Their history apparently began about a million and a half years ago, when a population of ancestral bears separated into two lines: the American black bear and the brown bear. From 850,000 B.C. on, periods of glaciation broke up the population of brown bears living in Europe and Central Asia into several different groups. The bears from the easternmost regions moved into Siberia and took advantage of the emergent Bering Strait land bridge to reach North America. There, they evolved differently from the brown bears they had left behind, and gave birth to the grizzlies, which are almost twice as large as the European brown bear. They are, however, still the same species, for they can be brought to breed together and produce offspring who are themselves fertile. From analysis of their DNA, it seems that the brown bears of the Alexander Archipelago, off southeast Alaska, were isolated during one of the last ice ages when, it is thought, they gave birth to the polar bears. The genetic distance existing between the brown and the polar bears gives reason to believe that this would have occurred around two hundred or two hundred fifty thousand years ago, an estimate that corresponds nicely with the dates of polar bear fossils. Specialists do not all agree on the place and exact time the polar bears would have appeared, but one thing is certain: some brown bears are genetically more closely related to the polar bears than to other brown bears. The polar bear should therefore be considered a mere subspecies of brown bear, all the more because these two bears are able to interbreed. The polar bear is a very recent species, having undergone a rapid morphological and behavioral evolution, though the genetic changes are slight. The extreme life conditions of the arctic milieu have certainly brought powerful selection pressures to bear on this transformation of some brown bears into polar bears.

Although they are genetically very closely related, brown and polar bears tend to avoid each other, which maintains the barrier between the two species. But the current planetary warming could change that situation. The vegetation and the various prey that offer the brown bear a suitable environment is stretching northward. The grizzlies are moving farther and farther toward the Arctic, where they are likely to come in contact with the polar bear. There are reports of hybrid animals from couplings between polar bears and grizzlies. If the icepack should disappear completely, then through interbreeding the last of the polar bears could eventually rejoin the large family of the brown bears from which they separated long ago.

—
Brown bear, *Ursus arctos*. Eurasia (s.h. 80 cm)

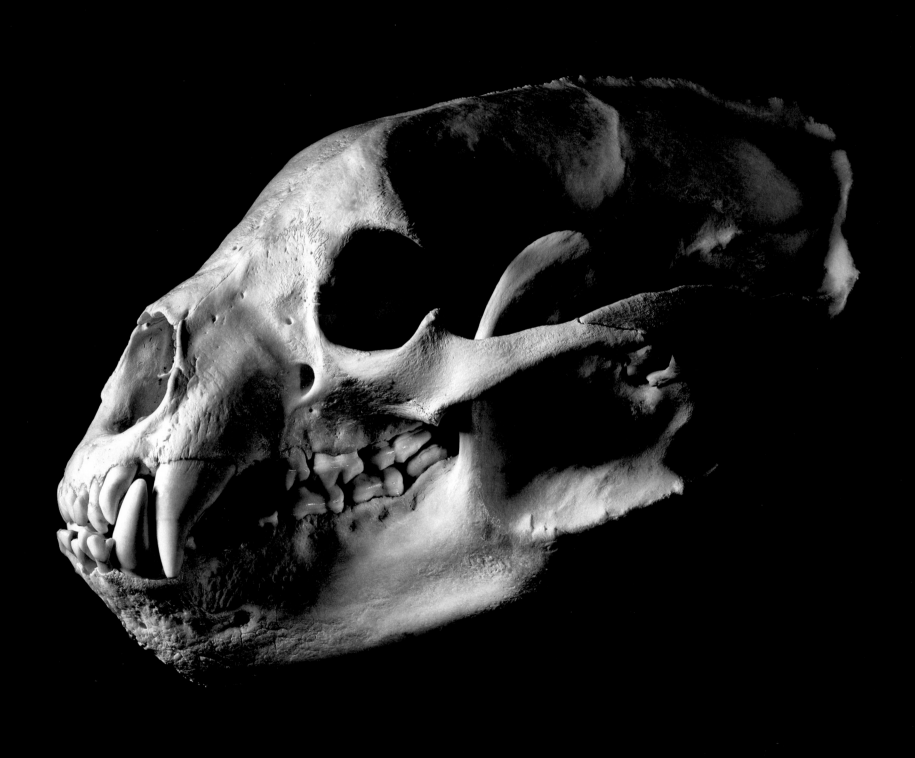

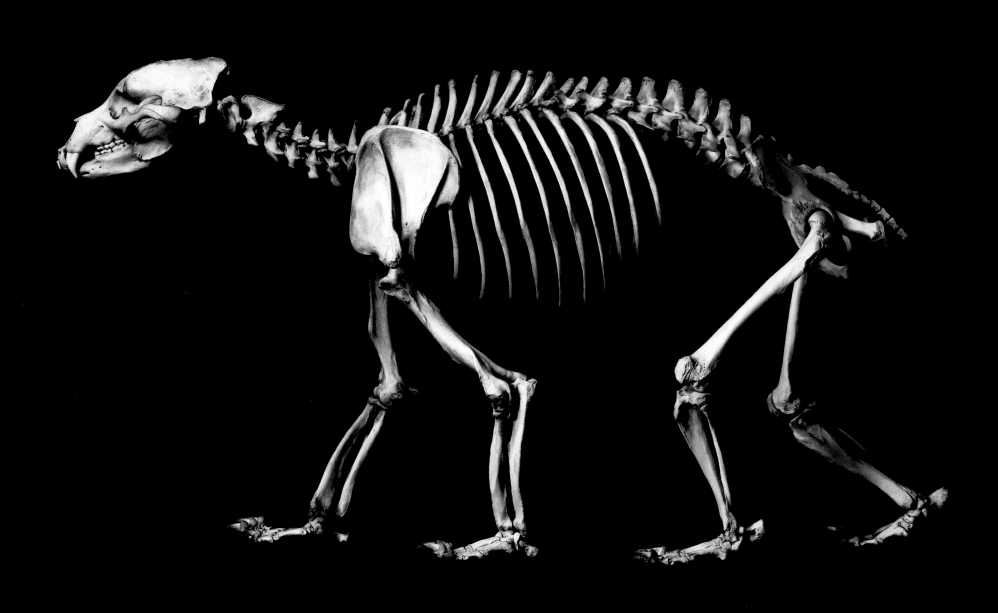

Grizzly, *Ursus arctos*. North America (s.h. 90 cm)

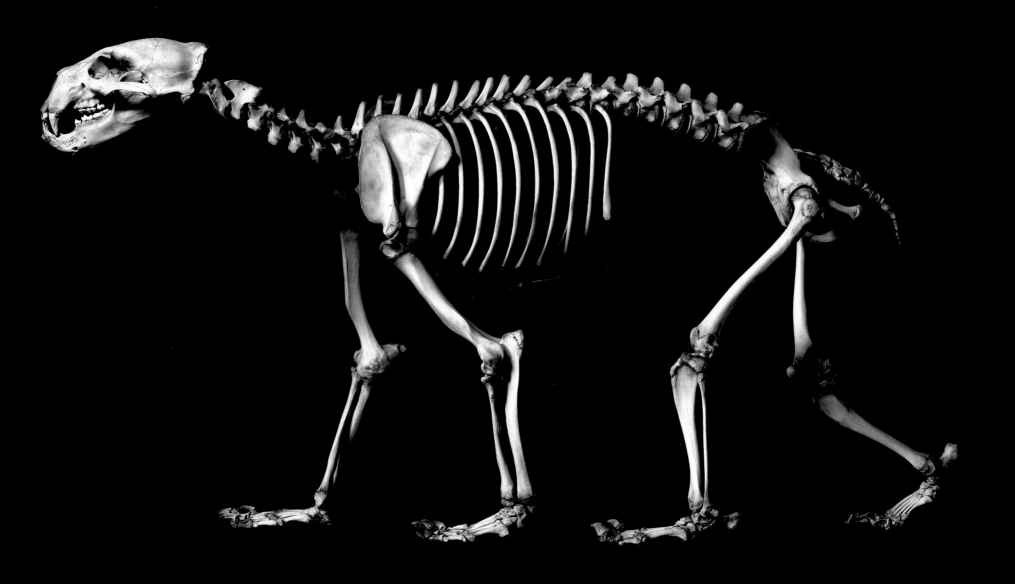

Polar bear, *Ursus maritimus*. Arctic regions (s.h. 85 cm)

CHAPTER 14
THE SEAGULL RING

The formation of new species, or "speciation," often results from the separation of several populations of a single species. Genetic changes accumulate and gradually render them more and more different, until they finally constitute distinct species. As this process takes a long time, often several millennia, only the end result can be observed: that is, twin species that are very similar but cannot be crossbred. But it is not easy to reconstruct the history of that divergence, for in general we do not know the starting species. The information from fossils is often inadequate. Indeed, since the birth of new species is linked to the development of a reproductive barrier between two populations, the important mutations in the process are primarily those concerning reproduction—for instance, the animals' biological rhythms or behavior, characteristics which cannot be discerned from fossils. There are, however, some cases that permit us to see past such obstacles to understanding the mechanisms of speciation: those animals described as "ring" species, whose populations allow us to observe in space what has gone on over time.

The best-known example concerns the herring and black-backed gulls, two species that cohabit in Western Europe. They form mixed colonies and nest at the same period and in the same regions. Their skeletons are practically identical, but the two species are easily distinguished in the wild: the black-backed gull has a deep grey back and yellow feet; the herring gull is somewhat larger, with a pale grey back and pink feet. They differ in behavior as well: the herring gull is a rather aggressive "sedentary" bird, whereas the black-backed gull is a rather shy migrator. When they nest in the same spot, the two self-segregate, grouping by species, and do not mingle. They do not emit exactly the same cries, and the courtship display is slightly different. This is enough to make for nearly complete reproductive isolation between the two species, although occasional hybridization does occur. The hybrids born in captivity are fertile, which proves the genetic proximity of the two species. As with the horse and the ass, this is clearly a case of two very close species, in which the separation is not biologically complete even though they are quite distinct.

Various close relatives of the black-backed gull live along the northern coasts of Europe and Russia, as far as central Siberia. Despite slight differences, they are all interfertile and are considered subspecies of the black-backed gull. As for the herring gull, that bird lives in Canada as well, in Alaska, and across the Bering Strait in Eastern Siberia. In the case of the black-backed gull, these are subspecies of the herring gull, distinct but still able to interbreed. At the point of contact between the two series, in Central Siberia, a subspecies of the herring gull cohabits with a subspecies of the black-backed gull. But there, the two species make up only one, for the individuals of the two populations can interbreed. In other words, from one population to the next, from one subspecies to the next, the progression from the black-backed to the herring gull is gradual as we move from Europe and along the arctic regions from west to east. All these populations form a great circle around the North Pole. The ring is broken at one point, since in Europe the two species are quite distinct.

This particular form of speciation is ascribed to the alternation of glacial periods and warmer periods, over the course of the Quaternary era. In warm episodes, an initial gull species living in Siberia expanded both toward the west and toward the east. In colder periods, the populations were forced back southward and lived on in "refuge" zones separated by glacier zones. There they started to evolve, each in its own direction. These episodes were not lengthy enough for the isolated populations to become different species, but the divisions occurred several times, culminating in physical and behavioral differences. As the differences were more marked at the two extremes of the chain, the two populations diverged so much that they became intersterile, which gave rise to the black-backed gulls in Western Europe and to herring gulls in Eastern Siberia. The latter crossed the Bering Strait and spread through Canada. They are thought to have crossed the Atlantic later, closing the circle as they rejoined their cousins, the black-back gulls.

Many subspecies and species of gull took shape over the course of this history. Thus, in eastern Canada, the ring produced other species, like the Iceland gull and the Thayer's gull, which are close relatives to the herring gull and which live in the north and east of North America. These two species do not interbreed, for behavioral reasons. Similarly, populations of black-backed gulls reached the Caspian Sea, the Black Sea, and the Mediterranean, producing the Caspian Gull and then the yellow-legged gull that lives on the Mediterranean coasts and on the Atlantic coast of Spain.

This history of the gulls is drawn from observation of the morphology and the behavior of these birds in the wild. Their DNA has also been analyzed, in order to study the degree of genetic variation and the amount of interbreeding. For instance, molecular biology has shown that the genetic connections between populations are very complex, the logical result of the number of species and subspecies involved. The comparison of the DNA sequences has not confirmed the hypothesis that says the European herring gulls came from Siberia via North America. They are thought to have actually followed a path parallel to that of the black-backed gulls. Thus the ring would be incomplete, the groups at the two extremes living separated on either side of the Atlantic.

Zoologists have identified several other examples of ring species for which the genetic findings have confirmed the zoological findings. This is so for a small sparrow that lives in Central Asia, the greenish warbler. North of the Himalaya regions there exist two separate forms that do not interbreed and are therefore considered to be two distinct species, but the two forms are connected by at least six populations that encircle the Himalaya and the Tibetan Plateau. Their morphology differs from one population to the next, as do their genes: the greatest differences have been measured in the populations living at the two extremities of the loop, which live in contact with one another. It is thought that the initial population lived south of the Himalaya and spread to the east and to the west, joining up again in the north.

But the gulls are in the process of adding a page to their long history. The West European black-backed gull has recently crossed the Atlantic and begun to colonize North America, closing the great gull rung before our very eyes.

—
Lesser black-backed gull, *Larus fuscus*. Eurasia (h. 23 cm)

European herring gull, *Larus argentatus*. Siberia, North America, Western Europe (h. 25 cm)

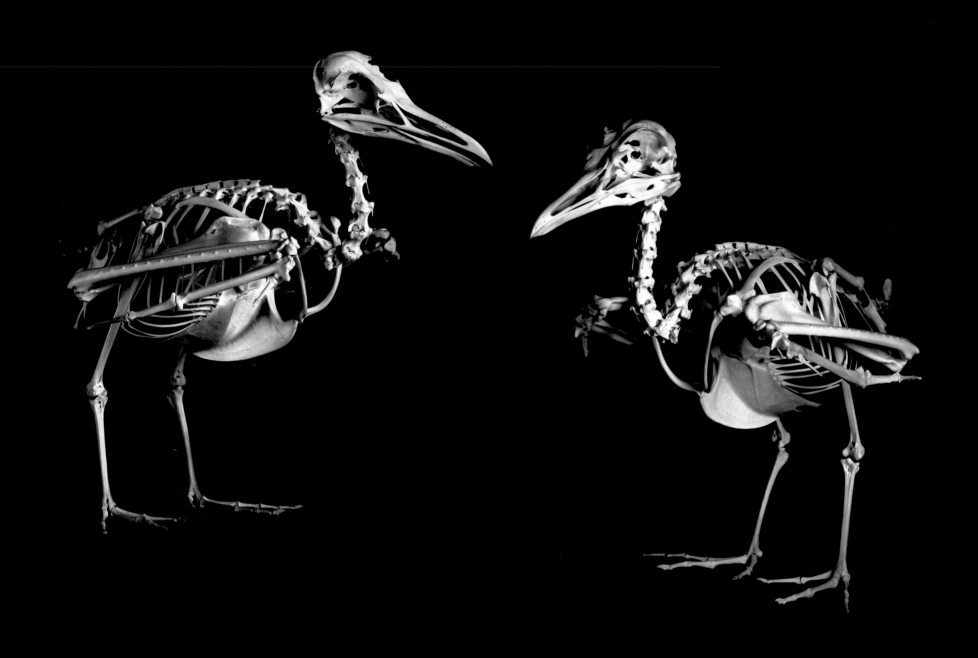

CHAPTER 15

OF MICE AND MEN

Along with man, the mouse is perhaps the most abundant mammal on our planet. It is the principal laboratory animal, but it is also a ravager that causes considerable damage, which explains the interest it holds for scientists. In the middle of the twentieth century, zoologists had attributed more than a hundred different denominations to the mice of Europe and Asia, from local populations to well-identified subspecies and species. All these mice differ essentially by behavior, coat color, and a few anatomical features like the length of the tail. This zoological profusion seemed to be confirmed by significant variations in the number of chromosomes, which range from twenty-two to forty in mice of nearly identical appearance. The detailed study of mouse genes has permitted a simplified classification. Biologists have managed not merely to reconstruct the history of the European mice, but also to discover new mechanisms that contribute to the birth of species.

In the nineteenth century, naturalists recognized two mouse species in Western Europe; the "city mouse" with a long tail and the "field mouse" with a shorter tail. However, this feature varied from one individual to the next: it happened that some "long-tailed" mice had tails shorter than some "short-tailed' mice. Zoologists therefore chose to class the two species into one, *Mus musculus*, which included a variety that lived primarily in homes, named *Mus musculus domesticus*. These days, Europe harbors four species of mouse. The best known is the domestic or house mouse, *Mus musculus*, the only one that has adapted to a commensal role, in contact with man. This species is the source animal for the many classes of laboratory mice. Two other species, *Mus spicilegus* and *Mus macedonicus,* live only in Eastern Europe, the one in the north and the other in the south. Earlier considered to be subspecies of the domestic mouse, they do not in fact interbreed with either it nor with one another. In fact, they are strictly wild, and never come to live in houses. The fourth species is the Algerian mouse *Mus spretus*, which also lives away from human habitation, in Spain, Portugal, and in the South of France. This is the famous "field mouse" that has finally regained a species status to itself, genetics having confirmed the relative significance of the anatomical criterion "tail length."

This Algerian mouse lives in small groups containing a male, a female, and their young. The domestic mouse,

on the contrary, is more polygamous, and lives in larger groups, with rather strict hierarchy. If the environment is wet enough, house mice are capable of subsisting outdoors. Through their presence alone, they can also eliminate the field mice that cannot bear the stress of that cohabitation. Laboratory experiments have confirmed that the two groups of mouse do not tolerate one another at all if they are brought together. In the wild, the two mice do not interbreed nearly at all. When they are made to do so, they produce hybrids whose males are sterile and females are fertile. Genetic analyses have confirmed that these were in fact two different species that split off several hundred thousand years ago. Originally, Central Asian mice reached the Near East and then continued their spread as they separated into two groups, one to the northern Mediterranean, the other to the south. The former gradually colonized all of Europe, while the others evolved on their own side, giving rise to the Algerian mouse. Ultimately these latter crossed the Straits of Gibraltar in ships and rejoined their cousins, who had followed a different evolutionary path. This is one of the mechanisms in the formation of new species: two populations separated by a geographic barrier evolve separately, such that they can no longer crossbreed and thus form two distinct species.

This speciation is called "allopatric," for it begins from a geographic separation of the populations into different "countries." But biologists have observed that a "sympatric" speciation could also occur, without a complete physical separation of the two populations. The phenomenon has been observed in the domestic mouse. Populations living in two separate parts of the same city had different numbers of chromosomes. The phenomenon occurs when two chromosomes attach and form one. The position of the genes is then shifted, but the overall composition of the genome remains practically unchanged. Still, the mouse's reproduction can be disrupted by that occurrence. What happens is that at the time of fertilization, the chromosomes of the ovum and the sperm cannot arrange themselves normally in the new cell. If the embryo's development is arrested, it means that the two mice are intersterile—cannot produce young together—even though they seem anatomically identical. So some "chromosomal races" of mouse act as though they are separate species. Over time, because the two populations no longer exchange

genes, other differences may appear that end in a definitive divergence into two true species.

Such chromosomal races have been seen in many cities of Europe and North Africa. Some of them appeared several centuries ago, and others are taking shape practically under our eyes. Another peculiarity: this type of speciation does not seem to correspond to any particular adaptation, for two neighborhoods of a same city do not always present very different environments. So chromosomal fusions seem to appear merely by chance, with no significant contribution from natural selection, except through the elimination of less viable forms. Rodents are not the only ones to undergo chromosomal rearrangements. They occur frequently in other zoological groups, like fishes or monkeys. Between the chimpanzee and man, there are ten rearrangements, which may have played an important role in the separation between our two species. Mice may already be an enthralling subject of study, but this phenomenon presents us with a particular interest because it could give us information on our own origins.

—
House mouse, *Mus musculus*. Originally from Eurasia, introduced globally (l. 15 cm)

Algerian mouse, *Mus spretus*, Southeastern Europe (l. 13 cm)

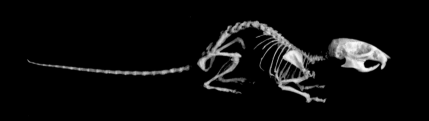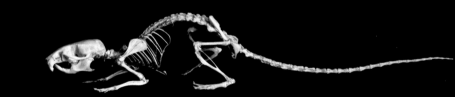

CHAPTER 16
THE SPARROW'S BEAK

Some types of animal have had great success over the course of evolution. That is the case for the beetles among insects (more than 300,000 known species, but there are probably many more), or the rodents among vertebrates (more than two thousand species). In birds, the sparrow group (passerines) includes more than fifty-three hundred species—more than half of all the birds in the world. They are on every continent (except Antarctica) and live in every sort of setting, from marshes to deserts and forests. At the center of cities, in the parks and gardens, one can commonly see several dozen species, or at least hear them. Indeed, they include most of the "songbirds": blackbirds, larks, warblers, nightingales, robins, finches, chaffinches, goldfinches, linnets, sparrows, and so on.

The passerines are different from other birds in the form of various bones (the palate, humerus, tarsus...), in the musculature of the wings and feet, and by the morphology of their spermatozoa. The syrinx—the singing organ—has a specially developed musculature that underlies its complex songs. DNA comparison of many species has shown us that these features were indeed the sign of a common origin. The passerines thus form a monophyletic group—that is, they all descend from a single ancestral species which transmitted its features. They are not very diverse in size or general shape, but they differ sharply from one another in plumage, in the beak shape, in song, and in behavior.

Each species has its own ecological niche, that is, it does not feed in the same way and it nests neither in the same place nor at the same time as the others. This sharing of milieu permits a very intense exploitation of available resources and reduces the competition among species. The adaptation of each bird to its ecological niche is linked to its behavior, its way of flying, its size, or the form of its beak. Small and large passerines seek different insects or seeds, as a function of the characteristics of its beak. The sparrow and the finch have a short thick beak, adapted to the consumption of seeds. The goldfinch's beak, rather long and pointed, lets it take small seeds from the tops of cardoons, from among the thorns. In the common crossbeak, the tips of the upper and lower parts of the beak curve and cross, making a shape useful for extracting the seeds from pinecones. With its rather short, narrow beak, the blue tit eats small insects as well as berries and seeds.

The sparrows thus constitute a stunning example of "evolutionary radiation," the birth of a great number of separate species starting from a single ancestor [see also the fishes of African lakes, p. 260]. In fact, close cousins of the finch and of the goldfinch provided Charles Darwin with one of the first examples of the birth of new species. This group of passerines, called Darwin's finches, live on the Galapagos Islands, off the coast of Ecuador in the Pacific Ocean. During his world tour aboard the *Beagle*, Darwin used the landfall in the Galapagos to collect several kinds of birds indigenous to those islands. They were of various sizes and with very different beaks, but clearly they belonged to closely related species. Six species of ground finch have a thick short beak, adapted to a diet based on hard seeds. They live in the driest areas of the islands. Some of them have a longer beak, which allows them to take nectar from the heart of cactus flowers. The six species of tree finch rarely alight on the ground; they hunt insects in the bush and in tree branches, except for one strictly vegetarian species. A thirteenth species is smaller and is insectivorous as well. All these forms have remained very closely related genetically, as shown by the many hybrids.

According to Darwin, these finches descend from birds that reached the Galapagos archipelago by chance. They then evolved in divergent directions as they made use of several types of food available on each island. The variations in size and in beak-shape apparently allowed the birds to take up different ecological niches which until then were unoccupied because of the archipelago's isolation and the relative scarcity of animal life. DNA analysis of the different species have confirmed Darwin's hypothesis, and clarified the relationships among the species. The medium ground finch and the cactus finch were closely observed from 1972 to 2001. In that period, their general size and the shape of their beaks changed several times, in response to climatic conditions. Dry periods favor the largest birds and those with thick beaks, for large-seed plants come to predominate. Evolution in the two species was revealed to be both very great and without any notable "tendency"; rather, it was linked to harsh changes in the environment.

Natural selection does nothing but single out the individuals whose genes are most favorable for their real life conditions. Thus it remained to discover which genes

of those contributing to the beak shape could give selection its foothold. Biologists have shown that a mere delay in the expression of gene BMP4 as a young finch develops makes a big difference to the final shape of the beak. So a small mutation could have big consequences for the finch's feeding pattern. Moreover, the shape of a bird's beak also influences its song. As this is an important element in reproduction, any change in the beak could have a direct effect on the probability of coupling, and reinforce the divergence between nascent species.

All present day passerines had a long history that has led to the rise of several thousand species from one ancestral species. The evolution observed over one short period can be extrapolated to far longer spans of time. If the beak size of a single finch population changes visibly in a few years, imagine what evolution can produce in several tens millions of years.

—
House sparrow, *Passer domesticus*.
Eurasia, North Africa (l. 15 cm)

Chaffinch, *Fringilla coelebs*.
Eurasia, North Africa (l. 15 cm)

European goldfinch, *Carduelis carduelis*.
Eurasia, North Africa (l. 13 cm)
—
Red crossbill, *Loxia curvirostra*.
Northern hemisphere (l. 16 cm)
—
Large ground finch, *Geospiza magnirostris*.
Galapagos (l. 16 cm)

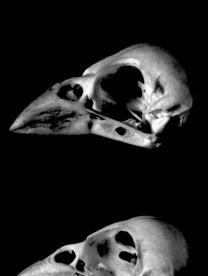
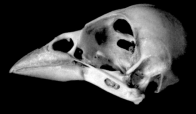
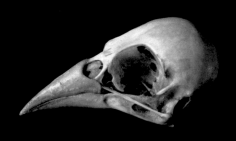
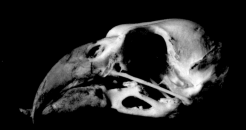
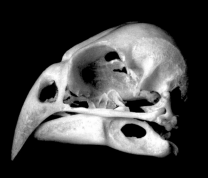

CHAPTER 17
A WELCOMING NEST

In the animal kingdom we find few animals more repugnant than the parasites, such as fleas, ticks, and tapeworms. Most of them are insects or worms, but there are also some parasites that are vertebrates, such as the lamprey that attaches to fishes and sucks their blood. The skua is a sea bird that attacks other birds to snatch away fishes they have caught. This behavior stirs less revulsion, but it does enter into the definition of parasitism: an "association" between two species in which one exploits the other. In contrast to a predator, the parasite does not cause the death of its host, at least not immediately. This way of life has played a very important role in the course of evolution. Indeed, the parasite reduces the overall capacity of its host by weakening it or by depriving it of some portion of its resources. Parasitism is thus a powerful factor in natural selection.

In birds, there is a particular form, called "brood parasitism," that has nothing to do with feeding, but with reproduction. The point is to multiply the number of one's descendants by delegating the essential parental tasks to other birds. In Europe, the best-known parasite bird is the common cuckoo, the size of a pigeon. The female lays an egg in the nest of another species, when those two parents are absent. She then swallows one of the eggs already there or pushes it out of the nest. The operation generally takes her under ten seconds. If the female host is unaware of the trick, she proceeds to sit on the cuckoo egg along with her own. At hatching, the young cuckoo pushes out the other eggs, or the other chicks if they have hatched first. The parents feed him as if he were one of their own offspring. Indeed, since hatchlings change appearance quickly, many birds do not notice their looks and figure that any bird present in their nest is part of their own brood. The arrangement benefits the cuckoo, which need not invest energy in parental care, and it seriously penalizes the host species by depriving it of descendants.

The cuckoo is such a parasite to a good thirty different species in Europe. Most of them are small insect-eating passerines, which ensures that the young cuckoo is properly fed. There are several "lineages" of cuckoo, each of them parasite to a single other species, such as the common redstart, the robin or the dunnock. The female cuckoos are "impregnated" by their host and will return to that same species to lay their eggs. It seems possible that this would lead to the formation of several species of cuckoo, each of them associated with a particular host. But the homogeneity of the species is guaranteed by the behavior of the males, who couple indiscriminately with any female. The host-specialization of the females is important because each of the host species lays eggs of established size and color. Depending on the case, the cuckoo's eggs mimic, more or less well, those of its intended host. While the cuckoo is eight times heavier than the redstart and has a different morphology, their eggs are almost the same size and the same pale blue color. Experiments have shown that the redstarts often toss out eggs that do not look like theirs. But other species, like the dunnock, readily accept sitting on eggs that are different from their own.

The egg may be accepted, but the young cuckoo's survival is not guaranteed. It sometimes happens that other cuckoos come to lay in the same nest, and throw out the egg of the preceding female. Moreover, after hatching, the newborn cuckoo does not always manage to get rid of the other eggs, especially those of the redstart, which nests in rocky niches. And finally, some species do not provide suitable food to the young cuckoo, and it dies before it is able to fly. So between cuckoos and their hosts there is a balance that depends on the tolerance of the hosts, on the mimicry of the cuckoos, and complex behavioral factors. This balance is highly dependent on the length of the history between hosts and cuckoos. In Great Britain, cuckoos became numerous only lately, between 4500 and 500 B.C., and they are still fairly well accepted despite their eggs being rather poor imitations. On the continent, the hosts are far less tolerant.

By comparing the different cuckoos and their hosts, it is possible to reconstruct the history of this sort of parasitism. For instance, it has been noted that birds that have never been confronted with cuckoos will accept even poorly imitated eggs, whereas populations which are accustomed to the parasite behavior systematically reject them. To begin with, the hosts are all "naïve," and rather easily accept eggs different from their own. But evolution rapidly favors the more mistrustful individuals, because they succeed in reproducing themselves, whereas those more easily tricked have very few descendants. Their low reproduction rate thus tends to reduce the overall naivete of the population. And the cuckoos are affected by evolution as well. Indeed, the young female reproducing for the first time goes to lay her eggs among the species that raised her. If her eggs are poor imitations, they will not always be nurtured, and she will have no descendants. Poor imitators are thus swiftly eliminated from the stock. In contrast, if her eggs do resemble those of her host, her young will have a better chance of surviving, and transmitting that capacity for mimicry to their own descendants.

Since it directly affects reproduction, brood-parasitism is thus under very strong pressure by natural selection, as much among the parasites as among the hosts. This double selection results in a "co-evolution": cuckoos who are ever more specialized, laying ever-better imitation eggs; and hosts who are more and more suspicious. It remains to understand how egg-laying parasitism can come about. Cuckoos are not the only ones to display this behavior; there are less elaborate forms of it in other birds. In several species of ducks, along with her own set the female will lay a few eggs in the nests of neighbors (of its own species). This behavior is strongly favored by selection, as it immediately increases the reproductive capacity of these females. It cannot, however, lead to a complete abandonment of the brooding task, for the survival of the species will be compromised. Evolution can thus come to a balance by an automatic regulation of the incidence of parasitic behavior. Evolution may also favor a different behavior, one that consists of laying in the nest of other species. Perhaps one day, cuckoos will be challenged by competition from the ducks.

—
Common cuckoo, *Cuculus canorus*. Africa, Eurasia (h. 15 cm)

Common redstart, *Phoenicurus phoenicurus*.
Eurasia, North Africa (h. 8 cm)

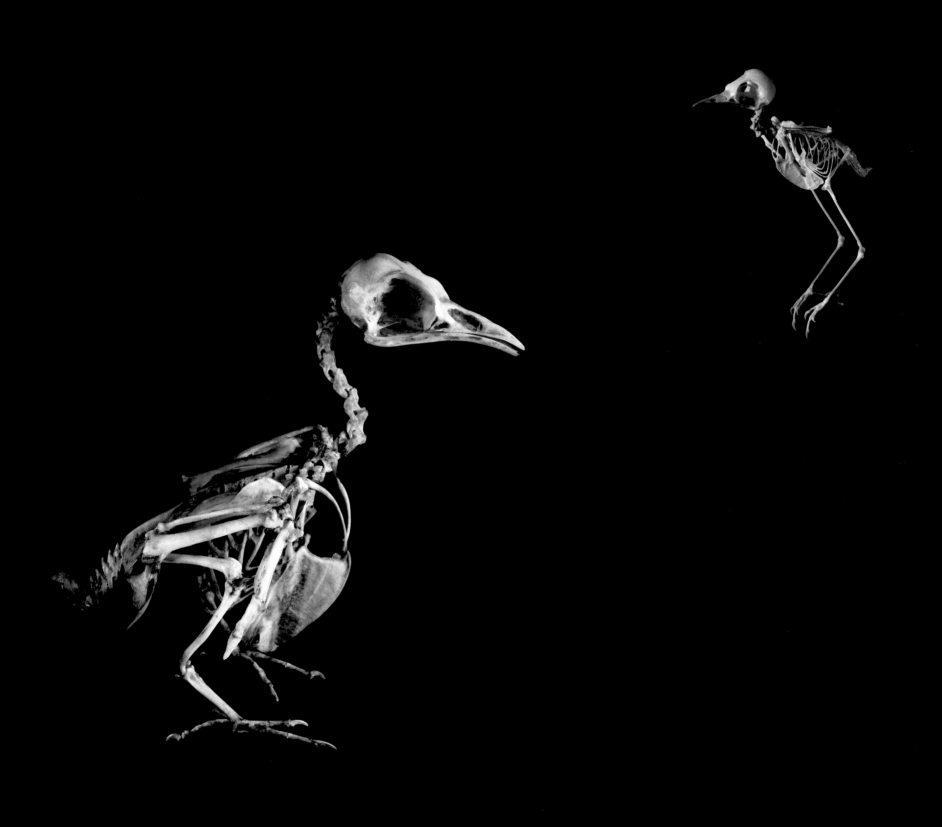

CHAPTER 18
THE RUNNING APE

After two centuries of research on the behavior, the anatomy, and the genes of apes, there is today no longer any doubt: our closest cousins are the chimpanzee and the bonobo. The apes (or hominoids) were very numerous in the past, but only five species remain: the orangutan, the gorilla, the chimpanzee, the bonobo (or "dwarf" chimpanzee), and the human being. In orangutans and gorillas, there are populations that are sharply separated which are often considered to be distinct species. The evolution of the apes recapitulates our own history. Among them, a still unknown ancestral species divided into two lineages. The first is the origin of chimpanzees and bonobos, the latter gave birth to a great number of species: australopithecus, paranthropes, archaic humans, and modern men. The era of that event and its subsequent history are the subject of passionate debate. The stakes are high, because it is a matter of better understanding what constitutes the nature of man.

We differ from chimpanzees and bonobos by anatomical and behavioral characteristics. For the past fifty years, primatologists have accumulated observations in the African forests and in zoos. The chimpanzees appear today as social primates displaying abilities far more elaborate than we might have imagined from studies done on individuals that are caged and removed from their social context. They show themselves capable of hunting in groups, of using stones to crack nuts, of helping congeners in trouble, of joining together to take power, of organizing killing expeditions against individuals from other groups. They play, laugh, lie, argue, and make up. Even though they cannot speak, because of the shape of their larynx, chimpanzees are capable of learning thousands of words in gestural language or by means of symbolic shapes. They can also use words in new contexts, showing that it is not merely a matter of imitation. The behavioral divide between chimpanzees and ourselves is deep, but we see in these apes a number of traits that in the past were believed to be exclusively human and that allow us to envision early signs of our present aptitudes in our common ancestor.

At the anatomical level, our two species cannot be confused. The skeleton is the single element that allows comparison of monkeys and today's humans to fossil primates. Many of the differences have to do with means of locomotion: man is strictly biped whereas chimpanzees are quadrupedal, even though they can

walk upright for short distances. Bipedalism has consequences for the whole of the skeleton. In the human species, the short broad pelvis supports the abdominal organs. In the chimpanzee this bone is larger, but long and narrow. A man's arms are shorter than his legs; the opposite is true in chimpanzees. The joints of the shoulder, the elbow, and the knee are significantly different. Bipedalism is also expressed by a repositioning of the foramen magnum, the cranial opening through which the brain connects with the spinal cord. In chimpanzees, as in all quadrupeds, it lies at the back of the skull, but in man, below it. The human skull is much bigger than a chimpanzee's.

These features are partly determined by the genes. Between man and chimpanzee there is barely a one percent difference in the overall sequence of the DNA (between the rat and the mouse, differences amount to 10 percent). However, the differences are distributed through the whole of the genome, and therefore affect most of the genes. This does not always affect the functioning of the proteins, whose synthesis is controlled by the genes, but the activity of some is markedly modified. The most different genes have to do with the sense of smell, with hearing, digestion, and the immune system. Our ancestors' evolution was subjected to powerful selection pressures that left traces in our genome. Biologists have tried to identify the genes that differ more than they might have through the effect of chance alone. They mainly concern resistance to microbes, the production of ova and sperm, DNA function in the cells, and nerve cell activity. These genes shaped by selection probably played an important role in our ancestors' survival and reproduction.

To understand how our two lineages diverged would require comparing the skeletons of fossil hominids—but no fossil chimpanzee has been found. To judge by DNA, the separation probably took place five million to seven million years ago. The causes of this speciation are still more obscure. All kinds of hypotheses have been proposed to explain the development of bipedalism. To stick with the evolutionist framework, we must understand why it would have become necessary. Natural selection acts only to promote a feature that procures some immediate advantage for the species. Man did not stand upright because that was useful for developing his brain; bipedalism merely rendered that

development possible [see page 254]. It may also be noted that Australopithecus man was practically bipedal, but had a brain comparable to a chimpanzee's.

Adaptation to an environment more open than the equatorial forest, with vast stretches of savannah, remains one of the most plausible hypotheses. Man is not only a good walker; over some two million years he has also shown all the characteristics of a good long-distance runner. With a brain larger than that of his ancestors, early man needed a diet richer in fats and proteins, because that organ devours so much energy. It was probably important for him to be quick to find the carcasses signaled by vultures' circling, after the large predators had their meal but before the arrival of the other carrion-eaters. These archaic men may also have hunted by chase, pursuing prey over long distances to exhaustion. That would explain why we have such long legs, which are even more useful for running than for walking.

Will our evolution continue? The whole history of life on earth gives us no indication of either a direction to the evolution of species or a stopping point, except by their extinction. Our own species has largely liberated itself from the normal game of evolution, however, by radically reducing the power of natural selection. Most of the imperfections linked to our nature, from myopia to the worst illnesses, can be compensated for, at least in the rich countries. In the short term, the occurrence of murderous epidemics could return a certain weight to natural selection, but that would concern only the resistance to that particular disease. In the long term—that is, over several million years—the future evolution of man is a matter for the fortune-tellers.

—
Human being, *Homo sapiens*. Worldwide (h. 1.70 m)

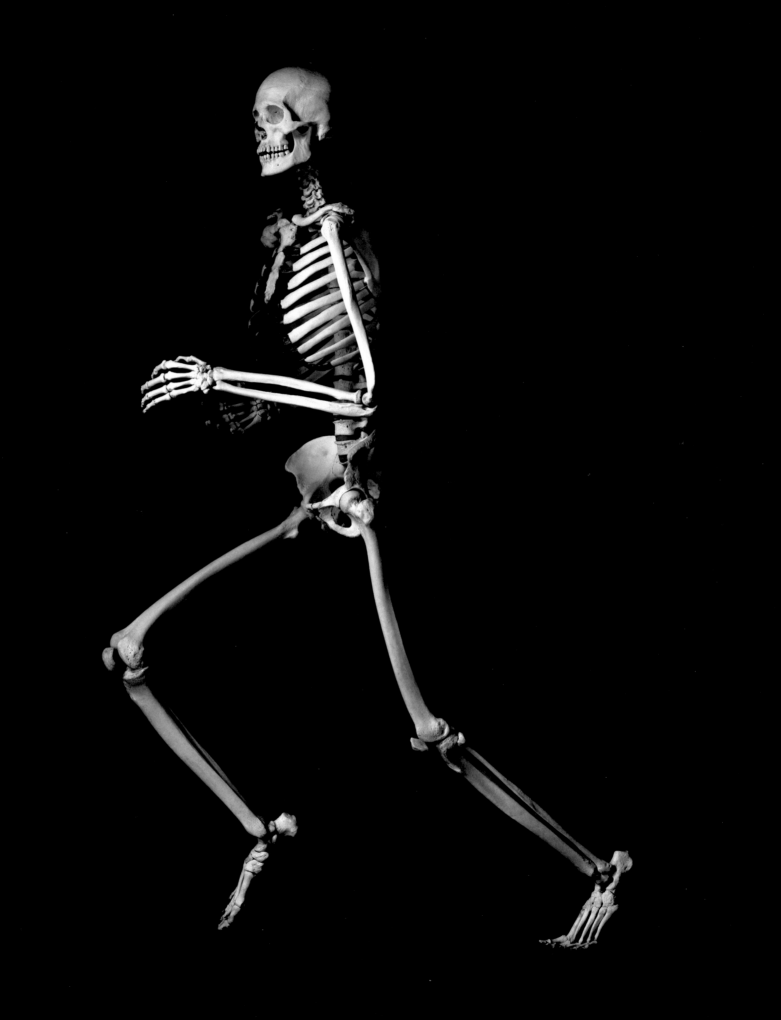

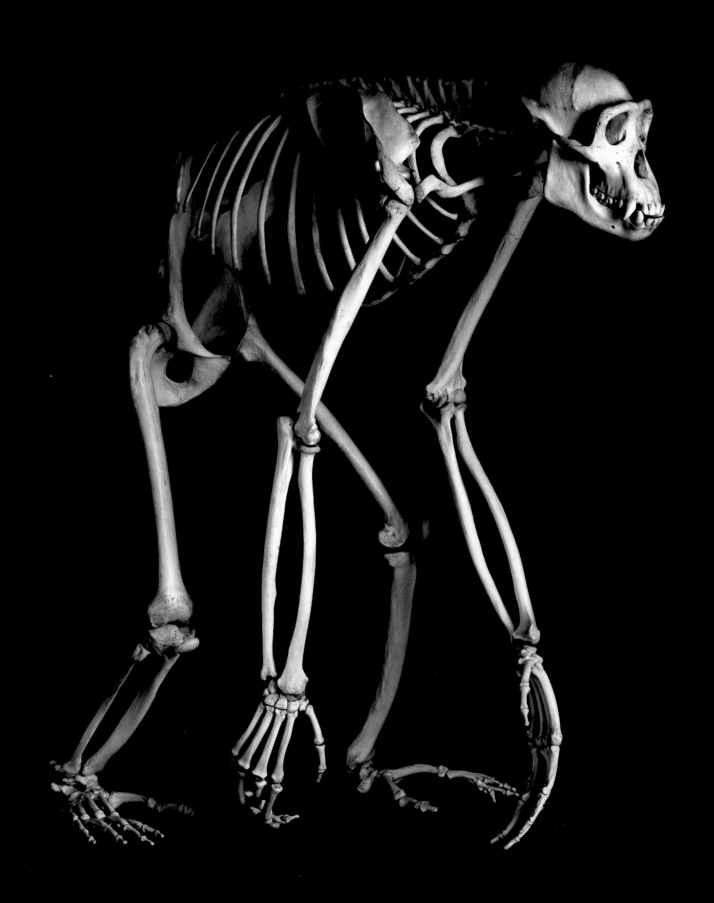

Chimpanzee, *Pan troglodytes*. Equatorial Africa (h. 95 cm)

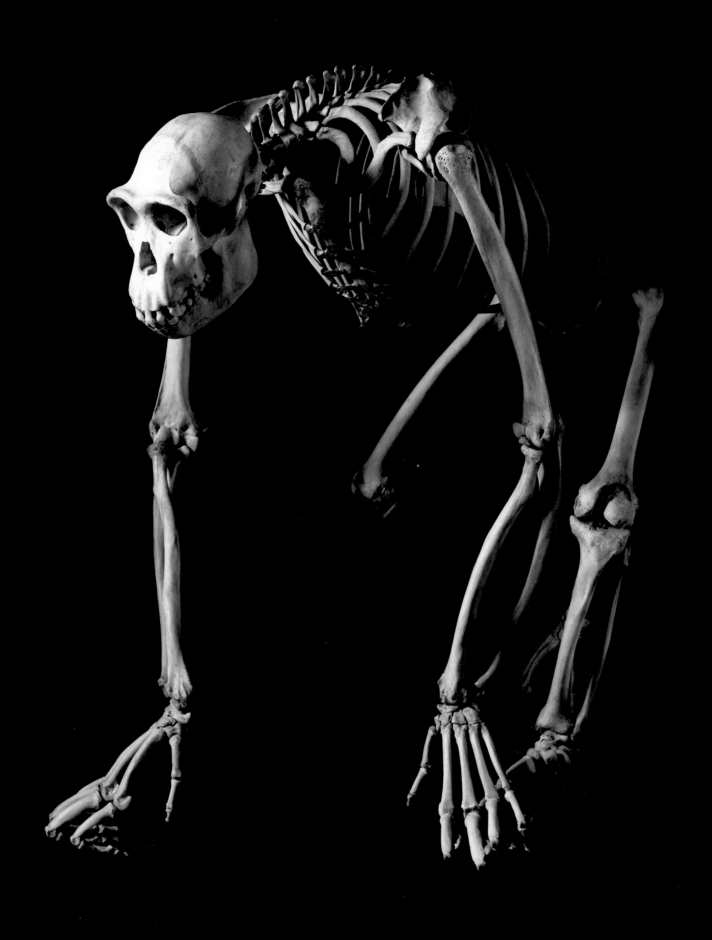

Chimpanzee, *Pan troglodytes*. Equatorial Africa (h. 95 cm)

PART III
SEDUCTION AND SELECTION

The complete title of Darwin's first work was *The Origin of Species by Means of Natural Selection, or the Conservation of Favoured Races in the Struggle for Life*. The theory of evolution has often been reduced to that "struggle for life," which is taken as the unending battle of each individual against its predators. The one who manages to survive can ultimately produce descendants to whom he will transmit his characteristics.

That vision of animal life is not baseless. It suffices to consider the number of eggs laid by a salmon to recognize that its thousands of spawn could not all reach adulthood and reproduce. The species does maintain a constant population over time, because on average only two offspring per couple survive. The great majority of the eggs and the small fry are swiftly eliminated by predators, without any true "selection" as such. That mechanism acts later, on the survivors of those first massacres, of whom only the swiftest or most resistant will leave descendants. Among mammals, the offspring are less numerous and the mortality somewhat lower because of parental care. When a lion attacks sick or frail zebras rather than those in good health, it is an eloquent picture of natural selection in action. The principle also functions among predators, with the most able having a greater chance of feeding properly, and the others at risk of dying of hunger in situations of scarcity. Predators and prey are both engaged in an evolutionary race, over the course of which we see the permanent elimination of individuals less able to compete [see page 102].

Although that aspect of animal life is not negligible, natural selection does not come down to a mere elimination of the weak by the strong. Darwin actually gave the notion a much broader meaning: "I use this term in a large and metaphorical sense, including (which is more important) not only the life of the individual but success in leaving progeny. Two canine animals, in a time of dearth, may be truly said to struggle with each other over which shall get food and live. But a plant on the edge of a desert is said to struggle for life against the drought." Thus, "Darwinian" selection is more complex than the mere relation between predator and prey. It also

includes the competition between individuals of the same species (an idea that scandalized the people who hold that Nature is harmonious and generous) and the effects of environment. Finally, Darwin emphasized a form of selection quite different from "vital" selection, one that is equally "natural" and that concerns not the survival but the reproductive capacities of the individual. Over the course of his research, he accords to that "sexual selection" more and more importance, to such a point that his volume on man's origins, *The Descent of Man*, is almost entirely devoted to sexual selection in the animal world.

Sexual selection describes the whole array of mechanisms that promote not survival but the preferential reproduction of some individuals in contrast to others. The qualities likely to favor an individual's reproduction rate are not necessarily the same as those that increase its chances of survival. Among most vertebrates, males and females both must be capable of recognizing and attracting each other and, possibly, of coupling. Among mammals and birds, reproduction also involves another essential stage: the raising of the young. Certain fishes, frogs, and reptiles also care for their young, a least for several days. In many species, the males and the females exhibit more or less marked differences in size, form, or coloration. If natural selection worked in the same way on all the individuals of a species, we could suppose that males and females would be nearly identical.

It is sexual selection that underlies this "sexual dimorphism." The males often have special ornamentation, such as the bright colors of fish and certain birds and the long plumes of peacocks and swallows. It is in the interest of the females to choose the brightly colored males, for their coloration is evidence that they are neither diseased nor weakened by parasites. In birds, monkeys and fish, it has been shown that the males chosen by the females reproduce more and have more descendants than the others. Their characteristics tend to spread throughout their species. Conversely, the females' "choice" is also the object of a selection: those choosing males who are lackluster or without special attributes will have

offspring of lesser quality, which themselves will have trouble reproducing, so this behavior is gradually eliminated by selection. These two aspects of selection reinforce each other, which explains why some ornamentation takes on excessive showiness. This can increase the male's risk of being noticed and captured by a predator, yet despite such a drawback, the traits persist because they promote reproduction. If the male's survival is compromised by it, the excessive ornamentation is ultimately balanced or eliminated by the workings of natural selection: the interplay between sexual and natural selections reaches an equilibrium as to the size and form of the ornamentation.

Sexual selection has another component: competition between males to accede to status as a reproducer. In their battles, some ornamentation becomes a veritable weapon, as in cervids [see page 104] and giraffes [see page 118]. This competition plays an important role in enhancing sexual dimorphism, especially in societies in which a male breeds with a large group of females—for instance, among deer or gorillas [see page 122]. In these species, the competition among males is very intense. Conversely, in monogamous species such as gibbons and some birds, sexual dimorphism is not very pronounced, and competition among males is rather minimal.

Anatomical and behavioral differences between males and females matches a deeper dissymmetry: between the reproductive cells, the ova and sperm. The ovum is an enormous cell, immobile and full of stored energy (like a chicken's egg, which is a single cell). The sperm is a minuscule cell, totally devoid of reserves but highly mobile. The females produce a limited number of ova, always very much fewer than the number of sperm. While there is competition among males and among females for reproduction, this also true for the sex cells—only a single sperm cell out of millions may fertilize an ovum. In other words, the ovum is a rare resource for which the sperm compete intensely. This dissymmetry recurs at the level of the individuals themselves: the female can produce only a limited number of descendants (although the number is

sometimes quite high, as for instance in fishes), so it is to her benefit to make a good choice in the male that will fertilize her eggs, in order to have high quality descendants of which many survive. Conversely, the males' reproductive strategy consists in fertilizing as many females as possible, again in order to create more descendants than the other males. Thus, there is a sort of spermatic competition among chimpanzees, for which couples are not firmly established because the females can couple with several males. Those males that produce a large number of sperm do better down the line, for they have more chances to gain descendants. This explains why the testicles of male chimpanzees are especially large compared with those of gorillas, which maintain strong control over their harem, and of gibbons, which live in stable couples.

All this happens in a completely automatic way, without the least "will" on the animals' part. One of the strengths of evolutionary theory is that it explains how complex behaviors can come about through extremely simple mechanisms. For instance, a male who happens to have an innate capacity to leave more descendants than others will transmit that trait to his offspring, who then will also have more abundant progeny. Thus, the incidence of this aptitude will increase in each generation. This mechanism does not imply any preestablished direction; sexual selection is as blind as "vital" selection, and works merely by favoring the traits that increase the individual's reproductive power. That could even end in reducing his longevity, if it does not diminish his reproductive capacities [see page 126]. Yet natural selection does not explain all aspects of animal anatomy or behavior. An animal is not a collection of organs but an integrated whole. A change in one organ from a mutation can have an effect on other organs. If an animal's capacities are improved in some respects and diminished in others, selection will end in a balance that is the best solution, not necessarily for the organ in question but for the whole animal, since selection ultimately functions to favor the individual's survival and reproduction. Also, some traits may simply be neutral as to selection. We know that many mutations have no observable effect on the animal, and therefore are not

selected—that is, neither eliminated nor favored. What becomes of them is entirely dependent on the random chance of the individuals' reproduction. Would that explain the number of horns on a rhinoceros? For those animals, is it really important to have two horns rather than one [see page 130]?

Sexual selection has certainly played an important role in our own evolution. The main pieces of evidence come from observing the behavior of the great apes as well as from a few skeletons of hominid fossils [see page 134]. The application of natural selection theory to human evolution has not found ready acceptance by Western societies. The absolutely nonmoral nature of the phenomenon, and its lack of purposeful direction, roused an unease that is still not dissipated, and which explains the rejection of Darwinism by some religious elements. At the same time, certain aspects of Darwin's theory have been accepted—but for bad reasons. For instance, the success of the notion of the struggle for survival is partly due to its unjustified extension into the realm of the social sciences. In the nineteenth century, theoreticians of capitalism used the concept to try to justify social inequalities, declaring them due to "natural" causes. In the name of selection, they argued that social assistance was no use and was even injurious to the proper functioning of society. In time, this "social Darwinism" was exploited by the supporters of the eugenics movement, who argued that human skills had reduced the influence of natural selection, whose effects should be balanced by eliminating "harmful" individuals. In the twentieth century, these theories served as scientific support for the Nazi extermination camps, as well as the forced-sterilization campaigns that occurred in the United States and in Sweden into the 1970s.

Such extrapolations of natural-selection theory to human societies was utterly alien to Darwin's ideas. According to him, natural selection had, on the contrary, favored men's altruistic tendencies, since it gave our ancestors a considerable advantage in the cooperative hunt for food and defense against predators. Natural selection thus allowed the emergence of a moral sense.

For Darwin, inequalities and violence are products of human societies and not Nature's doing. As to eugenics, he was a long way from that, since to his mind, empathy and altruism are among the qualities that characterize humankind: "Nor could we check our sympathy, even at the urging of hard reason, without deterioration in the noblest part of our nature.... We must therefore bear the undoubtedly bad effects of the weak surviving and propagating their kind."

CHAPTER 19
THE RED QUEEN

Lewis Carroll's heroine Alice is famous among biologists for at least one of her adventures. In a scene in *Through the Looking-Glass*, Alice and the Red Queen run as fast as they can but remain where they started. The Queen explains, "Now, here, you see, it takes all the running you can do to keep in the same place. If you want to get somewhere else, you must run at least twice as fast as that!" The story serves as a metaphor for one of the most famous aspects of the theory of evolution: the arms race that sets predators against prey in their struggle for existence.

In each predator species, natural selection favors the fittest individuals—that is, those who catch the most prey, feed themselves best, and above all can engender more offspring to whom they will transmit their traits. They are the fastest, the most cunning, the best camouflaged, or the best armed. Likewise, prey that are the fastest, the most cunning, the best camouflaged, or the best armed are favored, and will also transmit these traits to their young. The "Red Queen" theory, then, posits the occurrence of a co-evolution leading to the development of ever more effective species, and to a balance between prey and predators. As seductive as the idea may be, is this theory confirmed by the facts?

The great cats represent the archetype of the predator. The panther hunts from its hideout or closes in slowly to pounce on its prey. Its spinal column is especially supple, and its short but powerful limbs underscore the animal's adaptation to this type of hunt. Its joints are suited for quite diverse motions, notably at the wrist, which is capable of rotation. Thus, the panther can grip its prey, or clean its paws with its tongue. Its claws also let it climb into a tree to eat, sheltered from hyenas. Because its eye sockets are placed at the front of its skull, it has binocular vision for depth perception and can judge distances with precision. Its jaws open wide when it seizes its victim by the neck and strangles it. The zygomatic arches beneath the eye sockets leave a broad passage for the temporal muscles that provide for the vertical movements of the lower jaw. The jaw's articulation permits only this kind of action, but the panther does not chew its food. It just needs to bite to kill its prey, and then tear away the flesh with sharply pointed molars that slice like saws. These characteristics of teeth and jaws are particular to the great cats. More omnivorous animals, such as wolves and bears, have flatter molars that are suited to grinding their food.

For their part, the various species of antelope offer a broad range of herbivores to the predators who feed on them. The addax antelope, from the sub-Saharan desert, is one of the most massive and least swift species. Standing still, the bones of its limbs are aligned vertically, forming four columns that effortlessly support the weight of its body. The connections of the joints allow fewer possible movements than those in the panther, but they are more stable. Its broad hooves are adapted to the sandy, arid regions where it lives. The males use their horns in their battles during mating periods. Confronted with predators, the addax prefers to flee or, if cornered, to use its hooves more than its horns to resist. As in most ruminants, the eye sockets lie on either side of the skull, providing a visual field of nearly thirty-six degrees, which allows the animal to survey its surroundings with great efficiency. Attached to the broad flat surfaces of the mandible are the masseters, the muscles of mastication that control the lateral movements of the lower jaw. These movements are characteristic of an herbivore, which must chew food a long time in order to ease its digestion.

The addax and the panther seem perfectly adapted. Neither of the two species must "win out" over the other: the panther must not eliminate the addax, or it will be short of food. The addax must not systematically evade capture by the panther, or its proliferating numbers will lead to an overuse of the vegetation and, ultimately, to its death. This balance between predator and prey is not fixed for eternity. The Red Queen theory assumes that new characteristics, more useful ones, can take hold in a population and change the species overall. But if a predator becomes generally more skilled while its prey remains unchanged, the animal risks killing off its food supply, which would be harmful to its own species. There is some confirmation of such disruption of balance when a predator invades some territory where it had not been present before and brings about the extinction of one or several species. This situation corresponds to a telescoping between two different timescales—short "ecological time" and evolution's "long time." It has also been observed that the animal arms race sometimes undergoes a shift in direction. For instance, many species of saber-toothed tiger, armed with weapons far more terrifying than the fangs of contemporary cats, succeeded one another over nearly twenty million years and on almost every continent. The last of them became extinct a few thousand years back, just as giant Irish elk armed with enormous antlers have disappeared. These species did not eliminate one another; they probably died off during the ice ages, due to changes in vegetation and a reduction in their territories. The evolutionary race between predators and their prey is subject to many external elements, including climate change and disease epidemics. The interactions between predator and prey have given rise to countless mathematical models designed to test hypotheses concerning this model of co-evolution and taking into account its different ecological and evolutionary aspects.

In the real world, the evolution of the addax has probably reached a plateau, at least for the time being. The species has been so much hunted that it is in great danger of extinction. These days there are more addax in zoos than in their natural setting. Panthers are less endangered because, although they may have disappeared completely from the arid regions where the addax still roam, they remain rather abundant in the equatorial forests. If they do not die off, they will certainly continue to evolve, but we will probably not observe the changes, for human time is only a brief instant in the course of evolution.

—
Leopard, *Panthera pardus*. Africa, Asia (s.h. 60 cm)
—
Addax, *Addax nasomaculatus*. Sahara (s.h. 75 cm)

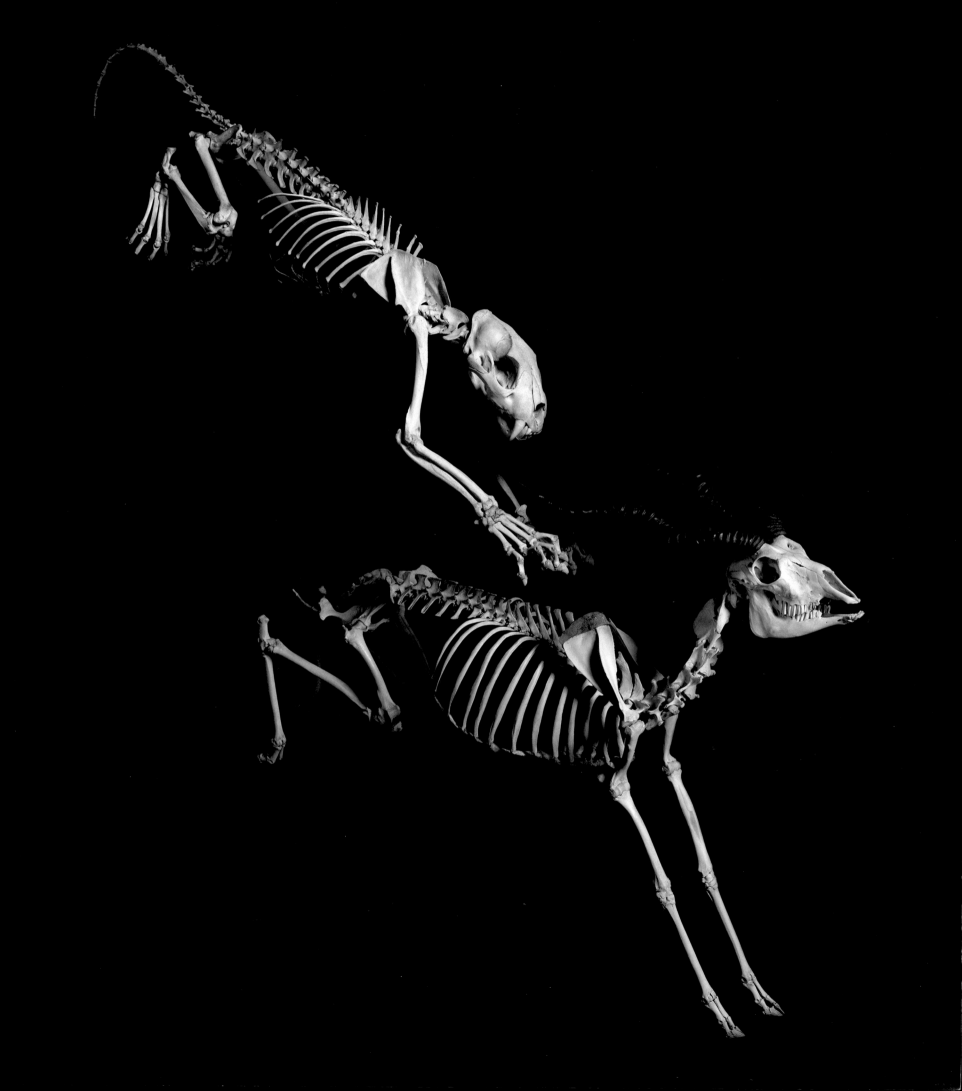

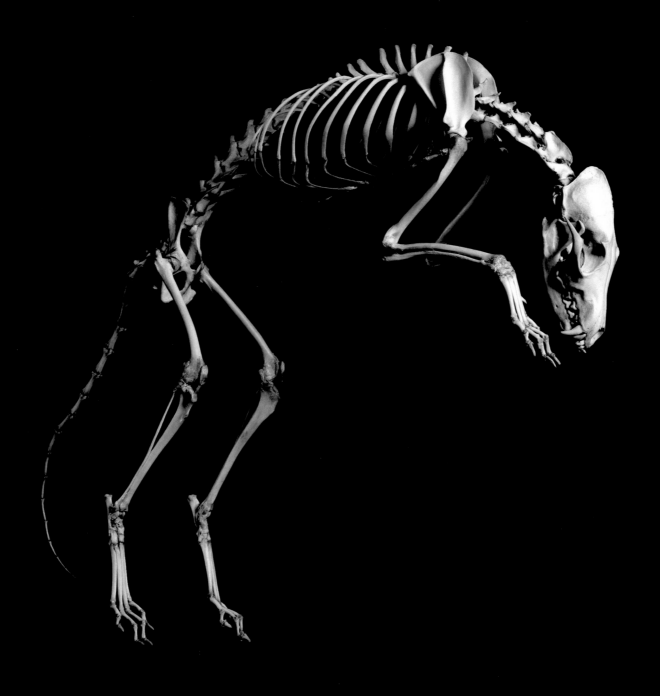

Red fox, *Vulpes vulpes*. Eurasia, North Africa, North America (l. 1.05 m)
Common vole, *Microtus arvalis*. Eurasia (l. 13 cm)

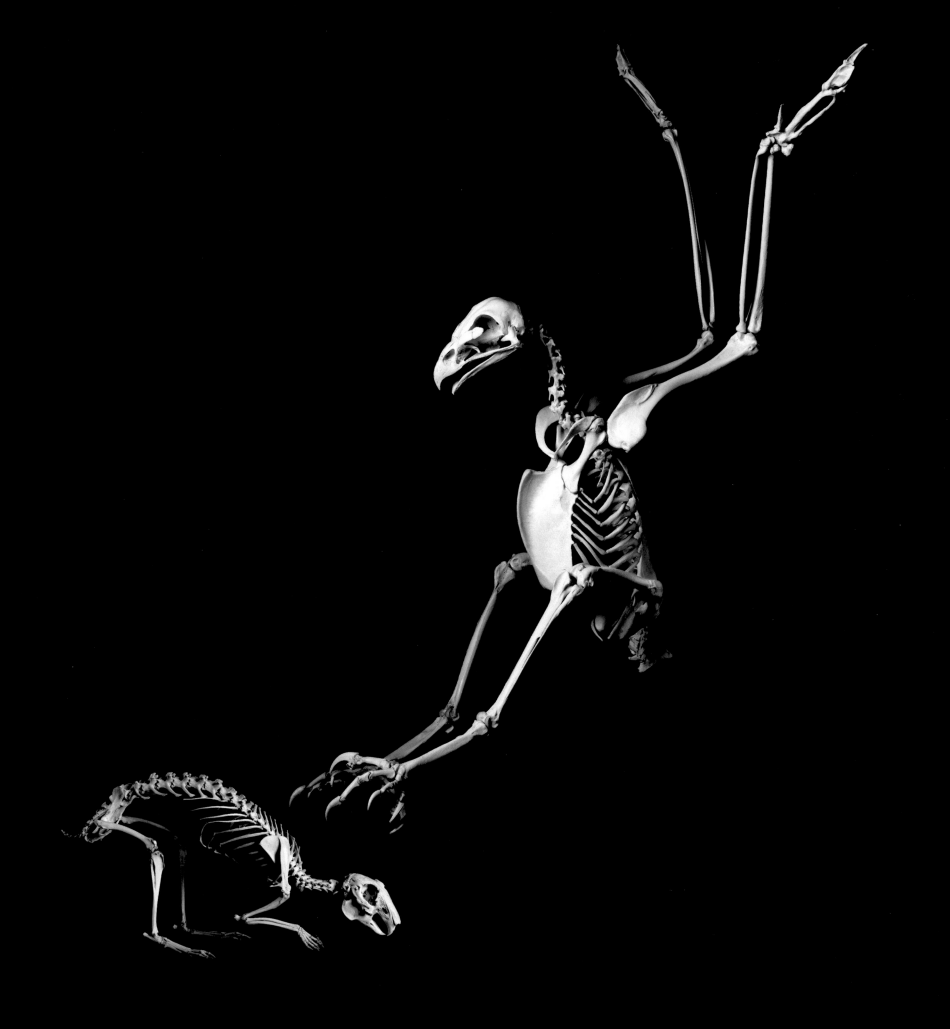

Rabbit, *Oryctolagus cuniculus*. Domesticated. Originally from Europe (l. 40 cm)
Golden eagle, *Aquila chrysaetos*. Eurasia, North Africa, North America (w. span 2.10 m)

CHAPTER 20
ARMAMENTS AND ORNAMENTS

The male water deer is armed with long, curved, slicing fangs that look more like a carnivore's than a peaceable ruminant's. The muntjac has antlers, as well as teeth shaped like tusks. The male roebuck has antlers, but no canines at all. The skulls of most ruminants bear ornaments—horns, antlers, or tusks. Over the course of evolution there have even appeared species with nine or ten horns. The giant Irish elk *Megaloceros giganteus* had antlers with a four-yard spread that weighed some hundred pounds.

The antlers of male cervids, like the stag and the moose, are an integral part of their skeleton. These antlers are made not of horn, but of bone. They are shed each year at the end of winter and then grow again, covered with "velvet," a thin layer of very moist skin that produces the bone material. The animal thus reconstructs its antlers every year, each time larger and with more branches. Bovid horns are permanent structures made up of a bony core covered with a horny sheath. There are other types of ornament, like the "horns" of giraffes, which are made up of a bony stem covered in skin and which are permanent. The North American pronghorn antelope has branched horns whose horny covering is shed each year, but the bony core is not.

Because the does have no horns and live most of the time apart from the stags, it would seem that the antlers play only a minor role in the defense of the species, even if a stag might occasionally use them against predators. The cervids are more likely to use their hooves and sometimes their teeth for defense. As for the bovids, both male and female bear horns, which they sometimes use against predators. Some antelopes with long, tapered horns, such as the oryx, are even said to be capable of killing an aggressor. Nevertheless, this defense function seems generally insufficient to explain the presence of antlers and horns, especially since other ungulates, like horses, have no such ornament.

It is in autumn that the stag's antlers become indispensable, when the males enter into competition for access to the females. The confrontation between two males begins with bugling, and then the two stags walk side by side. If neither one gives up, they fall on each other, tangling their antlers and trying to throw the adversary off balance by head movements. They often wound each other in these battles, in which mortality is considerable.

Only the victor in the duel can breed with the females of the herd (although some non-dominant males do occasionally manage to couple with a doe). The animal's size and strength, as well as his antlers, thus do seem to play an important role in his capacity to leave progeny. The long fangs of the muntjac and the water deer also have only one function: as weapons in the very violent struggles between males. Some bovids, such as the musk ox, butt heads, with their enormous horns functioning mainly as shock absorbers.

For nearly forty years, ethologists have been following a population of deer on the Isle of Rum, in Scotland. They measure the animals' individual characteristics, and evaluate their reproductive capacity and the heritability of their traits. They have been able to confirm that the most massive stags, the ones with the biggest racks, reproduce more than the others, and that their characteristics are transmitted to their descendants. The success of the males in battle is a good indicator of their abilities in other areas, such as the hunt for food and resistance to disease. The male loses his antlers each year and rebuilds them by producing several pounds of bone, which costs him a great deal of energy; thus, large antlers advertise that this male is especially good at the hunt for food. It also indicates he is probably not weakened by possible parasites. Antlers are produced under the influence of several hormones, such as testosterone, a male sex hormone with a major role in sperm development. Malformed antlers are often the sign of a testosterone deficiency, and therefore of a weakness in the animal's sperm. A high level of testosterone is important for reproduction, but it often brings secondary effects, notably a less strong resistance to infection. So, paradoxically, this is a further criterion of quality: it means that, despite the handicap that antlers constitute, the winner of the competition between males is in good health and especially vigorous—that this stag probably possesses other favorable characteristics that compensate for the negative effects of the testosterone. Big antlers therefore signal the generally high quality of the male, far beyond his mere physical strength. Biologists call the antlers an "honest" sign—that is, one that gives trustworthy indications that the does will bear fawns that are healthy themselves.

Stags with large racks of antlers are the object of a particular form of selection: sexual selection. The ornaments that play a role in reproduction develop under the influence of two series of genes: first, those in the male that determine the presence and characteristics of the antlers, and those in the females that draw her to this kind of ornamentation. Sexual selection is a mechanism that affects both sexes, but differently. Initially, an ornament may have been selected for reasons not linked to reproduction, but over time, the exaggeration of its characteristics depends on sexual selection. There is a snowball effect, with the males developing steadily showier ornamentation and the females exhibiting an ever more marked preference. This evolution can then lead to organs of excessive size that even become troublesome for the males. The point of equilibrium is reached when they can no longer compensate for the handicap, and the "vital" natural selection goes to work, by eliminating truly exaggerated characteristics.

There is another reason why the stags' ornaments represent a handicap: the larger they are, the more hunters covet them. The selective elimination from the population of animals bearing gorgeous trophy racks will thus be accompanied by an overall decline in the quality of the group, unless a hunting plan that respects the species takes account of the principles of evolution and does not work counter to sexual selection.

Red deer, *Cervus elaphus*. North America, Eurasia (s.h. 1.40 m)

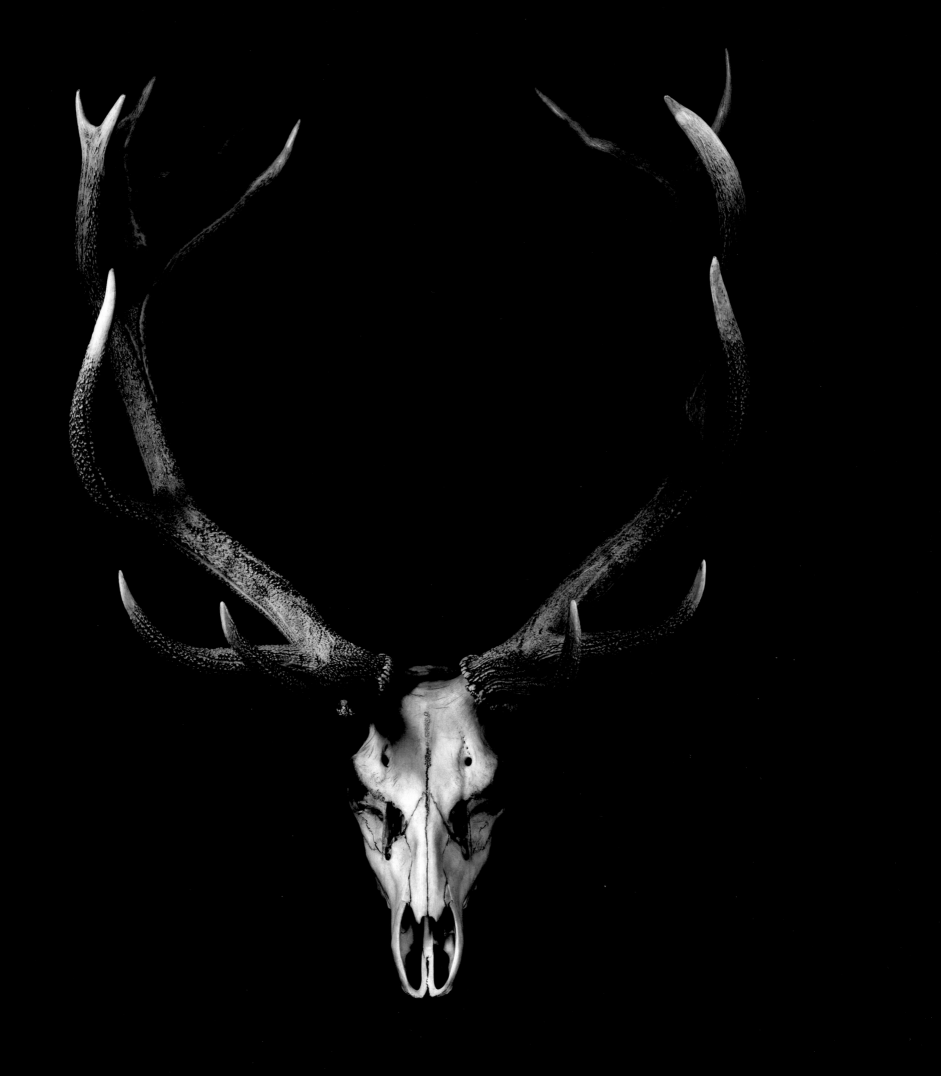

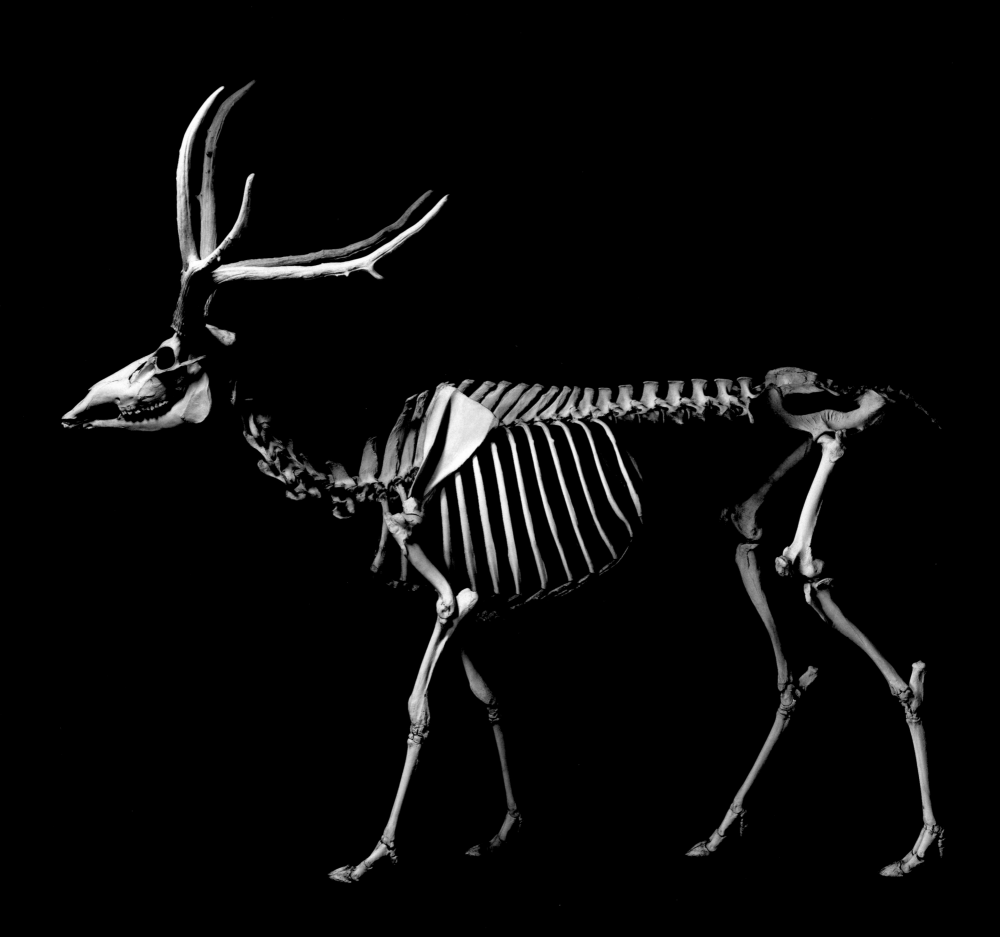

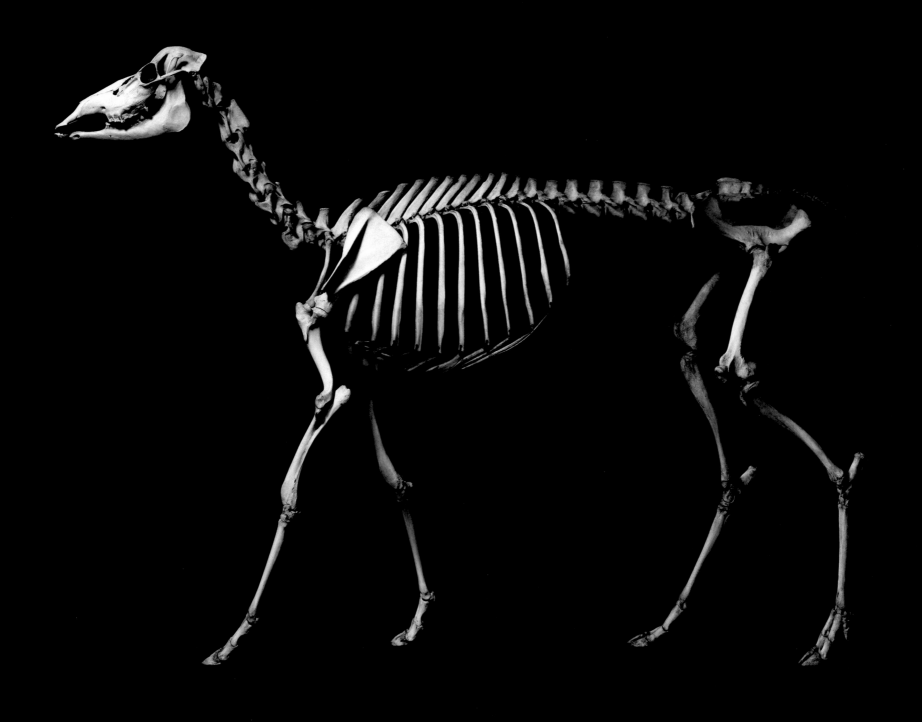

Père David's deer, *Elaphurus davidianus*. China (s.h. 1.15 and 1.05 m)

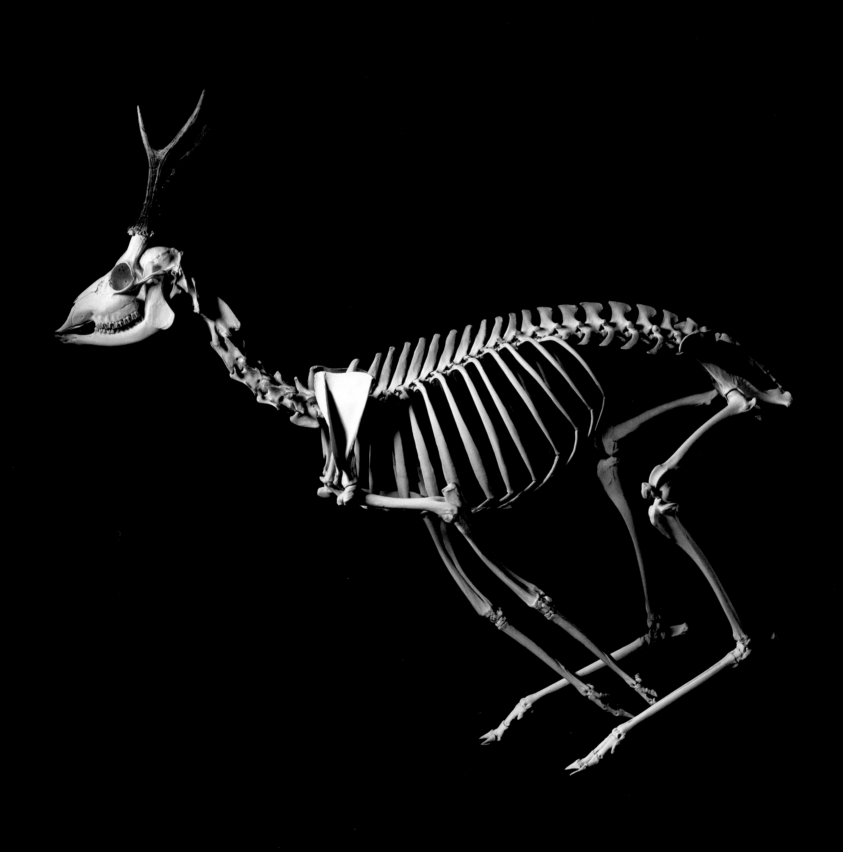

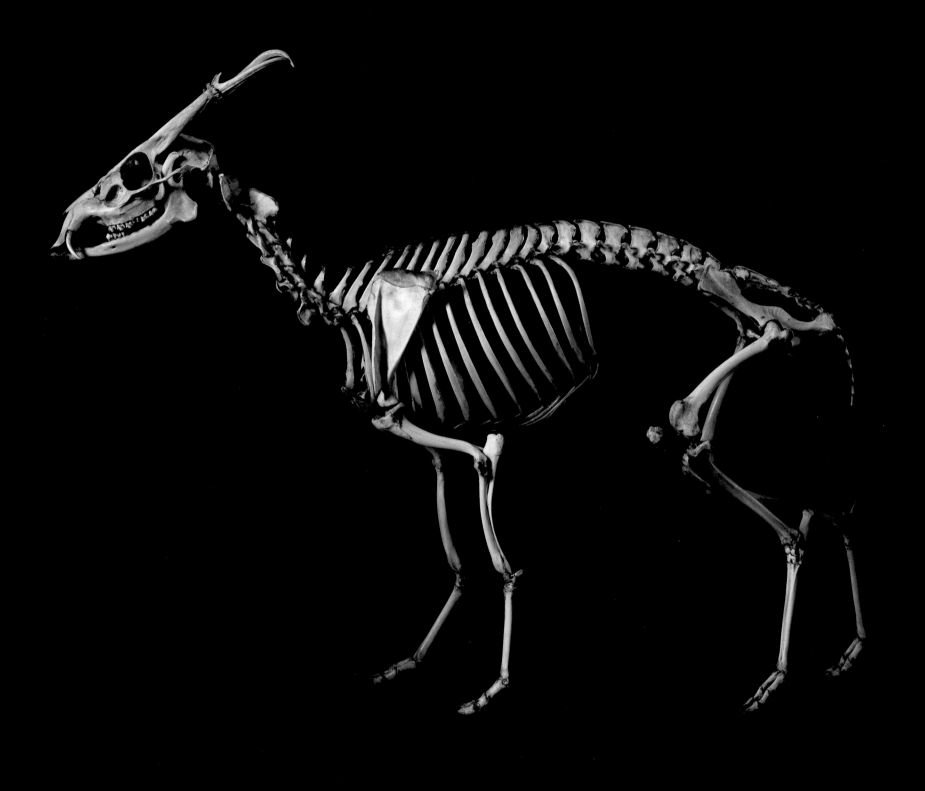

Barking deer, *Muntiacus muntjak*. South-east Asia (s.h. 86 cm)

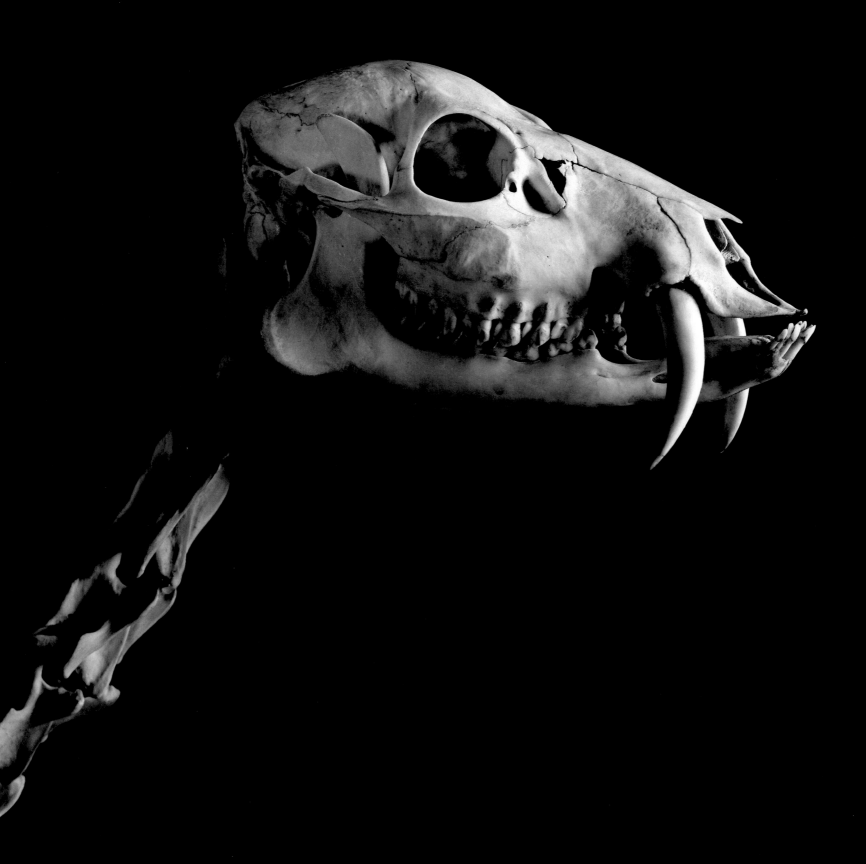

Chinese water deer, *Hydropotes inermis*. China, Korea (s.h. 47 cm)

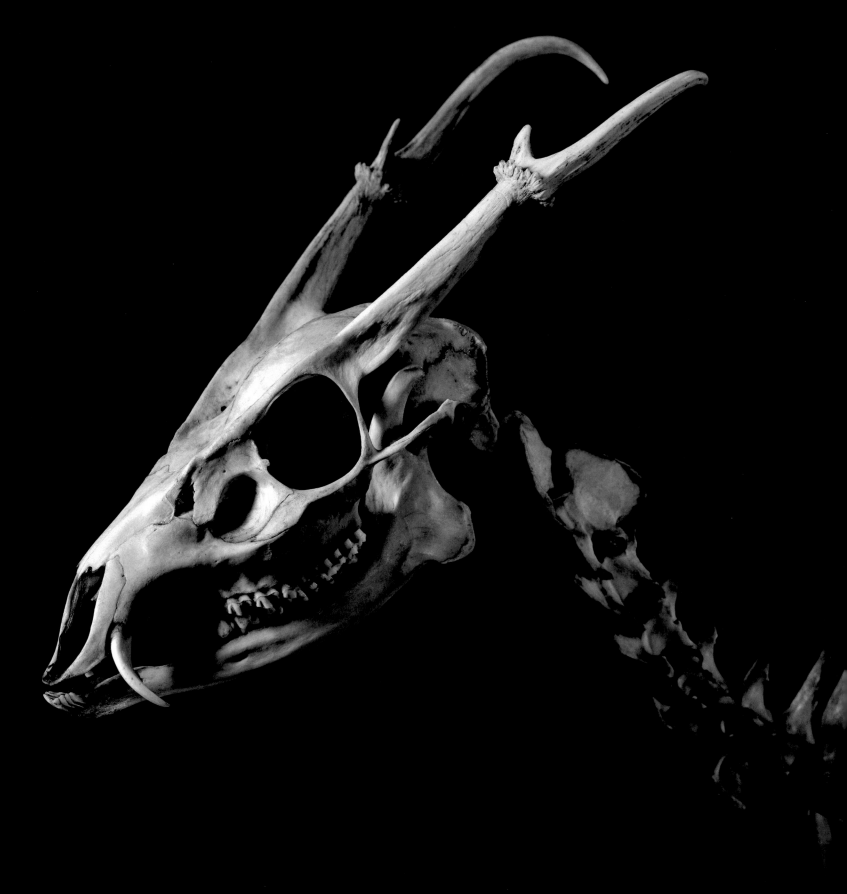

Barking deer, *Muntiacus muntjak*. South-east Asia (s.h. 86 cm)

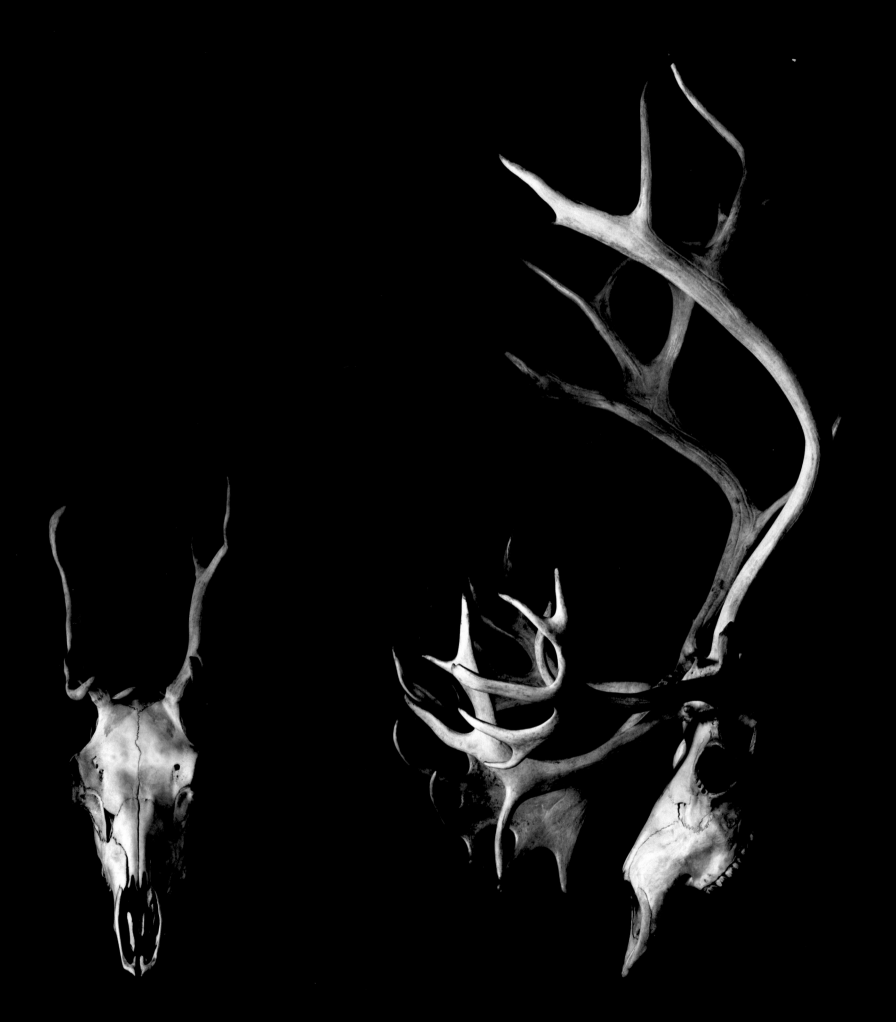

Caribou (U.S.), Reindeer (U.K.), *Rangifer tarandus*. Northern Eurasia, North America (s.h. 1.20 m)

Greater kudu, *Tragelaphus strepsiceros*. Sub-Saharan Africa (s.h. 1.50 m)

Musk ox, *Ovibos moschatus*. Northern Canada, Greenland (s.h. 1.30 m)

Scimitar-horned oryx, *Oryx dammah*. Chad, Niger (s.h. 1.10 m)

CHAPTER 21
THE MOST FAMOUS NECKS

In his *Zoological Philosophy*, published in 1809, Lamarck used the example of the giraffe to explain how an animal could evolve: "The giraffe...lives in places where the earth, almost always arid and without vegetation, requires it to graze tree foliage, and to strain constantly to reach it. That habit, sustained over a long while in all the members of the group, has had the result that its forelegs have become longer than the rear legs, and that its neck is stretched so long that the giraffe can without rising up on its rear legs lift its head and reach a height of six meters." By stretching its head high, he argued, the giraffe itself was responsible for lengthening its neck. Lamarck believed that this characteristic acquired by an individual was hereditary, and would be transmitted to its descendants. But that hypothesis, of the "inheritance of acquired characteristics," was later invalidated and is no longer considered to be a mechanism that could contribute to the evolution of living beings.

Sixty-three years later, in the sixth edition of his *Origin of Species*, Darwin returned to that same example, but in a quite different way: "The individuals which were the highest browsers and were able during dearths to reach even an inch or two above the others, will often have been preserved; for they will have roamed over the whole country in search of food. These will have intercrossed and left offspring, either inheriting the same bodily peculiarities, or with a tendency to vary again in the same manner; while the individuals less favoured in the same respects will have been the most liable to perish."

In this, Darwin was giving an explanation that conformed to his theory of natural selection: individuals who are—by chance—favored will survive more often than others, and their descendants will inherit their qualities. He meant especially to demonstrate that an organ like a giraffe's neck took shape gradually and not abruptly, which helps in understanding how all the organs came to evolve at the same time. The mechanism Darwin proposed—natural selection—won out over Lamarck's hypothesis, but his "explanation" of the giraffe's neck has never been verified. Still, for more than a century it has remained one of the favorite schoolbook examples to illustrate the idea of evolution and the mechanism of natural selection. (There was even less evidence back in Darwin's time, when no other living giraffids were yet known and extremely few fossil giraffids had been found.

Further close observation of giraffes in the wild has contributed new findings. It has been found that the females feed half the time with the neck extended horizontally, and thus do not always make use of their height, even though their necks allow them to reach foliage inaccessible to other herbivores. So the function of a giraffe's long neck may not be solely to attain food. It could also be useful for spotting predators or food sources at a distance, or it might be an instrument for shedding body heat, or a defensive tool. None of these hypotheses, though, is supported by convincing evidence. On the other hand, observation in the wild shows how male giraffes actually do use their necks. During mating season, the males fight each other, and they wield an unexpected but formidable weapon: they swing their neck like a golf club and hit one another with their head. The top of their skull happens to be very thick, with large air sinuses in the bone that absorb the shock of the blows. The battles end with the flight of one of the two protagonists, and sometimes even his death. The females choose as partner the victorious male, who is often the one with the more powerful neck. Thus, the organ is the equivalent of the cervid's antlers. It is not very practical, but it has developed through the action of sexual selection, as it guarantees more successful reproduction. And giraffes display all the signs of a dimorphism linked to that selection: the males are on average 60 percent heavier than the females; they have a longer neck and a more resistant skull. Their head and neck continue to grow with age, unlike those of the females, who do not fight among themselves in the same way.

The current use of the neck gives no indication as to why or how the elongation came about. One could posit two different evolutionary scenarios, both involving sexual competition and the search for food. In the first, the elongation of the neck would arise primarily from sexual selection and then, secondarily, allow access to fresh new food resources. The second scenario would start from a slight elongation that improved access to food, and go on to an increase through sexual selection. To decide between these two hypotheses, it may be useful to compare giraffes to their relatives, contemporary or fossil. In 1901 Western naturalists discovered another member of the giraffid species, the okapi. Cousin to the giraffe in several characteristics, such as its dentition and horns, it differs in its smaller size: it measures about a meter and a half tall at the shoulder—half the height

of the giraffe. Its neck has the same seven vertebrae, but they are each much shorter. Paleontologists have looked for fossils that could indicate the appearance of the common ancestor to the two, the okapi and the giraffe. The giraffids were far more numerous in the past, and in some places even constituted the principal species of large herbivores. The many giraffids who lived in Asia and Africa some millions of years ago probably resembled the okapi more than today's giraffe. Others, such as the sivatheriums, were huge, and more massive than the giraffe, but their necks were relatively short. Some species of sivatheriums, actually, have grown smaller over the course of their evolution. The diversity of the giraffes could explain the increase in neck length in one line, through competition among the different species inhabiting the same area. But all these data do not provide a clear enough picture of giraffe evolution to decide between the two scenarios. Darwin himself emphasized, in speaking about the giraffe: "The preservation of each species can rarely be determined by any one advantage, but by the union of all, great and small."

Giraffe, *Giraffa camelopardis*. Sub-Saharan Africa (s.h. 2.90 m)

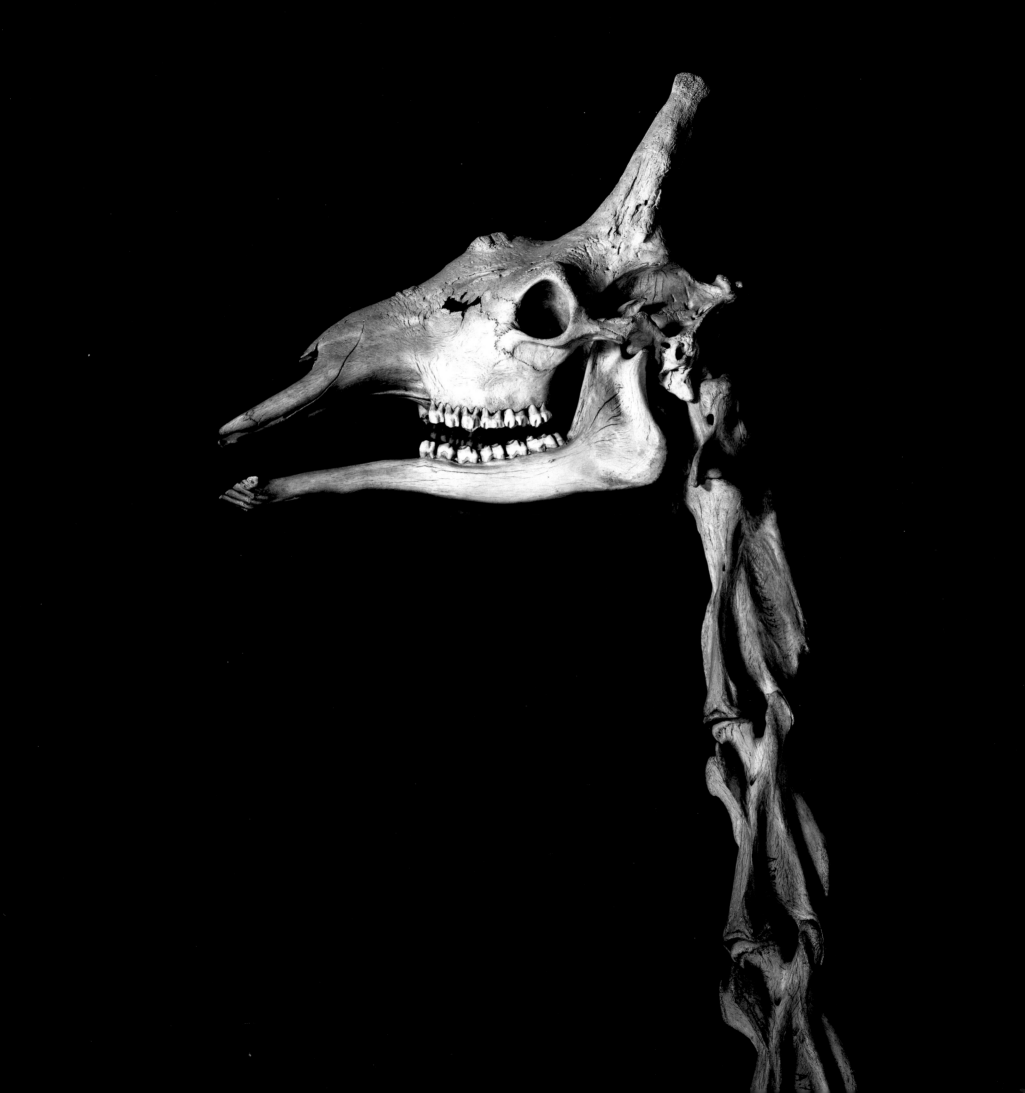

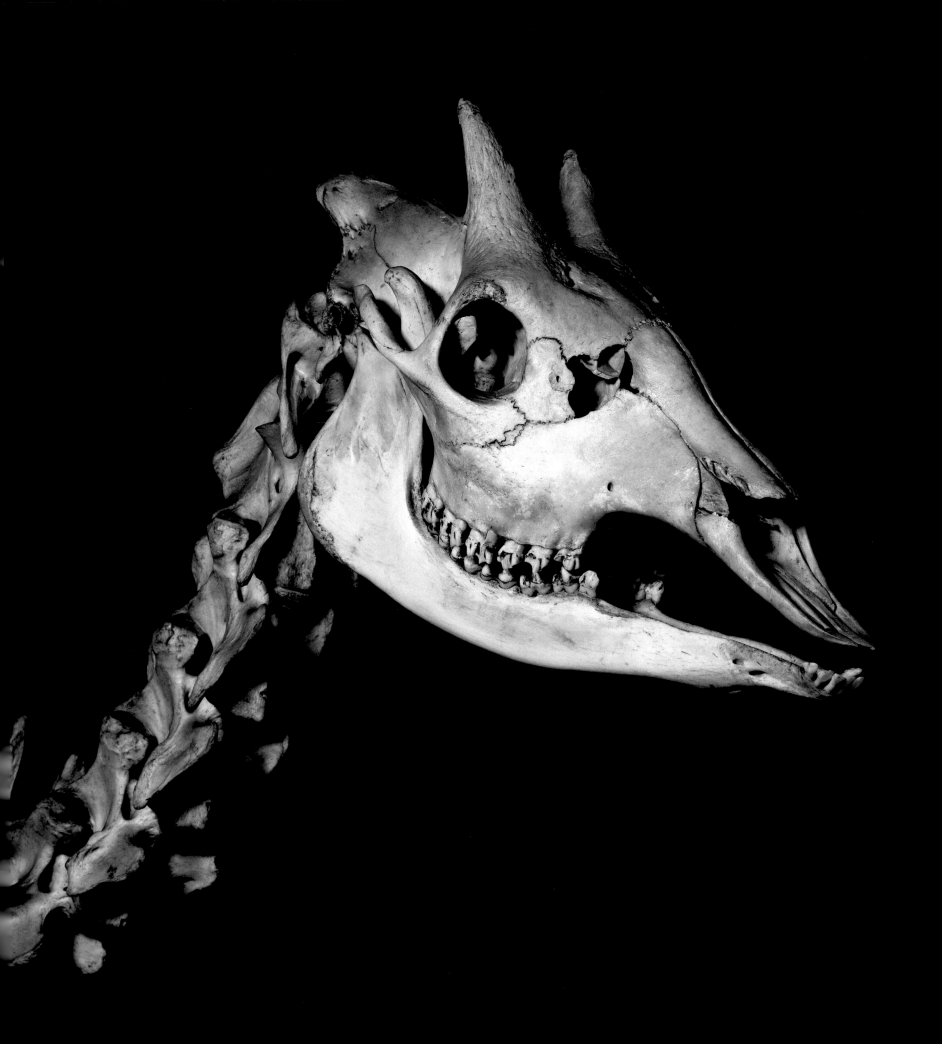

Okapi, *Okapia johnstoni*. Central Africa (s.h. 1.40 m)

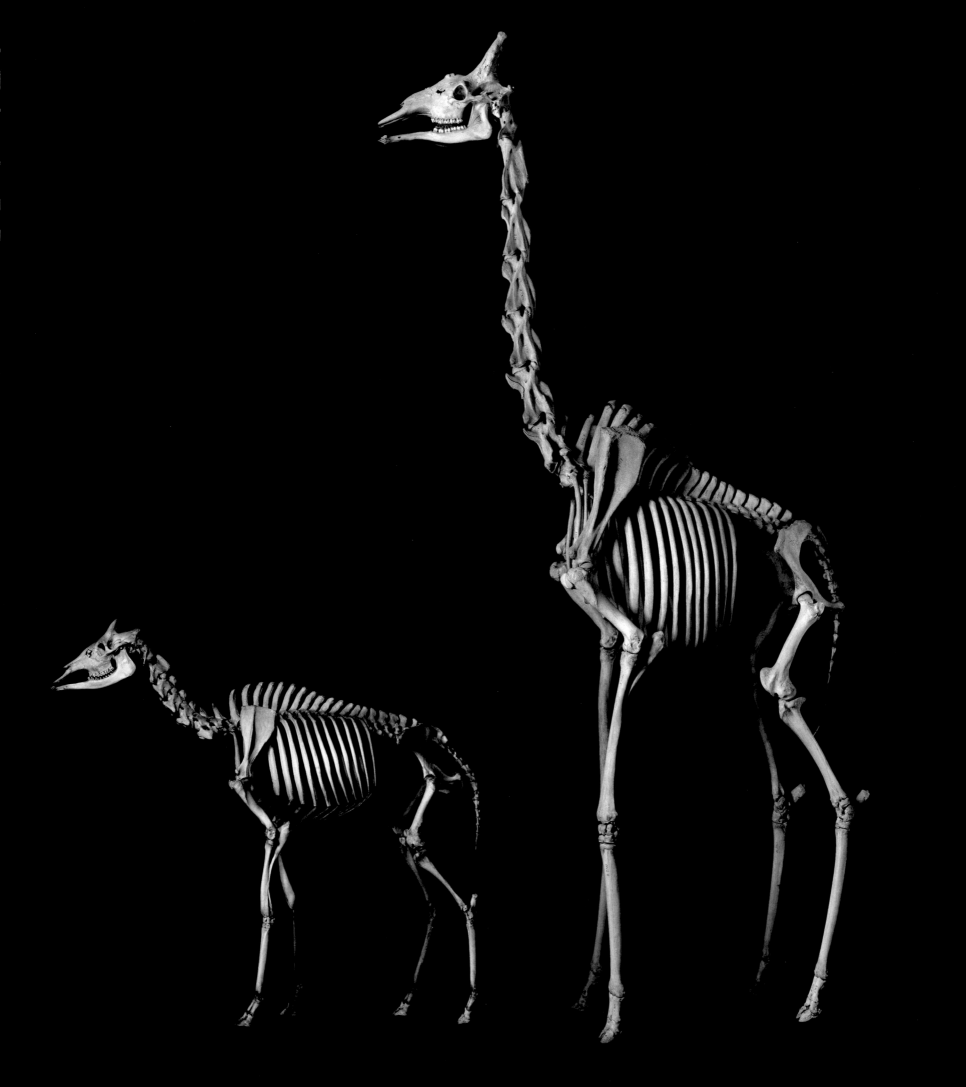

CHAPTER 22
COMPETING FANGS

A monkey's smile is not always easy to interpret. Depending on the species, the display of "open mouth, bared teeth" has quite different meanings, which vary from intense stress to friendly invitation. For instance, mammals' teeth are not exclusively meant for feeding. Whether the tusks of the warthog, the long fangs of the musk deer, or the fearsome canines of the gorilla, they notably play a determining role in reproduction.

A male gorilla's fangs attain nearly the length of a lion's. Those of the female are a good deal smaller, even allowing for the size difference in the two sexes. The gorilla is one of the primates in which physical differences between males and females—sexual dimorphism—are the most pronounced. With an average weight in the wild of about one hundred eighty kilograms, the males are twice the weight of the females. The crown of their skulls has a high crest to which are attached the powerful muscles of the jaws. This crest is much smaller in the female. Such a marked difference between males and females is the sign of a strong sexual selection. It also corresponds to a particular social structure. In gorillas, a group is typically made up of a dominant male, several adult females, and their offspring. The male sometimes tolerates the presence of young males, particularly his sons, at the fringe of the group. On the other hand, he behaves very aggressively toward other adult males. This social structure results from intense competition among males. As in the case of deer, the characteristics that might give them a reproductive advantage are favored: a large size brings greater muscular power and weapons of dissuasion such as prominent fangs. The selection the females practice also plays an important role, for they prefer to mate with the dominant males. Mandrills have a social structure similar to that of the gorillas, and their sexual dimorphism is even more pronounced, the males' fangs being especially intimidating [see page 16]. The reproductive rate of the males, estimated from their number of identified descendants, is strongly correlated to the length of the canines.

In the primates, it seems that body size is one of the factors that would explain the group structure. The larger the species, the greater the differences between the sexes and the more females included in the familial group. The females' selection among the males, however, has in turn an effect on their own size, for the offspring of a large male are themselves larger, whether male or female. The environment also contributes to the social structure. If the food is concentrated in certain zones, a male can supervise the territory in which the females can get access to resources. Conversely, if the food is evenly dispersed, a single male cannot exercise such control, especially in woodlands. In this case, the monkeys may live in large mixed groups, with less strong competition among the males. In such cases, one would expect a less marked sexual dimorphism, and that is what we see with some macaques and with chimpanzees.

The chimps live in communities sometimes as large as several hundred members. Depending on the available food, they form subgroups of varying size, whose composition can change rapidly. These groups are mixed, with a dominant male that is not necessarily the largest or the strongest. Chimpanzees are actually capable of cooperating to dethrone the dominant male, with his successor being more tolerant toward the "associates" that helped him attain the position. Thus sociability plays an important role, especially because the females do not necessarily choose the most powerful males; they are also likely to pick the most sociable individuals, those who readily participate in such activities as mutual grooming, which is very important for reducing tensions within the group. Sexual selection remains strong, but it is more complex as a result of the interaction between the social hierarchy and the varyingly amicable relations between individuals.

Certain primates do not display any sexual dimorphism to speak of. Male and female gibbons are the same size, and their canines are equally small in both. All the individuals are scattered in the trees searching for food. The competition between males is slight, and they form stable couples with the females. This "monogamy" corresponds to an environment with abundant resources distributed homogeneously.

What can we learn about our own origins from the various social structures of primates? It is important to take account of the sexual dimorphism in our own species, and of our position in the phylogenetic tree of the primates. Men are on average larger, heavier, and stronger than women. Our canines are small and almost the same in the two sexes. Our species's dimorphism lies between that of the chimpanzee, our closest cousin, and that of monogamous species that are clearly farther from us. It could be assumed, then, that our ancestors lived in rather large mixed groups, in which sexual selection was less marked than in chimpanzees. The two present day species of chimpanzees have rather different social behaviors, though. The bonobos have gained fame for their sexuality, which is much richer than that of other chimpanzees. Beyond reproduction, they use sex for play, for reconciliation, for comfort, and as a means of changing social status. The female bonobos form tight bonds with one another that provide a counterweight to the males' power. The dominant male is in fact the son of the dominant female. Chimpanzee society is more hierarchic, with pronounced male domination. The individuals are rather quarrelsome, but they are somewhat easier about sharing their food. Our closest cousins are neither the gibbons nor the gorillas but the chimpanzees and the bonobos. Our common ancestor, still unknown, is thus the source of three species with quite different social behaviors: the chimpanzees, the bonobos, and we ourselves. By our anthropomorphic criteria, we find bonobo life more pleasant than that of the chimpanzees, but there is no reason to think that we are more closely related to one group than to the other.

Male gorilla, *Gorilla gorilla*. Equatorial Africa (h. 1.35 m)

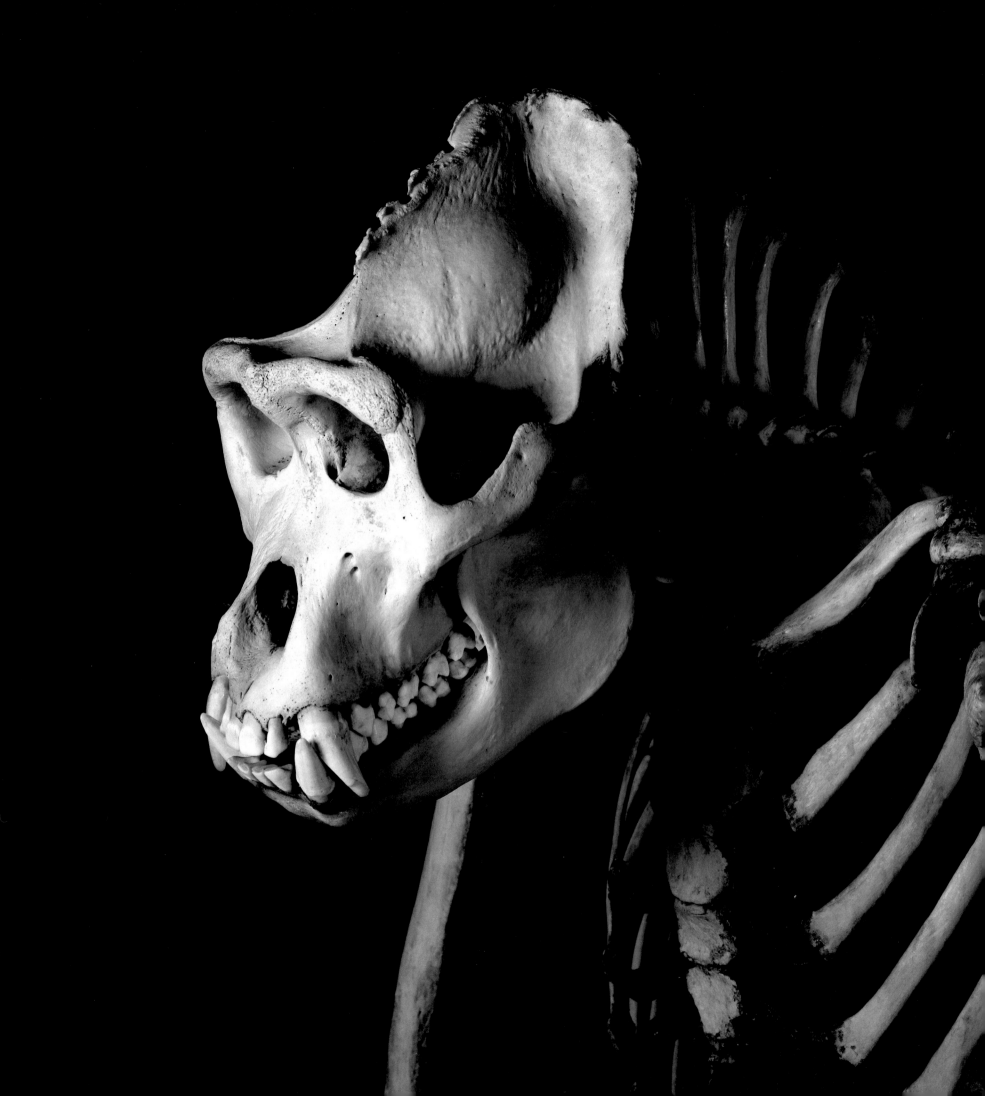

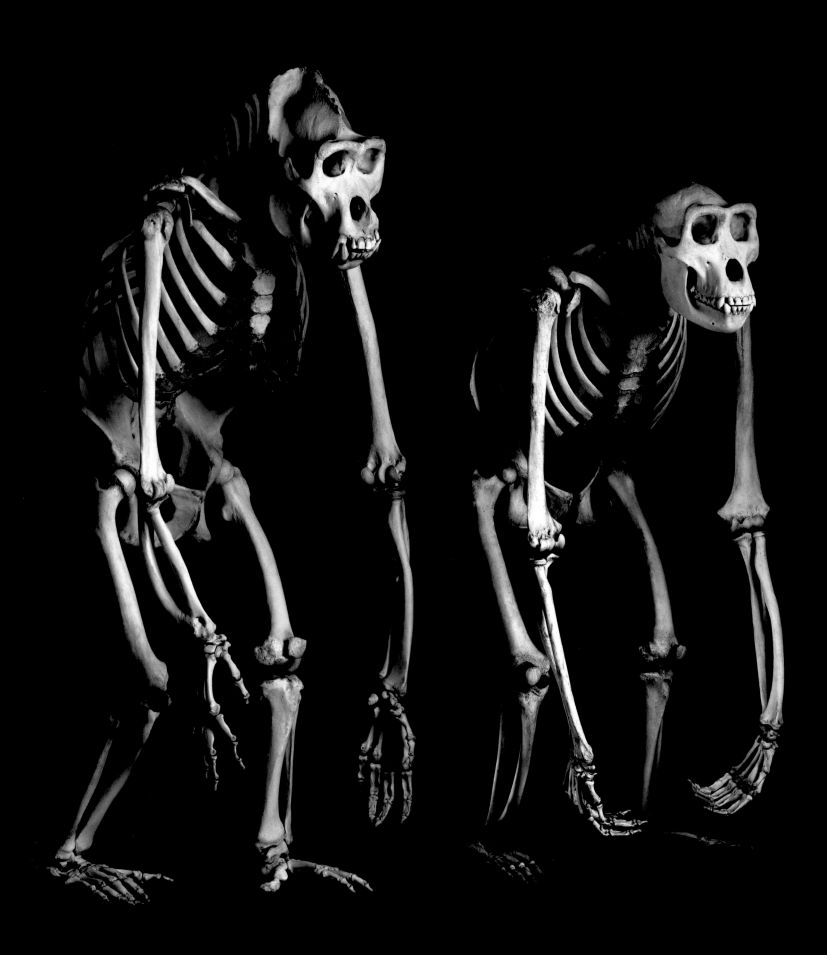

Male and female gorillas, *Gorilla gorilla*. Equatorial Africa (h. 1.35 and 1.10 m)

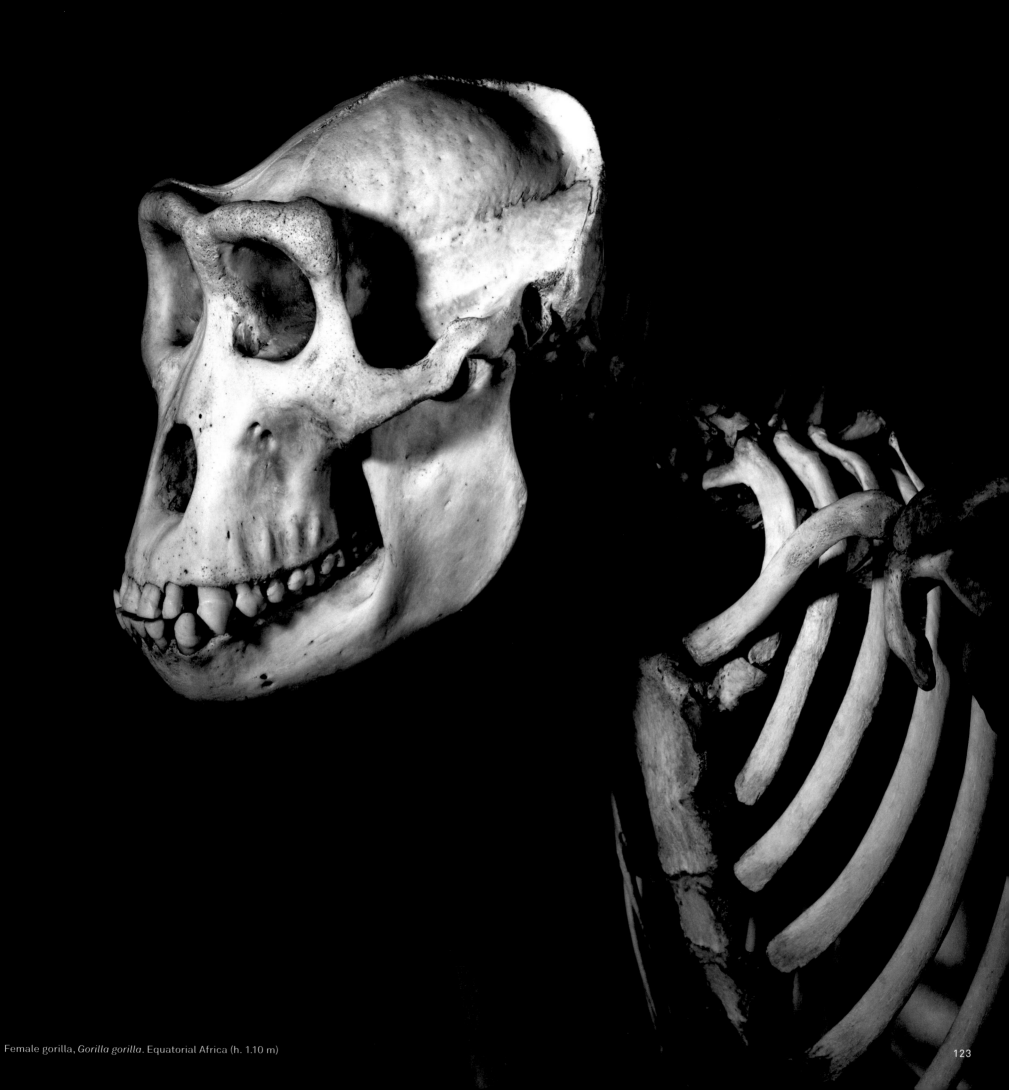

Female gorilla, *Gorilla gorilla*. Equatorial Africa (h. 1.10 m)

CHAPTER 23
LOVE BEFORE DEATH

The mortality rate of the babirusa, a type of wild pig, is often raised in a curious way: some individuals die of having their brain pierced by their own tusks. How could natural selection—known for promoting ever-greater adaptation in species—lead to such unfavorable anatomical structures? Actually, evolution does not work directly on the life of individuals but rather on their ability to leave descendants. In the babirusa, the tusk phenomenon is not an example of adaptation but a secondary effect of the reproductive process. In the animal world, sex is sometimes intimately linked to death, as it is for the praying mantis devoured by his mate or for salmon dying by the millions a few hours after laying their eggs.

The babirusa is part of the Suidae family, which also includes the boar and the desert warthog. Its chromosomes indicate that it is a fairly distant cousin, part of a line that separated from the other Suidae some thirty or forty million years ago. This long-ago divergence is due to the isolation of this species on a few Indonesian islands that for a long while lay far distant from the Asian continent. But the babirusa did retain certain characteristics of the Suidae, such as the snout for digging into the earth to seek roots and tubers. The babirusa uses its snout only in mud and marshy terrain, which explains its lack of the nasal bones that support the snouts of other wild pigs. But like the others, it also has long canines transformed into tusks. The bottom ones emerge from the lower jaw and point upward; the upper canines also grow upward, crossing the muzzle and then curving to the rear. They grow as long as thirty centimeters. In certain aged males, the tips of the tusks sometimes end by meeting the skull, which they gradually pierce until they bring about the animal's death. In the female, the tusks are much smaller or are absent.

The adult males are solitary, but they do join in competitive battle with their congeners in the mating season. They fight with the lower tusks, which can inflict serious wounds. The upper tusks are inoffensive; their function is mainly to protect the eyes from the tusks of adversaries. In their natural environment, these animals have evolved without predators. Their only serious wounds being those they inflict on one another, two of their tusks have lost their aggressive function and acquired a protective one. This is somewhat like the multiple branches of a stag's horns, which can fend off the blows aimed by other males. We know little about babirusa behavior, but these tusks may also be ornaments meant to attract females, like the stag's antlers providing this double function of competition and attraction (the word "babirusa," incidentally, means "pig-deer").

Not all the males die of the skull being pierced by their own tusks. In most of them, the tusks grow away from the skull, and their twisting form suffices to avoid any wound. Besides, the tusks do not reach a length great enough to threaten the animal's physical integrity until late in his life. By then he has managed to reproduce several times, and in so doing to pass along his characteristics to his descendants. The few cases of babirusas killed by their own tusks cannot diminish the advantage of having ever more formidable ones that can win over a female heart.

This seeming contradiction between the individual's survival and that of the species is widespread in the animal world. After the age of sixty or seventy, an elephant becomes incapable of feeding himself, for he has worn down the six sets of molars he was endowed with. He then dies of hunger, but he had probably had occasion to reproduce, and had already been eliminated from the sexual competition with the younger males. His death thus comes after he has exhausted all his reproductive possibilities.

In other species, such as salmon, mortality is the immediate consequence of reproduction. These fish, after some years spent at sea, return to lay eggs in the river where they were born. Swimming against the current and leaping the rapids is an exhausting task, all the more so because the salmon are not feeding all that time. Many individuals die on the way and therefore never do reproduce; this is the usual play of natural selection. Only the most resistant reach the egg-laying areas, but after reproduction most of them die of exhaustion. A few individuals, mainly females, manage to return to the sea and then to carry out a second and even a third reproductive migration. We might imagine that selection would favor these exceptional capacities, so that most salmon could reproduce several times. But because that is not the case, we can assume that a single egg-laying is generally sufficient to keep the species going.

These two species, babirusa and salmon, correspond nicely to the two poles biologists use for comparing animals' reproductive strategies. Some animals have a short life span and a high rate of reproduction; the parents do not take care of the young, whose mortality is very high. This strategy is widespread among insects and fish. Other animals develop slowly and live long; they have few offspring, but they take care of them, which reduces the mortality of the young. This is the case for most of the large mammals, like the babirusa. The survival of the species obviously depends on the good health of individuals, but only until they have seen to their own progeny. Thereafter, their individual fates no longer matter.

—
Babirusa, *Babyrousa babyrussa*. Indonesia (s.h. 75 cm)

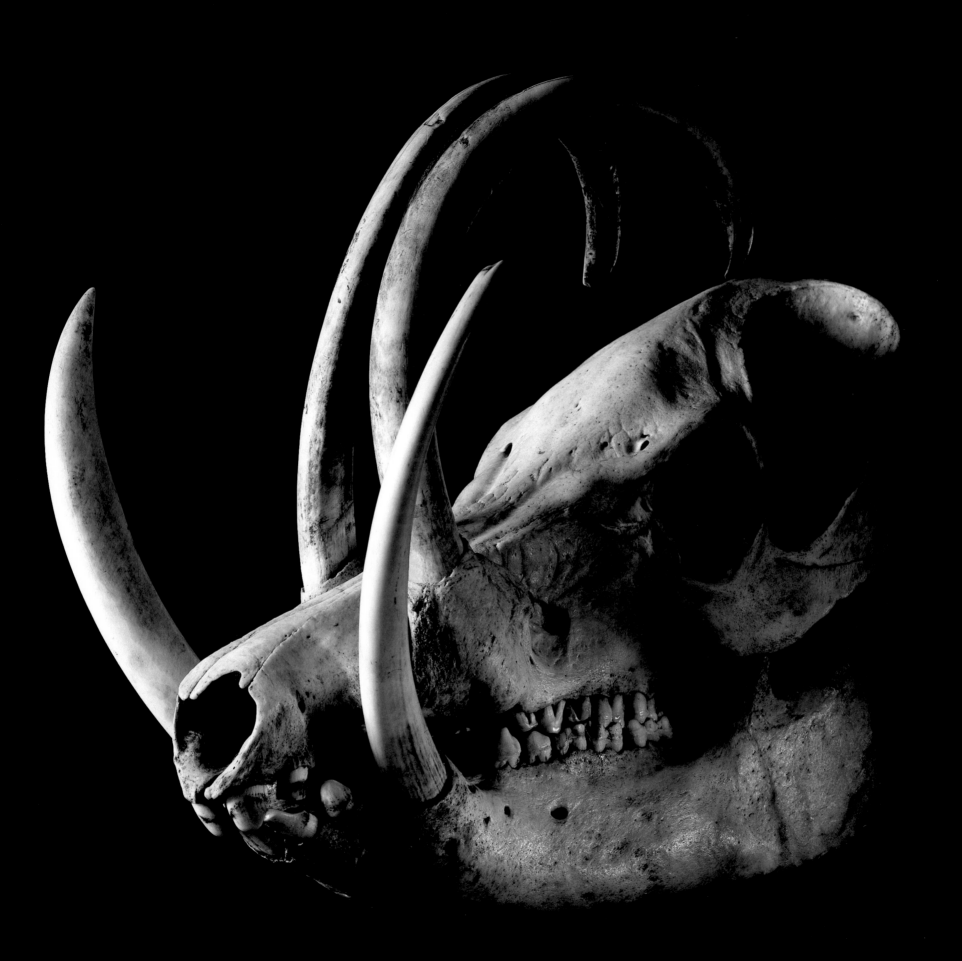

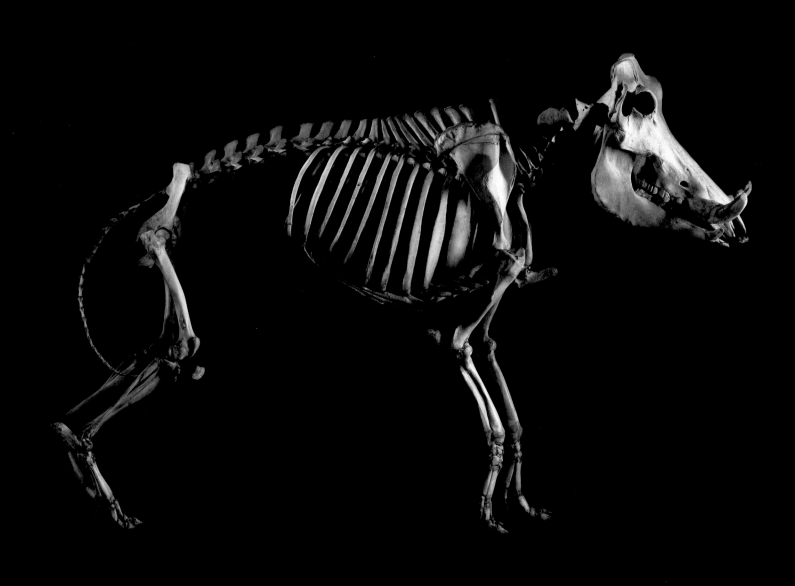

Warthog, *Phacochoerus aethiopicus*. Sub-Saharan Africa (s.h. 69 cm)

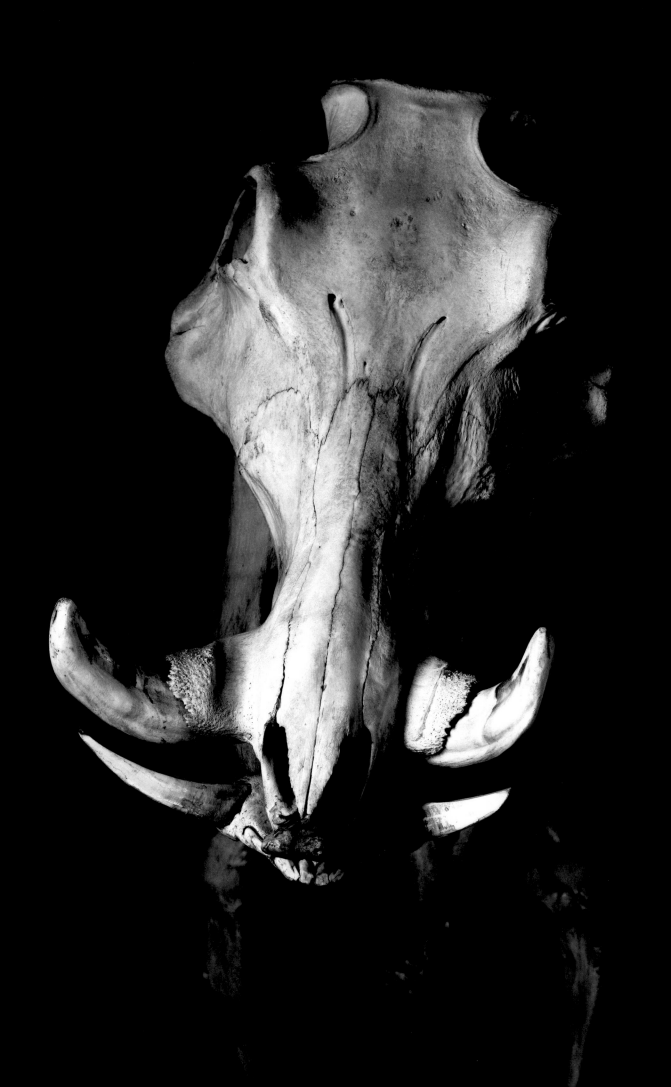

CHAPTER 24
THE NUMBER OF HORNS

Some species of rhinoceros have one horn and some have two. Does the difference result from natural selection? In other words, is it more advantageous for some rhinos to have two horns and for others to have only one? The theory of natural selection revolutionized biology, but some naturalists have pressed the notion to its limits by seeking the adaptive value of every single characteristic. It is easy enough to imagine the value of having two horns rather than one (or the reverse) and to claim that selection has favored the two-horned rhinoceros here and the one-horned elsewhere. But such accounts give no indication of the appendages' real role, if they do have one, or of the possible means by which selection has done the work. Can observation of living rhinoceroses provide such information?

At present there are five kinds of rhinoceros, and they differ by size, by certain skeletal details, and by their dentition. The black rhino, *Diceros bicornis*, and the white rhinoceros, *Ceratotherium simum*, both live in Africa but do not feed in the same way. Their heads carry two horns: the first measures as much as 1.6 meters and the second fifty centimeters, one third as long. The Sumatran rhinoceros, *Dicerorhinus sumatrensis,* has two horns, the first twenty to thirty centimeters long and the second much smaller, often a mere bump. The single-horned rhino of India, *Rhinoceros unicornis*, has only one horn, about fifty centimeters long, like the Java rhinoceros, *Rhinoceros sondaicus,* whose horn rarely surpasses twenty centimeters. Rhino horns are made of keratin, the material of nails and hair in mammals, but these are solid and not supported by a bony core as are the horns of bovids and antelopes. Keratin is produced by the skin on a rough, thickened area over the nasal bone, at the front of the cranium (and on the frontal bone, when there is a second horn). The horn continues to grow throughout the animal's life, by five to ten centimeters a year, and it wears down at its tip, for instance when the animal scrapes it against the ground. If some harsh shock causes the horn to fall off, it grows again.

The first thought is that the horn could be a defensive weapon against predators. The question is important, because removing the rhino's horn is sometimes recommended to discourage poaching. Rhinos are seriously endangered, because their horns command a high price on the Asian market for making supposedly aphrodisiac powders or to use as dagger hilts. De-horned females seem to lose their young more frequently, which leads to the assumption that their horns are in fact used to protect their offspring against predators—hyenas and lions in Africa, tigers in Asia. This function is disputed, however, for no one has actually observed such attacks, only noted the loss of the young.

Another hypothesis proposes that the horn is a weapon in male-on-male competition. It does in fact happen that male white rhinos attack other males who attempt to infringe on their territory. The battles intensify during mating season. In the two species of African rhinoceros, the males meet violently and inflict serious wounds. These battles are responsible for half the mortality in black rhinoceros (apart from poaching). A male's reproductive success appears to depend on his size and the length of his anterior horn. A large size and a long horn make him more formidable to other males and also more attractive to females. This conclusion cannot, however, be extended to the Asian single-horned rhinos, for the latter do not fight with their horns but with their lower incisors transformed into tusks. The African rhinoceros cannot fight that way, because he has lost his incisors. It is hard, then, to compare the behaviors of the African and Asian species. Another problem is that the competition between males is generally linked to a fairly pronounced sexual dimorphism. Now the male is significantly larger than the female in only two species: the white two-horned rhino and the Indian single-horned rhino. It is therefore not possible to link the number of horns to a role in rhinoceros reproduction.

If the purpose of the first horn is poorly understood, the presence of a second is even more puzzling. Significantly smaller than the first, it does not appear to constitute a very useful weapon. It could have some complementary role in confrontations between males, for example blocking the movements of the adversary's horns, but observations do not appear to confirm this hypothesis. The formation of this horn could also be merely an effect of the animal's size: thus, in the cervids, the largest species generally have larger and more branched antlers. But the smallest of the five species is the Asian two-horned rhinoceros.

A problem that does not find a solution could be a problem that is poorly formulated. The number of horns in rhinos may have no adaptive meaning at all. It could be just the result of random mutation. Some biologists have chosen this example to illustrate the idea that not all characteristics were necessarily adaptations, and that some biological function could be fulfilled in several different ways that are equivalent in terms of natural selection. Indeed, there is some variability in the number of horns, since some individuals have three and even five. Three-horned black rhinoceros are fairly common in Namibia. The famous Indian rhinoceroses that Dürer drew in the sixteenth century shows a small extra horn on its shoulder. These variations are probably linked to genetic factors on which selection has little influence.

So the number of horns on rhinoceroses remains unexplained. The two African bicorne species are related, as are the two single-horn species of Asia. As for the Sumatran bicorne rhinoceros, a genetic study shows it to be closer to the single-horned Indian rhino than to the two-horned African. Thus, genetics has grouped rhinos according to their geographic origin and not according to the number of their horns. It is possible that the ancestor of the five present day species had two horns and that one of them has disappeared in the lineage of the two single-horned species. The initial question then becomes: Why did certain rhinoceroses become single-horned? In the sciences of living things, replacing an answer with a new question is one way to move ahead.

—
Indian Rhinoceros, *Rhinoceros unicornis*.
India, Nepal, Pakistan (s.h. 1.55 m)

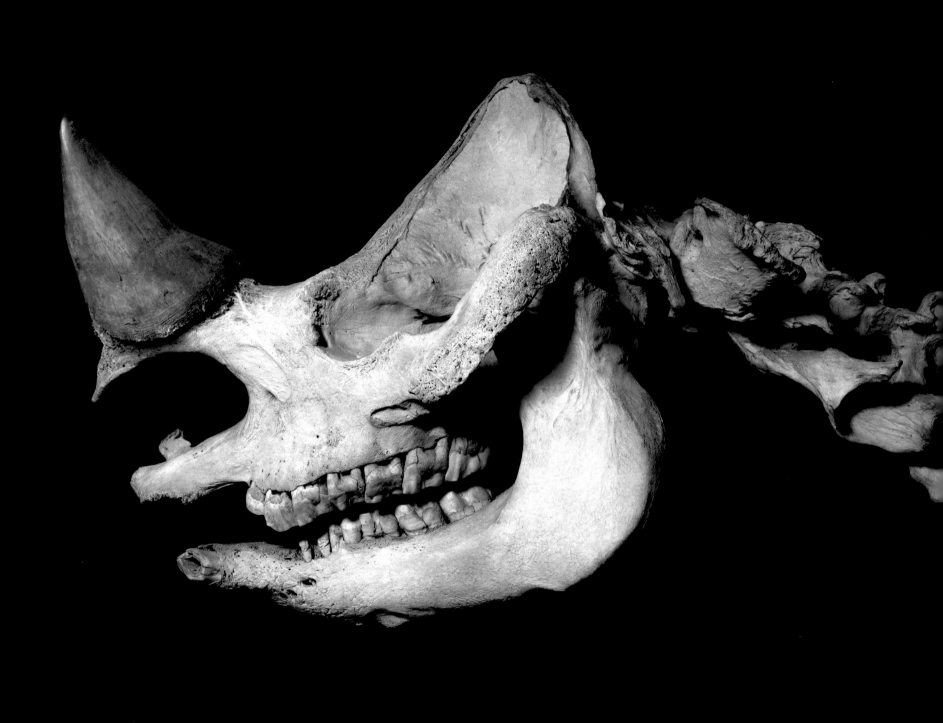

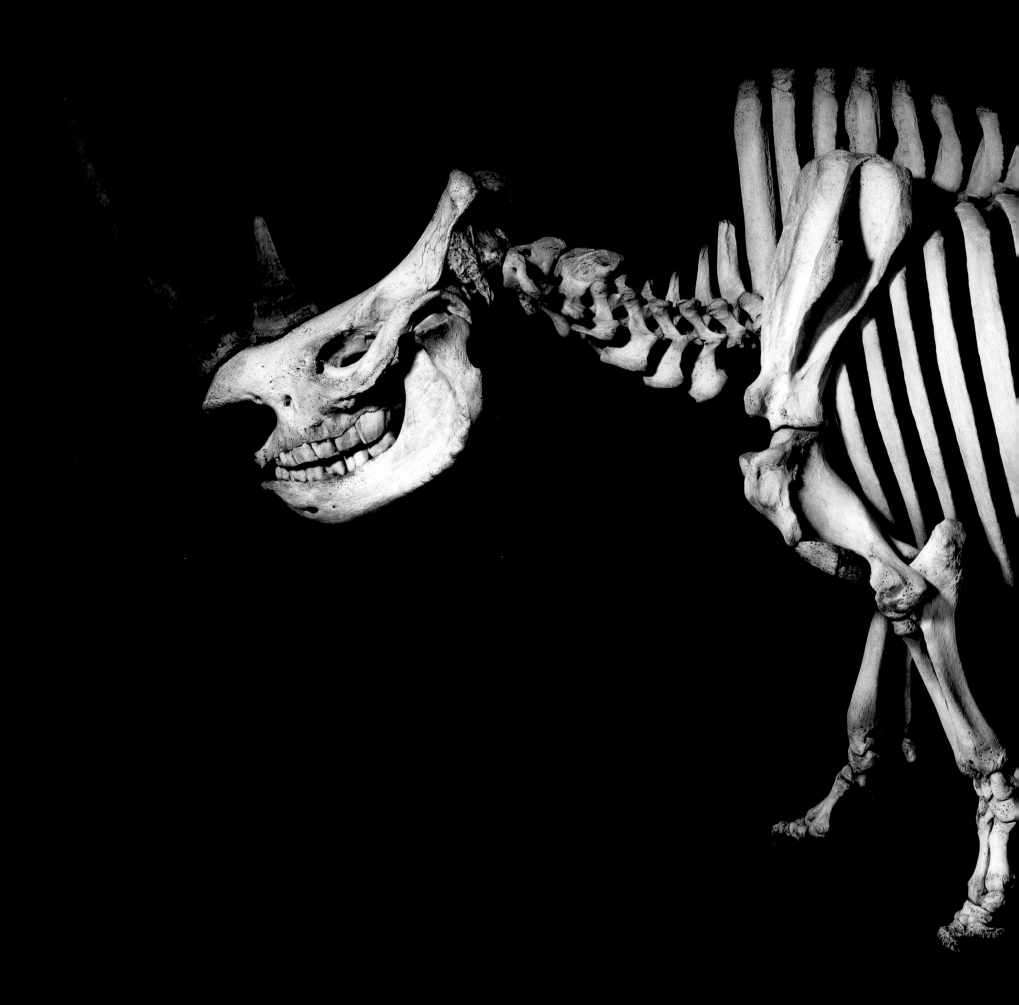

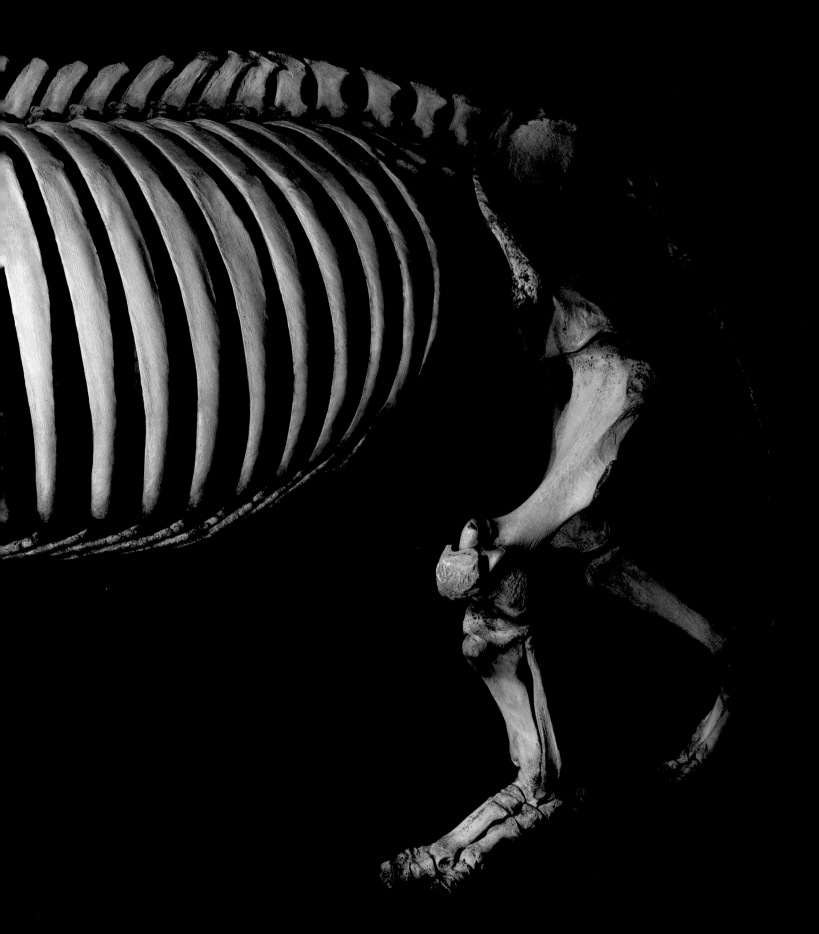

White rhinoceros, *Ceratotherium simum*. Sub-Saharan Africa (s.h. 1.55 m)

CHAPTER 25
THE GENDER OF BONES

Men and women are different, like male and female chimpanzees, and probably for the same reasons. Sexual selection, through the twofold interaction of competition between males and choices exercised by females, was already operating in our distant ancestors and has probably gone on throughout our evolution. That aspect of our history seemed so important to Darwin that he devoted more than half of his thick volume *The Descent of Man* to sexual selection in animals, before describing the way it may have shaped our physical appearance.

Sexual dimorphism is the whole array of what distinguishes the two sexes, beyond the obvious differences of ovaries and testicles and their products, eggs and sperm. There are other anatomical and behavioral characteristics, including overall size, the shape of the body and the external genitals, body hair, voice, and age at puberty. The form of the skeleton is an important element because it is one of the few available for studying fossil hominids. The distinction between men and women is useful in paleoanthropology and archaeology, as well as in forensic medicine for identification of skeletons in criminal situations.

Men are on average larger than women, but many women are larger than the majority of men. The distribution of biometric measurements, whether of total height or of any given bone, overlaps widely; a bone's size is not enough to determine its gender. To speak solely of the skeleton, there is no feature that by itself would allow us to distinguish with certainty a man from a woman. But two bones are particularly useful for determining gender: the skull and the pelvis. The cranium alone would permit identification in half the cases, thanks to a set of features that are more or less salient depending on the individual: among them, the man's mandible is stronger, with the chin more prominent and squarer, and his cranium comes to a more notable point at the rear, above the nape. The pelvis is more revealing still, for it is the most dimorphic bone in the human species because of its importance in childbirth. The pelvis has a ring structure, with the sacrum continuous with the spine at the back and, at the sides, the two hip bones coming together at the level of the pubis. The pelvic canal, running through the center of the ring, must allow for the passage of an infant, and it is proportionally broader in women. Moreover, in men the ischial spines point inward, whereas in women they are spread wider. With the cranium and the pelvis, it is generally possible to determine the sex of the skeleton. Since all characteristics vary from one population to another, however, to minimize the risk of error in making the determination, it is best to have available a whole group of skeletons of the same origin.

Sexual dimorphism appears gradually in the course of the embryo's development. Boys and girls do not begin to differentiate until the age of seven weeks. That explains why some organs are present in both sexes even though they play a biological role in only one of the two. For instance, the mammary glands and the nipple form in the embryo at the start of its development, whereas its genitals are not yet anatomically determined. Later on, the mammary glands remain very small in the man but grow large in the female from the influence of the ovarian hormones. Their persistence in the man has no particular function, but their elimination would probably require the establishment of some extra, and complicated, genetic machinery. Our primate origins offer a few possible ways to understand the function of the sexual dimorphism particular to humans. In all the great apes, the males are larger than the females. We are not exceptions in this regard; our own dimorphism is roughly as marked as that of the chimpanzees. Other elements are more difficult to explain, for they apply only to our own species. In comparison to other great apes, we are characterized by light body hair, a protuberant nose, wider lips, more muscular buttocks (an effect of our bipedalism), and much smaller teeth. A man's penis is proportionately larger than that of an ape. No external sign signals the ovulation period in women, whereas it is very visible in female chimpanzees. Men's beards and women's breasts are also typically human features. Our sparse body hair distinguishes us from the other apes and also differentiates men from women. Sexual selection has doubtless played an important role in the loss of our original fur covering.

Darwin suggested that the beard was an ornament that developed as an object of active choice by women. But the inverse is also possible—that women's lighter hairiness was a feature men selected them for, which led as a secondary effect to the same outcome in them, though in lesser degree. Some of the differences between men and women play an obvious biological role, such as the shape of the pelvis, but most of the features that characterize sexual dimorphism have no simple explanation. As for the other species, we may wonder about the adaptive value of each element: For what reason was it selected? Does it play a role in the competition among males? Is it an indicator of the quality of the male or the female? For instance, the development of the fatty masses of the buttocks and the breasts in women may have been favored because such reserves indicate a better chance of survival for the offspring. But they could also be permanent elements of attraction, which is important in a species where the onset of ovulation is not signaled by a physical change.

Ethologists have noted that male primates often have marked preferences for the oldest females, of high social rank, having proven themselves fertile and capable of caring for their young. They avoid young females who never borne offspring. In the course of our evolution, sexual selection has doubtless been gradually replaced by a "cultural selection." In current Western societies, it is more often youth (in both women and men) that is valued. In some of our behaviors, we have clearly moved away from the other primates.

Man and woman, *Homo sapiens*. Worldwide (h. 1.75 m)

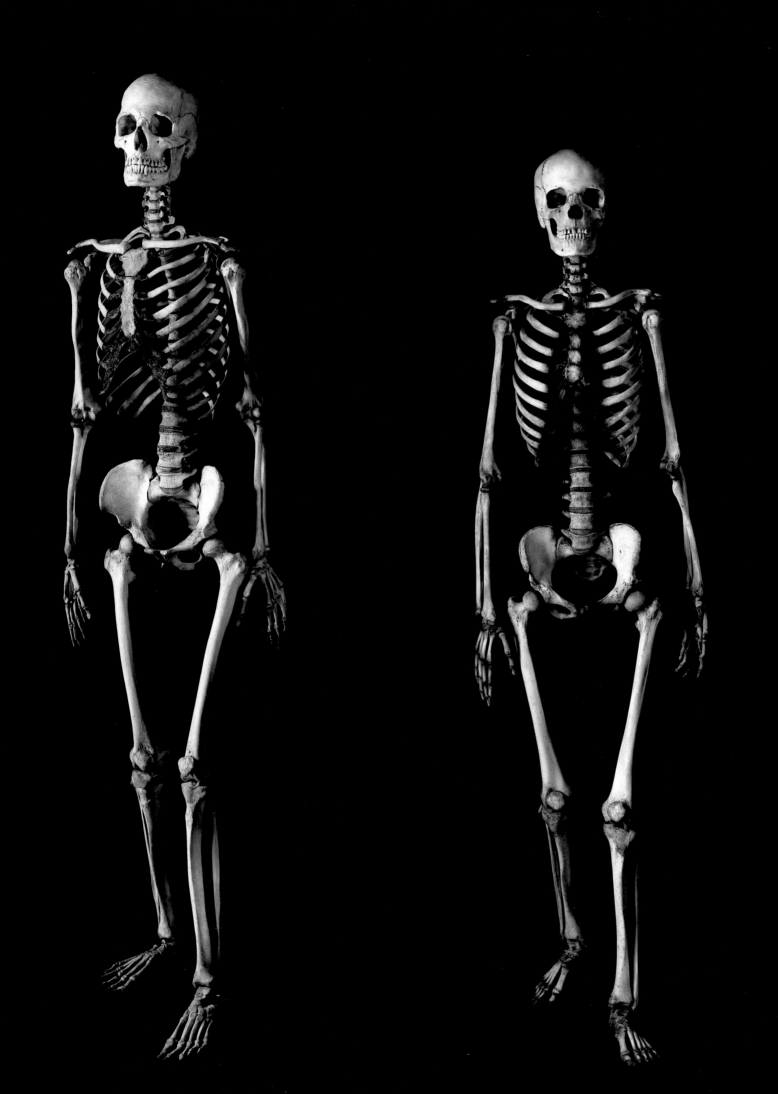

PART IV
EVOLUTIONARY TINKERING

"So marvelous an organ, which seems to be the masterpiece of organization, is one of the most dazzling proofs of the intelligence that presided over the formation of the animals." Thus did a *Dictionary of Natural History* describe the eye in 1818, in accordance with the principles of natural theology, which hold that nature's marvels are proof of the existence of God. The eye has always been a favorite example for the detractors of evolution theory: an organ so complex could never have taken form through the mere play of natural selection and without a blueprint already in germ in the earliest bacteria sensitive to light, several billion years ago.

In their view, the human eye—and man as a whole—was programmed from the beginnings of life. In *The Origin of Species*, Darwin takes the counter-position of that assertion. For him, the eye is only the outcome of a long series of transformations with no particular direction, but oriented by natural selection so that the organ should fulfill its function as well as possible yet without attaining "perfection." For the human eye is not perfect: the nerve fibers that transmit light stimuli to the brain pass in front of the retina and absorb some of the light. This strange arrangement is tied to the evolutionary path the organ has followed. But other paths were possible too. The eye of an octopus is constructed along opposite lines: unlike the vertebrate's eye, it has no blind spot. Evolution is subject to the constraints of environment, but also to the weight of various species' biological heritage—that is, the genes and forms transmitted from their ancestors.

For the geneticist François Jacob, "Evolution doesn't pull its novelties out of nowhere. It operates on what already exists, either transforming an old system and giving it a new function, or combining several systems to build another, more complex, one. The process of natural selection bears no resemblance to human behavior. But if we want to play with a comparison, we would have to say that natural selection operates not like an engineer but like a *bricoleur*, a handyman-tinkerer who doesn't yet know what he may turn out but picks up whatever falls into his hand, the most disparate objects—bits of string, chunks of wood, old cardboard—that might possibly provide him material; in short, it is a tinkerer…who through millions and millions of years has been slowly working and reworking his product, rearranging it, retouching, cutting here and lengthening there, taking every chance to adjust, transform, create…" All the organs show the effect of this evolutionary tinkering. Why is a bat's wing not built like a bird's wing? Why, conversely, does the fin of a manatee have the same structure as the human arm? To understand the origin of animal structures, one most move from the metaphysical "Why?" to the tinkerer's "How?"

The metaphor has its limits, though, since the *bricoleur* also has some purpose, even though he may get to it by a variety of detours rather than a direct route. Evolution has no long-term aims; it settles for seizing any opportunity to improve an animal's adaptation to the very real conditions of its environment and not to any future needs of its distant descendants. This lack of a plan also characterizes the concrete mechanisms of evolution. To understand them, it is necessary to proceed by completely upending the classical vision of nature. We tend to consider that Nature changes animals "with a view to" responding to their needs. It is actually the reverse that occurs: what the animal already has can be transformed by mutations, and can eventually come to provide for some new function. If that function acquired by chance answers a need, it will be kept. Carnivorous dinosaurs had hollow bones well before the birds appeared; the characteristic was useful for lightening the weight of the giant species, but it turned out to be perfectly adapted for flight, even though it had not been selected for that reason to begin with. This diversion of an organ to new or other functions is called "exaptation," but it is also sometimes called "pre-adaptation"—a poor choice of term because it implies anticipation of a future function. Selection foresees nothing; all it does is retain something that is immediately useful to the species.

Whether teeth or paws, vertebrates' organs give evidence of amazing plasticity, changing size, form, and function according to families or species [see pages 138 and 166]. But when the organ has disappeared, because at some moment it ceased to be useful and the genes are gone, it cannot reappear in the identical way even if it turns out it would be useful anew. In such a case, selection will make use of some other element, and follow a new path to create an analogous organ. Thus it is that some birds have reacquired teeth, quite different from those of their ancestors, and that the panda has acquired a new thumb which, though not a real finger, fills that function [see pages 160 and 184]. Evolution sometimes follows two parallel paths and ends up with similar results. In running mammals, the limbs are elongated and simplified, but the modalities of that development differ depending on the lineages: antelopes have two digits to each limb and horses only one. The two groups have evolved independently of each other [see page 178]. Similarly, two kinds of flat fishes live on the sandy ocean floor; each became flat in its own way [see page 188].

The comparison of homologous organs, like a cheetah's paw and a bird's wing, shows that the same elements can end as very different forms. But that does not indicate how they changed from one form to another, which is one of the fundamental questions in evolutionary theory. An organ's characteristics are largely determined by the genes of the species. Any important change in that organ presumes very significant mutations. Now we know that most mutations entail a dysfunction of the genes, or completely block their activity. How can a gene undergo mutations without its functioning being disturbed? It is known that the genome often includes several similar genes, sometimes arranged one after the other in series within the same chromosome. They are considered to be duplications of an initial gene. This is a fairly common phenomenon, which could easily change a gene's expression: if the gene is one that codes for a hormone, the presence of several copies of that gene can set off an increased

synthesis of that hormone and cause changes in the individual's growth or development. This kind of mutation can be good or bad, depending on the circumstances, and could possibly spread through the population over the course of succeeding generations.

Following such a duplication, there might occur another event that is even richer in evolutionary possibilities. As the initial sample of the gene continues to function normally, its copy can accumulate mutations over the course of generations without disturbing the life of the organism. The protein whose synthesis is determined by this new gene could provide for some other function than the original protein did. Nowadays we know of many genes or groups of genes that occur in several copies slightly different in form and providing diverse functions. For instance, the myoglobin of the muscles resembles the hemoglobin of the blood, as well as the neuroglobin of the nerve cells and the cytoglobin present in most cells. These proteins are all capable of oxygen fixation, but they carry out different functions in the different tissues. Analogous globins are present in other animal groups, such as mollusks and insects. Detailed comparison of the genes that code for all these proteins shows that they all derive from one ancestor gene, probably from before vertebrates appeared, and that there have been several instances of duplication followed by a differentiation.

If such mutations affect genes involved early in the individual's development, at the embryonic stage, profound anatomical changes can result. The study of the embryo has always seemed important for the study of evolution. Some biologists, such as Haeckel, held that "ontogeny recapitulates phylogeny:" in other words, in the course of its development, an individual is said to pass through all the evolutionary stages that have led to the emergence of its species. Actually, the embryo does not resemble its adult ancestors, but it has been noted that the embryos of the different vertebrate groups do bear a greater resemblance to one another than their adult forms do; they are astonishingly alike very early in development, and then differentiate more and more. The progress of molecular biology has renewed the field of embryology, thanks to analysis of the genes implicated in the very earliest stages of development. Those are fundamental structural genes, which can be compared among species [see page 62]. This synthesis of the two disciplines is nicknamed Evo-Devo, for "evolutionary developmental biology."

One of the most promising concepts for understanding how small-scale mutations can bring about big changes is something biologists call "heterochrony," which was introduced at the end of the nineteenth century by Haeckel and brought forward again in the late 1970s, notably by Stephen Jay Gould. Heterochrony is a discrepancy in the timing of two processes of an animal's development, with one occurring sooner than the other or at a different rate. Since sexual maturity is often accompanied by a halt in growth, a species that becomes "adult" later has a longer time for growing and can thus get larger. Moreover, since various organs do not all grow at the same speed or in the same way, this could lead to variations in the form of the adult animal. This may explain the huge size of the antlers on the giant stag *Megaceros*. If we compare the different cervids, the antlers grow proportionally more than the body. Because *Megaceros* was especially large, its antlers seem enormous to us. Conversely, dinosaurs' brains seem minuscule but are normal for reptiles of that size, as the brain generally grows less than the body as a whole. Biologists have registered many cases of heterochrony, involving slower or accelerated development, longer or shorter periods of growth. A striking example is animals termed "neotenic" or "pedomorphic:" their sexual organs develop faster than the rest of the body, and the adults retain a juvenile morphology [see page 192].

The complete genomes of several animal species have been sequenced, allowing for more and more detailed comparisons. The vertebrate genome has been revealed as far more complex than was imagined two decades ago. The genes are duplicated, fragmented, encrusted with sequences that also sometimes code for proteins. DNA also contains enormous non-coding segments, whose use is still largely unknown. This structure, complicated and disorderly at least in appearance, does not seem like the work of an engineer who conceived each species according to some well-considered plan, but far more like the clever yet laborious tinkering of a craftsman adding his own touch to the miscellaneous assemblage bequeathed by its ancestors.

CHAPTER 26
THE UNICORN'S TOOTH

In 1558 Guillaume Rondelet published a *Complete History of the Fishes* in which he described the dentition of the "lamia," the white shark: "The teeth [are] hard and very sharp, triangular, serrated on either side like a saw and arranged in six rows. Those in the first row are visible outside the maw, and tilt forward; those in the second are straight; those in the third, fourth, fifth, sixth are mostly curved to the inside of the mouth.... This fish eats others, it is very greedy, it devours men whole, as we have learned by experience: for at Nice and at Marseille [fishermen] used to catch white sharks, in whose stomachs a whole armed man was found." The fear that sharks inspire ever since men have been sailing the seas is linked to the few attacks actually attested to, but mainly to that profusion of teeth that seem to spurt from the jaw, the better to slice flesh.

That very formidable jaw was already at work in the sharks' ancestors, several hundred million years ago. The presence of teeth that are both numerous and all alike is a primitive feature in vertebrates. In the course of evolution, the dentition of mammals and some other species underwent a double transformation: the teeth became fewer and took on extremely varied shapes. Another marine animal, the narwhal, is one of the most astonishing examples, with its single tooth transformed into a tusk. The range of dentition in vertebrates presents a highly varied picture, which permits us to understand how evolution went from the shark's innumerable daggers to the narwhal's "horn."

Over their lifetime, sharks grow a hundred successive sets of teeth. The rows of teeth are fixed in the gums and gradually move forward, as if on a rolling sidewalk. They keep shedding throughout this progression, so that the shark always has a perfect set of teeth. Traces of this dental parade persist in mammals, with "milk" teeth replaced by permanent teeth in the course of development. In bony fishes, like the angler, the teeth are not confined to the jawbones and may cover the palate as well. They are often similar in shape throughout the mouth, but in some fishes they form flat milling surfaces for grinding crabs and shellfish. In amphibians and reptiles, the teeth are only in the jawbones and often all have the same form. This is the case in crocodilians, in which the teeth are not merely welded to the bone but implanted in a socket as in mammals. In venomous snakes, two teeth are differentiated and transformed into fangs that are threaded with a channel through which they inject their poison.

The lesser number of teeth and their specialization are much more advanced in mammals. Except for the cetaceans, they never have more than some fifty teeth. A typical carnivore, such as the lion, possesses long pointed canines with which it kills its prey, incisors with which it can grip or cut the meat on the carcasses, and molars that slice like shears. The hyena's molars, which are flatter, are used to grind the bones of carcasses in order to eat the marrow; the sagittal crest at the top of its skull attests to the power of the muscles that work the jaws. Some mammals, like the ungulates and rodents, have teeth that grow continuously. The beaver, for instance, has in each jaw two incisors that it uses like wood chisels to cut the trees it uses to build its dams. Its twenty premolars and molars, also constantly growing, serve to grind his foodstuffs. Like all rodents, the beaver lacks canines. Its teeth wear down, but the perpetual growth compensates for the abrasion, and they keep a constant length. The tusks are also continuously-growing teeth, but since they do not wear against each other, they get longer throughout the animal's life. In the elephant, the two tusks are its upper incisors, whereas in the walrus they are the upper canines. The walrus sometimes uses them to help climb out of the water and onto the bank, but they are primarily weapons used in sexual competition. Their size and their form also indicate its age and sex to other walruses, the tusks of the females being far smaller than those of the males. This specialization of the teeth is one of the features that distinguish the first true mammals from their reptile ancestors. But evolution moves in no particular direction, and some species later returned to a homogeneous dentition. The orca, like all the cetaceans, descends from terrestrial mammals with differentiated teeth [see page 206]. It has about fifty cone shaped teeth, with a far greater resemblance to the teeth of fishes or reptiles than mammal teeth. Some dolphins have as many as two hundred sixty, finer and smaller. Not all the cetaceans followed this same path: the baleen whale lost all its teeth, and the narwhal has only the one left—its spiral tusk, which in the male can reach a length of nine feet. It is sometimes present in the female, but shorter and straighter. The narwhal's horn is an incisor tooth rooted in the upper left jaw; it pierces the upper lip to point ahead. A second incisor usually remains enclosed in the cranium but sometimes does emerge to the outside. The narwhal's tusk has been interpreted as a weapon for hunting fishes, or else as a tool for breaking ice or digging into sediment. Recent observations show it to be rich in nerve endings that could provide the animal with information on the odors and temperature of the water. All these "descriptions" come up against the rarity of direct observations and against one proven fact: most of the females have no tusk. So it cannot be a vital organ. It would seem rather that, like the walrus's tusks, it is an ornament involved in sexual competition.

The narwhal's tusk has long been cited as "evidence" for the existence of the unicorn. From the seventeenth century on, the marine origins of that horn has practically no longer been questioned, and the unicorn has become the narwhal. Except for its tusk, the animal has no teeth. Its fetus, though, has sixteen of them, but only one develops, and it becomes the longest tooth in the animal kingdom. Despite its extraordinary tusk, the sea unicorn is functionally toothless.

Shortfin mako, *Isurus oxyrinchus*. Temperate and tropical seas (max. l. 4 m)

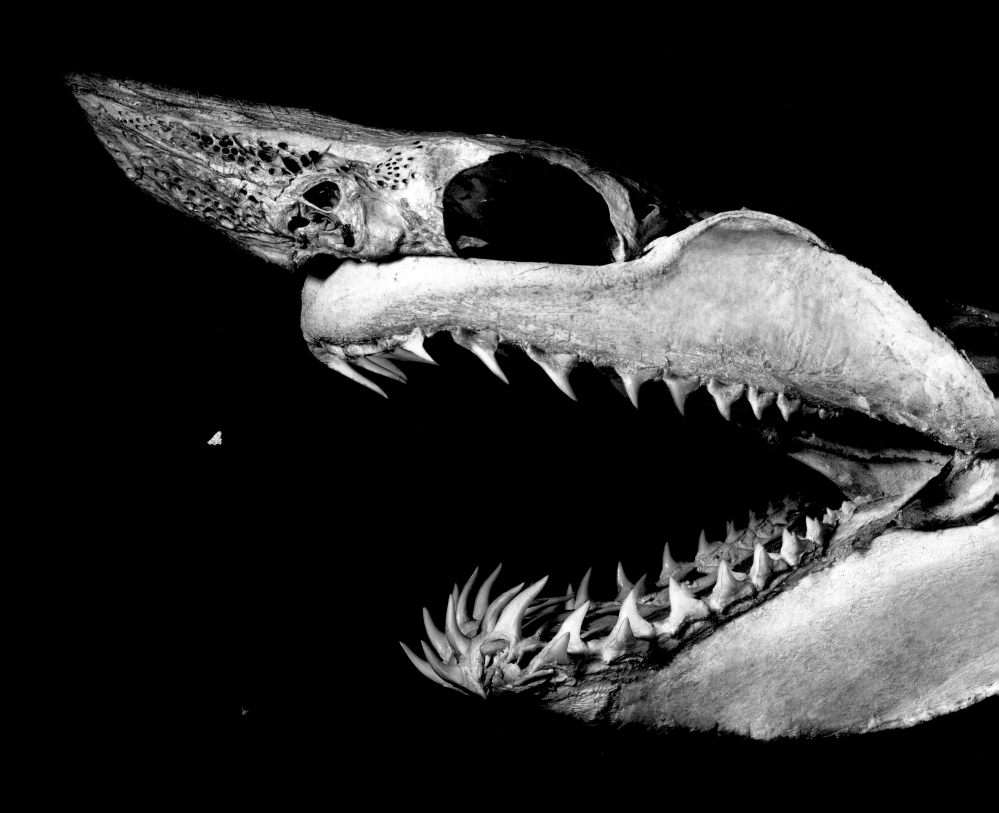

Orca, *Orcinus orca*. Oceans worldwide (l. 5.25 m)

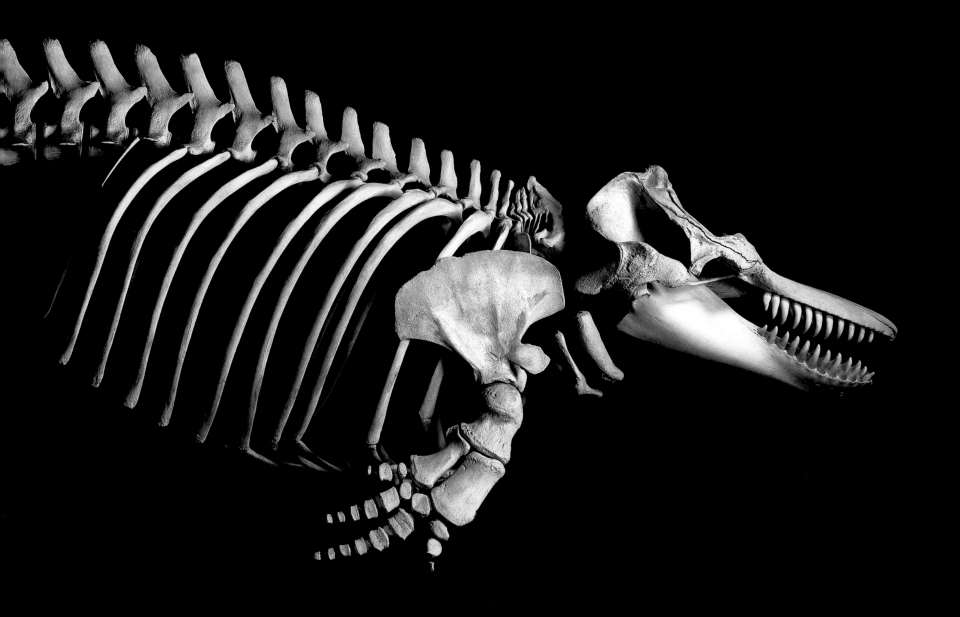

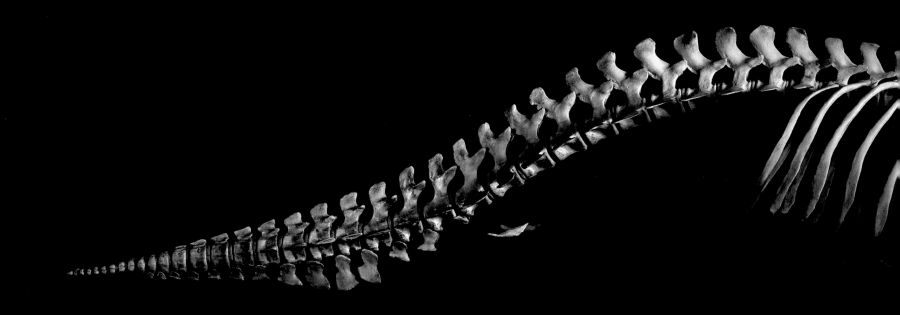

Narwhal, *Monodon monoceros*. Arctic Ocean (l. 6.30 m)

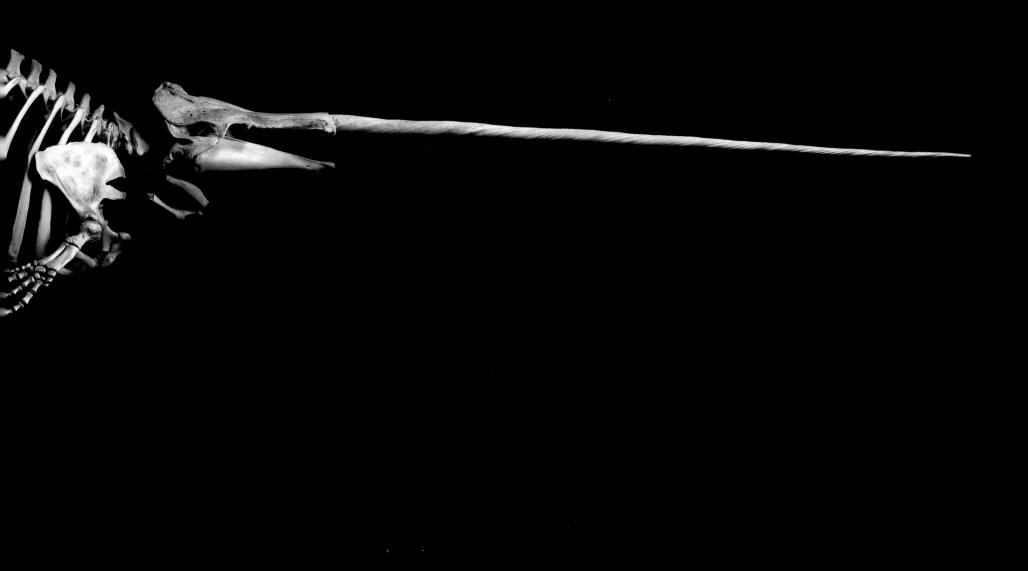

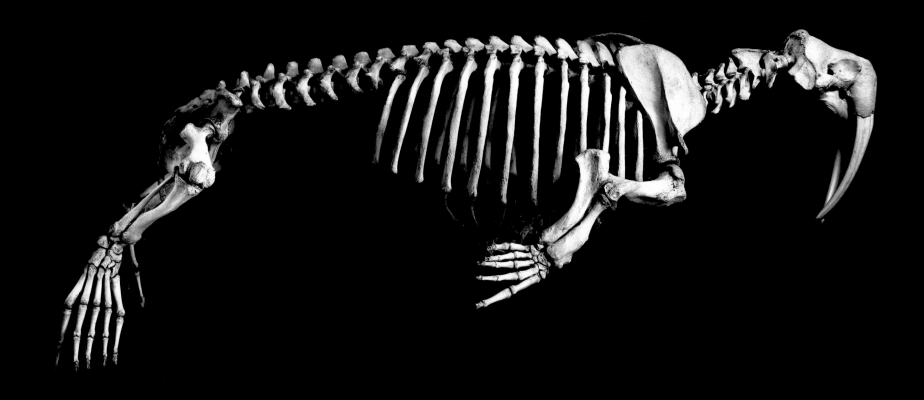

Walrus, *Odobenus rosmarus*. Arctic coastal seas (l. 2.60 m)

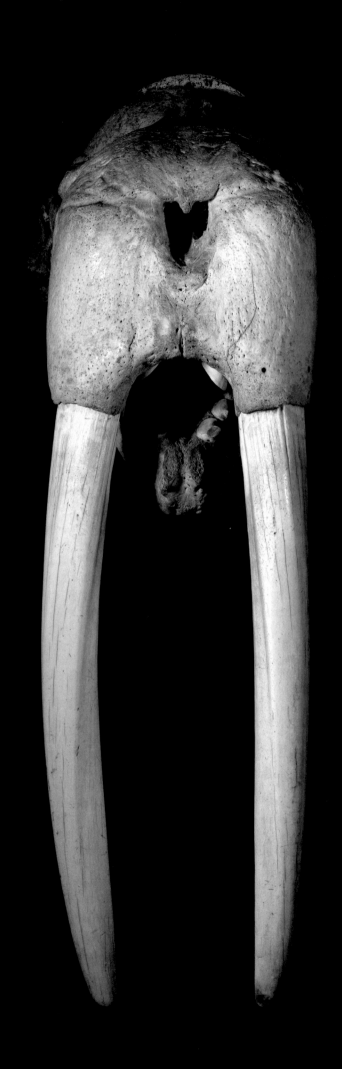

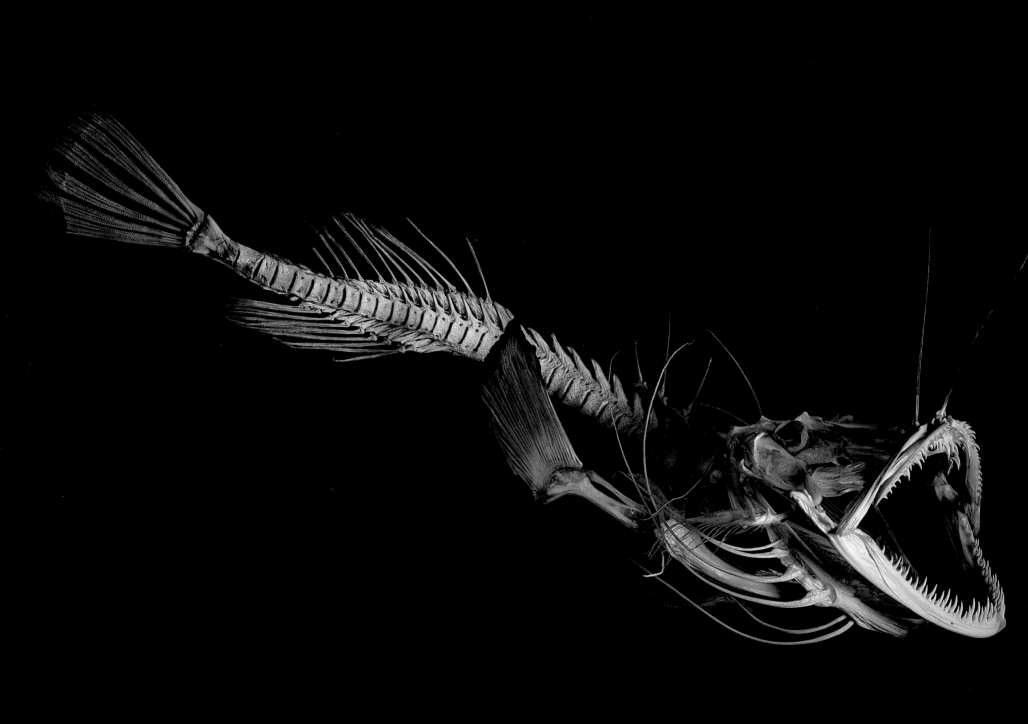

Angler, *Lophius piscatorius*. Northeastern coast of the Atlantic Ocean (l. 1 m)

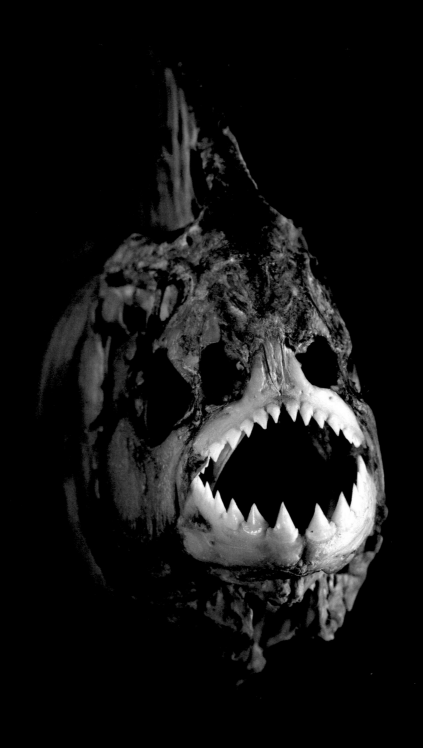

Redeye piranha, *Serrasalmus rhombeus*. Amazon (l. 26 cm)

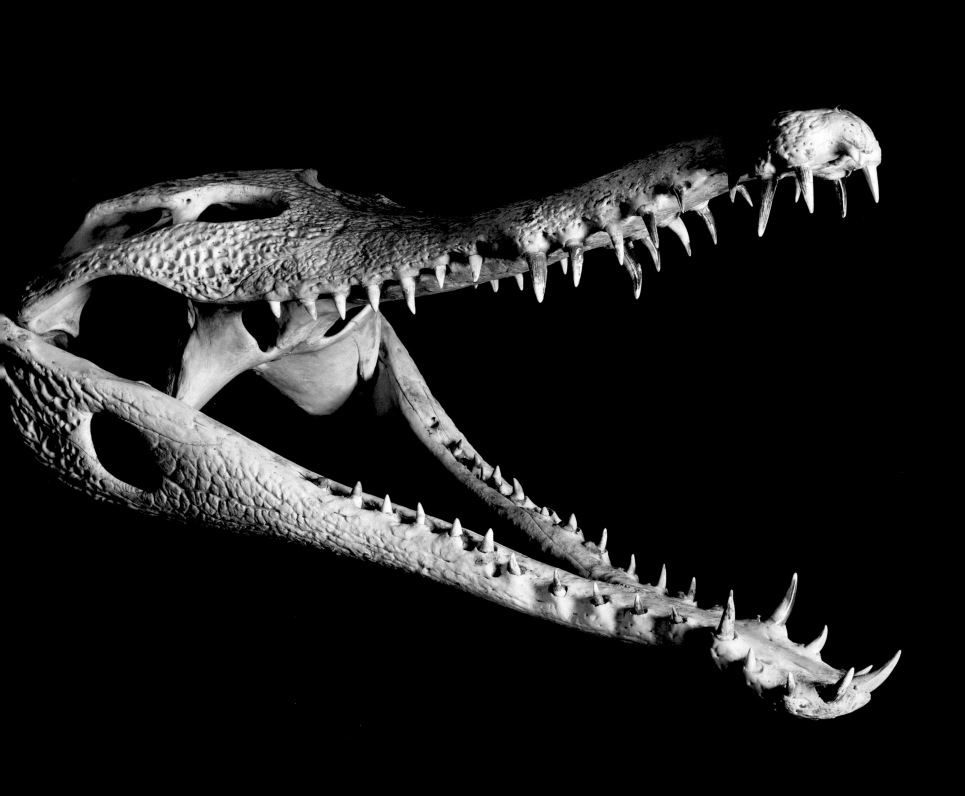

Gharial, *Gavialis gangeticus*. Bangladesh, India, Nepal, Pakistan (max. l. 6 m)

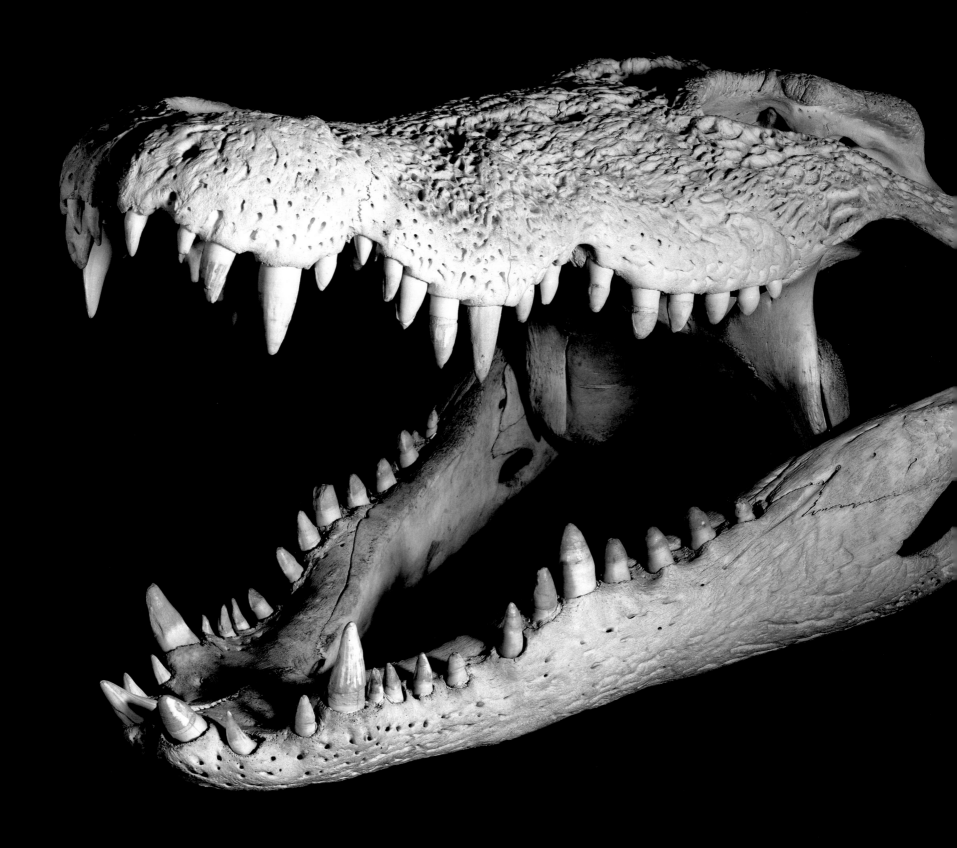

Nile Crocodile, *Crocodylus niloticus*. Africa (max. l. 6 m)

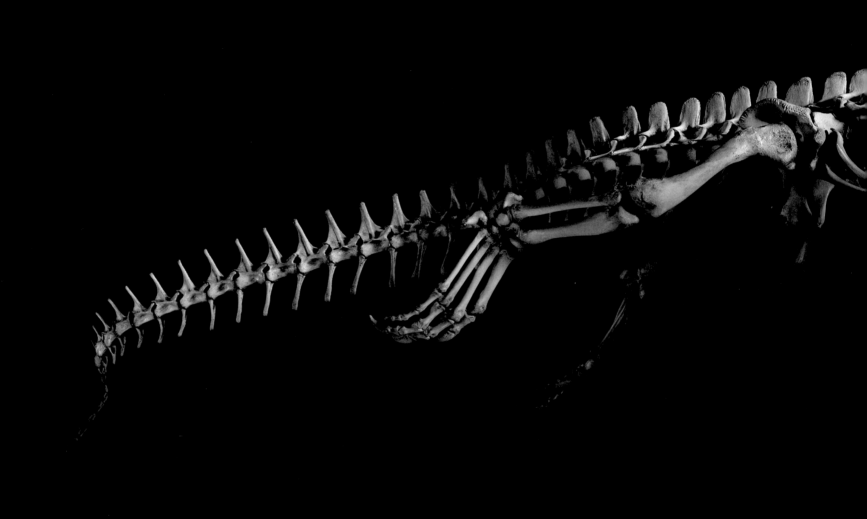

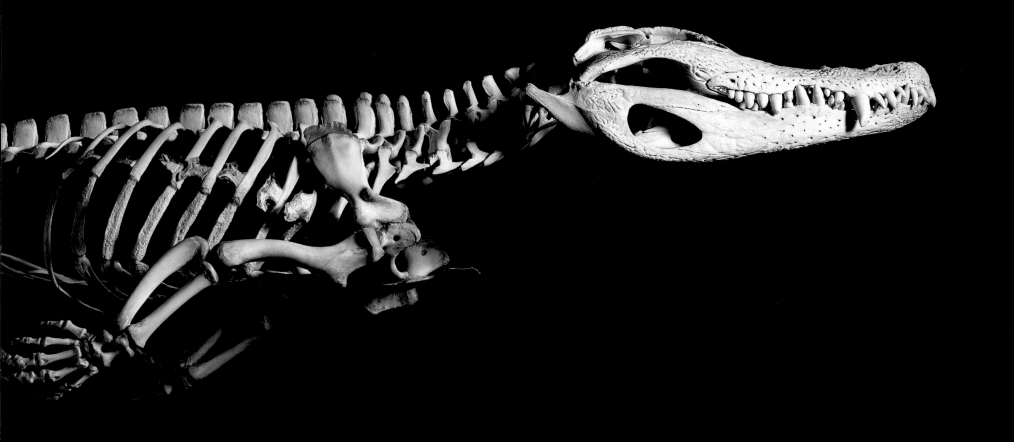

American alligator, *Alligator mississippiensis*. Southeastern United States (l. 1.80 m)

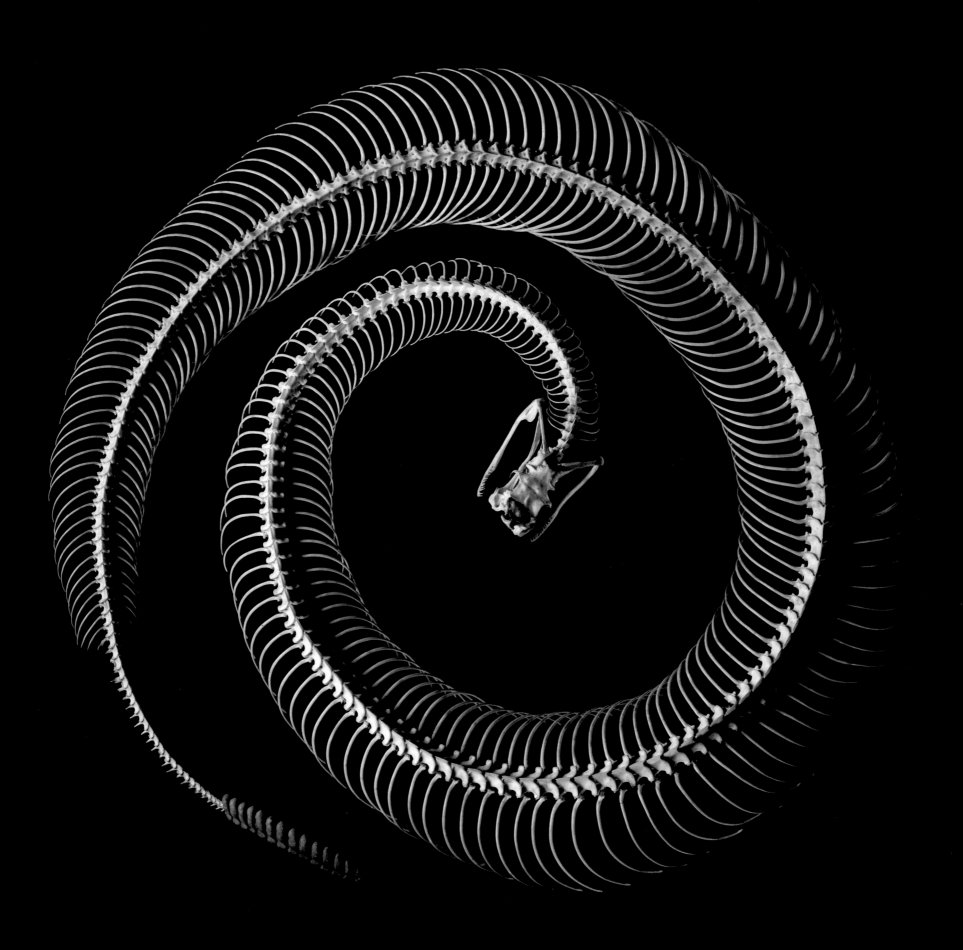

Rattlesnake, *Crotalus sp.* America (l. 160 cm)

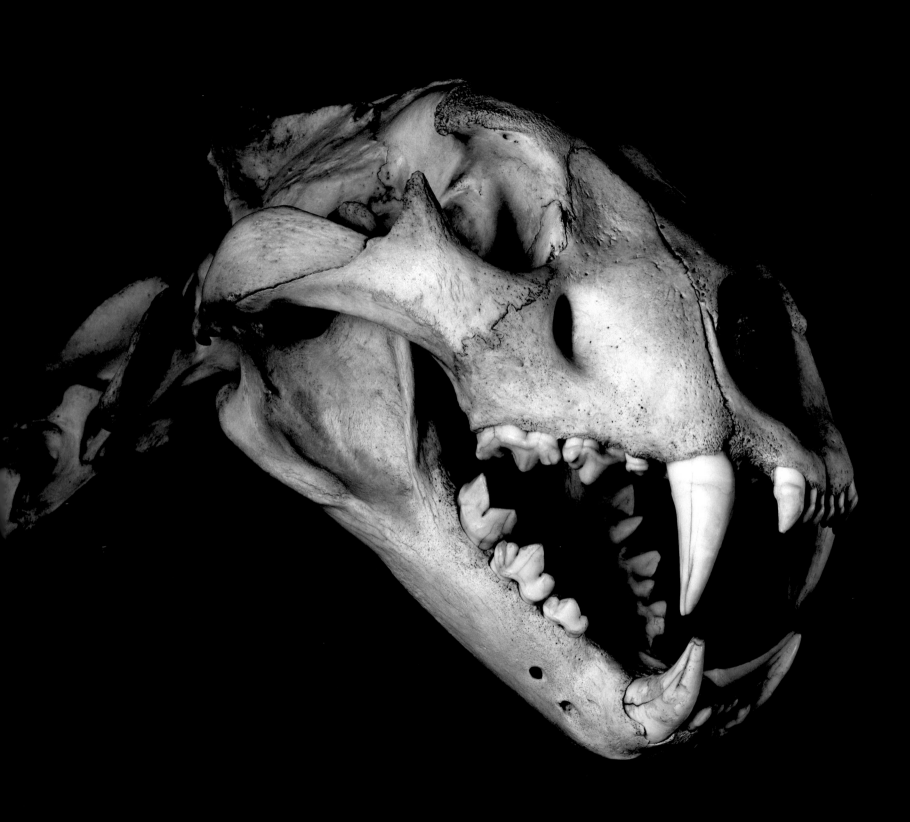

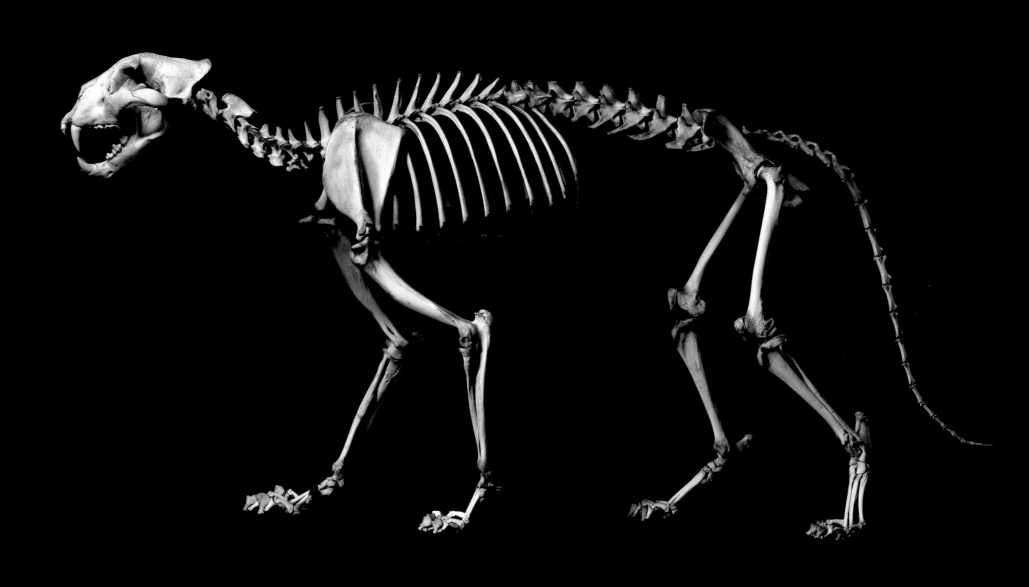

Lion, *Panthera leo*. Sub-Saharan Africa, India (s.h. 90 cm)

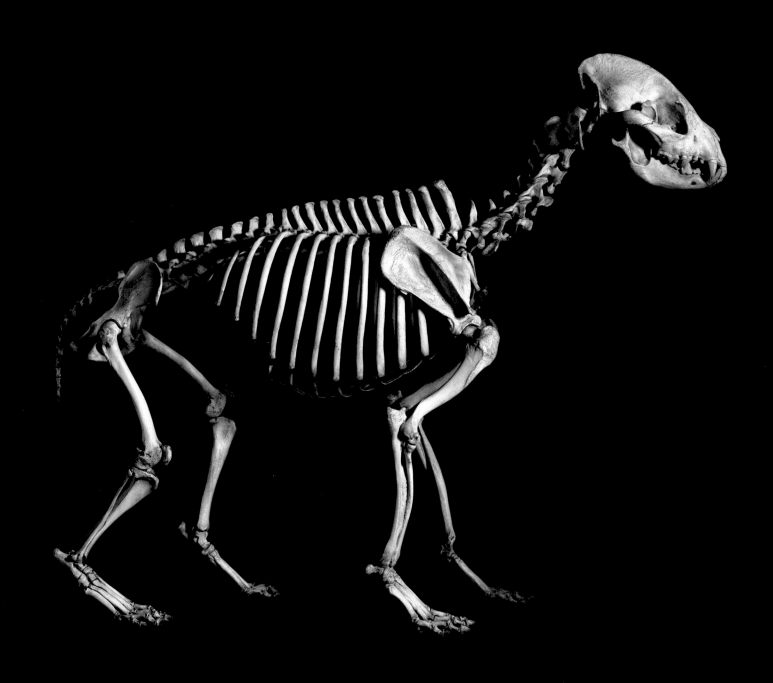

Hyena, *Hyaena sp.* Africa (s.h. 58 cm)

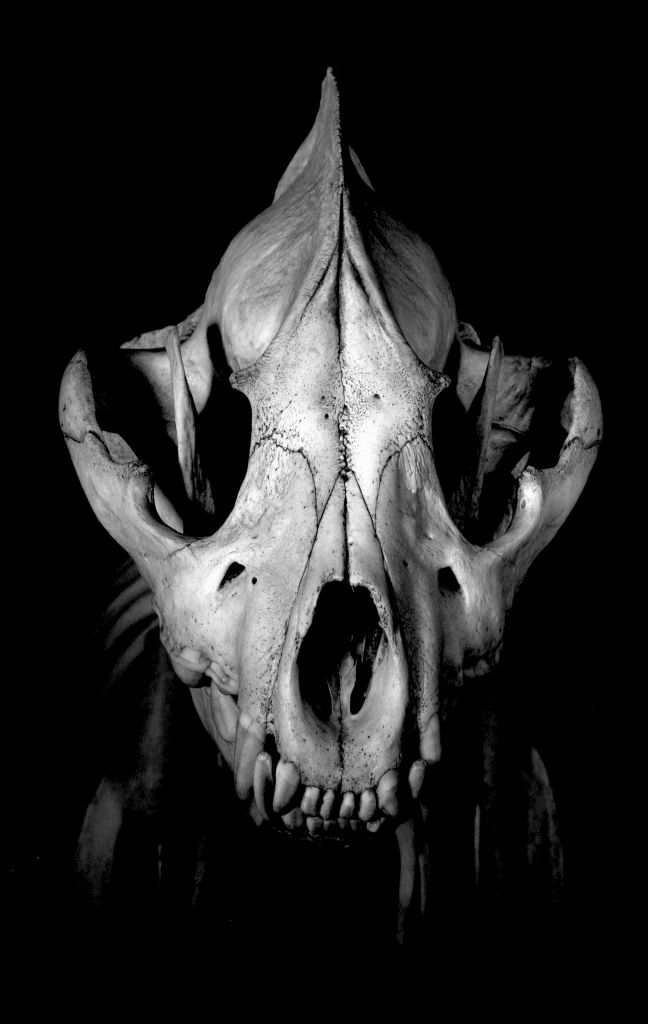

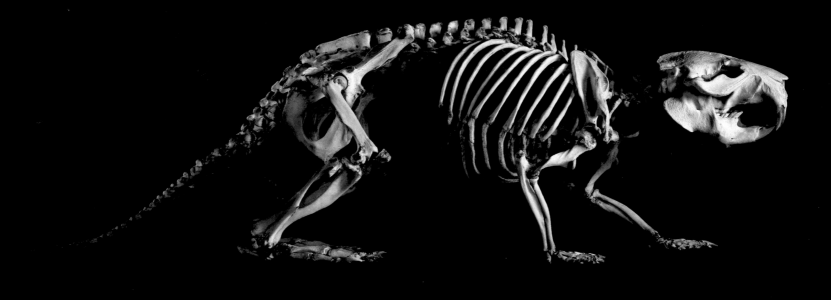

Beaver, *Castor fiber*. Europe, Northern Asia (l. 83 cm)

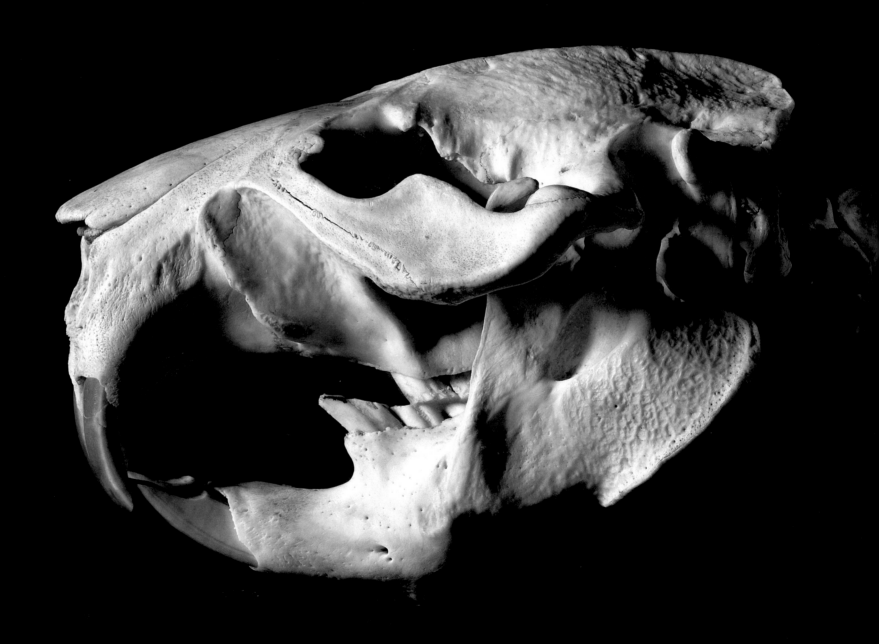

CHAPTER 27
TEETH OF HORN

When chickens had teeth, they were not yet entirely chickens and still partly dinosaurs. The ancestors of today's birds were actually little carnivorous dinosaurs with heavily armed jaws. Some of them acquired feathers and became capable of flying. After the massive extinction that marked the end of the Mesozoic era, some dinosaurs survived in the form of their descendants: birds with teeth. These later lost their teeth, a phenomenon that occurred in several zoological groups, among which are tortoises, many amphibians, and the baleen whales. Although most birds did quite well without them, evolution led some species to grow teeth again, but without returning to an earlier state. Between true and mock teeth, birds reveal how some pathways of evolution open and close.

About seventy-five million years ago, birds were still cohabiting with their dinosaur cousins. The best-known fossils belong to seabirds. Their jaws generally harbored a large number of small teeth that aided in catching fishes. Some older toothless birds, like *Confuciusornis*, are known, but they probably belonged to lineages that died out without descendants. After the general extinction that struck the fauna sixty-five million years ago, the birds remained the sole masters of the skies, with a morphology that gradually approached that of present day species but still with teeth. Then, about sixty million years ago, they lost them for good and became much like the birds we know.

For flying carnivores like those first birds, teeth were useful for seizing slippery prey, but they were also a dense, heavy feature that encumbered flight; eliminating them could make an important difference in weight [see page 198]. Birds born with smaller or missing teeth had an advantage compared with congeners with heavy jaws. Natural selection probably steered bird evolution in that direction, the more readily because tooth loss can be considered a rather simple transformation. Indeed, during an animal's embryonic development, it takes only a minute accident to block the chain reaction that leads to the formation of teeth. Such an accident could be a mutation that affects just a single gene, deactivating the protein it was meant to produce. An event of this kind has been observed by biologists studying mutant chickens, which were incapable of getting past the eighteenth day of incubation. One of their genes carried a "lethal" mutation that causes the death of the individual before hatching. This disastrous mutation had a secondary effect—it restored the chickens' ability to produce teeth. Their embryos actually showed some very surprising organs at the rim of the beak: tiny buds with the structure of teeth. But these buds did not grow, because the embryos' development was blocked. The gene responsible for this mutation has been grafted into normal chickens, but only in their oral cavity, where it did not cause too much disruption in the animal's development. It did stimulate a start to the formation of conical teeth like those of crocodiles, the closest present day cousins of the birds.

Other experiments have been carried out to clarify the nature of that blockage to tooth formation in today's birds. Embryonic tissues from mice, tissues incapable by themselves of producing teeth, were put in contact with more superficial tissues from chicken embryos; they then produced tooth buds. More interesting yet, the mouse tissues thus stimulated produced not mammal (mouse) teeth but bird teeth. The chicken tissues, then, are still capable of transmitting the signal that normally sets off tooth production—but this signal probably has other functions in birds nowadays. Some of the genes implicated in tooth formation are still active in the birds, but others have disappeared or are totally inactivated, for instance the BMP gene, known for its multiple functions in the formation of the jaw and teeth. This experiment also shows that the signals that set off tooth production are equivalent in chickens and mice. So it is a matter of very ancient genetic and biochemical chain reactions, inherited from common reptilian ancestors of both mammals and birds.

Lacking teeth, birds have a beak, a horned sheath that surrounds the jaws and is sharpened by the two parts wearing against each other. The horn can thus achieve enough edge to slice into foodstuffs. Raptors cut away the flesh from their prey, and parrots hull the fruits they pluck from trees. Grinding food, which is important for a bird that eats hard vegetable matter, is aided by the ingestion of tiny pebbles that act as millstones inside the bird's gizzard, crushing the seeds and breaking down the fiber. Despite these adaptations, the loss of the teeth has still turned out to be troublesome enough that some birds—since any regression is impossible—invent a new way to produce teeth. In the merganser, a diving duck, the whole edge of the beak is serrated. Its many sharp points, tilted to the rear, allows it to hold firmly to the prey it captures underwater, especially small fish, snails, and worms. These "teeth" are much like the small pointed teeth of the reptile ancestors of the birds, but they are mere horned points that are an integral part of the envelope covering the beak. Many other birds have a dentated beak, such as the blue heron and the Atlantic puffin, which hold onto the fish they catch in this way. The Canadian snow goose and the wigeon use the feature for other purposes—to cut and shred the fibrous aquatic plants they feed on.

The absence of a few genes that set off the formation of teeth constitutes a nearly insuperable impediment for the birds, for those genes are lost for good. In the merganser duck they have not recurred, but mock teeth have formed by other means. For evolution, it is simpler to modify the form of an existing organ—the beak—than to return to the tooth-making recipe that has been lost for sixty million years.

Common merganser, *Mergus merganser*. Northern hemisphere (h. 31 cm)

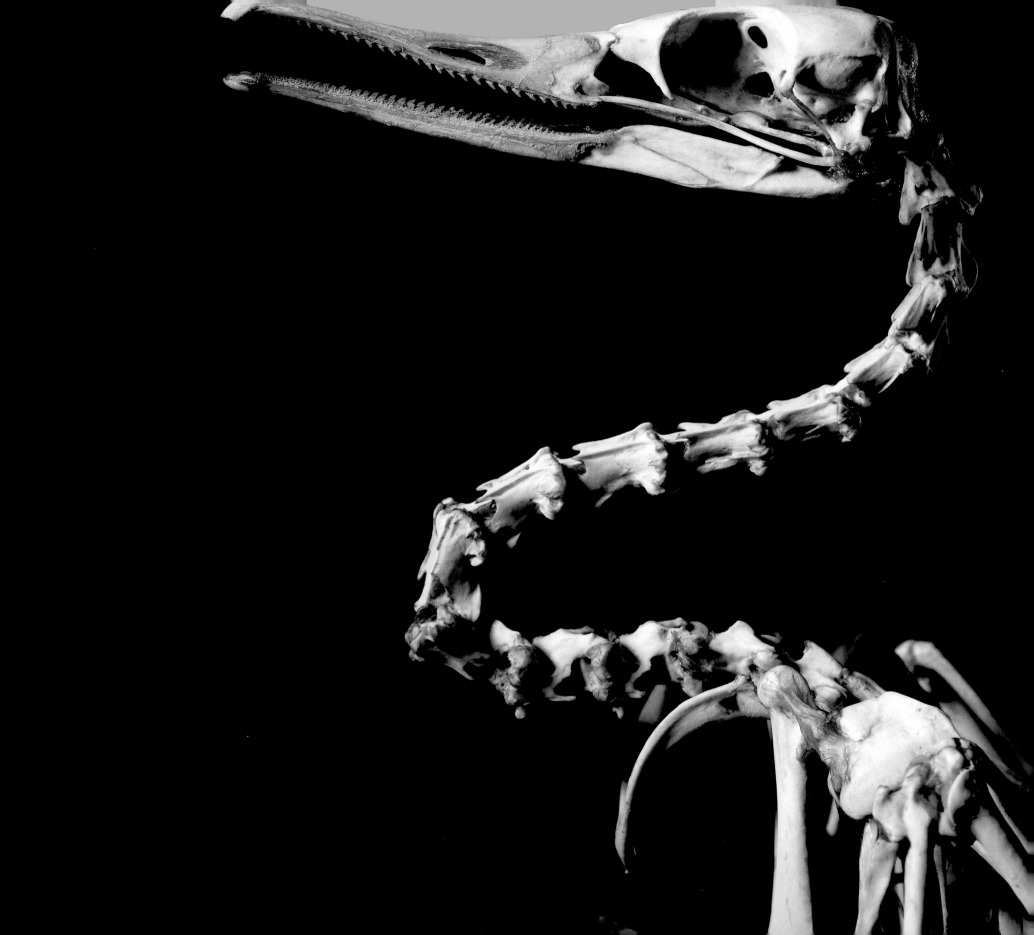

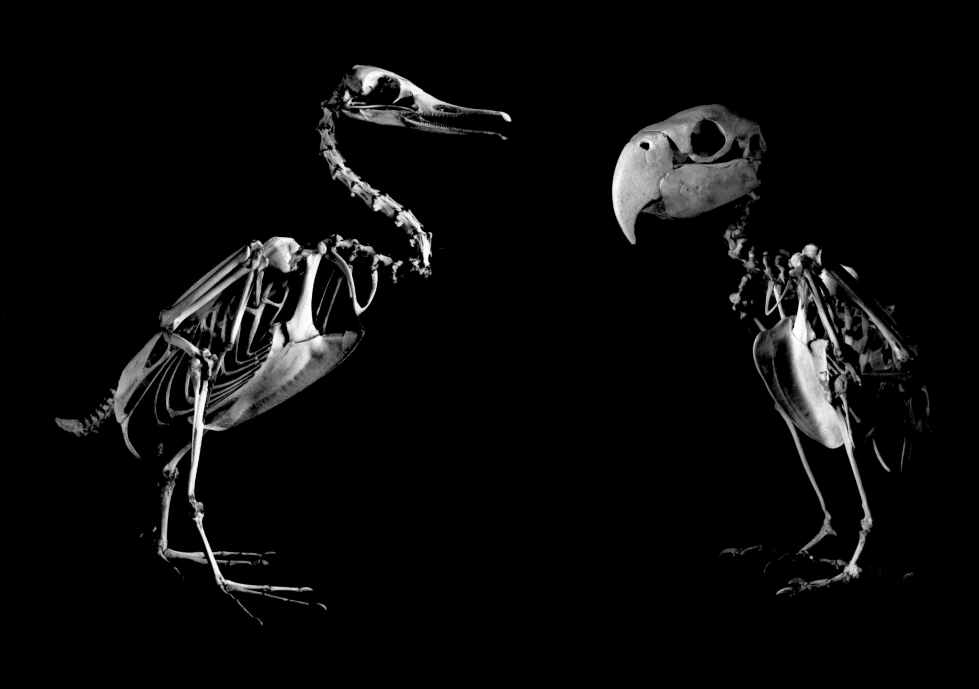

Common merganser, *Mergus merganser*. Northern hemisphere (h. 31 cm)
Scarlet macaw, *Ara macao*. South America (h. 29 cm)

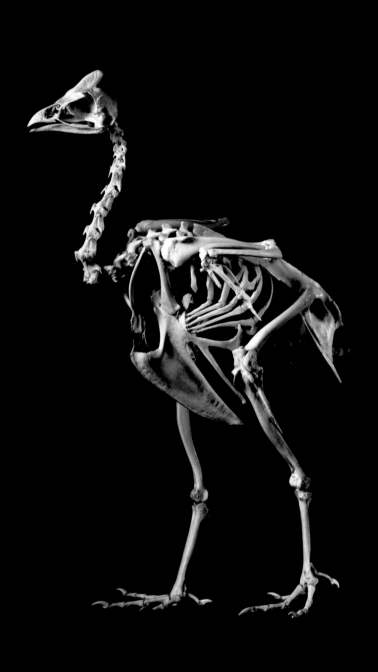
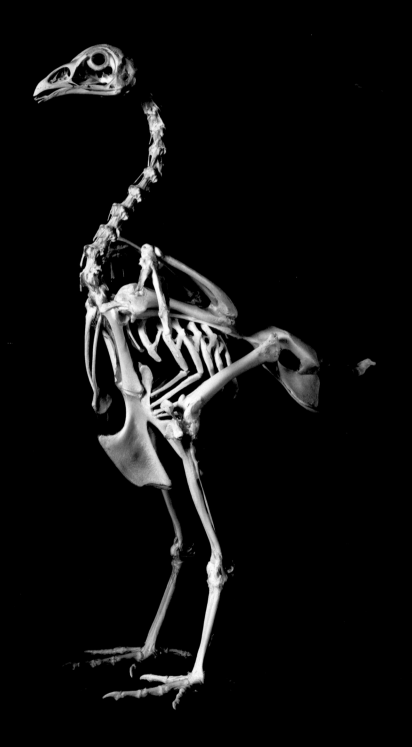

Helmeted guineafowl, *Numida meleagris*. Domesticated. Originally from Africa (h. 32 cm)
Hen, *Gallus gallus*. Domesticated. Originally from Asia (h. 38 cm)

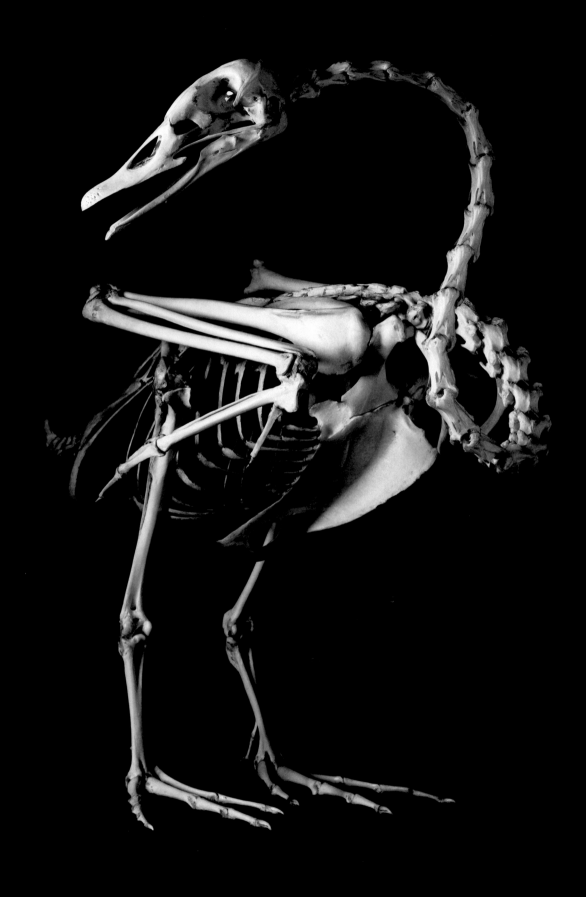

Black swan, *Cygnus atratus*. Australia (w. span 1.80 m)

Rhinoceros hornbill, *Buceros rhinoceros*. South-east Asia (w. span 1.20 m)

CHAPTER 28
PAWS, WINGS, AND FINS

"The bird, drawn by need toward water to find the prey he lives on, spreads the digits of his feet when he wants to slap at the water and move across its surface. From this constantly repeated spreading of the digits, the skin that joins the digits to their base contracts the habit of stretching; thus, over time, the broad membranes binding together the digits of ducks, of geese, and so on, have taken the form that we see today." For Lamarck, adaptations in animals were the outcome of transformations bent to their needs. The constant use of an organ would strengthen it and, conversely, non-use would cause it to die away. This vision of evolution has often been condensed into the formula "function creates the organ," which expresses this aspect of his theory of change.

This expression, which seems rife with good common sense for everyday life, gives a picture of evolution that is at once reassuring and false. Reassuring because it presumes that some force intervenes to steer evolution in the right direction, one that will give animals the adaptations made necessary by their mode of life. We prefer a benign, efficient Nature to a Nature that is blind, that arrives at those same solutions by chance after much trial and error. And a false picture, because biologists have never been able to bring forward evidence for that force that is supposedly urging animals to evolve in a direction determined by their needs. Species change constantly, but by chance, and the circumstances of their environment make for a radical sorting-out, accepting or rejecting new things.

Until the disappearance of the dinosaurs sixty-five million years ago, mammals stayed small, with fairly little variety of form. The fauna could be represented by an array from the shrew-mouse to the badger. After the extinction of the great reptiles, mammals moved into all environments left vacant, and adopted extremely diverse ways of life. In a few million years, they experienced an evolutionary proliferation that brought about species of every size, including carnivores, herbivores, and omnivores, land animals and animals underground, in trees, in sea and sky. Around fifty million years ago, there were already whales and bats, monkeys and bears, or at least species like them. The mammals showed astonishing plasticity, their limbs developing into feet for walking or leaping, feet become shovels or fins or wings. The badger is plantigradous: it takes support from the ground with the whole foot. With its short, powerful limbs, it is a typical walker and a digger. The cheetah is digitigradous; it is the animal's digits that rest on the ground when it walks. The limbs are elongated and display a Z-form characteristic of running predators. The speed of an animal is a function of the relation between the length of the metatarsals (the long bones of the feet) and the femur. Other adaptations help to reduce the energy cost of running. Thus, through their elasticity, the tendons that provide the cohesion and suppleness of the vertebral column store up, and restore, the energy expended at each step. In animals that leap, like the jerboa (jumping mouse) and the kangaroo, the rear limbs are longer and more powerful than in animals that are thoroughly quadrupedal; and there too, the tendons act as springs and reduce the energy required for each leap. A climber like the lemur has long limbs with opposable thumbs, very useful for gripping branches. In the flying fox, a large bat, the arms and the fingers are very elongated, and they support the patagium, the membrane of skin that constitutes its wing.

Even more than the extreme specialization of the organs, sometimes it is their disappearance that most clearly reveals certain mechanisms of evolution. The manatee, a mammal with an exclusively aquatic way of life, is for that reason totally without rear limbs, and it moves about by oscillating its flattened tail. Its arms are flippers that mainly serve for steering and maintaining balance in the water. Some birds, too, have lost a very important feature: their capacity to fly. For penguins, this is merely a change in function; they still use their wings, but for swimming. Their skeleton shows other adaptations, such as solid, denser bones, which would be too heavy for flight but which now help the animal to dive deep. The loss of flight also applies to a group of running and walking birds, such as the ostrich and kiwi. The kiwi is a woodland bird the size of a chicken, native to New Zealand. It lives on the ground and feeds by digging its long beak into the earth, hunting out insects and worms. Its wings are so small that they can barely be made out beneath its plumage. Their bones and muscles are very rudimentary, and the breastbone is totally absent. The kiwi's long bones are not air-filled like those of flying birds but contain marrow. When it sleeps sheltered in its burrow, the kiwi sets its beak under its wing; this seems to be that organ's last remaining function.

A muscle that is not used atrophies, but this acquired characteristic is not transmitted to descendants. An organ can disappear in a species only if it is actively eliminated by natural selection. For that to occur, it is not enough that the organ should have lost all usefulness; it must also have become a disadvantage. That is the case with the kiwi's wings. Indeed, flight is a highly efficient means of locomotion but extremely costly in energy (at least for small birds that fly by flapping their wings, gliding, or soaring [see page 196]). If the energy cost of flight is greater than the advantages it confers, natural selection will favor the animals that cannot fly, whereas in other circumstances such animals would be quickly eliminated. Thus, in the absence of predators, birds have no need to fly if they can find food on the ground. A bird lacking wings has an advantage, for since it never flies, it can devote the unexpended energy to other uses, like reproduction. This is the case with the kiwis, isolated from the rest of the world for tens of millions of years with no dangerous predators. Those born with vestigial wings, unable to fly, had an advantage over those that still had wings, for the former were better adapted to this particular environment. In the kiwi's case, it is not the lack of use that brought on the disappearance of wings; on the contrary, it was their loss that allowed the abandonment of a useless, costly function.

—
Kiwi, *Apteryx australis*. New Zealand (h. 38 cm)

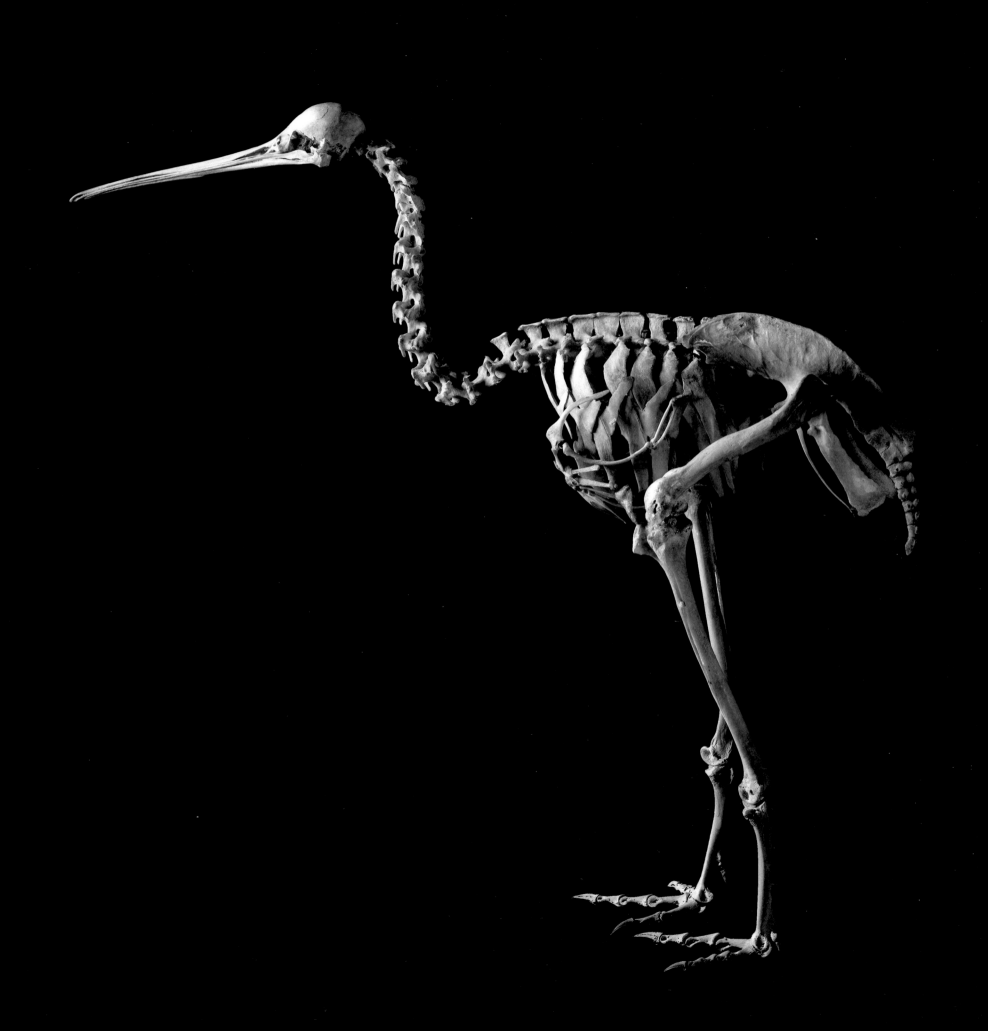

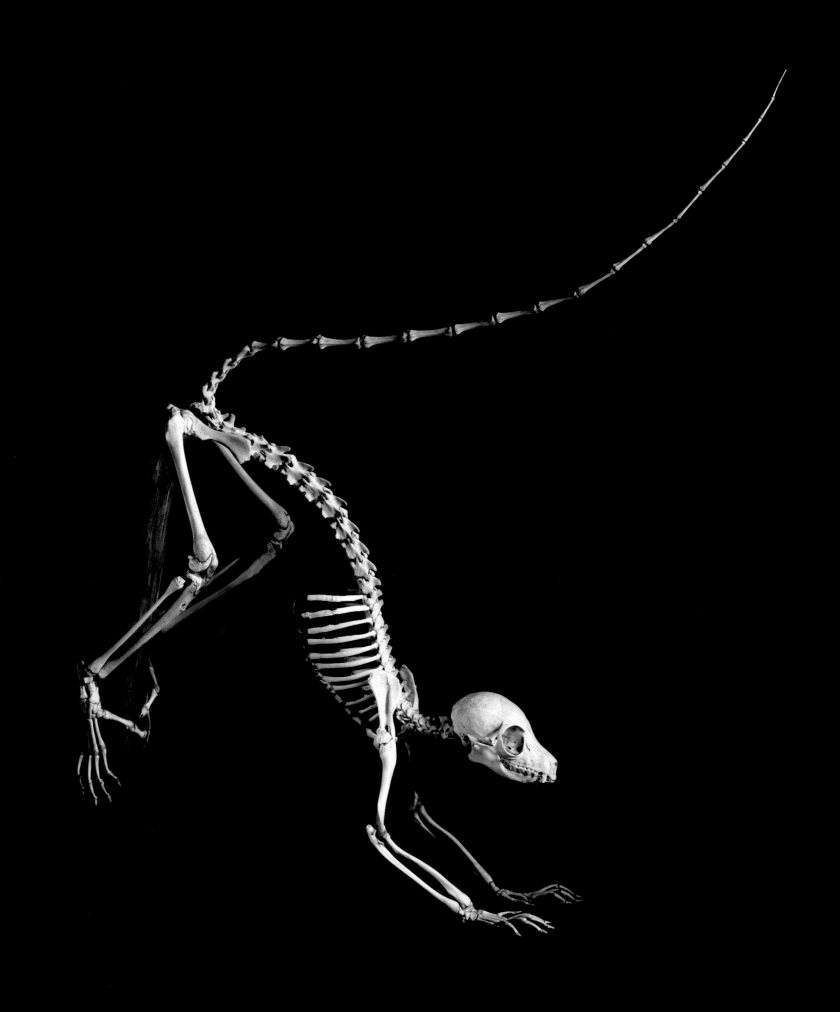

Ring-tailed lemur, *Eulemur mongoz*. Madagascar, Comores (l. 79 cm)

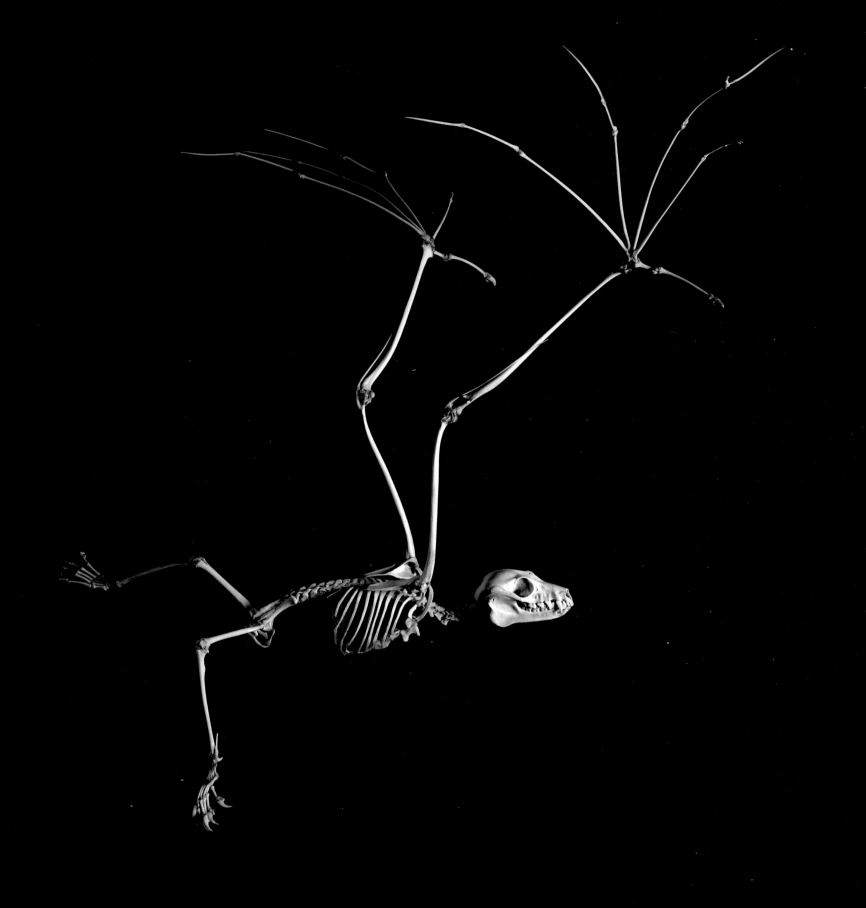

Vanauatu flying fox, *Pteropus anetianus*. New Caledonia (w. span 84 cm)

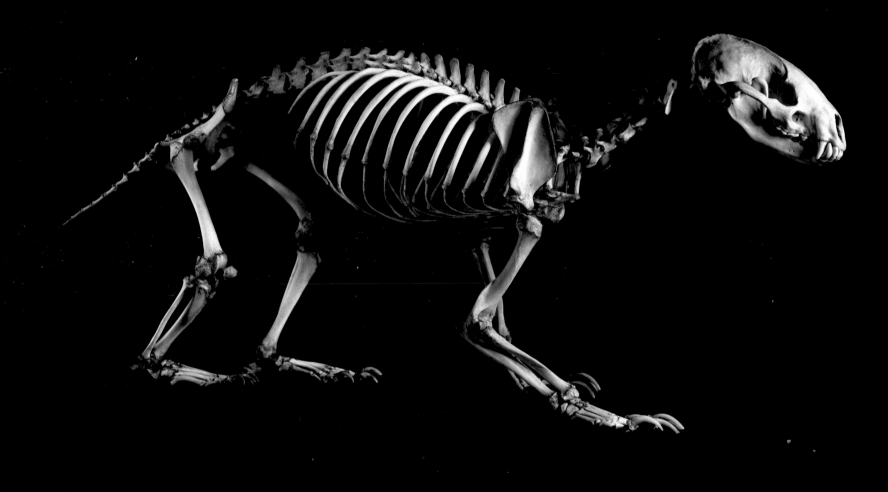

Eurasian badger, *Meles meles*. Eurasia (s.h. 25 cm)

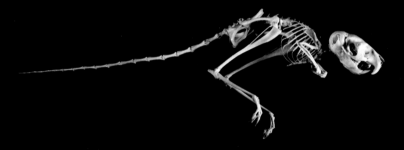

Lesser Egyptian jerboa, *Jaculus jaculus*. North Africa, Arabia, Central Asia (l. 27 cm)

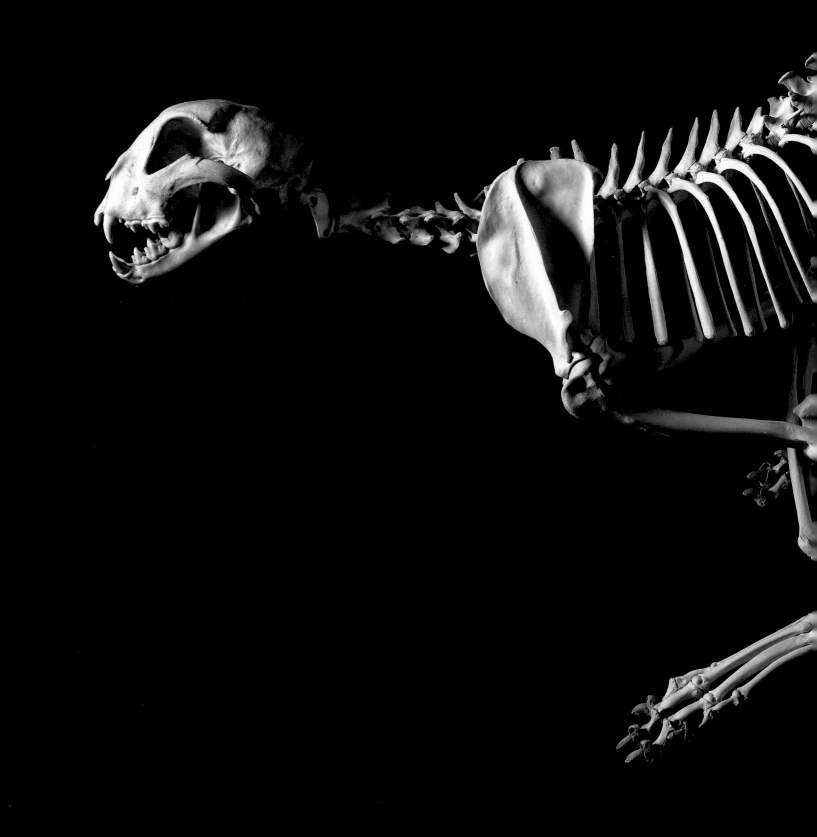

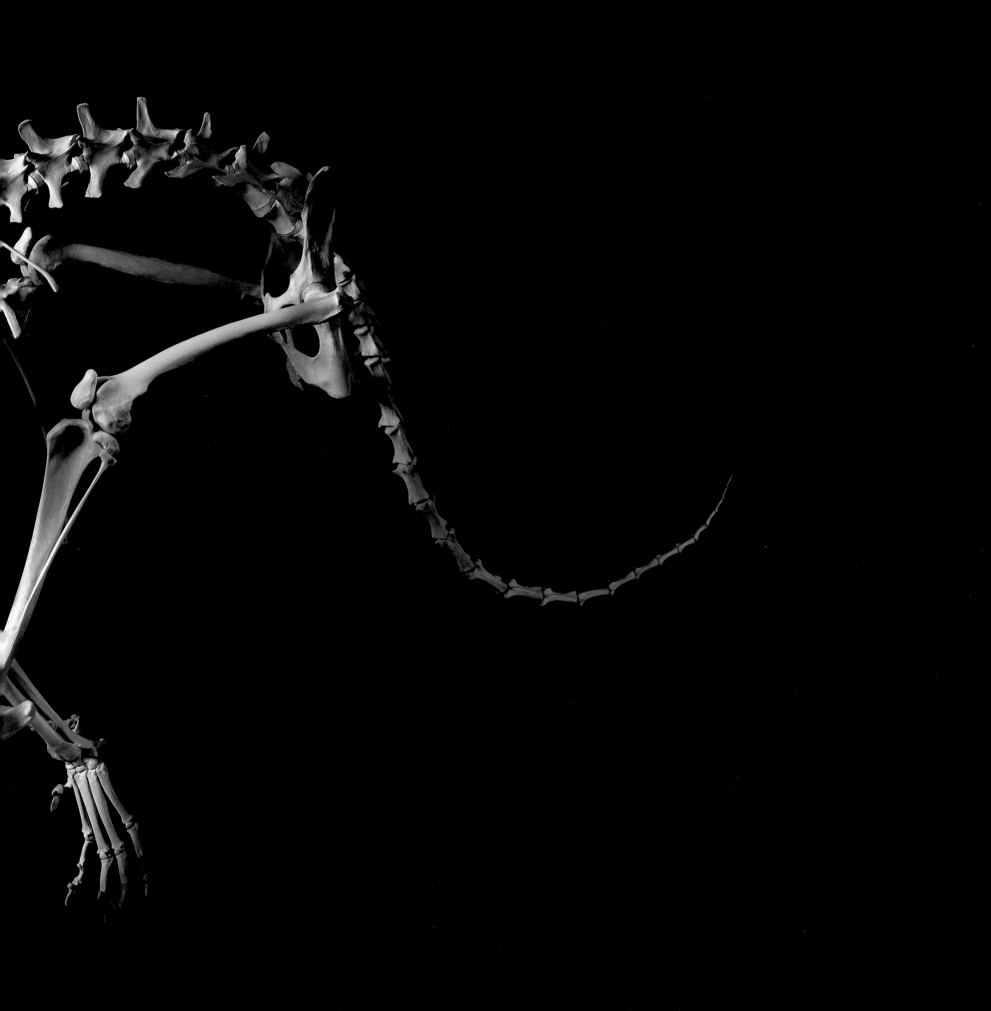

Cheetah, *Acynonyx jubatus*. Sub-Saharan Africa, Middle East (s.h. 70 cm)

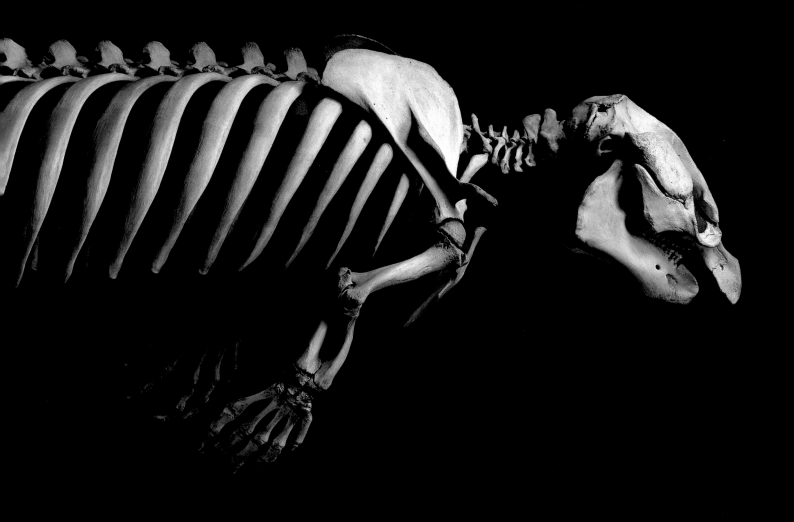

Manatee, *Trichechus senegalensis*. Western Africa (l. 2.15 m)

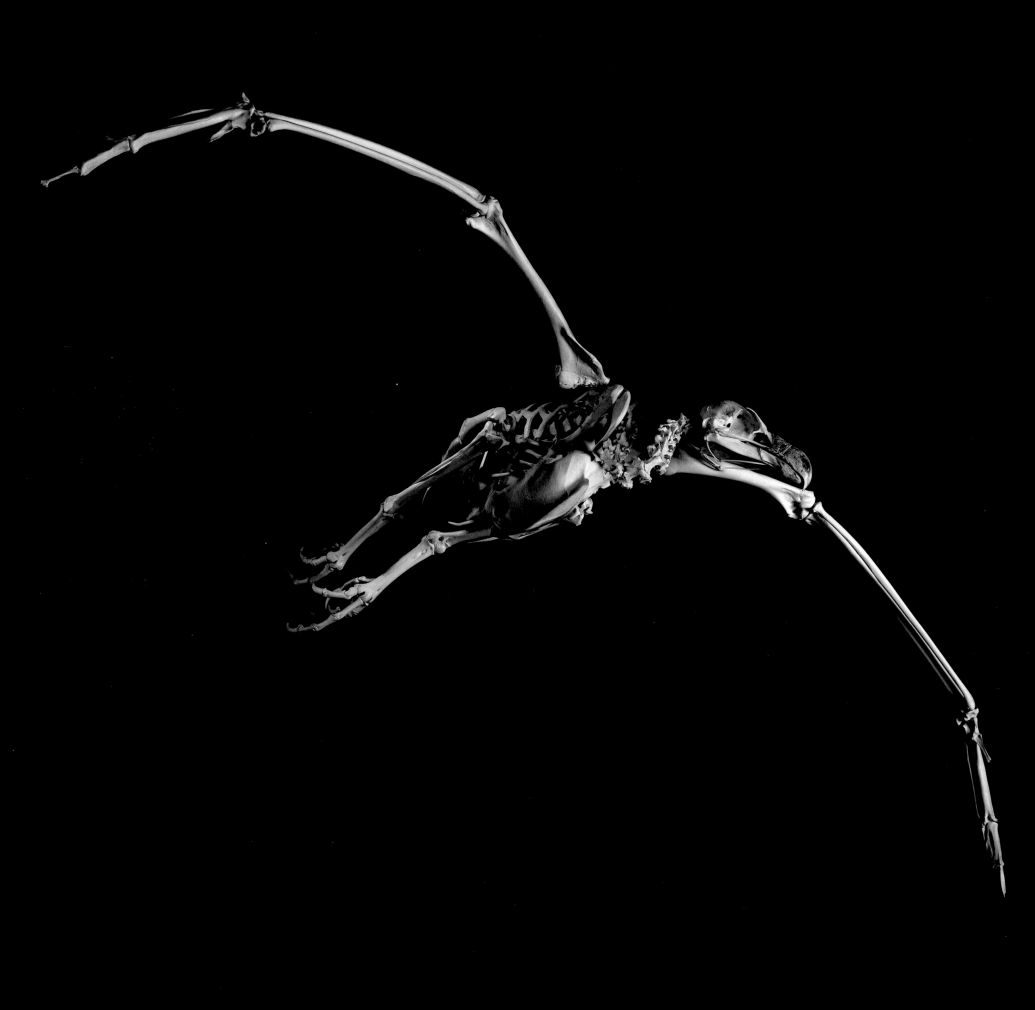

Griffon vulture, *Gyps fulvus*. Africa, Eurasia (w. span 1.50 m)

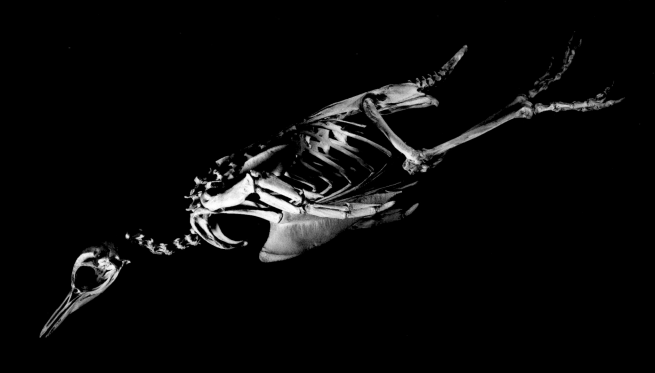

Magellan penguin, *Spheniscus magellanicus*. Southern coast of South America (l. 60 cm)

CHAPTER 29
THE LAST DIGITS

Veterinarians are sometimes assigned a strange operation: removing one or two extra digits from a newborn foal. In some cases, biologists interpret this anomaly not as a freak (like a two-headed calf) but as an atavism, a feature inherited from the colt's distant ancestors. Few organs have given rise to so much debate as the horse's digit, an organ shaped by several tens of millions of years of evolution.

The horse is an ungulate: it has hooves that are homologous to fingernails or to the claws of other mammals. They are a rigid corneous envelope encasing the last phalange of the single remaining digit on each limb, and have a characteristic flattened shape. In the hand (or foot) reduced to that one digit, the equivalent of the palm or the sole is the cannon bone flanked by two slender splint bones that are the vestiges of two other digits. The drawn-out foot is long, like the other segments of the limb—the shin and the thigh. The four limbs are at once lengthened by the stretching of foot or hand and made lighter by the absence of four digits. These features represent a very advanced adaptation to running, and to a way of life in wide-open spaces—the steppe or the savannah.

Horses and other equids, like the onager and the ass, belong to the perissodactyl (or odd-toed ungulate) group that also includes the tapir and the rhinoceros. The rhino has three digits to each limb. The tapir has three digits on the rear limbs but four on each front limb. But the third digit, the thickest, is located in the center position relative to the body axis, as it is in the rhinoceros. The importance of the central digit is one of the points in common among these animals, which also share other anatomical characteristics. Several fossil horses show fewer digits, with all the transitional forms from four or five functional digits to a single one flanked by two splint bones. The two side digits grew progressively smaller as the ligaments stabilizing the central digit grew stronger. Very few perissodactyls still exist these days, but they remain diversified, with species that are morphologically different from one another: heavy, massive animals with rather short feet such as the rhinoceros; smaller animals, such as the tapir; and large animals with long, narrow feet that have lost almost all their digits, such as the horse.

A second lineage of ungulates, the artiodactyls (even-toed ungulates), has produced the same morphologic types, with, for instance, the hippopotamus, the boar, and the dromedary. These species are readily distinguished from the preceding group by the even number of toes forming the hooves. This element could seem hardly important, but in fact it summarizes a great number of features that mark a sharp distinction between the two lineages since their beginnings, more than sixty million years ago. The artiodactyls first lost their thumb, and the axis of their limbs shifted slightly. In the boar and the pig, the two central digits are long and strong; the two outer digits, which are smaller, barely touch the ground. Bovids, such as cows and antelopes, have only two functional digits, the two others being reduced to small hooflets. The tylopoda, or camelids—llamas and dromedaries—retain only two digits. Their long slender limbs, like those of equids, are also adapted to running.

The ungulates are all herbivores, for which swiftness can be a decisive advantage against predators. The running speed of a species depends on several elements, such as its overall size and the length and frequency of its stride. The elongation of the limbs mechanically allows for longer strides. The stretching of the feet that results from the loss of digits also plays an important role, for the lighter weight of the limbs lessens their drag. The ungulates have other adaptations to running, such as a special shape to the astragalus. This ankle bone is somewhat different in the artiodactyls and the perissodactyls, but in both groups it stabilizes the foot by blocking any lateral rotation. All the ungulates have lost their clavicles as well; only muscles and tendons attach the front limbs to the spinal column. Thus, the shoulder blade can participate in the leg action, which increases the length of the stride. This arrangement also absorbs the shock at each thrust.

All these characteristics were acquired independently in the two lineages, which appear at the same time in the fossil archives. Artiodactyls and perissodactyls descend from a single ancestral species, still poorly known because its fossils are rare and incomplete. This ancestor probably belonged to the condylarthra group, mammals with five digits that lived in the Upper Cretaceous period (about 70 million years ago). The perissodactyls appear to have differentiated a little earlier. They represented the great herbivores of the early Tertiary period but were gradually replaced by the artiodactyls, in particular by the ruminants.

The parallel adaptation for running in the two lineages may have come about through a mere chance of evolution, for they evolved separately—one with four or two digits, the other with three or a single one. There is no reason to conclude that one structure is superior to the other. The swiftest ungulate is actually not the zebra as is often claimed, but an artiodactyl: the cervicapre antelope, which can reach one hundred kilometers per hour. Besides, many other factors affect the running speed of animals. For instance, dromedaries are not especially fast, despite their very long limbs and their two-digit feet. For their part, carnivores have retained the suppler digits and the claws from their ancestors. Their feet have lengthened, but they are not nearly so long as those of the ungulates; the principal innovation helping to increase their speed is the suppleness of their spine. This is how the cheetah too can exceed one hundred kilometers an hour over a short distance. The wolf can match the speed of a horse and run for as long.

All horses with several digits are not examples of atavism, nor do humans with six digits prove that our ancestors had more digits than we do. Mostly, these are only simple developmental anomalies, with no evolutionary meaning. But in certain cases, what we are seeing is a hyper-development of the splint bones, which evokes the polydactylia of the ancestors of present day horses. Archaic horses with three digits lived in North America up until less than five million years ago. Other species survived for two or three million years in Africa, where they were living alongside our own ancestors. The loss of digits is so recent that it would take only a small genetic shift for some individual to retrieve his ancestors' traits.

Rear paws: Indian tapir, Common zebra, Domestic Pig, Camel

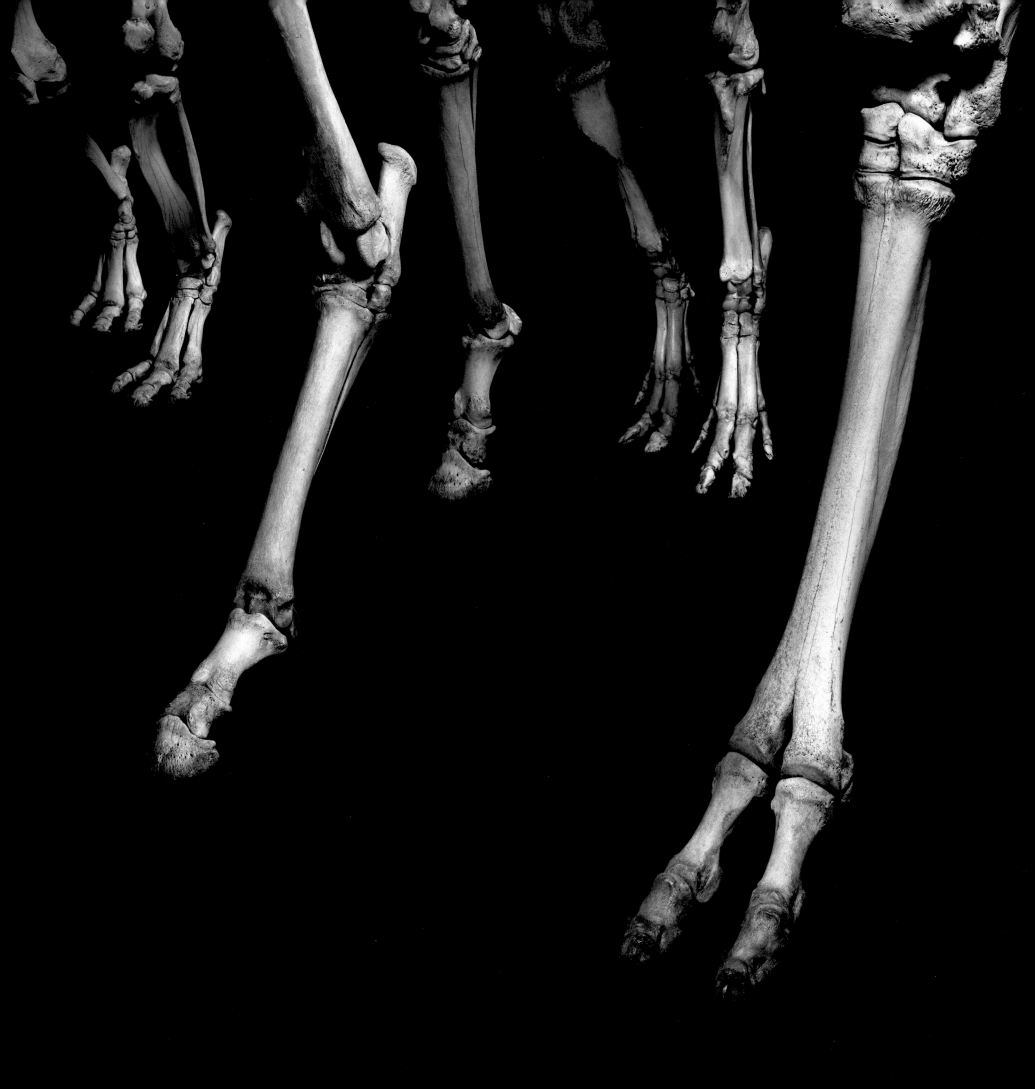

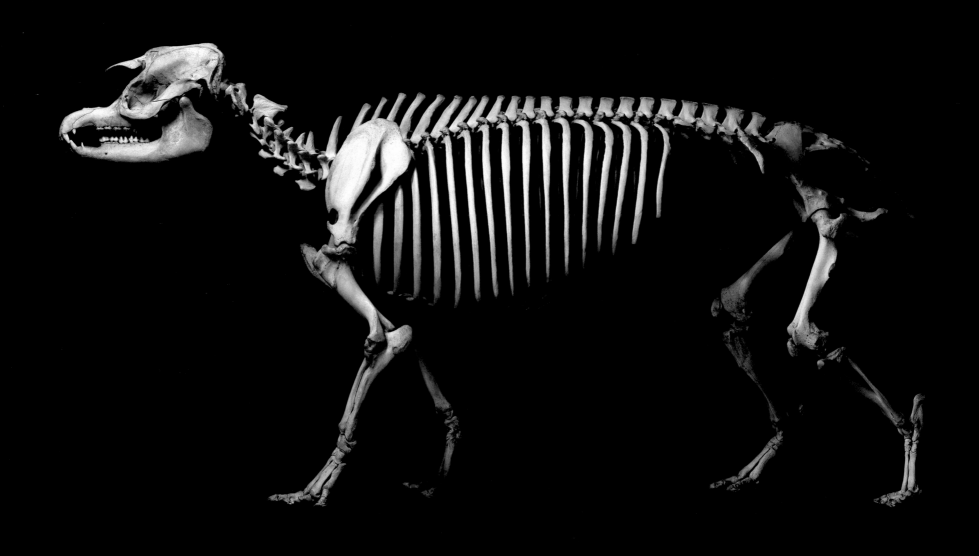

Indian tapir, *Tapirus indicus*. South-east Asia (s.h. 90 cm)

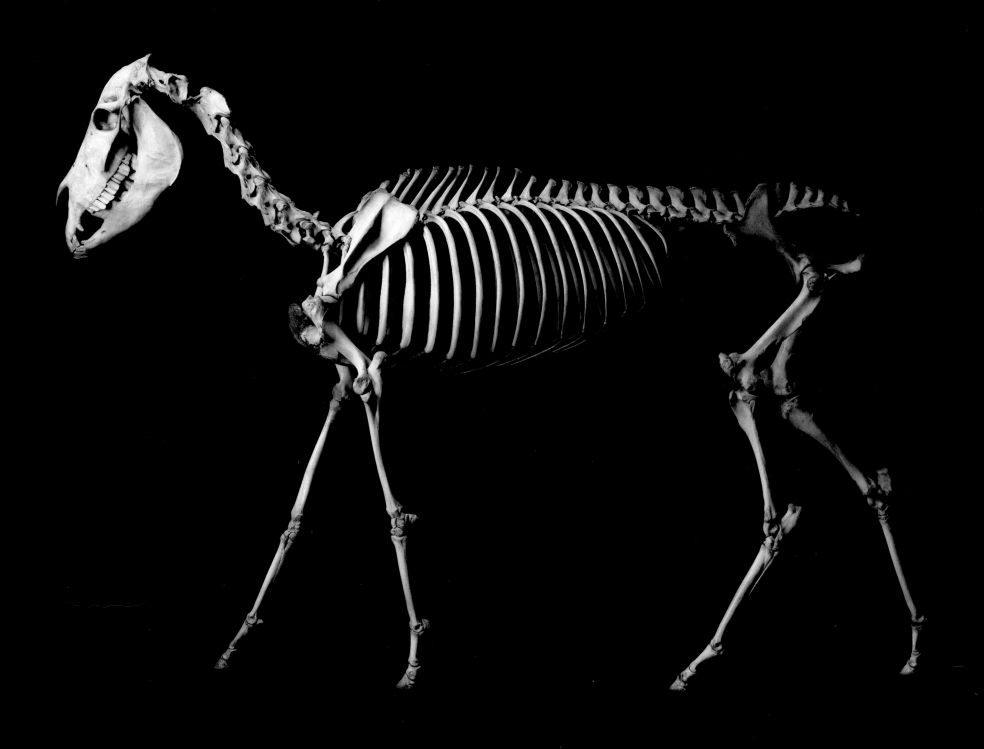

Onager, *Equus hemionus*. Asia (s.h. 1.05 m)

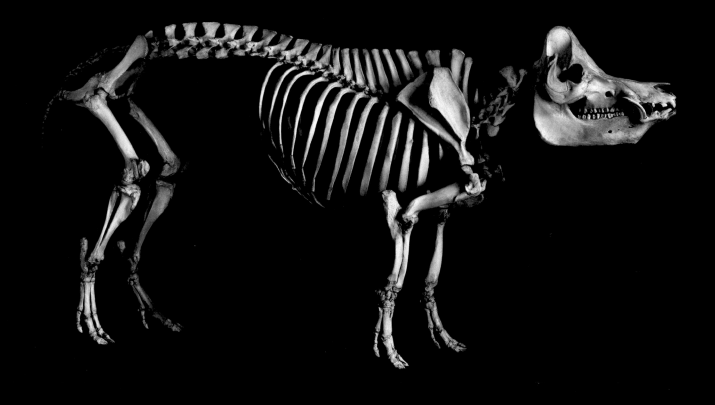

Domestic pig, *Sus scrofa*. Domesticated. Originally from Eurasia (s.h. 80 cm)

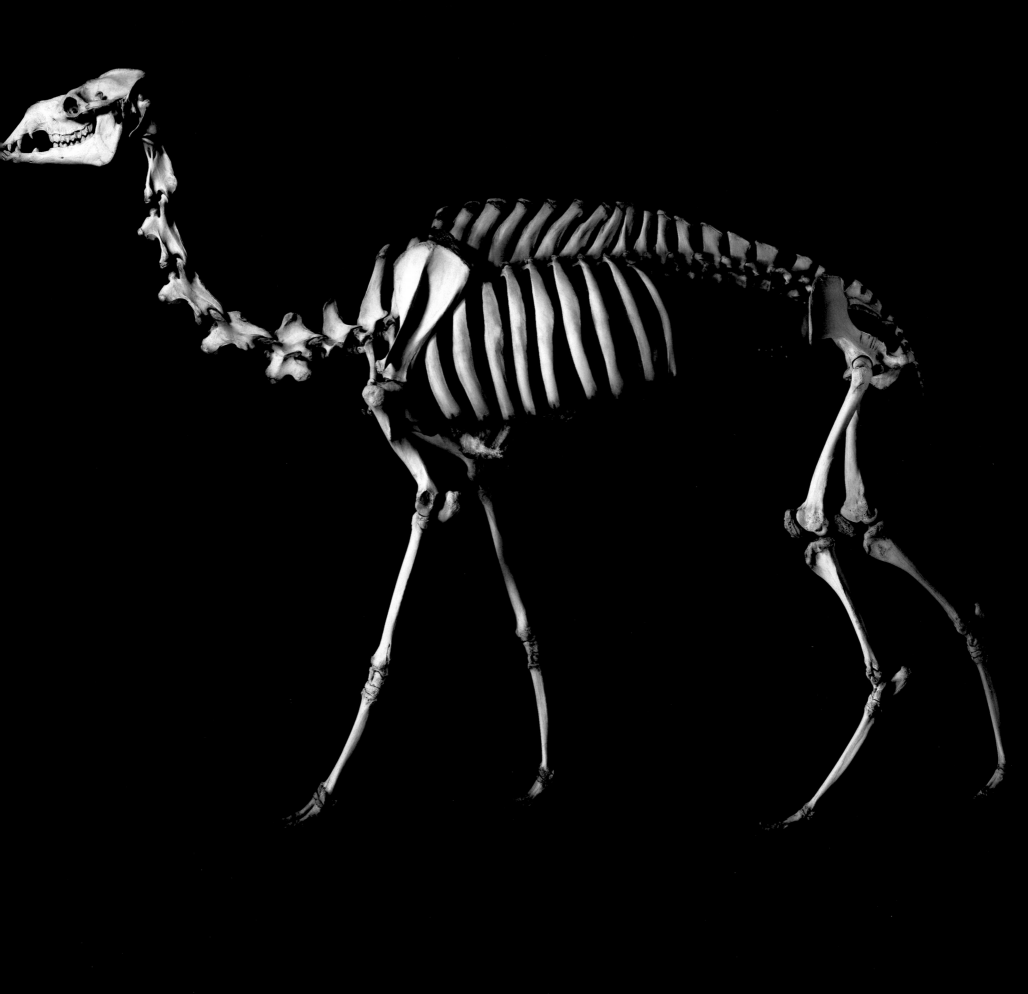

Camel, *Camelus dromedarius*. Domesticated. Originally from Africa (s.h. 1.75 m)

CHAPTER 30
THE TWO PANDAS

The giant panda acquired a certain celebrity status in the 1970s, when China made a friendly gift of some of the animals to various countries. The panda is known as well for a small bone of a particular shape which, around that same period, Stephen Jay Gould chose as a dramatic example of the tortuous pathways of evolution. In a monthly column in a science magazine, the American paleontologist sought to illustrate the idea that the oddities of nature are far more revealing of the mechanisms of evolution than are the most obvious adaptations. For Gould, the "panda's thumb" teaches us more about evolution than the bat's wing or the horse's hoof.

The panda eats almost nothing but bamboo leaves. During its meal, it grips a stem with its paws so as to tear off its leaves. Although it lacks an opposable thumb, it can still hold the stem thanks to a sixth "digit" that forms a pincer with the palm of the hand. This false digit has a different structure from the other five digits: it is not supported by the phalanges, and it has no claw. If we compare the panda's paw to that of a brown bear, we see that in fact it is a bone in the wrist—the radial sesamoid, much longer in the panda than in the bear. The bone is present in many mammals but is generally rounded and smaller; it serves to ease the rubbing on the tendon of the first digit (the true thumb, parallel to the other digits). We humans also have two small sesamoid bones at the base of the big toe, and a very large one on the knee, the patella (kneecap). In the bear, the radial sesamoid is a bit larger than in other carnivores. It is bound to its own (very small) muscles.

The panda, like other bears, descends from carnivorous animals whose true thumb is pointed forward, parallel to the other four digits. In carnivores, transforming a digit to render it "opposable" would require complex changes, particularly at the level of the knuckles, which are specialized for running or walking. But when an opposable digit would be a significant adaptive advantage, converting the larger, more mobile sesamoid of some animals is a simpler solution: the necessary bone and muscles are already present. Their transformation into an opposable "thumb" requires only a small-scale evolution.

Gould was in fact seeking to persuade the North American audience that evolution follows unforeseeable pathways, and that it is futile to look for the hand of God behind every adaptation. Our own, true, opposable thumb is no help in deciding between the two hypotheses, of a "natural" evolution or one that is "directed," because the organ suits its function perfectly. In contrast, the panda's thumb is an evolutionary contrivance tinkered out of an organ that was not at all meant for that purpose originally. This strange adaptation, Gould says, is proof that evolution is not directed by a divine engineer who could be said to choose the most aesthetic solution to a biological problem, but that it utilizes what's available in accordance with the animal's structure and history. Pushing the analysis further, Gould notes that the bone in the panda's foot that is equivalent to this "thumb" is also larger than it is in other bears, but without that greater size having any obvious advantage for the animal. It could be merely the consequence of the parallel development pattern in the limbs, with the genes responsible for their structure operating in both the front and rear limbs.

Distant cousins of the panda have thrown some further light on the evolution of the sesamoids in carnivores. Another family, the procyonids, also possesses somewhat enlarged sesamoid bones. These carnivores, which include, notably, the raccoon and the red panda, are famous for their capacity to grip objects. In the raccoon, it is the thumb that becomes slightly opposable and increases the ability to grasp, but in the red panda the sesamoid is also put to use. Like its homonym the giant panda, this animal lives in Central Asia and feeds on bamboo. Because of certain resemblances between the two species, zoologists have called this one a panda, but neither the name nor the shape of its sesamoid is enough to affirm that the red and the giant panda are near kin.

Zoologists have had great trouble classing the two pandas, the red and the large. They have sometimes been placed in the same group, sometimes been separated, and have wandered from one family to another, following criteria set out by the systematicians. The two pandas have been considered members of the bear family (ursids), raccoons (procyonids), weasels and martens (mustelids), and even skunks (mephitids). They have sometimes been allotted their own family, the ailuropodids, in which they were the sole members.

Molecular analysis, from proteins to DNA, has confirmed the anatomical arguments that separate the two pandas, and has clearly placed the giant panda among the ursids. As to the red panda, DNA has provided no clear answer: it is close to the procyonids but also to the mustelids. The two families are actually strongly related [see page 281]. This uncertainty merely shows the limitations of molecular techniques for settling such questions—studying DNA or proteins does not always help to differentiate between long-ago events that occurred within a short time. Besides, these studies have shown that the common ancestor of the red and the giant panda lived about forty million years ago, and that the lineage of the great panda diverged from the other bears around twenty-two million years ago.

The increased size of the sesamoid would thus have occurred independently in two different lines of descent, the bears' and the procyonids'. And we also know of a fossil species close to the red panda whose sesamoid operated as a prehensile thumb like that of the giant panda. This species, the *Simocyon*, which lived in Spain ten million years ago, used it to climb about in even the smaller branches of trees, whereas the other carnivores of the time were mainly terrestrial. This let the animal escape predators or hide its own dead prey in the trees. Its near relative, the red panda, put that innovation to another use: grasping bamboo stems. Stephen Jay Gould died before the *Simocyon* was discovered, but he would probably have appreciated that unexpected addition to the story of the panda's thumb.

—
Paw of giant panda

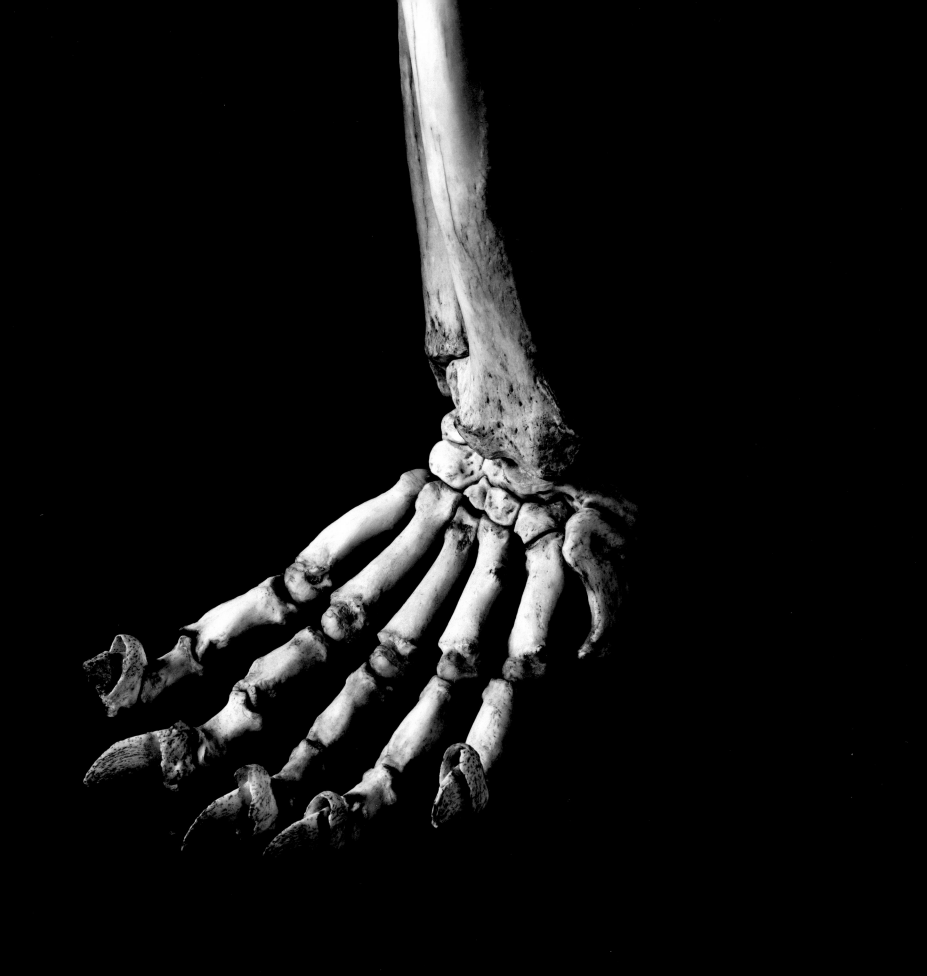

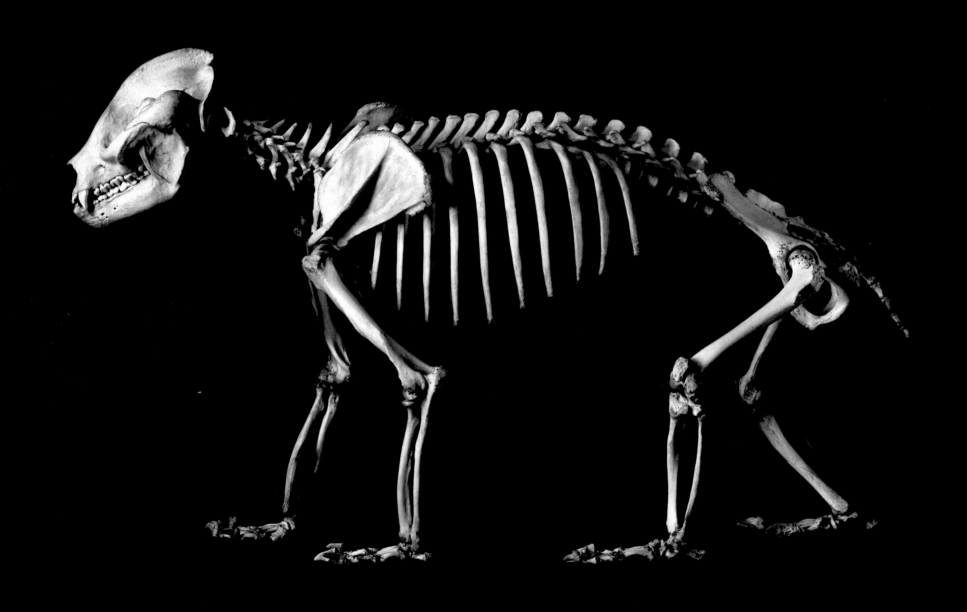

Giant panda, *Ailuropoda melanoleuca*. China (s.h. 65 cm)

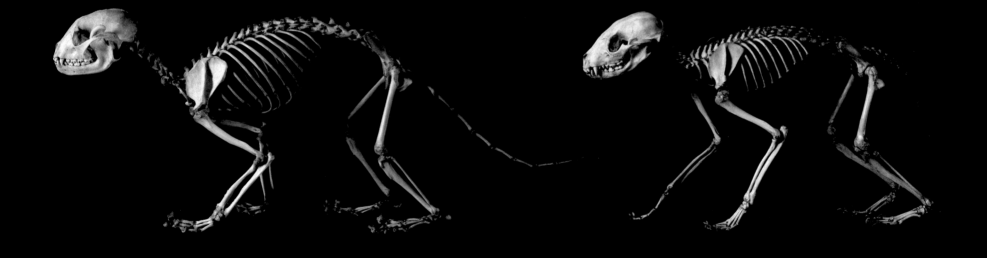

Red panda, *Ailurus fulgens*. Asia (s.h. 24 cm)
Raccoon, *Procyon lotor*. North America, Eurasia (s.h. 21 cm)

THE MUTANTS OF THE DEEP

Science-fiction films sometimes show us "mutants" caught in "metamorphoses" that prefigure the ineluctable "evolution" of our own species. This biologicizing vocabulary is supposed to make plausible some transformations that mingle very different phenomena. Metamorphosis is a strictly individual transformation, as in the caterpillar turning into a butterfly; evolution involves modification in descendants over the course of several generations. Movie mutants are typically "Lamarckian," for they are said to pass down to their descendants the shape they have acquired. Old-time werewolf or giant fly with a human face, their fate is rarely enviable. But most real metamorphoses result in adults that seem to us more "perfect" than the larvae they came from. Who would not prefer to turn into a butterfly or a frog rather than stay a caterpillar or tadpole? But there is one example of a metamorphosis that produces a freakish adult, bizarrely asymmetrical, that actually reveals an astonishing adaptation to a particular environment.

Just hold a turbot or a sand-dab upright to see this curious thing: the mouth is fairly normal, but the fish has both eyes on the left side. The other side is whitish and blind. The flatfish, or "pleuronectiformes," include more than seven hundred species, from the flounder to the halibut, a giant that can grow to three yards long and six hundred pounds. These fishes are all readily recognizeable by their flattened shape and, above all, by their heads with both eyes on the same side. Like other flatfishes, the turbot spends much of the time lying on the floor of the sea, partly buried in the sediment, which assures it a very effective camouflage. If the right eye were located in its normal position, it would be useless, and would probably quickly become blind through lack of light stimulation. The fact of having the two eyes on the same side is thus a considerable advantage. The flatfishes are not born deformed, though; they become that way.

The female turbot lays some tens of thousands of eggs, which are immediately fertilized by the male and left in the water. The larva that emerges some days later does not look unusual. It swims in a vertical posture, and its two eyes are located on either side of the head. It feeds on plankton and grows rapidly. After a few weeks, its right eye starts to migrate toward the top of its head, then over and down the left side. The eye stops migrating when it approaches the left eye, which has not changed position. Actually, it is not that the eye moves but that the cranium undergoes an asymmetrical growth: certain bones vanish, others are reshaped or come into being, and all these rearrangements translate into a displacement of the eye socket. The larva then descends to the sea floor and lies on its right side, the two eyes looking upward. The lower surface loses pigment while the side exposed to the light gradually takes on a brown coloration. The dorsal and ventral fins lengthen and surround the turbot's body. The right pectoral fin stays in place and thus lies under the fish, against the sediment. In other species, it disappears. The fish's behavior has changed as well; now it swims in a flat, or horizontal, posture, by undulations that are quite different from the movements of other fishes.

This asymmetric growth is a veritable metamorphosis, comparable to the one that transforms a tadpole into a frog. The cranium is not the only organ to be affected. The brain is also remodeled, in such a way that the displaced eye remains active. The right nostril follows the same path and moves from the left side to a position near the other nostril. The jaw loses its initial symmetry, and the teeth shift place. The musculature changes as a function of the new way of swimming. The fish's structure itself is affected, for it loses the bilateral symmetry common to all vertebrates. This transformation takes place in response to a thyroid hormone, thyroxin, which is very common in animals. In amphibians, this growth hormone sets off the tadpole's metamorphosis; in man, it plays an important role in the embryo's growth and development, especially of its skeleton, and acts on many physiological functions in the adult.

The Atlantic turbot is a "sinistral," or left-sided, species, whose eyes migrate to the left. The halibut, the plaice, and the sole are "right-sided." There are a few rare exceptions—left-sided individuals whose species is customarily right-oriented. In some species, the individuals are right- or left-oriented according to their region. Cross-breedings have shown that metamorphosis occurs at the direction of genes that specially determine to which side the eyes will migrate. Other flatfishes—the psettodids, or spiny turbots—may be oriented to either right or left. The adults continue to swim in a vertical posture, and their musculature is more symmetrical than that of other flatfishes. They are also the only pleuronec-tiforms with spiny fins. For flatfishes, these are archaic characteristics, probably close to those of their ancestors. So the psettodids could teach us about the origins of flatfishes and their relation to other present day species. The pleuronectiforms probably descend from a group of fishes with spiny dorsal fins and with paired fins set near the head. These characteristics make them similar to the perciforms, the perch and bass group.

Near the coasts, the seafloor is an extremely rich environment. In the soft sediments hide myriad crustaceans, sea urchins, worms, and shellfish. It is easy to find something to eat there, but also easy to hide away from predators. The pleuronectiforms have occupied this particular ecological niche at the price of a transformation with no equivalent in any other vertebrates. But they are not the only fish to live on the floor and must give over a little space to the skate. Skate are no more closely related to the turbot than to any other fish, since they belong to the chondrichthyes, like sharks, and like them they have a cartilaginous skeleton. They live lying on their bellies, their "wings" being prolongations of their flank. Their shape results from a flattening—that is, only a change in shape. Intermediate forms do exist between fusiform (spindle-shaped) sharks and the rays, such as angelfish and guitarfish, which give us a way to imagine how fish with cylindrical bodies are compressed. This is not a metamorphosis: the turbot, asymmetrical, is a flatfish; the ray, symmetrical, is merely a flattened fish.

Turbot, *Psetta maxima*. Northeastern Atlantic, Mediterranean (l. 38 cm)

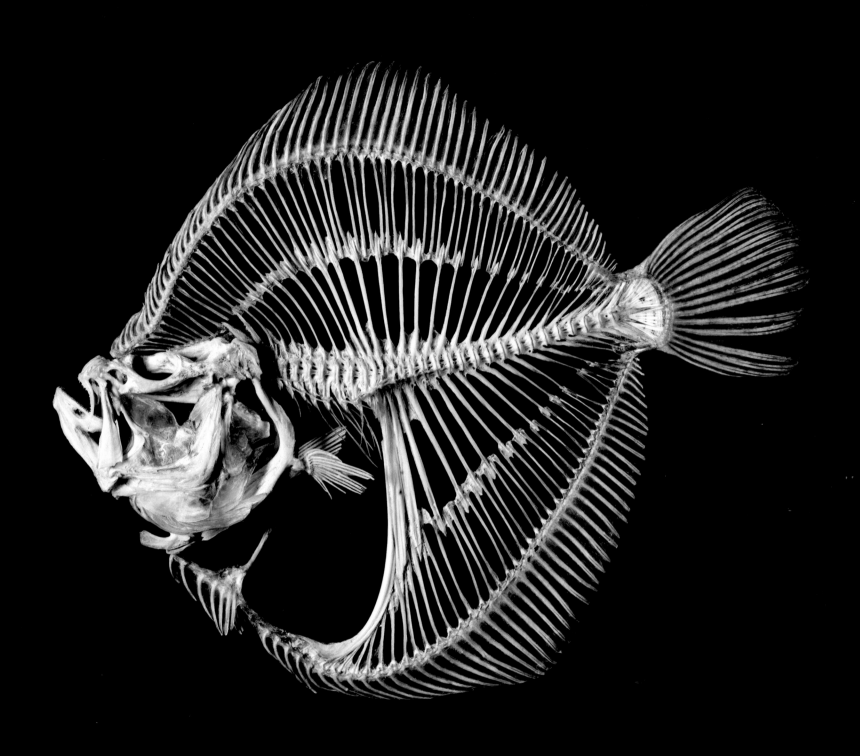

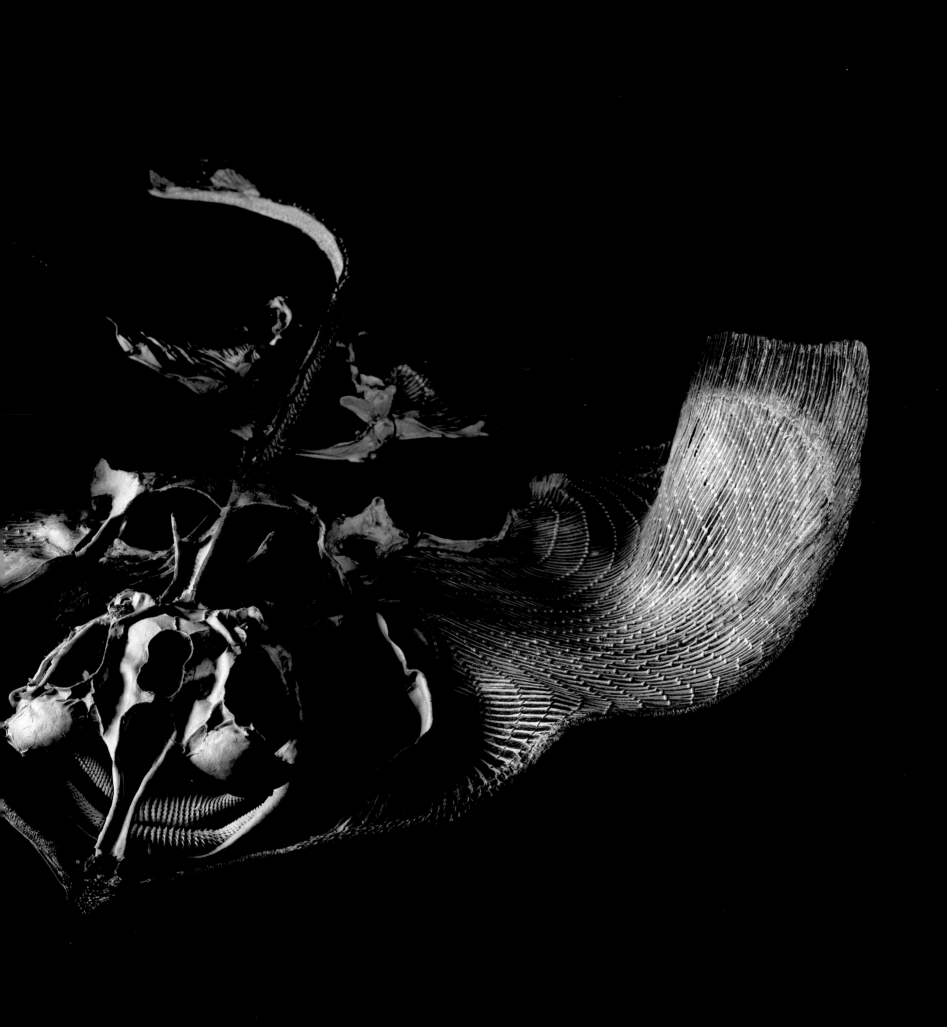

Common skate, *Raja batis*. Global oceans (w. span 91 cm)

CHAPTER 32
ADULTS STILL INFANTS

In 1749 Benoist de Maillet imagined how fish thrust onto the dry shore had developed into birds: "Their fins, being no longer soaked in the waters of the sea, split and warped from the dryness. Although they did find, amid the reeds and herbages into which they had fallen, a few foods to sustain themselves, the spines of their fins, now separated from one another, stretched longer and took on barbs.... The small ailerons beneath the belly, which, like their fins, had helped them to move about in the sea, turned to feet and served for walking upon land.... A hundred million may have perished without being able to accustom themselves to it, but that two did manage it sufficed to give rise to the species." In reality, this description resembles that of another natural phenomenon: metamorphosis, in which, for instance, caterpillars turn into butterflies and tadpoles into frogs. Metamorphoses are not evolution, but they do give clues to its mechanisms.

How does a species acquire a new morphology and change into a different species? Experiments have shown that it takes very little to obtain visible changes in the look of a species—or instance, the mouse and the fruit fly, two animals subject to much laboratory study. A point mutation, affecting a single gene, provokes the start of a lineage of yellow-pelt mice or a line of fruit fly with stunted wings. These modifications are transmitted from generation to generation. Similarly, breeders of domestic animals sometimes obtain, by chance, new mutations, which they then reinforce in descendant offspring by clever cross-breeding. Mutations affecting anatomical or behavioral features important for reproduction can lead rapidly to the advent of a new species [see page 90]. But most small-point mutations are not sufficient to do so; larger-scale changes would be required, but they must not involve serious consequences for the development of individual animals.

In its native region, the American Southwest, the amphiuma is called the "Congo eel." Its long gray-brown body, its slick, smooth, hairless skin, and its branchial slits (gills) give it the look of an eel (and it is wrongly assumed to come from Africa). The presence of feet and all its other anatomical traits, however, link it unmistakably to the salamanders. The amphiuma is part of a group of amphibians that present an astonishing feature: they become adult in the larval stage! Like the tadpoles of frogs, the larvae of salamanders live a life that is totally aquatic. They lack feet and have gills. In principle, after a period of growth, these larvae metamorphose. They acquire four feet and lungs, and become capable of reproducing. In the amphiuma, the metamorphosis is incomplete: its feet are tiny and incapable of supporting its weight out of the water. It loses its gills but keeps the branchial slits on either side of the head. Its eyes remain lidless. Despite this morphology, which is still partly larval, the amphiume has become truly adult in that it is now sexually mature and can reproduce. The axolotl, another salamander, acquires normal feet in the adult stage but keeps its external larval gills and goes on with its strictly aquatic life.

This phenomenon, called neoteny, is interpreted as a disjunction in the timing of some stages of development. Sexual maturity is reached before metamorphosis is completed, which puts a stop to any further development. The axolotl has been much studied, for its development is not permanently blocked; injections of thyroid hormone readily stimulate the completion of its metamorphosis. Neoteny suggests that important morphological transformations can result from minute variations in the concentration of a hormone or its rhythm of secretion. Such changes could be the effect of simple mutations that influence the activity of a protein or the regulation of its production.

Neoteny is only one of many cases of discrepant timing in development, more generally known as that "heterochrony," described above. These phenomena relate to the absolute duration of the different stages of development and their relative speeds. For instance, a slower maturation will simply translate to an increase in size with no change in morphology. In the case of hypermorphosis, a late maturation leads to an overdevelopment of certain adult features. In running birds that cannot fly, it seems that the stunted smaller wings result from an arrested development of certain bones in the embryo stage. This would be a form of neoteny, with the adults possessing only quite rudimentary wings. In the galliformes—birds of the chicken group—the sternum and breastbone appear very early in the embryo's development. Therefore a reduction in these two bones would make for a profound disturbance in the animal's overall development; this is confirmed by the absence of galliformes with truncated wings. Conversely, in the columbiformes—the pigeon group—the sternum hardens late. Its possible atrophy would thus be the result of a "local anomaly" compatible with quasi-normal development. This group has produced birds incapable of flight, like the famous dodo, recently extinct.

Another example holds special interest for us, for it concerns our own species. Among primates, the human is characterized by a significant diminishment of the face. Instead of forming a muzzle that projects forward, our face is an almost entirely straight plane downward from the forehead, except for the nose (whose form is also a human characteristic). In an adult chimpanzee, prognathism (a protruding jaw) is far greater than it is in the youngster. The adult's face becomes very prominent in relation to the skull. Conversely, in the young chimpanzee, the face is smaller and so the cranium seems more voluminous, as in the human. In other words, the resemblances between our two species are far greater in the young than in adults. And given other differences that grow more marked with maturity, the adult human looks more like the young chimpanzee than the adult. Retaining some juvenile traits into adulthood, the human is neotenic in relation to the chimpanzee. Similarly, in the human species, the woman is more neotenic than the man, conserving as she does a hairless face and a smaller nose. In the man, the increased secretion of testosterone in adolescence stimulates bone growth in the jaw and chin and the development of the nose. Is it possible that, as his name indicates, Superman is afflicted by an exaggerated form of masculine hypermorphosis?

Amphiume, *Amphiuma means*, Southeastern United States (l. 88 cm)

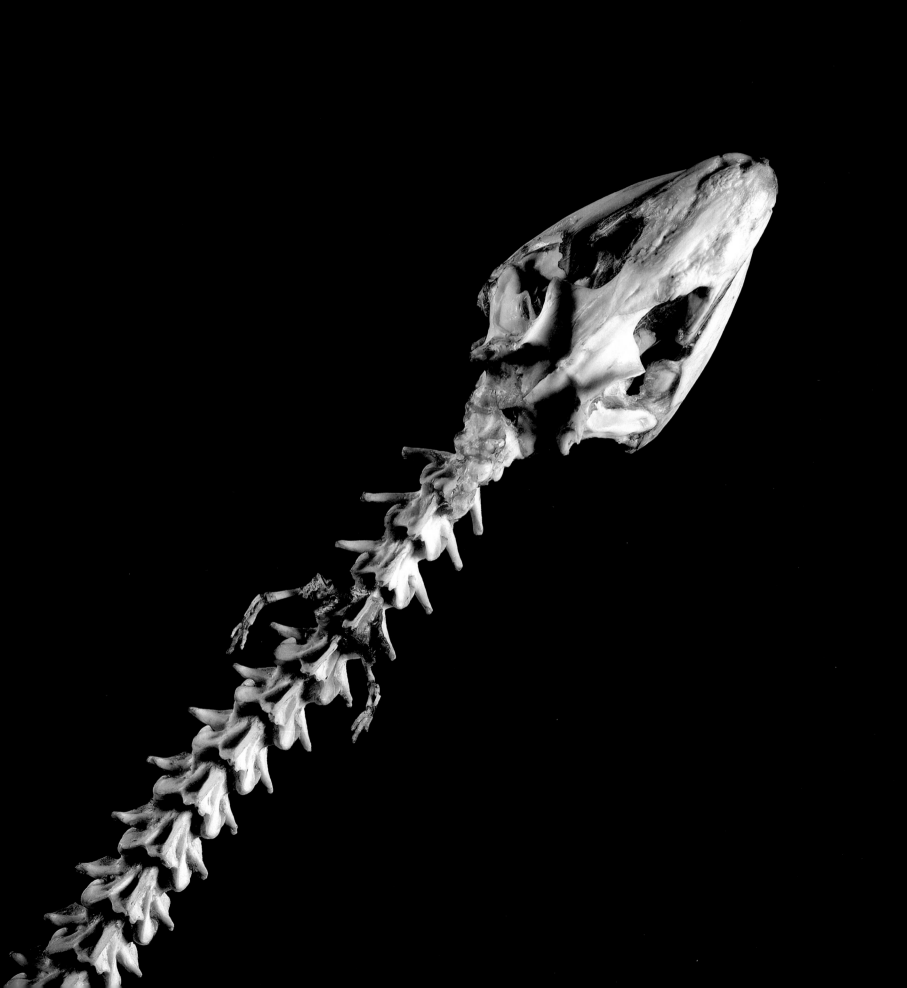

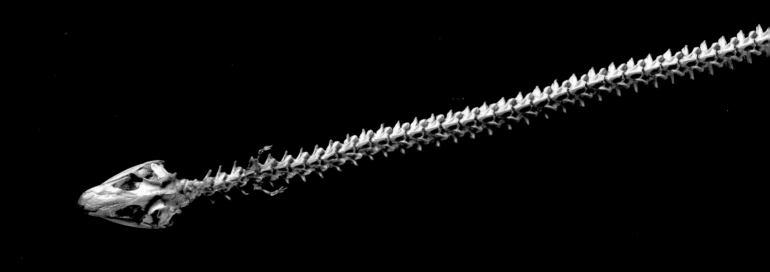

Amphiume, *Amphiuma means*. Southeastern United States (l. 88 cm)

PART V
THE POWER OF THE ENVIRONMENT

Bird feathers, because they are at once rigid and lightweight, are ideal for flying; the dolphin's hydrodynamic shape permits it to reach great swimming speed; the anteater's jaws are precisely suited to capturing ants. Each detail of an animal's anatomy has some part in its way of life, and the sum of these details ensures its adaptation to its environment. But if the animal did not have suitable teeth, stomach, feet or eyes, it would quickly die; if the entire species were not adapted, it would disappear. In this sense, to say that an animal is well adapted is a tautology. Describing an organ's adaptation involves relating its form to its function, but that still leaves out an essential point: the origins of that adaptation. For a creationist, it is simply a direct proof of divine know-how. For a supporter of Intelligent Design, it is the outcome of a plan ideally conceived and worked out. For a biologist, it is an interim stage in evolution.

Adaptation is in fact not a stable state but a historical process, in the course of which an initial organ is transformed and may possibly acquire a new function. The most astounding aspect of adaptation is perhaps not that the bird's wing allows it to fly but rather that both the bat's wing and the bird's were formed by different pathways, out of the same barely differentiated arm, and that the two are equally effective [see page 198]. More broadly, an animal's adaptation means that all the aspects of its anatomy and behavior have been shaped by its environment and its way of life. The word "adaptation" is actually just as ambiguous as the term "evolution." In physiology, adaptation describes the changes that occur in the organism from some occurrence—for instance, physical exertion, or a rise in external temperature, or a mountain journey. The organism's responses can be immediate (an increased heart rate) or slow (increased production of red blood cells). Like the strengthening of an organ by its use, physiological adaptation of the organism is a temporary change that involves only the individual and is therefore not hereditary. But evolutionary adaptation is a real transformation of the species, through the interplay of mutation and selection. Natural selection acts at two levels: as a mechanism for eliminating mutations that are unfavorable in relation to the constraints of the environment, and as a mechanism for preserving innovative mutations that give the species some new equipment it can put to use in exploiting that environment.

An animal's environment, or its ecosystem, is not solely defined as a landscape: forest, steppe, mountain, ice pack, coral reef. It also includes various climatic factors, the degree of light, and the type of soil and water, as well as the range of species the animal lives among: its congeners, its predators and its own potential prey, its parasites, and even species that mean little to the animal but that nonetheless affect its existence one way or another. An animal's adaptation is the expression of a balance between it and all the components of its surroundings, which themselves interact.

Some adaptations seem remarkable because the present stage in an organ's evolution does not make clear the history of its successive transformations. A dolphin is externally so much like a fish, its organs are so profoundly changed compared with those of other mammals, that it could be considered an example of perfect animal adaptation. But in comparing two animals that live in the same environment, can we say that one is better adapted than the other? Is the sea otter, with its four feet, less well adapted to a marine environment than the seal, whose feet have become fins? The otter is less modified in form by marine life, but it gives birth to its young in mid-ocean, whereas the seal gives birth on land. Among mammals, the otter, the seal, the sea lion, and the dolphin have very different shapes, all of them "perfectly" adapted to their environment but presenting very diverse degrees of transformation by comparison with their ancestors. These groups have no particular genetic relationship, but they provide evidence that all the intermediate forms between a quadruped and a dolphin can be viable and well adapted to life in the water. Thus, observation of current species yields data on the evolution of cetaceans, to be filled out by fossil study and DNA analysis [see page 206].

A totally marine animal, the dolphin can be compared with a tuna or an ichthyosaurus, a marine reptile of the Mesozoic era. The three species have the same spindle form, which makes for swift passage through a medium far denser than air. They also have similar dorsal fins and the same type of dentition—many small teeth, typical of fish-eaters. Yet the three groups have very different ancestors: the dolphins and the ichthyosaurs descend one from a mammal and the other from a reptile, both land quadrupeds, whereas the antecedents of the tuna have never left the oceans. Here, it is adaptation to an environment or to a particular way of life that led in the end to resemblances acquired by different routes. This phenomenon, called "convergence," illustrates both the plastic nature of the basic vertebrate structure and the power of the constraints that influence the evolution of species. Similarly, several groups of vertebrates have adapted to an underground life; the ancestral characteristics of certain reptiles have favored this evolution, which has occurred independently in several lineages and given rise to footless lizards and to snakes [see page 226].

The geological history of our planet, with its climatic and geographic upheavals over hundreds of millions of years, has played a very important role in the evolution of living creatures. The temperature and pressure that prevail in the depths of the earth cause a partial fusion of the rocks. The internal heat stimulates vast convection movements in this viscous matter that pulls along the cold, rigid plates of the earth's crust. The continents move apart or closer at the rate of a few centimeters a year. Time and again, all the emergent land masses have been joined into a single super-continent—Pangaea—that then broke apart, the continents again drifting away from one another. These movements have been described in detail through the theory of tectonic plates. Bringing together several disciplines of geology, this theory has provided an understanding of many phenomena that have long been puzzling, such as the presence of identical fossils on separate continents and the heterogeneous distribution of certain present day species over the surface of the globe.

Evolution of fauna, then, has occurred through chance with the dislocation and regrouping of continental

masses, isolated species sometimes finding vast spaces to colonize, with new vegetable populations, new rivals, new predators. Such continents as Australia and South America have been separated from the rest of the world through tens of millions of years, and their fauna still bear the traces of that isolation [see page 242]. On another scale, a similar phenomenon occurred in the volcanic islands that were colonized by a smaller number of species [see page 86] and in African lakes invaded by cichlids, small fish that have experienced a remarkably quick evolution [see page 260].

Climate has often changed over the whole globe due to the shifting positions of the continents, variations in ocean currents, and astronomical factors. All these phenomena are both slow and long-lasting, but the earth has also been affected by far more violent events, such as showers of enormous meteorites blacking out the atmosphere with immense clouds of dust and bringing on worldwide drops in temperature. Huge volcanic eruptions have had similar effects, through ash emissions thrown up over thousands of years. These catastrophes have played a significant role in the evolution of fauna and flora throughout the world. They have caused mass extinctions of species and thus made room for new groups to settle into ecological niches left vacant. This is what occurred for the dinosaurs after the extinction of a great many reptiles in the Late Triassic period, two hundred million years ago, or for the mammals after those dinosaurs disappeared [see page 166].

By reason of climate, topography, and the nature of each continent's soils, vegetation has been subject to differing conditions and has evolved in the different ways. Herbivorous animals have changed as a function of the variations in their foodstuffs. For instance, when grasses appeared and began to colonize the continents, leaf-eaters adapted and became grass-eaters. Animals themselves acted on the flora by fertilizing plants, dispersing their seeds, and eating certain plants rather than others. In that co-evolution of plants and animals, some groups adapted better than others to the new opportunities. Such is the case for the ruminants, which

came to supplant the great herbivores that had predominated until that time [see page 220]. Although the resources of each continent were not identical, they did offer equivalent ecological niches. In Africa, the great carrion raptors are the vultures, which are related to eagles; in America, it is the condors, which are closer to storks and herons. Similarly, ants and termites live everywhere in the world, which has led to the development of several species of ant-eating animals that are different from one continent to the next [see page 232]. Another element in an individual's environment is its social group, notably among birds and mammals. Ethology, the science of animal behavior, has long utilized the concepts of evolutionary theory—for instance, to explain birds' actions during the mating display, or the hierarchic relations within animal societies. It may be there, in the relations among group members, that we should seek the origins of so important an organ as the human brain [see page 254].

Mammals appeared about two hundred twenty million years ago, almost at the same time as the dinosaurs, but they had to wait another hundred fifty million years for the environment to turn favorable for them—that is, for the dinosaurs to disappear and leave free a good many ecological niches. Their own survival is not the result of a better adaptation to the environment than the dinosaurs had achieved; no animal could adapt to a catastrophe as violent as the fall of a meteorite. But mammals were small, unobtrusive animals that probably led a nocturnal life, keeping to tunnels by day and emerging at night to search for seeds and insects. Perhaps they were able to adjust their metabolism to withstand periods of drought or cold or shortage of food. All these characteristics, together with a capacity to regulate their internal temperature as in all current mammals, probably played an important role in their survival. From the start of the Tertiary era, they were able to put to use all the potentialities of their structure and physiology. Then they gave rise to very different forms, from bats to whales.

Among monkeys, hominids were very successful, with many species in all sizes, before finally regressing and

leaving room for the cercopithecoids (macaques and baboons), perhaps for reasons of climate. But, taking advantage of the general chilling of the planet and of the spread of savannas and prairies, a few hominids gave rise to early man. Still, in the profuse expansion of fossil species, nothing indicates any special bias favoring man. Our species, with its large brain, is the product of a very long history (three and a half billion years since the origins of life), full of all sorts of leaps and setbacks—and totally unpredictable.

CHAPTER 33
SKY CONQUERORS

Birds, bats, and man are the only vertebrates to have truly conquered the aerial environment, capable of maintaining their position there and moving about in it with ease. Less well known is that many animals such as serpents, frogs, fish, and rodents practice forms of flight that are more rudimentary, from simple parachuting to gliding. The major requirement for the aerial environment is energy, for it calls for an enduring victory over weight. A second difficulty is sensory in nature: it requires finding one's bearings navigating in a three-dimensional space, where the least error can have dramatic consequences. Flight necessitates major mechanical and behavioral adaptations, but it offers obvious advantages: it allows escape from predators (if they themselves do not fly) and the rapid exploration of vast territories. Since the arrival of flying insects (which discovered flight well before the vertebrates did), the aerial world is also an important reservoir of food. Only flapping flight (as different from gliding or soaring flight) is sufficiently maneuverable to make use of that resource, but it would have required a number of adaptations and thus cannot have appeared suddenly. Do the intermediate forms of flight observed today provide any understanding of how species acquired the ability to fly?

A very diverse array of animals "invented" gliding flight, each in its own way, thanks to adaptations specific to each group. Flying fish pick up speed and then leap out of the water to glide over short distances by means of their oversize pectoral fins. In flying frogs, the fingers and toes are much elongated and bound together by fine webbing that acts as a parachute. Flying lizards have ribs that extend from either side of the body and support a membrane of skin, an adaptation that also occurs in several snakes. In flying mammals, such as the galeopithecus (the flying lemur), the elongated limbs are connected by a broad fold of skin, the patagium. To glide, they must climb into a tree and then thrust off for another one, somewhat lower. All these animals have variously acquired some bearing surface, which, though it does not help them to lift off, does effectively slow their fall. Most live in equatorial forests and can move swiftly from tree to tree by this means.

The only present day vertebrates that fly by flapping are bats and birds. In the bat, the wing is a skin membrane supported by the arm and four very elongated fingers (the thumb is free). Its bones are very fine. The sternum, or breastbone, has a keel shape where the muscles for lowering the wings are attached; the lifting muscles are located on the back. During flight, the rear feet are thrown back to the sides and support the patagium. In birds, the adaptations to flight are very different. Their skeleton is made lighter by many hollow bones, some of which are filled with air and are involved in respiration. The vertebral column, the ribs, and the pelvis form a rigid structure, reinforced by the two clavicles, which are fused into a "wishbone." The sternum has a well-developed keel supporting the pectoral muscles that power flight. Depending on the species, these muscles make up one quarter to one third of the animal's total weight. A bird's wing is constructed of three similar-length segments: the arm, the forearm, and the hand, which is reduced to three digits partly joined together. The bones support the remiges, the large flight feathers that form the bearing surface of the wings.

Sparrows, pigeons, and other birds that live in the woods and gardens fly by flapping their wings. They can also glide on the air, but cannot soar for very long distances. Only some birds endowed with great wingspan can actually soar by utilizing rising air currents. Albatrosses spend most of their lives at sea; they surf on the winds thrust upward by the ocean's swells, and so can soar for hours without a wing-beat. Similarly, many gulls ride the rising air currents that form when the wind hits a cliff. Vultures seeking out animal carcasses hundreds of miles away from their nests, as well as migrating long-legged wading birds, use the lifting thermal winds—"bubbles" or columns of warm air that form above soil heated by the sun—and sometimes rise to altitudes of several thousand feet. Soaring flight is very technical, but it demands much less energy than flapping flight. Still, the great soarers must be able to take off and land, and thus must beat their wings. This type of flight is sometimes considered a mid-stage between gliding and flapping flight, but it actually constitutes a very advanced adaptation to the possibilities offered by the aerial environment.

To acquire flapping flight demands significant anatomical modifications. The transformation of a climbing animal into a gliding animal is simple, even though it does demand a general lightening of weight, a lengthening of bones, and the formation of a membrane of skin. These adaptations can be acquired progressively, since each small modification procures an advantage, however slight. The fauna of today show numerous examples of jumping animals that are to some degree gliders, able to brake their fall. The passage to flapping flight requires more profound changes in the skeleton and the musculature. It is possible to imagine such an evolution from an animal of the galeopithecus type to one of the bat type, even though the two groups are not particularly close relatives. For instance, the flying lemur has skin membranes between the fingers that might prefigure the bat's complete wing. It would still have to acquire the joints and muscles necessary for flapping flight. For their part, birds descend from small dinosaurs that were carnivorous, biped, and terrestrial. Some dinosaurs bore feathers, but often too few or inadequate in structure to be able to fly. Even if the details of their evolution are unknown, it is very probable that the feathers appeared before flight. They seem to have taken shape by a transformation of down-like filaments that served to keep constant the internal temperature of some small dinosaurs. Larger, more rigid feathers may have had a role as courtship ornamentation before they were recruited for flight.

Originally, the wing-flapping action itself may have simply helped birds in running, without flight being foreseen in any way. Chickens, for instance, use their wings to flee, to perch, and to climb a slope, but they do not truly fly. Today, neither fossils nor living species can settle the question: we do not know whether birds descend from a terrestrial animal that beat its wings or from an animal that climbed and glided.

Snowy albatross, *Diomedea exulans*.
Oceans south of the Tropic of Capricorn (w. span 2.10 m)

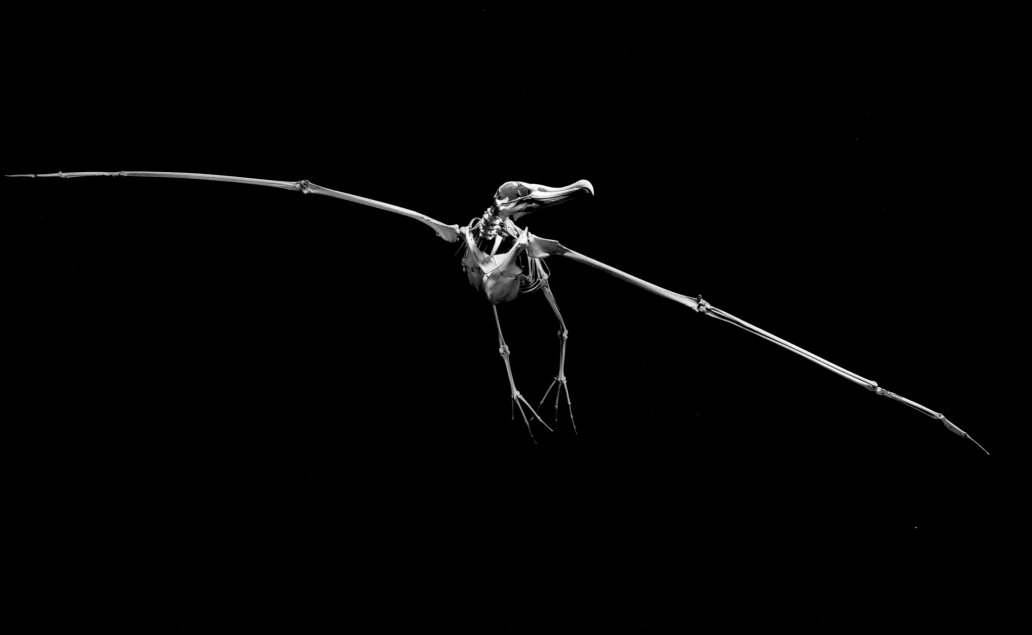

Common wood-pigeon, *Columba palumbus*. Europe, Middle East, North Africa (l. 28 cm)

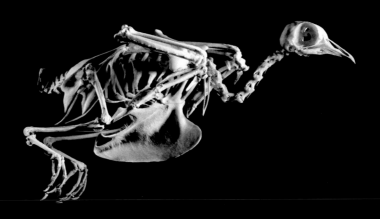

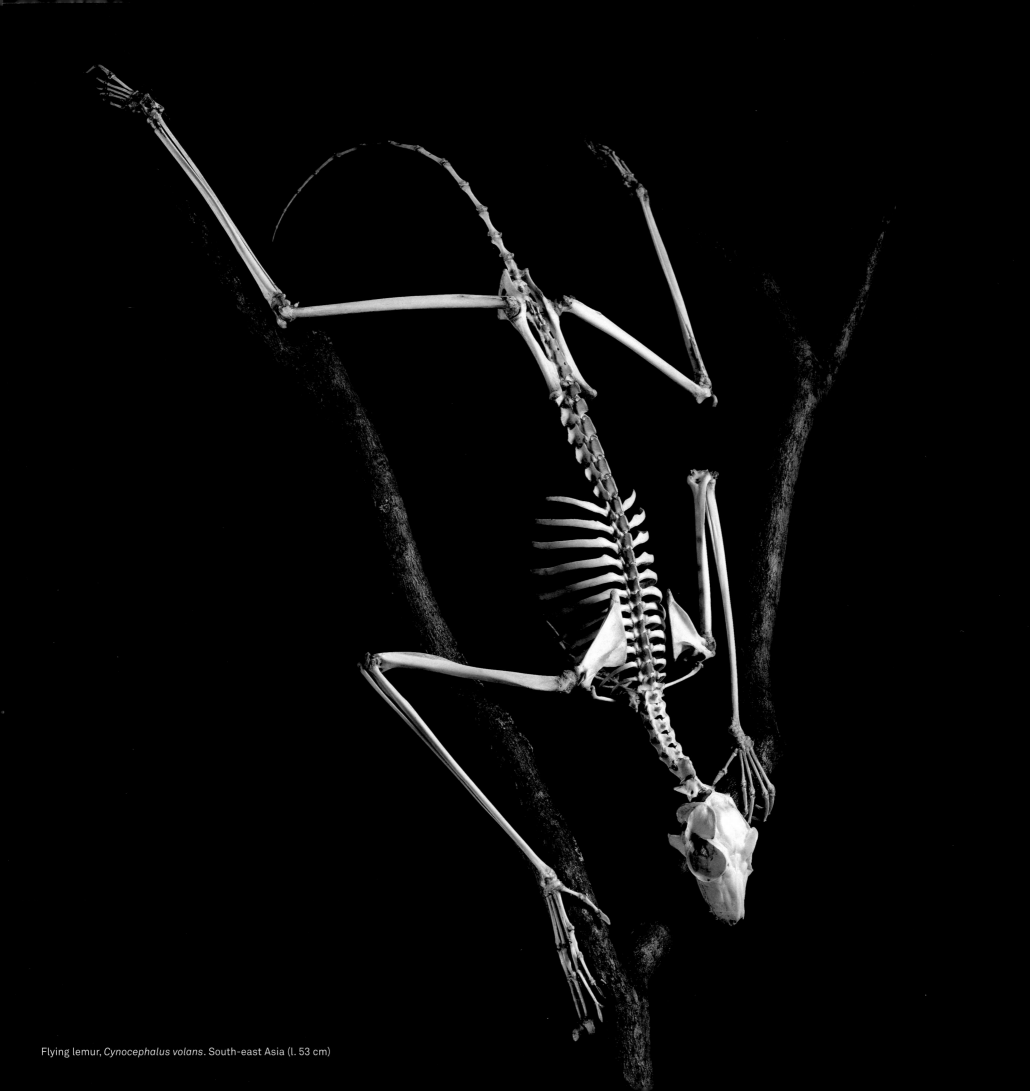

Flying lemur, *Cynocephalus volans*. South-east Asia (l. 53 cm)

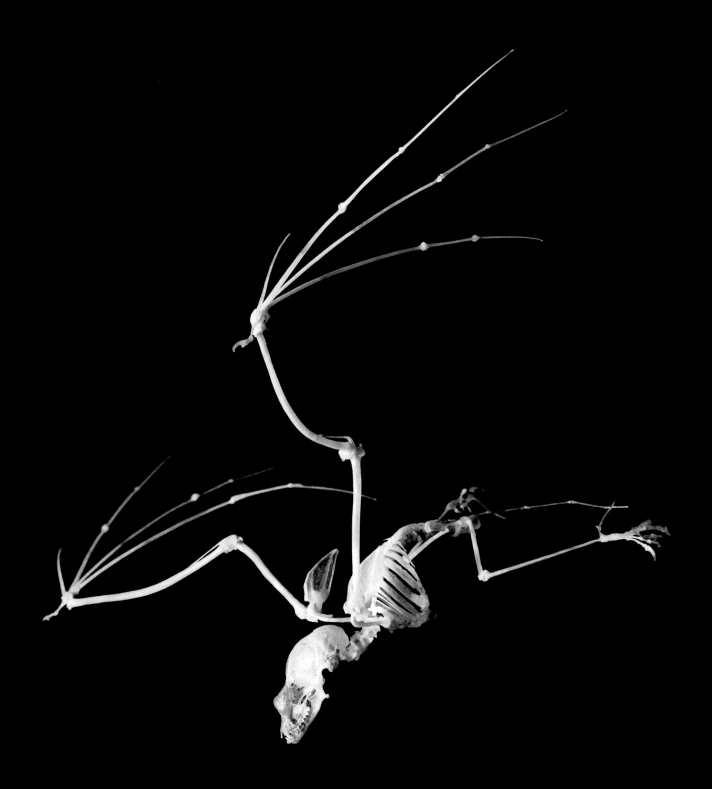

Greater horseshoe bat, *Rhinolophus ferrumequinum*. Eurasia (w. span 36 cm)

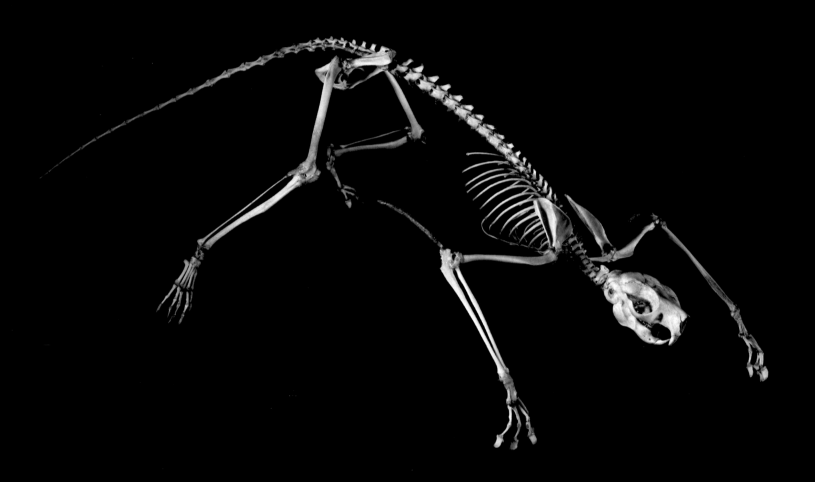

Flying squirrel, *Anomalurops beecrofti*. Sub-Saharan Africa (l. 52 cm)

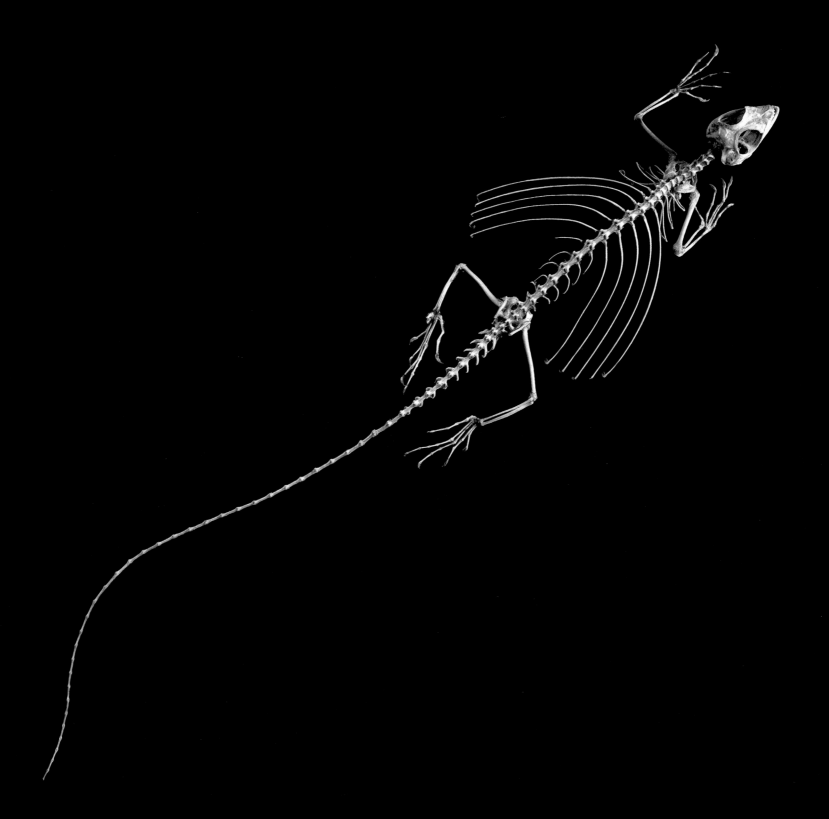

Flying lizard, *Draco volans*, South-east Asia (l. 17 cm)

CHAPTER 34
SEA COWS

The sea calf is a seal of the North Atlantic. The sea cow is one nickname for the manatee. Sailors and fishermen have long given sea animals the names of land species that make them a little more familiar despite their strangeness. Similarly, whales have long been considered giant fish, even though the designation was a subject of lively controversy. Once their true nature as marine mammals was acknowledged, the question of their origin was bitterly debated. The transformation of a land animal into an aquatic animal is certainly hard to imagine. How could some intermediate creature—half ox, half dolphin—manage to live? What are the ancestors of the whales, and how did they manage the transformation? It has taken the joint efforts of zoology, comparative anatomy, paleontology, embryology, and molecular biology for these questions to find answers and for the origin of whales to be finally brought to light.

Some whale fetuses have toothbuds that disappear before birth. The skeleton of adult cetaceans shows some small bones exactly where the rear legs of mammals are generally located. These bones are the vestiges of the pelvis and femurs. They are more massive in the males, slimmer and longer in the females. We assume that they play some role in coupling, as an attachment point for the muscles of the penis, and perhaps in giving birth. Cetacean embryos possess four buds of limbs: the two at the front become fins, but the two rear buds regress rapidly as the embryo develops, and produce only small, incomplete bones. It sometimes happens that these vestiges develop a little more and that rudimentary rear limbs appear in the sperm whale or in dolphins. Ephemeral teeth and vestigial feet are the last traces that whales have retained of their quadruped ancestors.

Even though they are not directly related to the cetaceans, present day animals such as the otter and the seal give us a way to imagine that evolution. Indeed, they illustrate different types of adaptation to the marine environment. The sea otter is a quadruped carnivore. It has thick, impenetrable fur and can submerge for several minutes at a time to seek out shellfish deep in the water. It moves rather awkwardly on land but swims very well, by a vertical undulation of the body and tail. It thus makes use of the spinal suppleness that characterizes its family, the musteides (which includes weasels and martens). Sea lions belong to another family of carnivores, the pinnipeds, whose morphology has undergone a more profound adaptation to the aquatic environment. Their arms have become swim paddles with which they "fly" underwater. Their rear limbs, too, are shaped into webbed fins and are used for turning. On land, a sea lion can bring its feet forward, and it becomes a quadruped. It can jump and even gallop. Its near cousin, the seal, on the other hand, must crawl when it comes onto land, for its hind limbs stay permanently turned to the rear. In the water, it moves by beating its webbed feet horizontally and uses its arms very little.

Cetaceans, such as the whale and the dolphin, are the mammals most profoundly transformed by their adaptation to the marine environment. Their bones are spongy and rich in fat, which increases their buoyancy. The spindle shape of their body and the absence of hind feet make for a considerable reduction in water resistance. The dorsal fin is supported by a tight structure of connective tissue. The animal moves by vertical beating of the caudal fin. Their arms are flattened into swim paddles, and serve mainly to sustain the body's balance. Cetaceans breathe through a blowhole, the nasal opening located on top of the head. This arrangement allows them to keep the head almost entirely submerged; they swim faster even as they expend less energy. The top of the skull, strongly concave, bears the "melon," a sac full of complex fats that focuses sounds emitted by the blowhole. These sounds project onto surrounding objects—fish, rocks—and their echo returns to the animal, channeled through the lower jawbone to the middle ear, whose small bones, the ossicles, have been profoundly transformed. From the otter to the dolphin, we note that the gradual loss of use of the rear limbs is no handicap, but part of the various adaptations to the marine environment. This parallel evolution of very different species shows that the transformation of a quadrupedal animal into a whale is possible, even though it in no way clarifies the true origin of cetaceans.

The recent discovery of cetacean fossils has given us a more precise picture of their ancestors, and of their passage from the terrestrial environment to the oceanic. The most ancient of them, *Pakicetus*, lived fifty-two million years ago. This quadruped, the size of a wolf, ran probably quite well on small hooves shaped like claws. It had a terrestrial way of life and its tail was not flattened into a fin. One bone in the ankle, the astragalus, shows the animal to be a near relative of the artiodactyls (pigs and ruminants), but the bones of the inner ear indicate that it is related to the cetaceans. *Ambulocetus* (etymologically, "walking whale"), a little more recent, had the skull and teeth of a cetacean. On land, it moved about on four feet, but it was also a good swimmer. It has no real equivalent among present day animals. Its manner of life was close to that of the sea lion but it swam more like an otter, by vertical undulations of the pelvis and tail. *Basilosaurus*, around forty-five million years ago, had many adaptations seen in cetaceans, mainly a very elongated body and forefeet transformed into fins. Its hind limbs were reduced in size and probably no longer served for locomotion. One lineage of cetaceans later benefited from an adaptation with no equivalent among other vertebrates: it specialized in a type of foodstuff from the aquatic setting—plankton and schools of tiny fish. Its teeth disappeared and were replaced by long corneous blades, whalebone (baleen) plates that acted as filters for holding in food.

Findings from molecular biology have brought spectacular confirmation of paleontological discoveries, by bringing the cetaceans and the artiodactyls into a single group, the cetartiodactyls. In other words, a cow is more closely related to a dolphin than to a horse; the true "sea cow" is neither a manatee nor a seal but a whale.

Southern sea lion, *Otaria flavescens*.
Coasts of South America (l. 1.90 m)

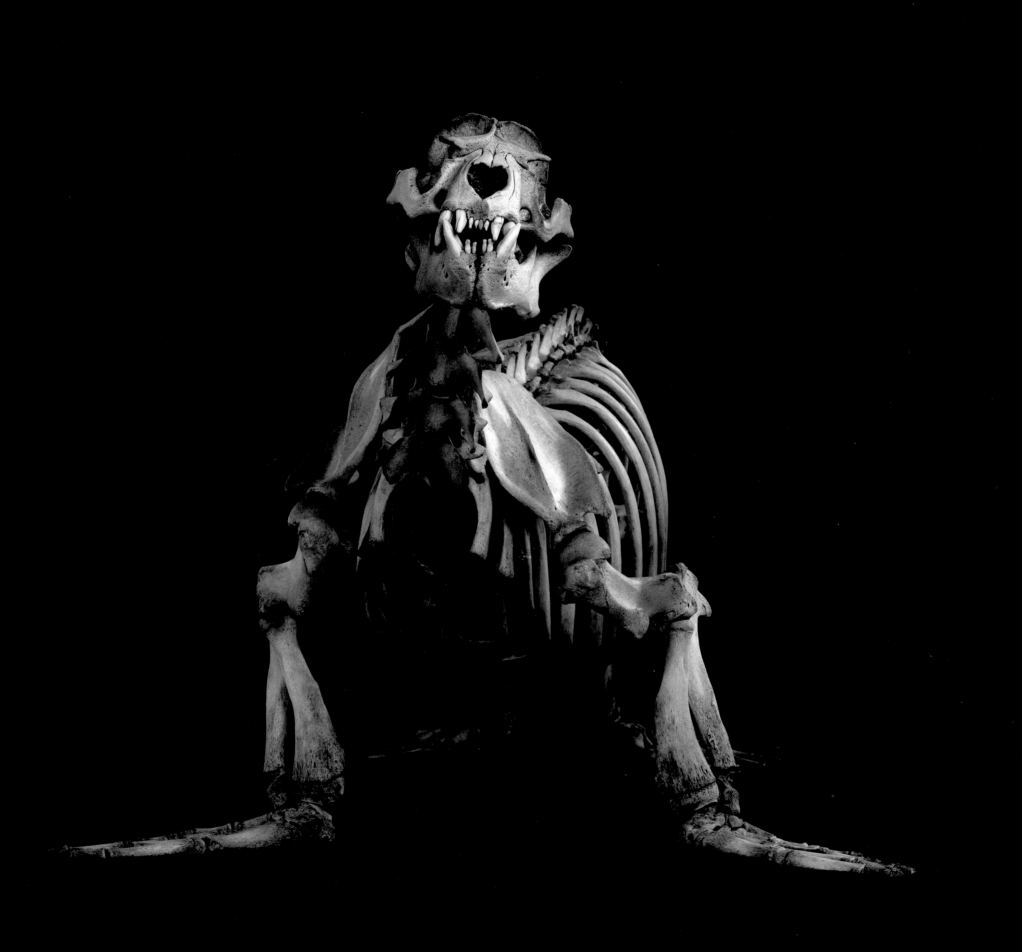

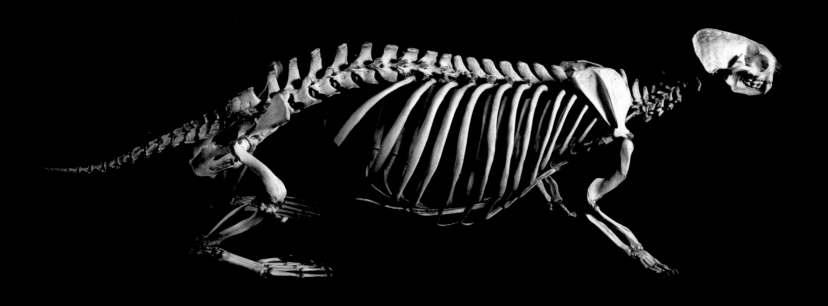

Sea otter, *Enhydra lutris*. Coasts of North Pacific (l. 1.17 m)

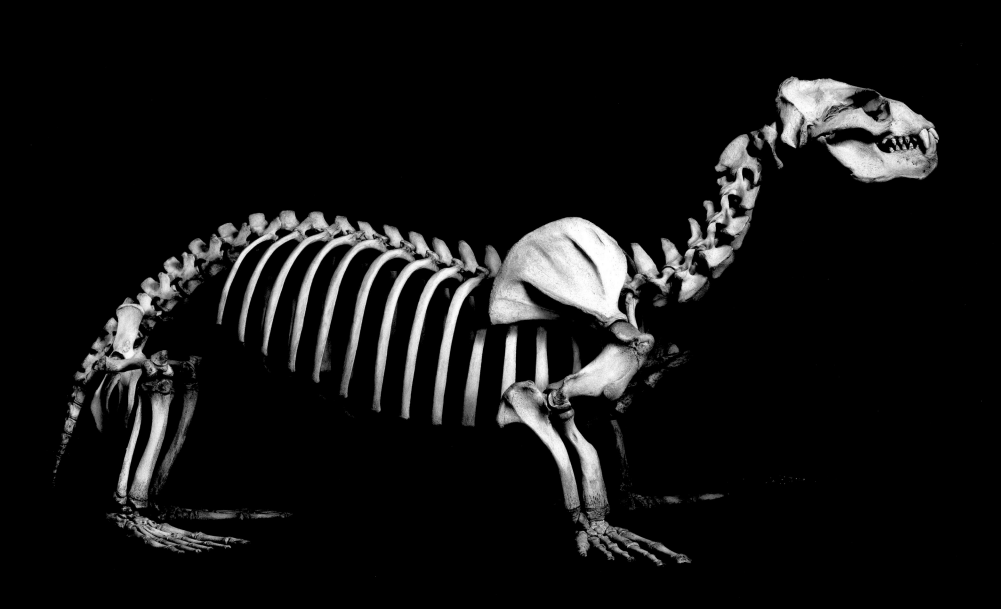

Southern sea lion, *Otaria flavescens*. Coasts of South America (l. 1.90 m)

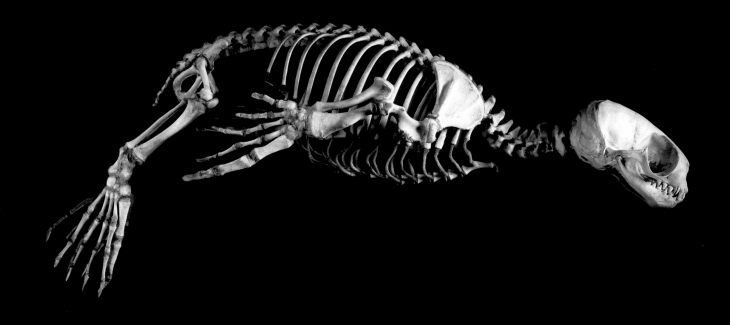

Northern fur seal, *Callorhinus ursinus*. Coasts of Pacific Northwest (l. 55 cm)

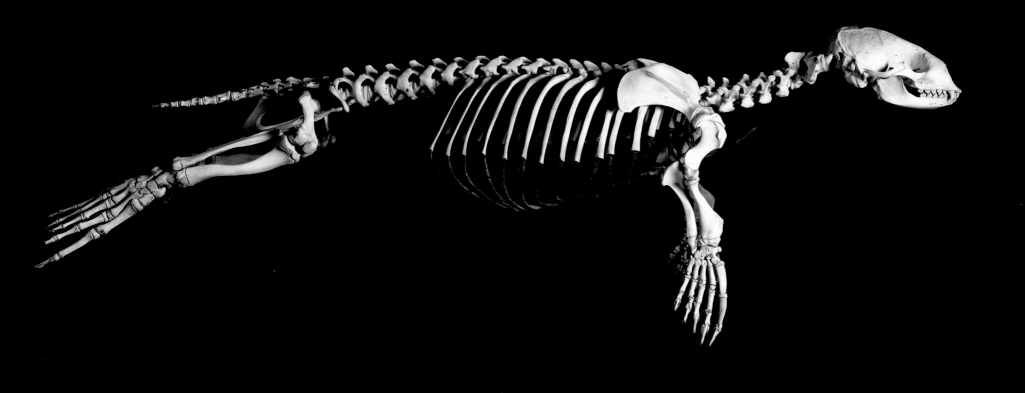

Harbor seal, *Phoca vitulina*. Coasts of the Northern Hemisphere (l. 1.20 m)

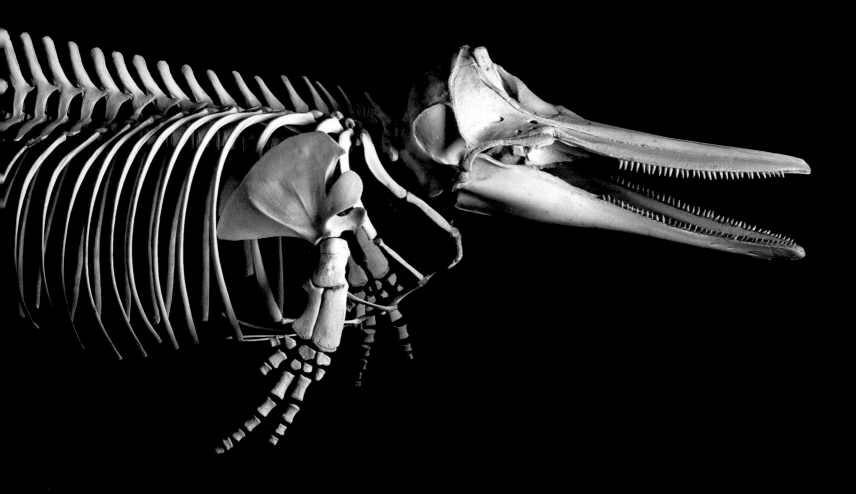

Striped dolphin, *Stenella coeruleoalba*. Global oceans (l. 1.70 m)

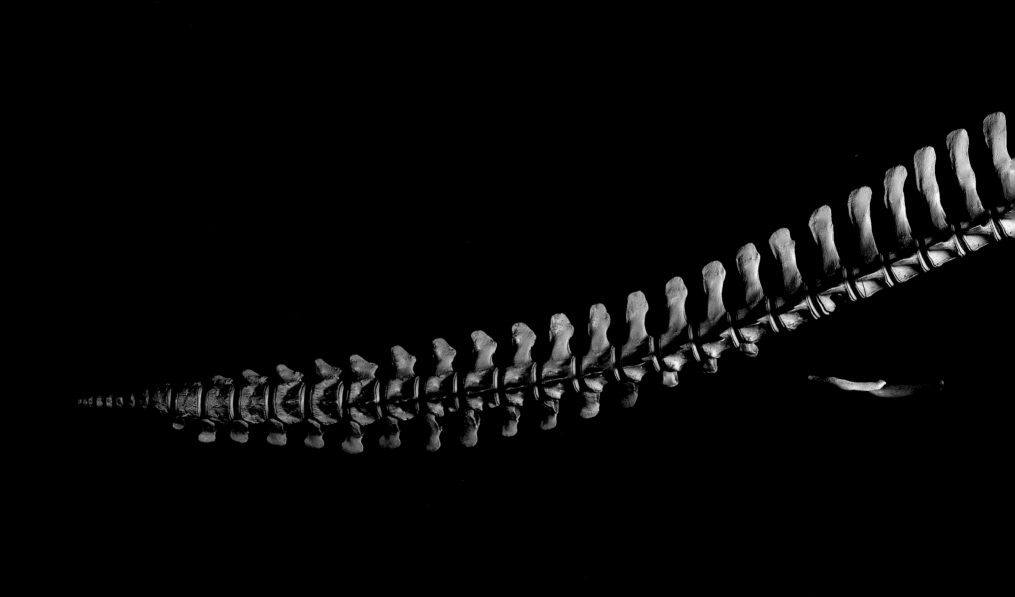

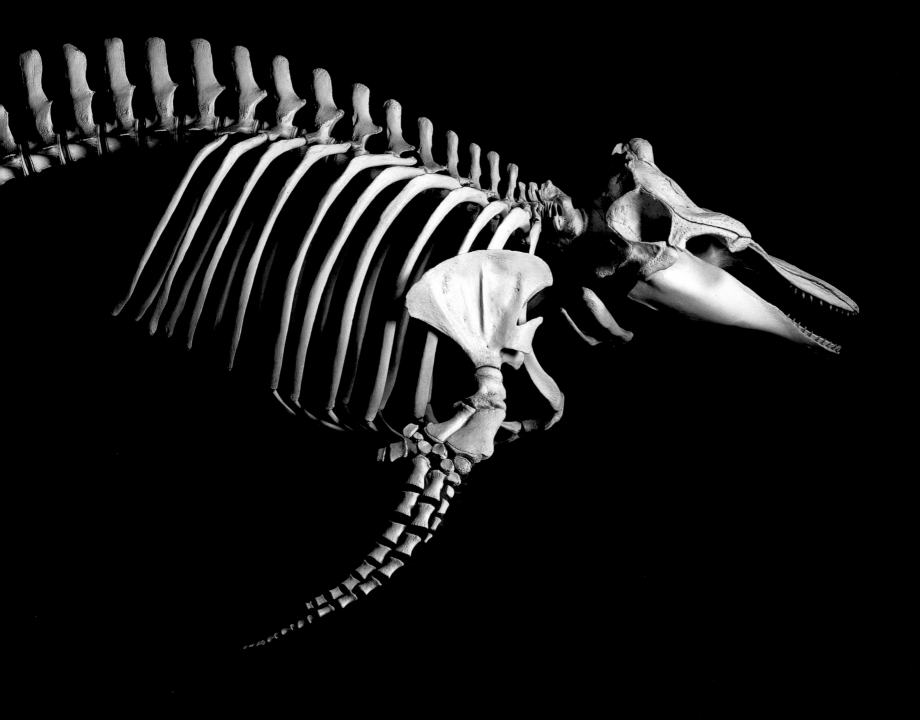

Pilot whale, *Globicephala melaena*. Global oceans (l. 4.45 m)

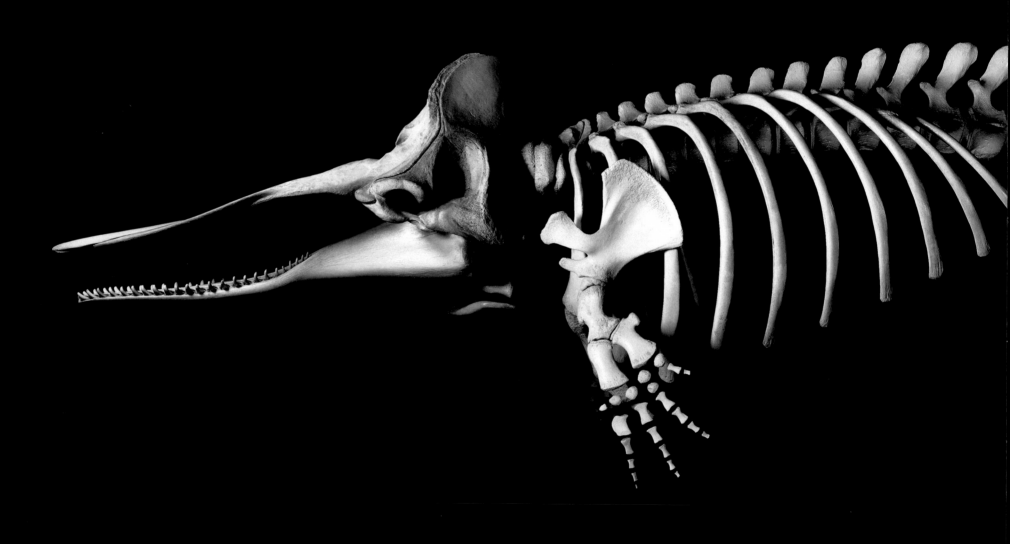

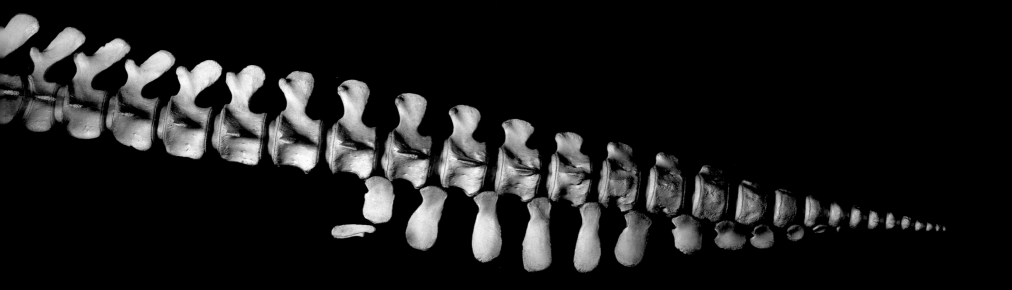

Sperm whale, *Physeter macrocephalus*. Global oceans (l. 9.15 m)

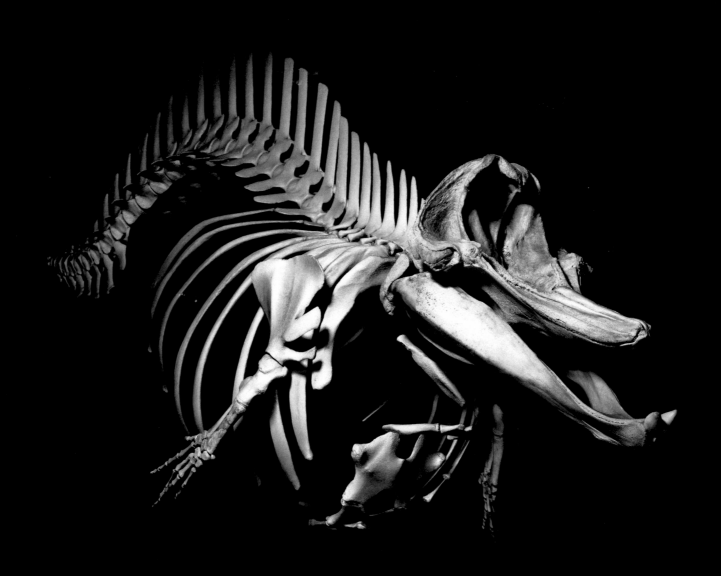

Beaked whale, *Ziphius cavirostris*. Global oceans (l. 5 m)

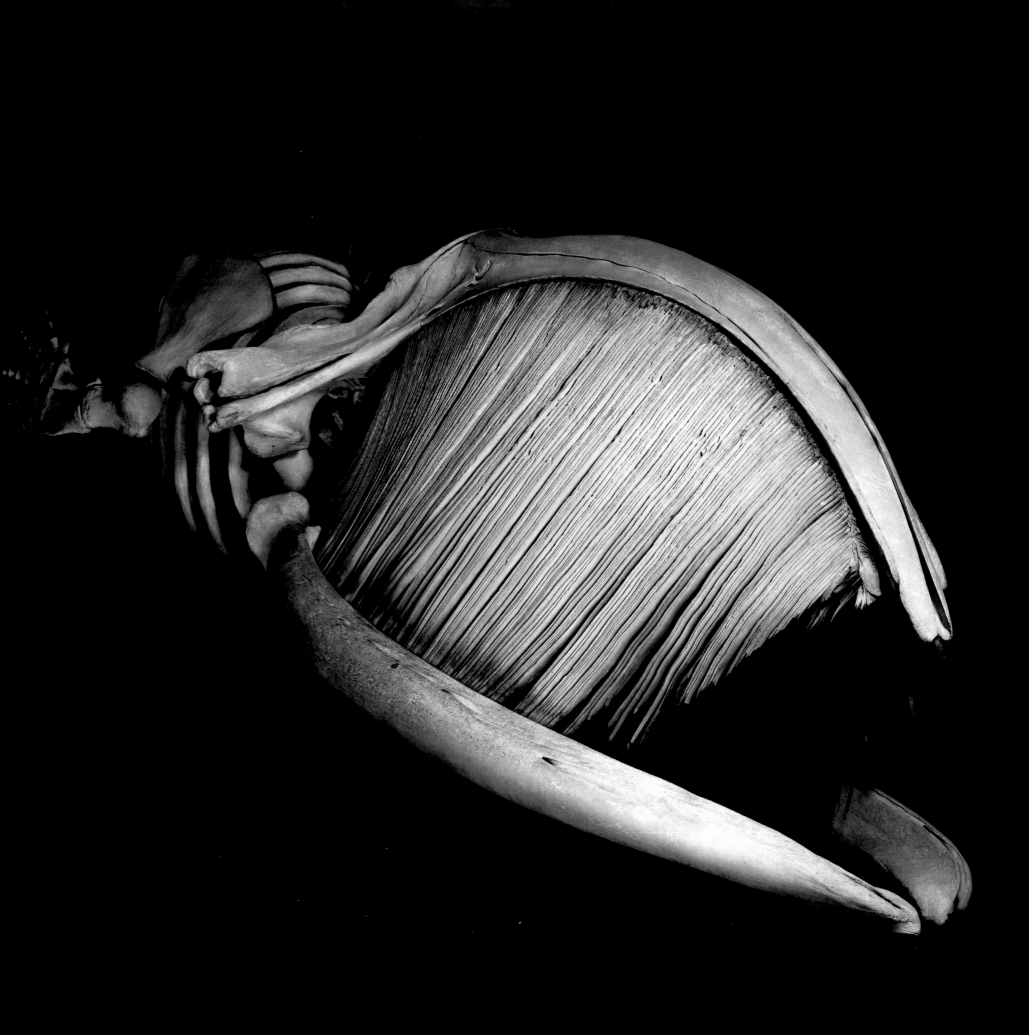

Southern right whale, *Balaena australis*. Antarctic (l. 15 m)

CHAPTER 35
THE TRIUMPH OF THE RUMINANTS

Ruminants do not get good press. A typical character from the anthropomorphic bestiary, it is the perfect counterexample of the sharp young wolf: the bovine gaze as against bloodthirsty energy. The ruminant, though, is one of evolution's greatest successes, a model herbivore without which lions and wolves would not have much to put in their mouths. Their only serious rivals among mammals are rodents, which can claim a success perhaps still more dazzling but which are on average much more unobtrusive and only a few of which could compete, in weight and size, with the smallest ruminants. Today ruminants number more than one hundred ninety species, the most numerous being the bovids (cattle, sheep, antelopes) and the cervids (deer, stag, reindeer, moose). Their size ranges from the forest duiker, barely larger than a rabbit, to the buffalo and the giraffe. They live in every natural environment, on every continent except Australia and Antarctica. Their success has mainly to do with two features, one skeletal and the other visceral: their teeth and their gut—most significantly, the rumen—which enable them to exploit to the hilt an abundant resource, the grass of the prairies.

Most herbivores must chew their fibrous food to facilitate its digestion. For that, ruminants have molars that grow continuously and are strengthened by enamel crowns. Their steady growth makes up for the wear from grinding. This constant abrasion causes the formation of two wear surfaces, from which there emerge ridges composed of an enamel harder than the two other materials in the teeth, the dentine and the cement. This structure is the same as in other ungulates (like horses) and in rodents, but the ridges have different shapes. The ruminants are also distinguished by the absence of upper incisors, which are replaced by a hard corneous pad; they grasp vegetables between the lower incisors and this pad, and the tongue also helps the process. On the other hand, their lips are less mobile than a horse's, which lessens their capacity for facial expression. Their skeleton presents a characteristic feature, the fusion of two small bones in the foot (tarsus), the cuboid and the navicular. This particularity distinguishes the ruminants from other mammals, in today's species as well as in fossils, but it does not seem to be a determining factor in their evolutionary success.

The essential element is their unequaled ability to get the most from their vegetable intake. They possess a complex stomach, with four parts in which the foods undergo a very elaborate start to the digestive process. The rumen functions as a fermentation chamber where a population of bacteria and protozoa predigests the foodstuffs. The food material then moves back from the rumen to the mouth to be masticated again, which furthers the bacterial action. When the vegetal mash is sufficiently liquid, it moves on to the next segments and then into the intestine. There, the animal finishes off the food breakdown and also digests the protozoa and the bacteria from the rumen, all of which in a cow amounts to some five hundred grams a day. The journey of the foodstuffs through the digestive tract takes about eighty hours. Since their digestion is more thorough than it is in other herbivores, bovids can eat less, but they must be more selective and choose the tenderest vegetable matter.

In the perissodactyls—the group that today includes the horse, the tapir, and the rhinoceros—fermentation also takes place, but it comes later in the course of digestion, which is at once faster and less efficient. These animals can quickly consume great quantities of a food that is of lesser quality; the quantity ingested makes up for the lesser yield from their digestive process. When they come into contact, ruminants and equines complement each other rather than compete: antelopes tend to consume young shoots, while zebras can be content with older, tougher grasses. Also, the ruminant's bacteria can recycle the urea produced by the breakdown of proteins, which lowers their need for nitrates in food. The perissodactyls, on the other hand, must eliminate the urea they produce, which obliges them to drink more often. In the desert, a donkey must drink daily, in contrast to the oryx or the camel.

A climate change left a decisive mark on the respective evolutions of these two groups. In the Eocene, between fifty-five and thirty-four million years ago, the main ungulates were the perissodactyls. Far more diverse than today, those animals had the same ecological prominence as ruminants do now. Later on, the perissodactyls declined while the ruminants became gradually more numerous. Sixteen million years ago, the ruminants experienced a rapid diversification, which initiated the group's present richness. This replacement of the perissodactyls by the ruminants coincided with a major change in vegetation worldwide. At the end of the Eocene, the terrestrial climate became colder and drier everywhere. Some of the forestland was replaced by prairie, a change that forced important anatomical and behavioral adaptations. Grass is actually a hard food, because it contains minute grains of silicon. Consuming it requires teeth that grow continually, to make up for the wear. Grass is also an abundant food, but it does not grow throughout the year, so large herbivores are forced to migrate regularly. That upheaval in the flora caused a regression of grazing woodland species, such as tapirs and most rhinos. The equids would have been better able to resist; about twenty million years ago, the archaic horses who ate leaves had in fact given rise to larger species, with teeth in constant growth, which were capable of eating grass. Despite this adaptation, the equids surrendered the terrain to the ruminants, which ended up dominating most environments. We do not know exactly whether the eclipse of the equids is due to direct competition from the ruminants, or whether ruminants simply benefited from the decline of the earlier ungulates.

Today the triumph of the ruminants is complete, all the more so because some species multiplied under the hand of livestock breeders. Having appeared late in this history, humans have abandoned the strictly vegetarian diet of their ancestors and made use of the ruminants' ability to carry out a complex operation that humans could not have done for themselves: converting grass into a rich, tasty steak.

—
Barbary sheep, *Ammotragus lervia*.
North Africa (s.h. 94 cm)

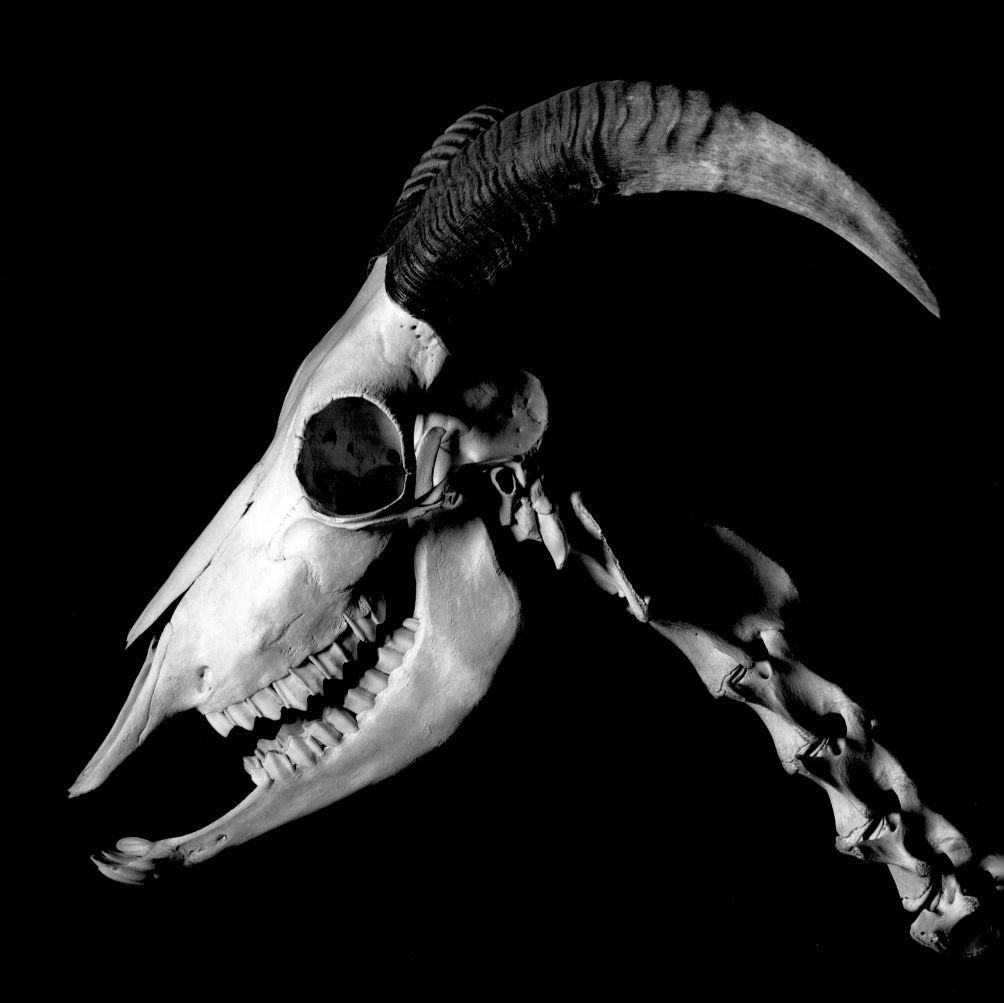

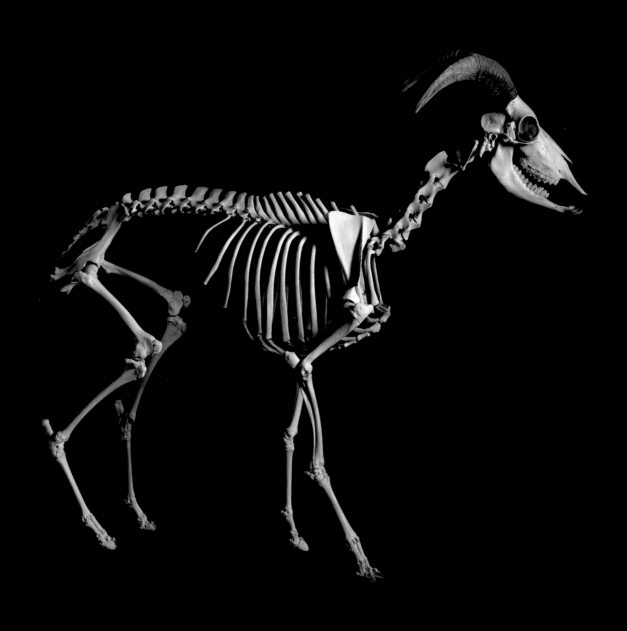

Barbary sheep, *Ammotragus lervia*. Northern Africa (s.h. 94 cm)

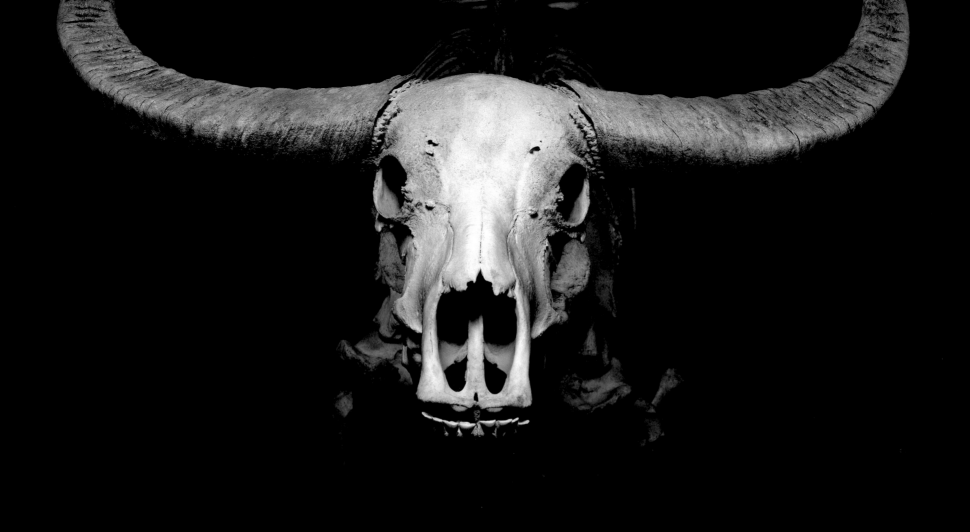

Water buffalo, *Bubalus bubalis*. Domesticated. India, Nepal, Thailand (s.h. 1.30 m)

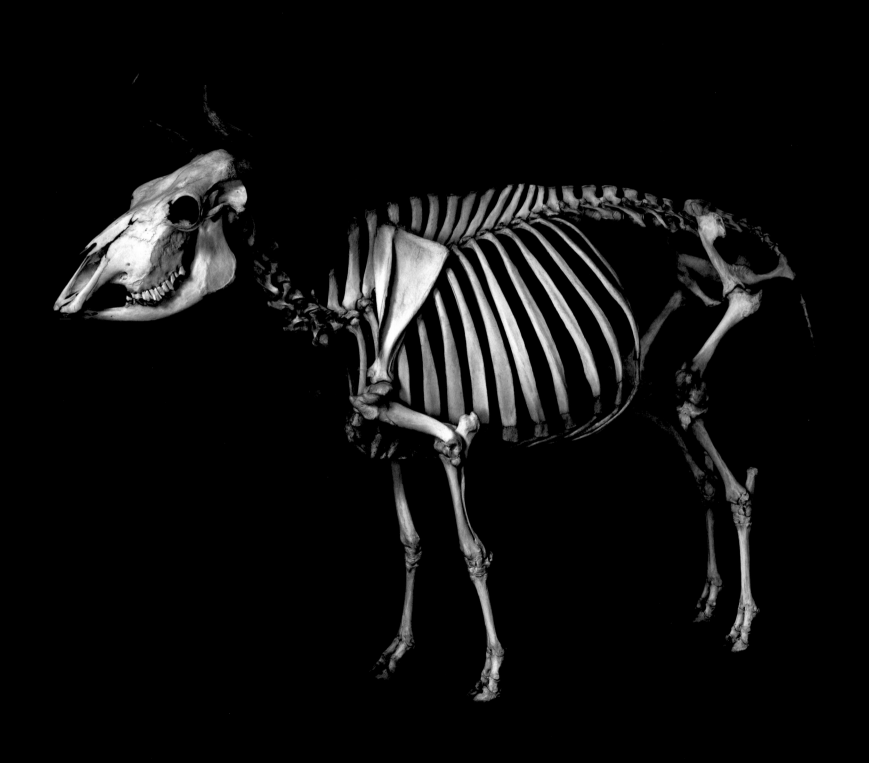

Cow, *Bos taurus*. Domesticated. Originally from Eurasia (s.h. 1 m)

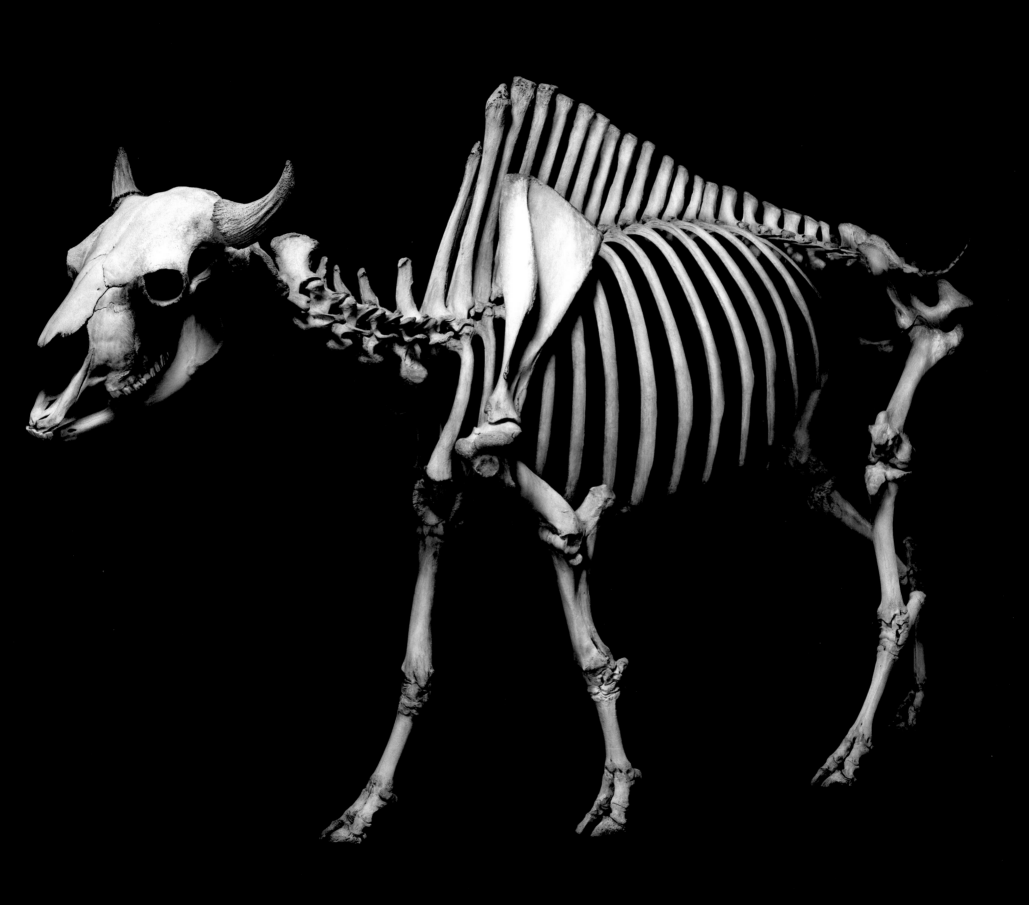

American bison. *Bison bison*. North America (s.h. 1.50 m)

CHAPTER 36
LOST LEGS

"You shall be accursed among the cattle and all the wild beasts: on your belly you shall go, and you shall eat dust all the days of your life." The biblical curse underlines the ancestral aversion that serpents rouse in us and that we share with many monkeys. Sliding silently along the ground, these reptiles are seen as furtive, unpredictable creatures, wily and dangerous. In fact, we don't even know which are the most terrifying—vipers with their poisonous fangs, or boa constrictors who can swallow a sheep whole, or gigantic half-imaginary sea serpents. But snakes inspire more than just fear. The complete absence of limbs is for us a prospect so horrifying that we labor to understand what advantage an animal might possibly draw from it. Biologists do not share that general feeling, however, and have demonstrated that the snakes' lack of limbs is not a shameful degeneracy but an adaptation useful to a particular way of life.

Snakes are not the only reptiles without feet. Several families of lizards include apodal (footless) species that differ from serpents in skull structure or the presence of eyelids. The scincids are reptiles that look like lizards or varans. Numbering more than twelve hundred species, this highly diversified family includes species with four long feet (such as the giant skink), species with tiny feet (such as the three-toed skink), and species totally without feet. The tail is especially long and attenuated. The slow-worm, another footless lizard, is an anguid related to the varan. Just as there are serpentiform lizards, there are also serpents with feet. The python, for instance, has two pointed spurs on the body surface. These spurs are claws attached to bones located beneath the spine and are vestiges of a pelvis and femurs. Other snakes, the typhloids, also bear vestiges of rear feet. They have a cylindrical body, not slim like other snakes, with a rounded head and very small eyes. They live a burrowing life, feeding on small prey such as ants or termites. From their archaic features, in particular their vestigial feet, we may suppose that they resemble the ancestors of snakes, which we therefore picture as burrowing reptiles with small feet. The picture is reinforced by the underground way of life of many current species of lizards with very small feet or none at all.

According to another hypothesis, snakes descend from reptiles adapted to the sea, for instance the *Mosasaurus*, the great marine carnivore of the Secondary (Mesozoic) era that is close to varans and whose limbs became swimming paddles. The oldest fossil snakes we know had small vestigial feet and lived in a sea environment. But today's sea snakes are not especially related to varans. Moreover, the hypothesis of a terrestrial origin is supported by genetic analyses of present day species and some fossils of snakes with large feet. Nor do we know, besides, any example of a marine reptile that returned to land. present day sea snakes, therefore, would be merely reptiles with a secondary adaptation to the sea, as was the case for many species of tortoise, iguana, and varan. If snakes actually are terrestrial in origin, it remains to explain how they lost their feet. In lizards, their smaller size is often associated with an increase in the number of vertebrae. The long body and the reduction of the limbs, which favor undulating movements, would permit the animals to slip into the fissures of rocks or burrow into the ground more easily. Humus and shifting earth contain abundant and varied animal life: insects, rodents, moles, and so on. Snakes, which are predatory reptiles, can pursue all these potential prey into their underground tunnels, where they would be inaccessible if the snake had large feet that would hinder its advance.

On the ground, the snake's crawl is generally accomplished by a horizontal undulation. This movement is the same as a lizard's, in which the undulations are synchronized with the movements of the feet. The lizard's locomotion is therefore compatible with subsequent animal forms that lack feet. This certainly partially explains the loss of limbs occurring so often in this group, and in an independent fashion. When the feet are very small, their motions are disconnected from those of the spinal column. As it moves about, a lizard with tiny feet flattens them against its body and slides along, pushing off from irregularities of the ground, exactly like an apodal lizard or a snake. Similarly, it does not use its feet at all to dig into the sand. Its diminished limbs are used for other functions, such as reproduction or mating display—which is indicated by the fact that in some species, the vestigial limbs are more developed in the males than in the females. And those vestigial femurs on the snake are sometimes connected to the male's two penises, helping to insert them into the female's cloaca.

There exist today twenty five hundred species of snake, which live in all environments on all the continents except for Antarctica. Their form is thus a true evolutionary success. Other animals have had a similar evolution, at least as concerns the limbs. The cetaceans lost their hind legs, and exhibit the same tendency as snakes to an increase in the number of vertebrae. We have seen whale fossils almost serpentine in form; the whale probably moved about by undulating its entire body on a vertical plane. Biologists are looking to discover if there are genetic factors common to the vanishing of feet in snakes and in whales.

Even if it was a burrowing way of life that promoted their arrival, snakes later evolved in other directions, since there exist species that are arboreal or aquatic. Today's sea snakes are rather small, but in the past very large species have been described, like the sea serpents of Nordic myths and the Loch Ness monster. In engravings, they are almost always shown in great vertical undulations, their looped bodies thrusting partially out from the water. If these monsters did exist, then, they would be related to whales and not to snakes.

—
Gopher snake, *Pituophis catenifer*.
North America (l. 1.50 m)

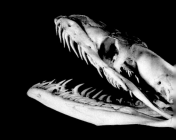
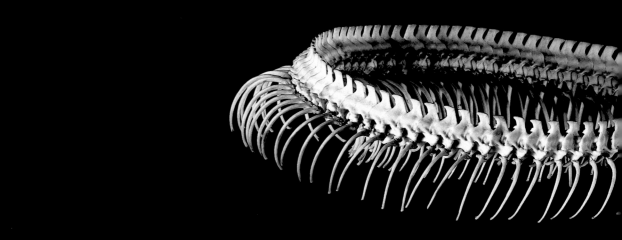
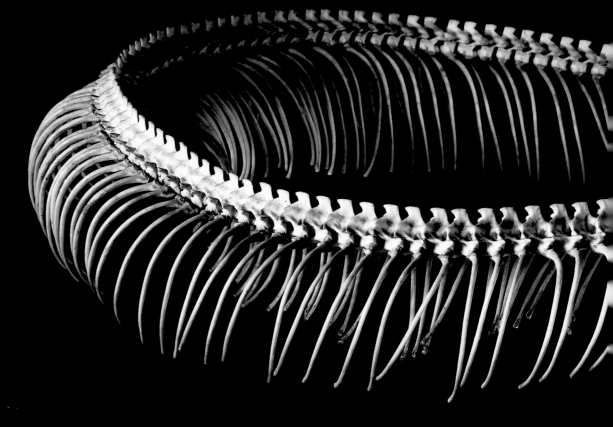

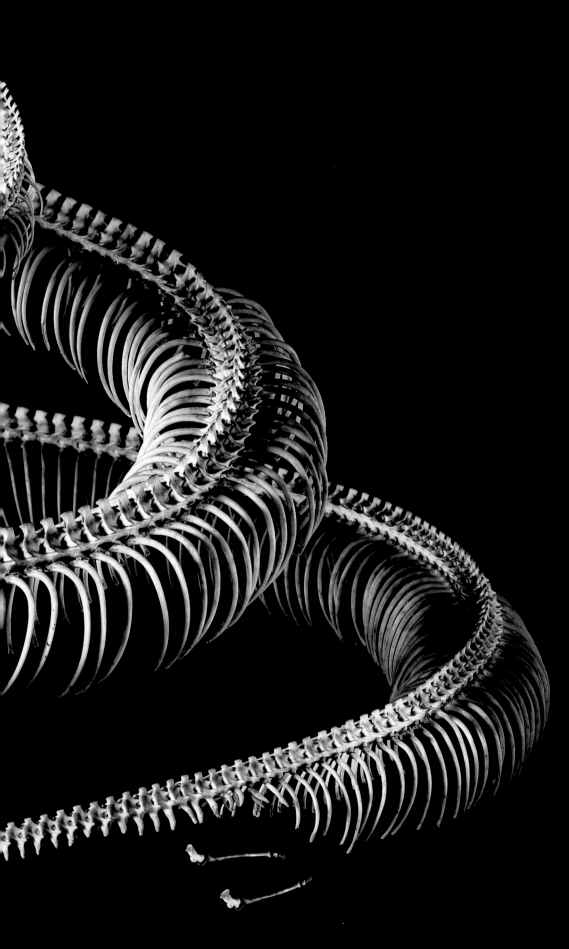

Python, *Python sp.* Tropical Africa, Asia, and Australia (l. 2.30 m)

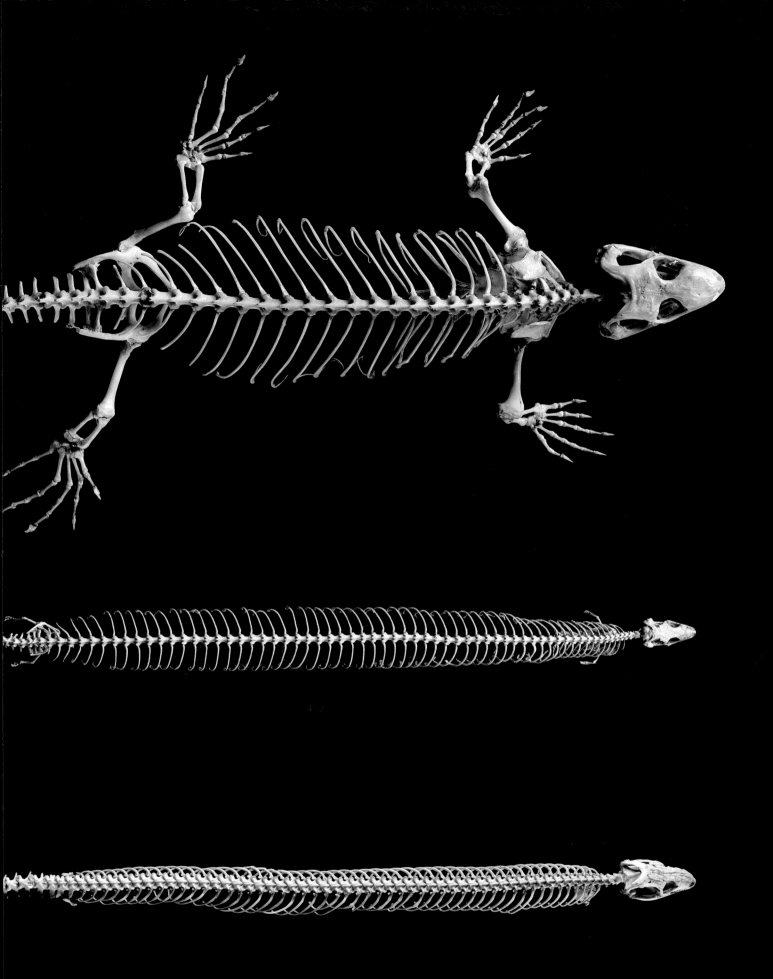

Giant skink, *Macroscincus coctei*. Cape Verde Islands (l. 55 cm)
Three-toed skink, *Chalcides chalcides*. Southwestern Europe, North Africa (l. 55 cm)
Blind snake, *Typhlops reticulatus*. South America (l. 92 cm)

CHAPTER 37
EATING ANTS

There are tetrapods with no feet, carnivores that are herbivorous, and some of the "toothless" Edentata have teeth. The names of the zoological categories sometimes seem contradictory, but their strangeness is often the result of the history of zoology. The heritage of three centuries of debate, they also reflect the history of the animals themselves over the course of evolution. Snakes are actually tetrapods because their ancestors had four feet [see page 226]. Similarly, the giant panda is a carnivore related to bears, even though it only eats bamboo [see page 184]. As to the Edentata group, it was created by Cuvier in 1798 to bring together animals in which teeth were absent or minimal and whose nails were especially tough, such as the anteater, the armadillo, the pangolin (scaly anteater), and the aardvark. Most Edentata have neither incisors nor canines, even though some do possess molars reduced to small cylinders without enamel. Their skeletons look alike, but the living animals do not. The anteaters are covered in fur and the pangolins in corneous scales; the armadillos have an articulated carapace; the aardvark's skin is nearly naked, which has earned it the nickname "earth pig."

Zoology is not a fixed science. The Edentata order has disappeared, for the grouping was artificial. Indeed, those species' similarities come not from a possible genetic relationship but from a similar way of life. Most of these animals are eaters of ants or termites, a diet that offers enormous advantages: these insects are a nearly inexhaustible resource for nourishment of excellent quality, rich in proteins. There are an estimated million billion ants on the earth—representing a biomass amounting to a million tons. The creatures are very small, but they live in dense groups. A single ant colony can number twenty million individuals. Termites, which are largely confined to warm regions, also form huge colonies.

Among the eaters of ants, the best known is doubtless the giant anteater, or tamanoir. It has powerful front feet that help it dig into the ground to reach the ants' nests. Its elongated muzzle conceals a long, sticky tongue with which it can capture hundreds of ants at a time. Its eyes are very small, which lessens the risk of stings. Other, less useful, organs are minimized. For instance, the anteater has no need to kill its prey before swallowing it, or even to chew them; its dentition is reduced to a few

small molars. Similarly, its skull has no zygomatic arches, the curved bones that usually support the jaw muscles.

The South African aardvark, which feeds essentially on termites, also used to be listed with the Edentata group. Zoologists separated it from the anteaters and now consider it a cousin of elephants and manatees. It constitutes by itself the order of Tubulidentata ("with tube-shaped teeth"). Pangolins have also been lifted out of the Edentata, by reason of their particular traits: their scales, and a stomach specially adapted for the digestion of insects. The seven species of pangolin today form another order, the Pholidota ("covered in scales"), whose closest living relatives are the carnivores.

Finally, the only animals left in the Edentata group in the strict sense are the four species of anteaters, the twenty species of armadillos, and the five species of sloth (the only ones who do not eat insects). Although these animals do not look alike, zoologists have gathered them into one group with a new name, in order to avoid confusion with the old category of Edentata. They are called Xenarthra ("with strange joints") because some of their vertebrae have additional joints that distinguish these species from other mammals. The pelvis is bonded to several vertebrae, the whole together making for a characteristic rigid structure. The xenarthra also have a variable number of cervical vertebrae, which is very unusual in mammals, which almost all have seven. These characteristics justify putting these species in one group. This is not the case for the non-American anteaters—whose vertebrae, notably, are different from those of the xenarthra—and which do not themselves make up a "natural" group: that is, all descending from one common ancestor and including all the descendants of that forebear.

Xenarthra evolved in South America nearly sixty million years ago, at a time when that continent was an island. In the past they were far more diverse, with some huge forms, like the Megatherium, or "giant sloth," and the Glyptodon, a great armadillo three meters long whose rigid armor weighed one ton. When North America was joined to South America, two and a half million years ago, these giant forms disappeared. Before that event, the ecological niche of American anteaters was occupied in the rest of the world by other species: the marsupial anteater in Australia, the pangolins in Africa and Asia,

and the aardvark in South Africa. Each continent thus harbors its own eaters of termites and ants. Externally, these species have little resemblance and have been classed in different families. They are distinguished by their size—which ranges from a rabbit's to a pig's—appearance, behavior, and even mode of reproduction. Their skeletons reveal a number of commonalities, however: any animal specialized to eat ants must be capable of reaching the insects' nests, which are often deep underground; it must also be able to capture a large number of prey very quickly, so as not to expend more energy hunting them than they will ultimately provide once they are digested.

These different insect-eaters appeared independently of one another through the course of evolution. Their ancestors bore no particular resemblance to one another, but they evolved in the same direction, to the point of developing similar forms now. Zoologists call this mechanism "convergence" [see also page 242]. These similarities between species come not from a common ancestry but from an extensive adaptation to a highly specialized way of life based on making use of a nutritional resource that is abundant and difficult to get at. With its classification adjusting to the progress of zoology itself, the old order Edentata has been replaced by three separate orders: Xenarthra, Pholidota, and Tubulidentata.

—
Giant anteater, *Myrmecophaga tridactyla*.
South America (l. 1.67 m)

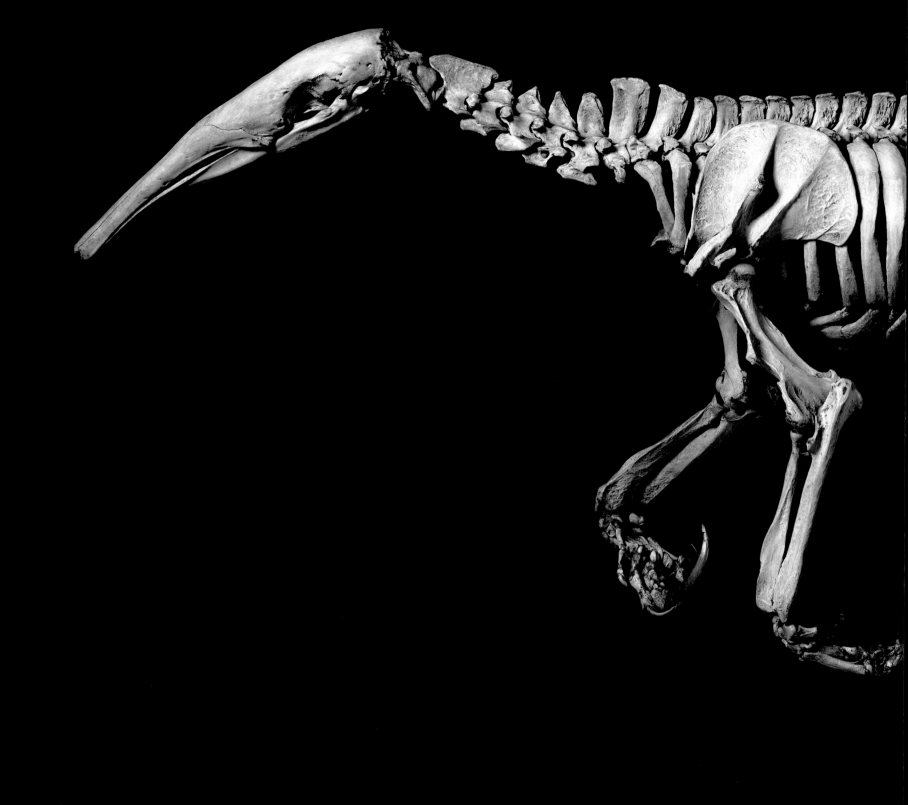

Giant anteater, *Myrmecophaga tridactyla*. South America (l. 1.67 m)

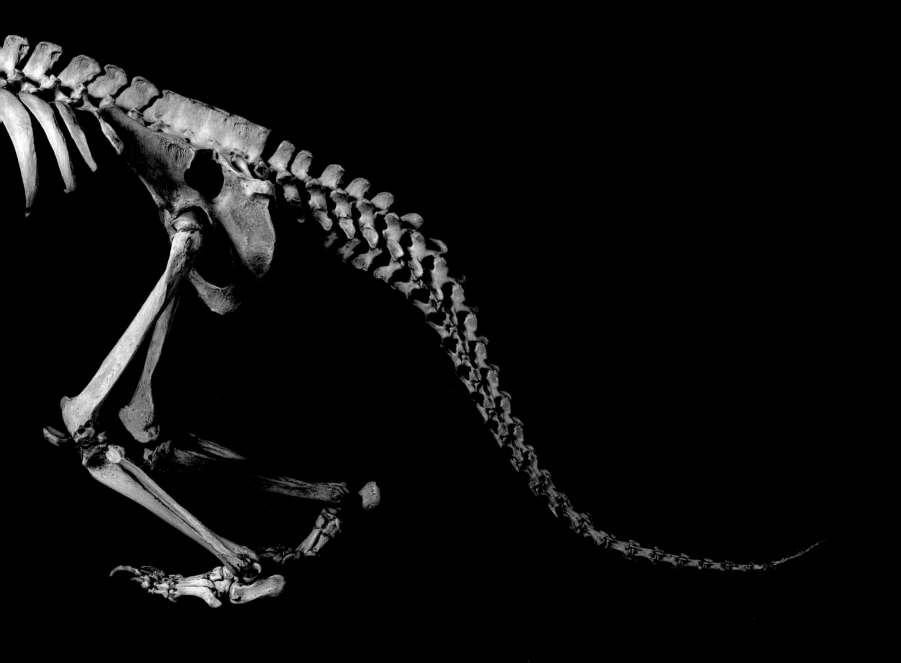

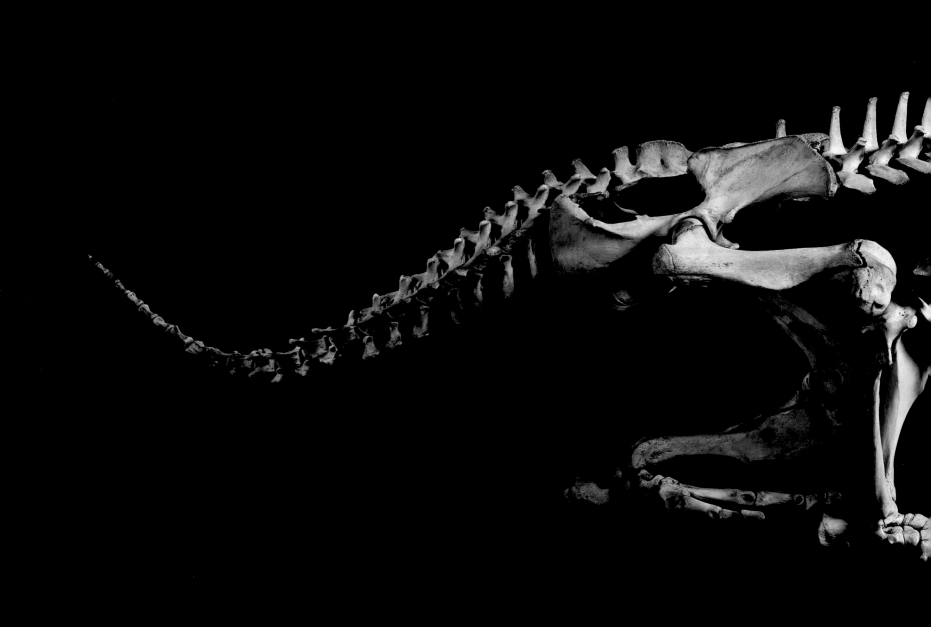

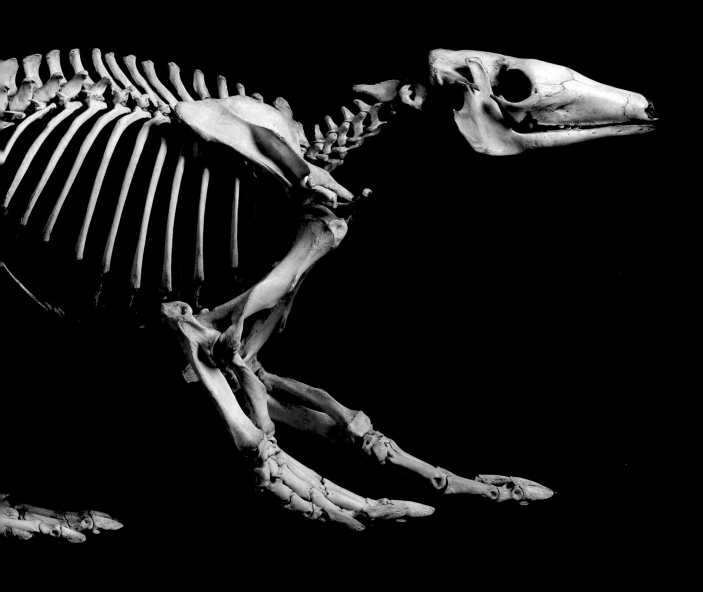

Aardvark, *Orycteropus afer*. Sub-Saharan Africa (l. 1.36 m)

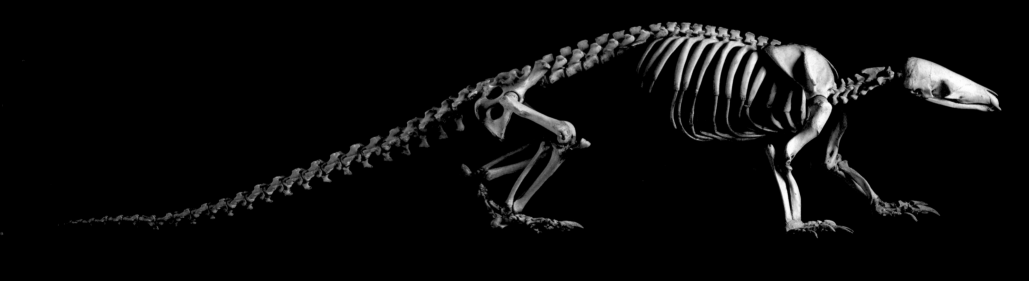

Malayan pangolin, *Manis javanica*. South-east Asia (l. 72 cm)

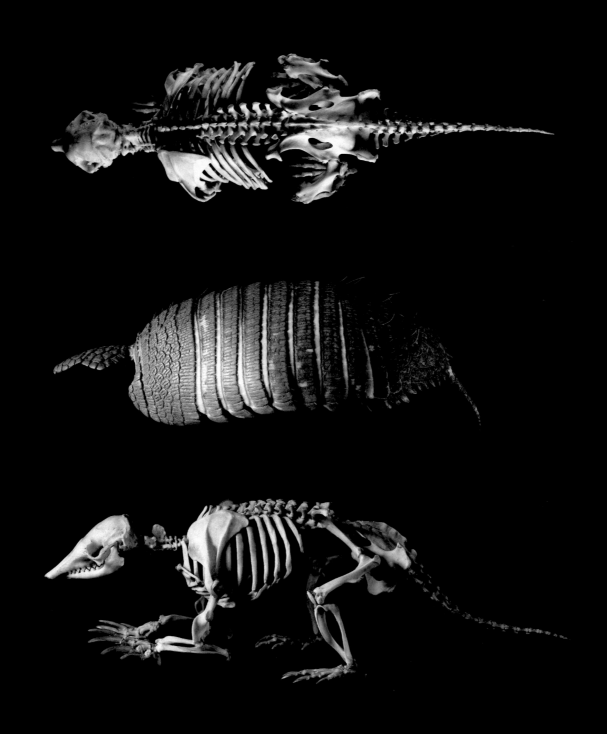

Seven-banded armadillo, *Dasypus septemcinctus*. South America (l. 33 cm)

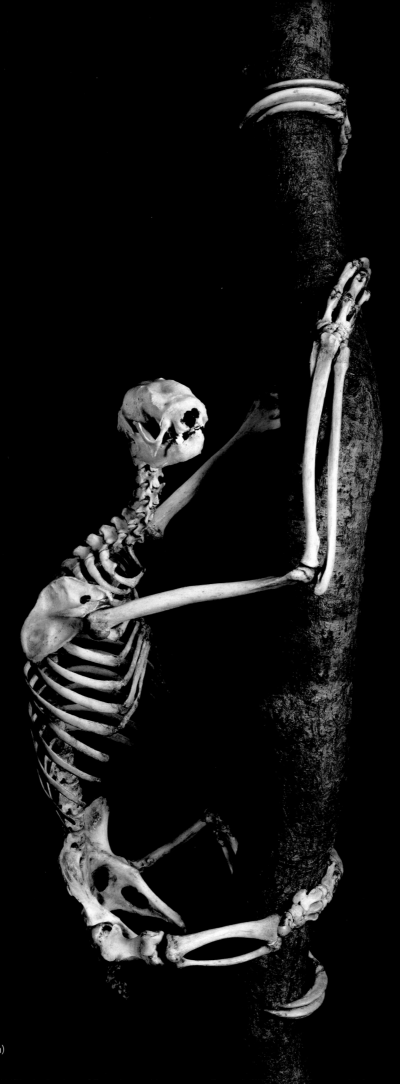

Maned sloth, *Bradypus torquatus*. Brazil (l. 60 cm)

CHAPTER 38
MIRROR CONTINENTS

Charles Darwin had extensive knowledge of English flora and fauna when he embarked, at the age of twenty-two, on a journey around the world aboard the *Beagle*. This five-year voyage was for him a constant source of wonderment and questioning. At the far side of the world from England, the least insect, the most ordinary flower, seemed astounding to him, as much for obvious differences as for unexpected similarities to species that were familiar to him. It is difficult, today as it was yesterday, not to wonder about the history of life when we see that Australia has its own moles that are different from all the other moles in the world, or that birds like African ostriches are running about in South America.

Australia is a particularly striking example of these "mirror breeds," both similar and profoundly different in regard to the fauna of other continents. For instance, the quoll is a small carnivorous mammal that is found only in Australia. Also called the marsupial cat, it more closely resembles the marten, with the same way of life. It climbs into trees and hunts small mammals, birds, and insects. The cranium and the skeleton of the two species are much alike. Similarly, the marsupial mole is much like the European mole, in size and shape as well as in its way of life. It digs tunnels and feeds on the small animals it finds underground. Like the European mole, it is practically blind. The skeletons of the two moles, Australian and European, display the same adaptations to digging, with short, thick arm bones and tough claws on the hands.

But beyond the obvious resemblances, comparison of these species living on distant continents shows an essential difference: the modes of reproduction. In mammals called "placental," the embryo is nourished through the intermediary of a placenta. In marsupial mammals, such as the kangaroo, the newborn is very little developed. Naked and blind, it grips its mother's pelt, crawls to a teat, and attaches to it, inside the marsupial pouch. Nicely protected, it continues its development there. The skeletons give no direct indication as to reproduction, but certain features differentiate the two groups. For instance, the marsupials have two small "epipubic" or "marsupial" bones that reinforce the abdominal wall. These bones are absent in placental mammals. Also, the back of the marsupial's mandible has a characteristic angular prolongation. The marsupials have been a separate group from other mammals for more than one hundred million years. Their common ancestor is not the same as that of the placentals (these two groups do themselves share an ancestor, of course, but further back in time). The marsupial mole is more closely related to the marsupial cat and the kangaroo than to the European mole or any other placental mammal.

If the marsupials have been separated from the placentals for such a long time, why are the resemblances so strong among some of them? The answer comes not from evolution but from geology and ecology. Australia separated from the other continents about forty million years ago, when it had no placental mammals. The Australian marsupials therefore never suffered any competition from the placentals, in contrast to the experience of their cousins in America or Europe, who were almost all eliminated. They were able to diversify as they adapted to the various resources of their environment, and today they occupy the same ecological niches as their placental "homologues" do elsewhere. The sea otter, the anteater, and the mouse all have marsupial equivalents in Australia. The ecological constraints are so powerful that the animals have undergone an evolution parallel to that of other mammals. Their resemblances are tied not to their genes but to pressures from their environment.

This convergence can be ecological without being morphological, as the kangaroos show. Australia, in fact, has no herbivorous quadruped of the gazelle or deer type. In their place are the various species of kangaroos that live on grasses and leaves. The skeletons of a gray kangaroo or a vicuna, which is an ungulate relative of the llama, have very different general shapes, but their crania show similar adaptations. Both herbivores have long narrow jaws, whose incisors help to grip and tug clumps of grass. The toothless space between incisors and molars, the "diastem," facilitates the action of the tongue in positioning the food during mastication. Evolution has exercised strong pressure in the realm of alimentation, and has brought about an important convergence in the form of the jaws. On the other hand, the rest of the body is very different in the two. The kangaroo moves by leaps and bounds, thanks to its powerful rear legs and its long tail, which serves as a balancing pole. Its arms, in contrast, are quite rudimentary. The vicuna is a running animal that gallops on all four feet. In different ways, both animals are capable of reaching high speeds and escaping their predators. It might have been predicted that evolution in the marsupials would produce grazing herbivores that could make good use of the natural prairies, but nothing would have led one to guess that they would move about by bounding rather than by galloping.

The story was similar in South America, which remained isolated for a long time but was often colonized by mammals arriving from North America or Africa on rafts of branches carried by ocean currents. That is how small monkeys, probably from Africa, invaded the forests of South America some thirty to thirty-five million years ago. They then evolved differently on either side of the ocean. The two lineages vary in the shape of their noses or the number of teeth, but they both gave rise to species that adapted to moving about in the trees: the gibbon in Asia, the spider monkey in South America. The latter have long prehensile tails, while the gibbons have no tail at all.

The emu is a large running bird native to Australia. The Old World harbors another species, the ostrich, which once lived in Asia and Africa. South America counts two "ostrich" species, the nandus, which are also runners. The common ancestor of these four birds probably lived at the end of the Secondary (Mesozoic) era, more than sixty-five million years ago, but it is not known whether it originated in Africa or in South America. Its descendants colonized the other continents when the landmasses were still close. One of the two South American nandus was described in the nineteenth century by a young naturalist. The fellow had not yet worked out the general theory that would first propose an explanation of the resemblances among different running birds. This theory would make him famous, and later earned the nandu the nickname "Darwin's ostrich."

—
Mole, *Talpa europaea*. Eurasia (l. 14 cm)
—
Marsupial Mole, *Notoryctes typhlops*. Australia (l. 11 cm)

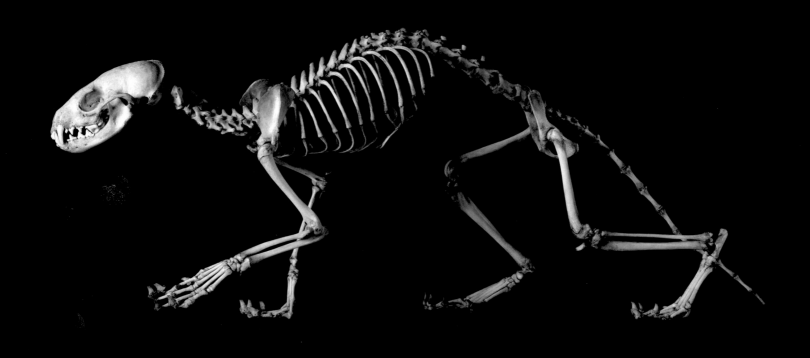

Beechmarten, *Martes foina*. Eurasia (l. 67 cm)

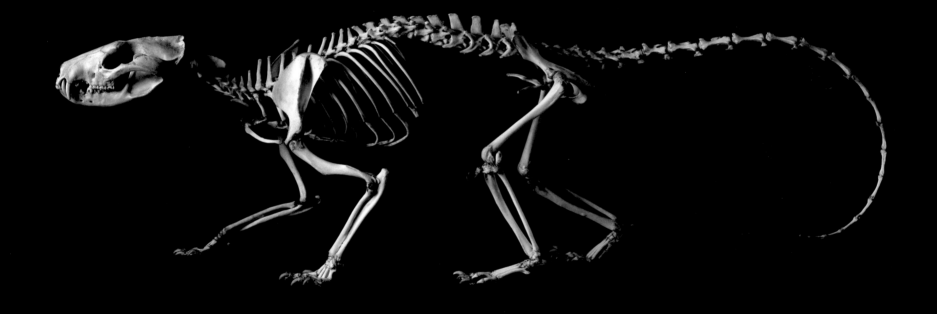

Quoll, *Dasyurus sp.* Australia (l. 81 cm)

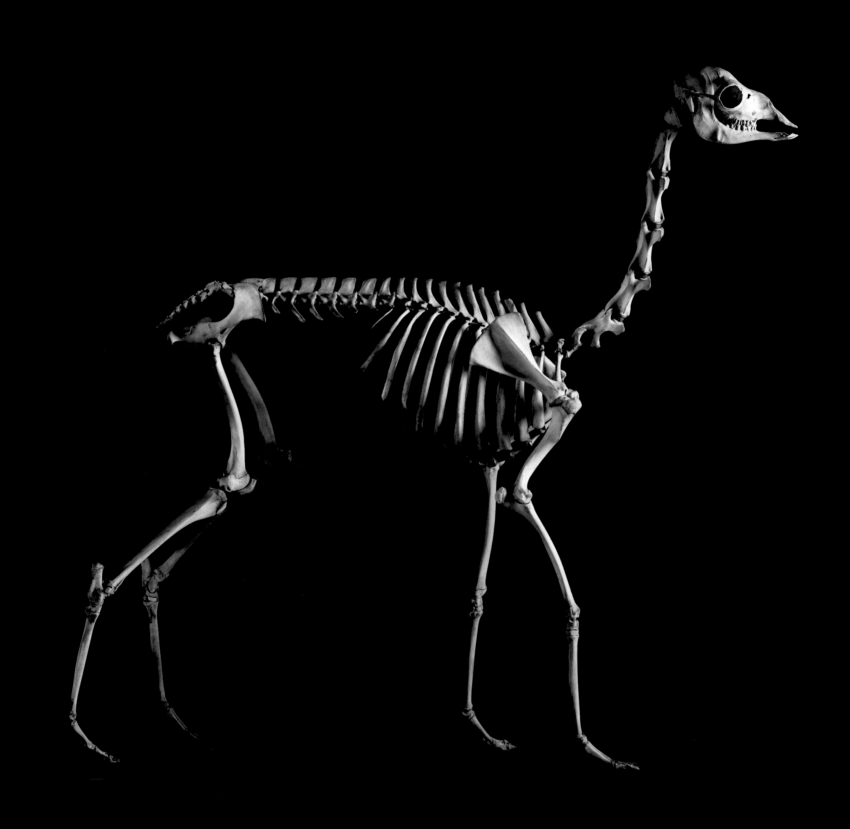

Vicugna, *Vicugna vicugna*. South America (s.h. 80 cm)

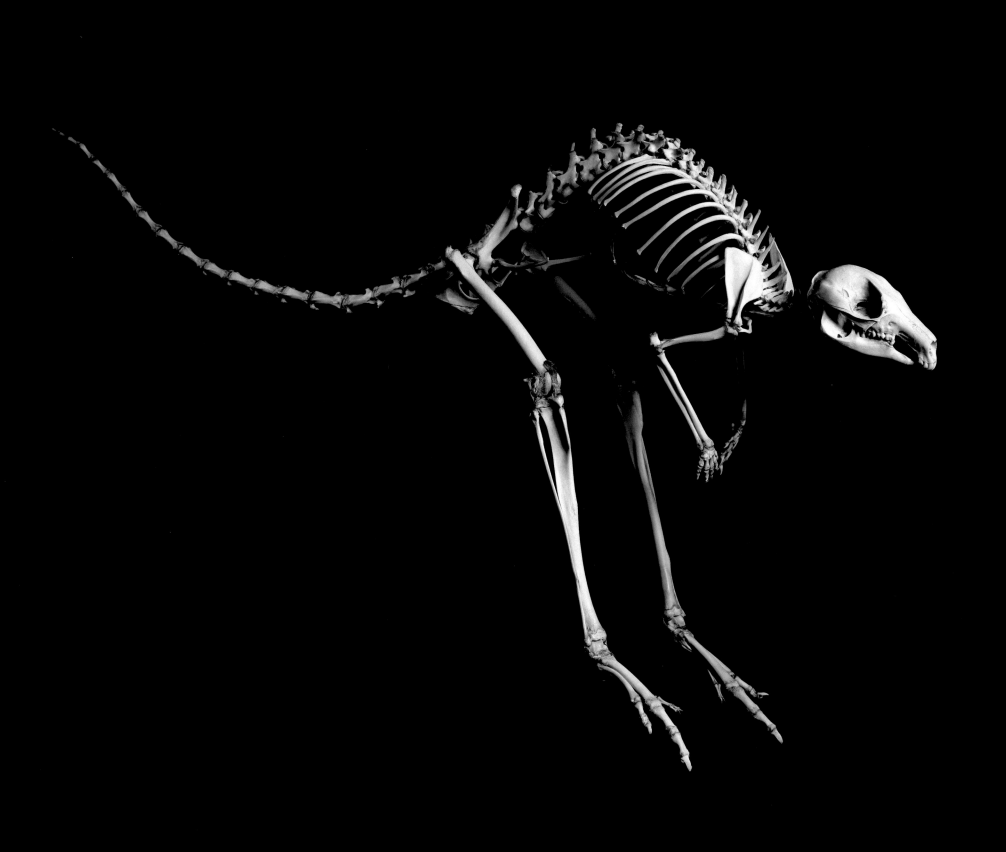

Red-necked wallaby, *Macropus rufogriseus*. Australia (l. 86 cm)

Vicugna, *Vicugna vicugna*. South America (s.h. 80 cm)

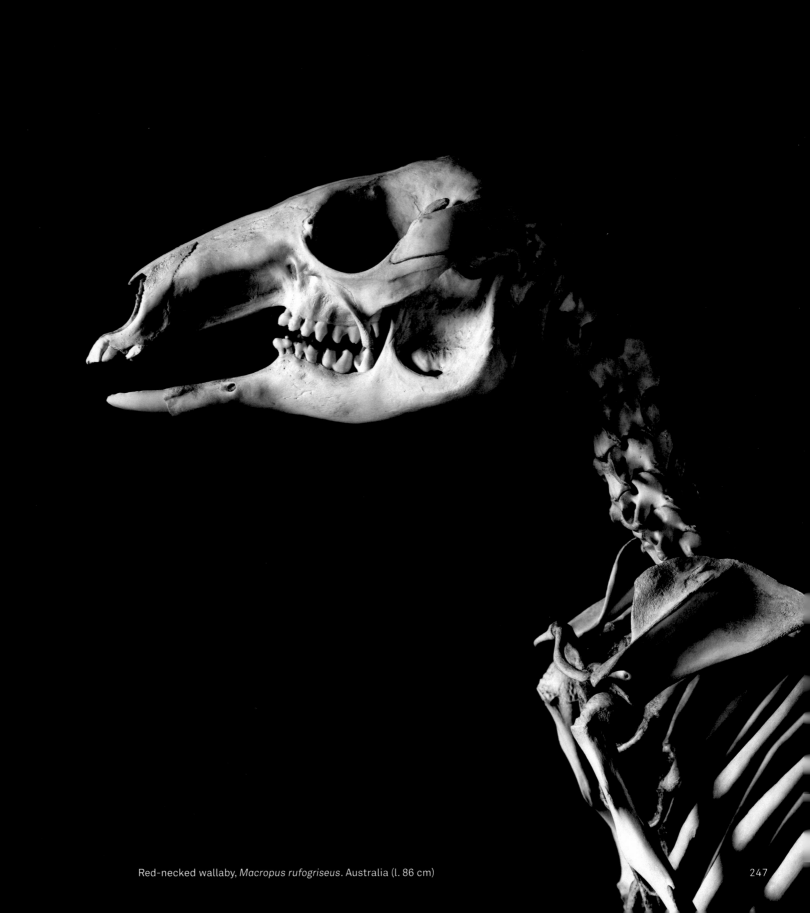

Red-necked wallaby, *Macropus rufogriseus*. Australia (l. 86 cm)

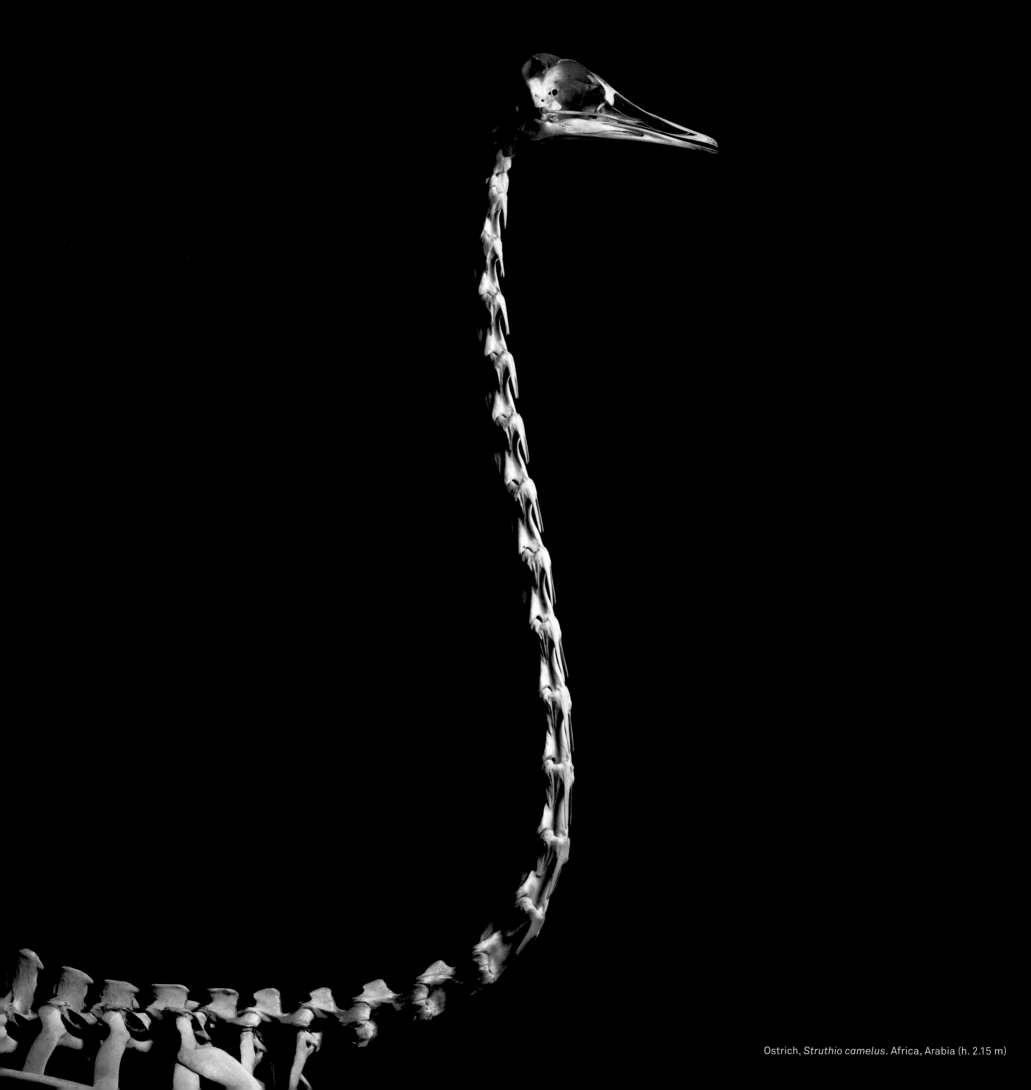

Ostrich, *Struthio camelus*. Africa, Arabia (h. 2.15 m)

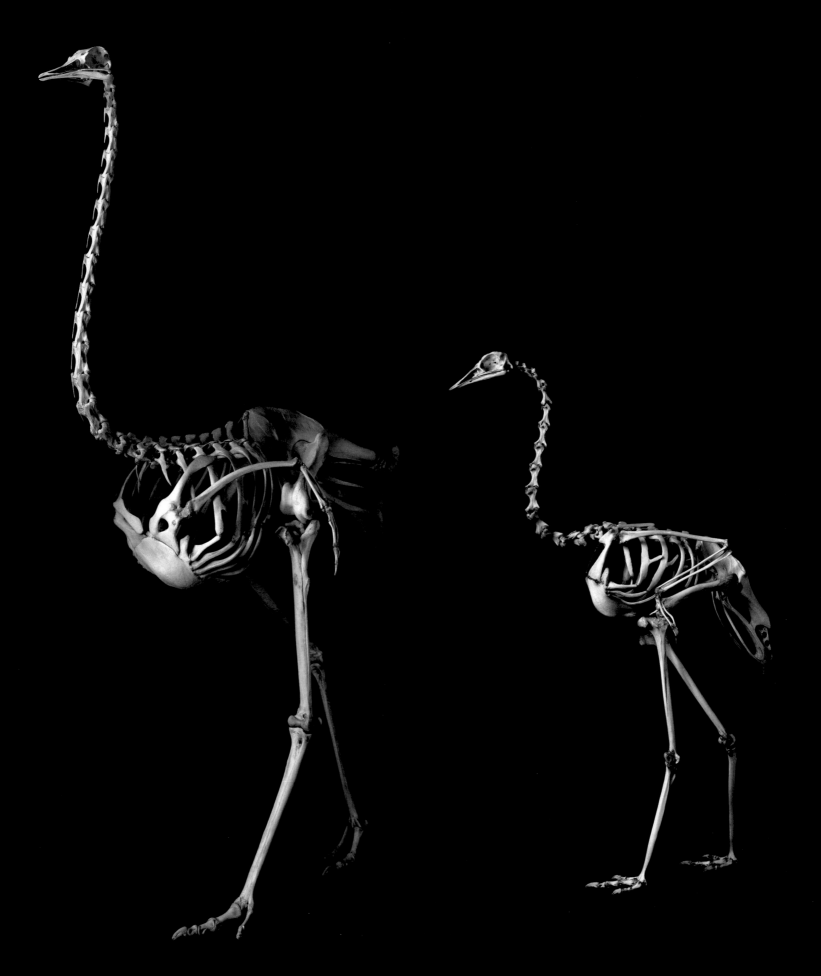

Ostrich, *Struthio camelus*. Africa, Arabia (h. 2.15 m)
Greater rhea, *Rhea americana*. South America (h. 1.20 m)

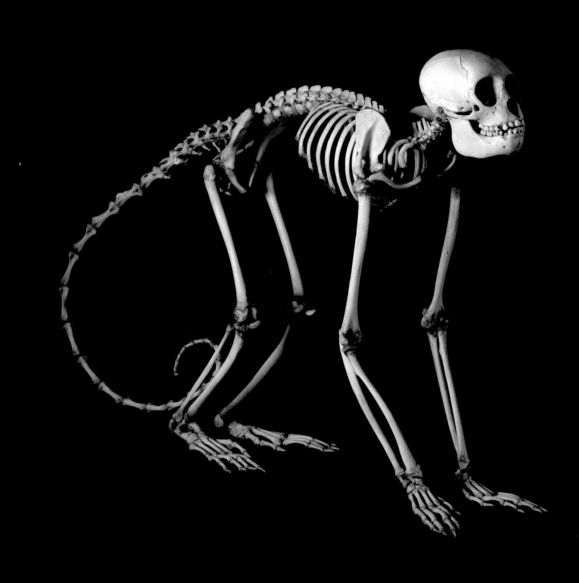

Humboldt's wooly monkey, *Lagothrix lagotricha*. South America (l. 94 cm)

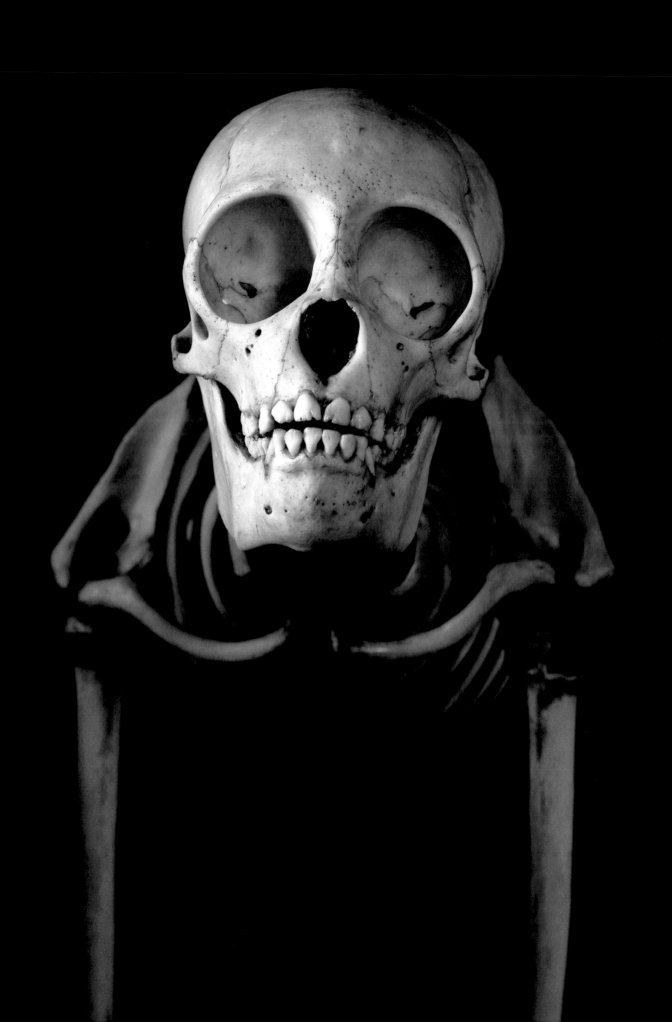

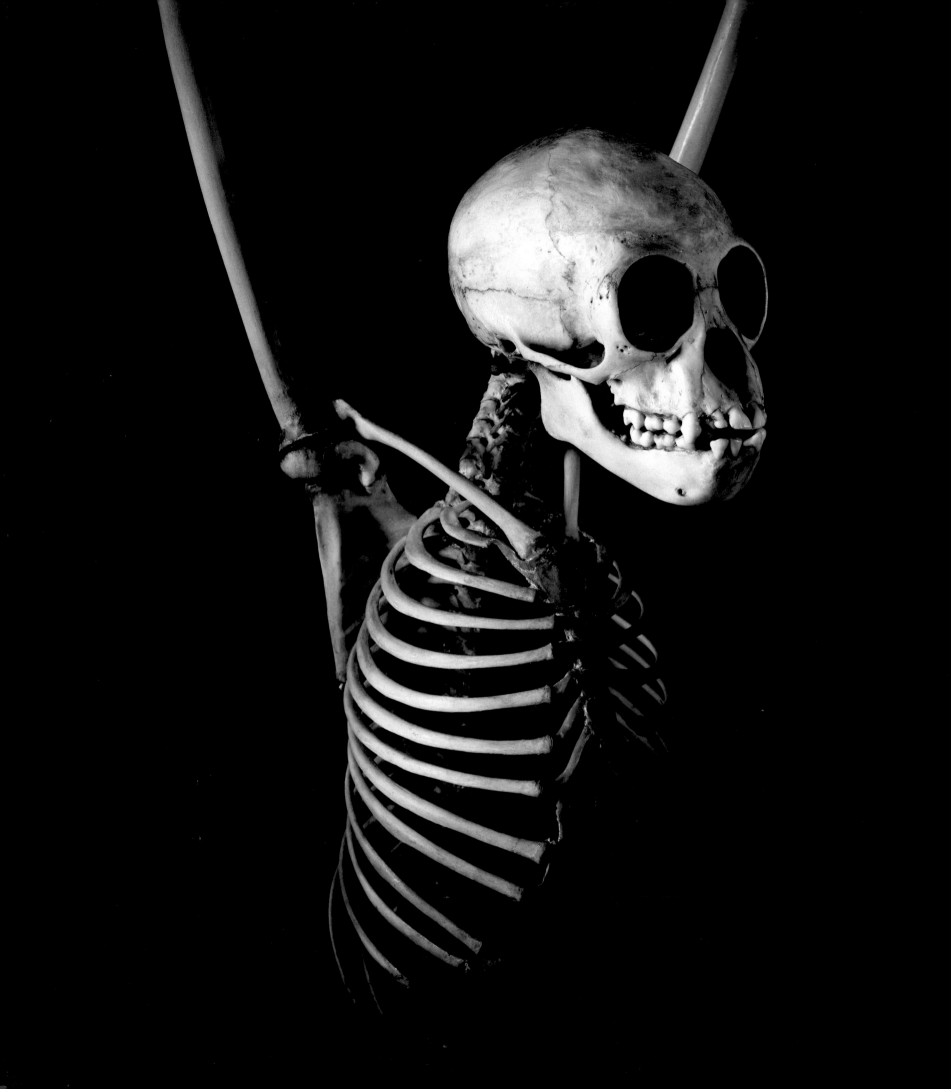

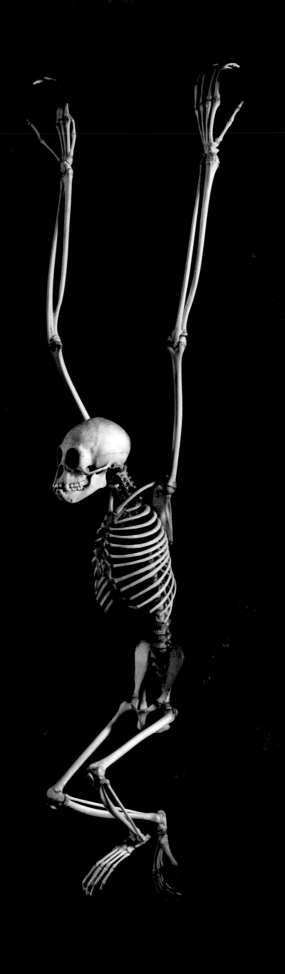

White-cheeked gibbon, *Hylobates leucogenys*. China, Laos, Vietnam (h. 90 cm)

CHAPTER 39
BIG SKULLS

At once the traditional representation of death and the protective casing of our brain, our skull has great importance for us, symbolic as well as biological. For more than two centuries it has excited passionate observation—not without certain a priori assumptions, whether comparing men to women, one race to another, or our species with other primates. Many investigators have taken special interest in its external form and its overall volume, characteristics that are easy to measure and highly informative. The intracranial volume does give some indication of the volume of the brain, and thus of the number of nerve cells it contains. Its form also reveals certain aspects of its evolution, from the first vertebrates up to present day species.

In the comparison between species, the absolute size of the brain is not a very useful index. Ours is smaller than the elephant's or the whale's, which could be a vexing fact unless we consider the overall size of those animals. Within the same zoological group, the brain's mass is roughly proportional to that of the body, probably because it takes more nerve cells to manage a large organism than a small one. But a number of other factors intervene, like the animal's metabolism. Thus mammals, which must constantly monitor their internal temperature, have a bigger brain pound for pound than do reptiles, which do not regulate their temperature. Other factors are linked to the phylogenetic heritage of the animals or to their way of life. Thus, primates have bigger brains than most other mammals. As for humans, with an average volume of fourteen hundred cubic centimeters, they surpass even that primate norm, still allowing for proportion. But humans are matched in this domain by dolphins.

Still, the brain's size does not express the range of its capabilities. In the human being, it varies by individual from one thousand to two thousand cubic centimeters, without justifying the slightest conclusion as to the relative capacities of the different owners. Among species, the shape also gives some indication as to the relative importance of the different zones: for instance, the area that plays a role in vision, or smell, or the animal's equilibrium. The facial bones may add more data: for instance, primates' eye sockets are always set to the front, so the visual fields of the two eyes superpose almost completely, which makes for excellent stereoscopic vision and depth perception. This is a factor important for species that originally lived in trees. As is shown by fossil skulls, the visual field is a major element in the great increase in brain volume of primates early in their evolution.

The search for food has probably not been the most important factor in this evolution, which was strongly influenced by another essential parameter: the size of the social group. The first monkeys were herbivorous animals for which developed mental faculties were not especially necessary. To feed on fruits and leaves, it is enough to be capable of recognizing them and possibly remembering where to find them. In the same way, spotting predators and avoiding them are part of the basic capacities of most animals. Hunting does assume further aptitudes, since one must sometimes anticipate the prey's reactions in order to capture it, but those capacities are also fairly widespread. On the other hand, life in society constitutes an environment that is especially complex and variable. Important in all the activities of daily life is the ability to keep track of the rank of other individuals, as well as of friendly or hostile relations among them. Primatologists have noted the importance of social relations in most primates, macaques and chimpanzees. In chimpanzees, these relations are especially complex. For instance, chimps have shown that they are able to consider the knowledge and emotions of their congeners. When the size of the group increases, the amount of information to deal with grows exponentially; a big brain becomes a very useful organ. And then it is powerfully subject to natural selection—for example, because it confers an advantage in sexual competition.

Social relations may also be the basis of some typically human abilities, like spoken language. Monkeys cannot practice this kind of language, but they communicate all sorts of information through sounds, facial expression, gestures, and posture. They greatly value personal contact, like mutual grooming of the coat. Some baboons devote twenty percent of their time to this activity, whose principal function seems to be to allay tensions within the group. This is important for its cohesion—for instance, in the search for food and for defense against predators. Beyond a few dozen members, it becomes impossible to practice generalized grooming. Language could be a kind of verbal successor to grooming, selected for its importance to the survival of the group. But it could actually be merely an epiphenomenon, an emergent property associated with the whole range of the capacity to process information. It is certainly what happened with humans as to reading and writing, two faculties important today but which were surely not shaped by natural selection. Our brain is capable of learning to read, but it was not originally selected for that.

Whatever the precise reasons for the increase in the brain's size, the improvement of its abilities must have been a great advantage. The selection of ever-larger skulls was in fact accompanied by significant secondary effects on the conditions of birth, with a considerable mortality rate of mother and child. For, paradoxically, the cranium of a baby at birth is large enough to make the birth difficult, and not large enough to have attained a development comparable to that of other mammals. In effect, the human infant is born at a stage of extreme neural prematurity. Considering the volume of the adult human brain, pregnancy should last sixteen or seventeen months for the infant to be born at a stage of development comparable to that of other mammals— for instance, when he is capable of moving about on his own. This biologically premature birth presumes a great parental investment for the beginnings of the child's life, far more than that of the other great apes. But if our brain is larger than that of our ancestors, it does not in the slightest imply that it is smaller than our descendants' will be. It is unlikely that it could grow by much, unless women's pelvises were to grow accordingly. Furthermore, unless natural selection should move in that direction, we have no reason to fear that we will someday come to look like the big-headed Martians in science-fiction films.

—
Human being, *Homo sapiens*. Worldwide (h. 1.70 m)

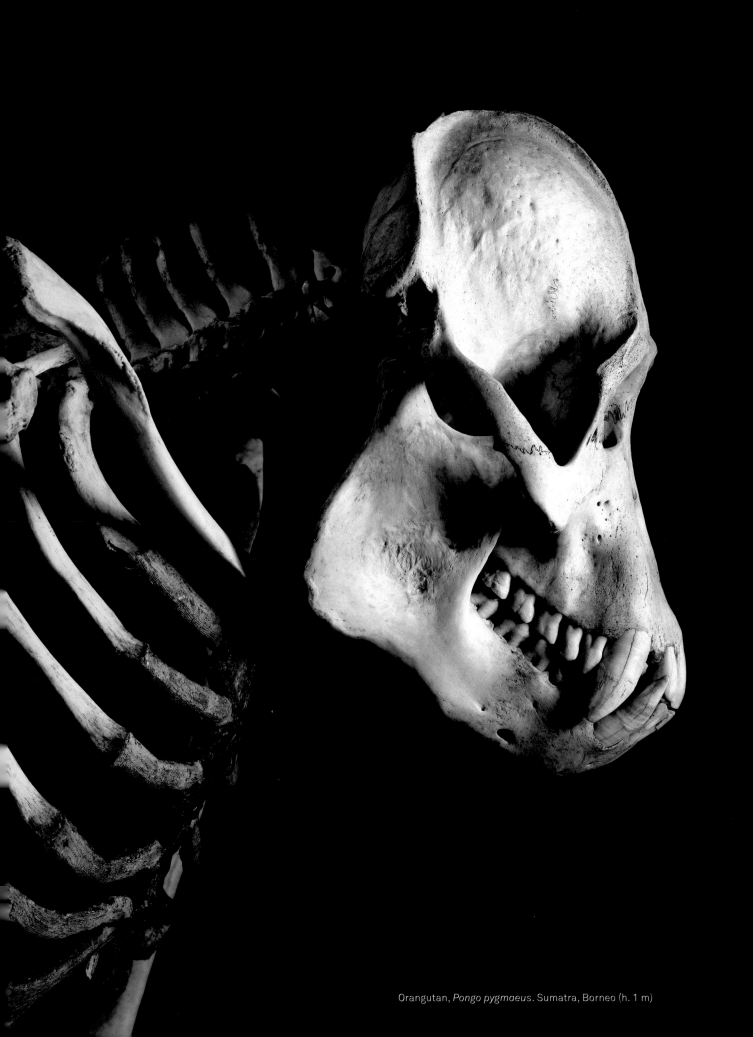

Orangutan, *Pongo pygmaeus*. Sumatra, Borneo (h. 1 m)

PART VI
EVOLUTION AND TIME

For most of their history, the evolution of living creatures is written not in man's time, nor in that of historians or archaeologists. The basic unit of time for paleontologists is closer to the millions of years than to the hundreds. Since the beginnings of life, the history of evolution stretches over more than three and a half billion years. The first multicelled animals appeared six-hundred to eight hundred million years ago, perhaps earlier. It is difficult to grasp these spans of time, which are truly unimaginable but are also the only way to comprehend evolution—that is, the immense accumulation of mutations that have affected hundreds of millions of generations before being pitilessly sorted out, and advanced or eliminated, by natural selection.

There is another aspect to time: direction. We are particularly aware of the cyclical phenomena, such as the seasons and the succession of generations, but evolution's time is linear. Its entire history is marked off by transformations of the environment through the action of living beings themselves. Major events of the history of the earth occurred a single time, in very particular circumstances that no longer exist today. Louis Pasteur's disproof of the theory of spontaneous generation—the idea that living things could arise from non-living matter—was for a time considered to be an obstacle to the theory of evolution. His assertion seemed incompatible with an essential event: the very birth of life. The contradiction was overcome when it was found possible to re-create the primitive atmosphere of the earth, which was originally without oxygen and rich in carbon composites. Laboratory experiments showed that those initial conditions, so different from the present-day atmosphere, permit the occurrence of life (even though we do not yet know the exact mechanisms). For hundreds of millions of years, plants and animals remained strictly aquatic, protected by the water from the harmful effects of the sun's ultraviolet radiation. Algae gradually produced oxygen, which was merely a waste product of their metabolism. The oxygen accumulated in the atmosphere, and chemical reactions produced the protective ozone that allowed living creatures to colonize the continents.

Consideration of the concrete conditions of evolution also gives a better understanding of the relation between microevolution and macroevolution [see page 69]. Although genetic variations within a population or between neighboring species are of the same nature as the differences between higher-level taxons, the rise of "phyla" occurred in very particular circumstances. In the fossil archives, we see at about five-hundred-forty million years ago the sudden appearance of very diverse animal forms of rather large size (up to several dozen centimeters), whereas the earlier animals were minuscule and barely differentiated. This period of growing biodiversity was so rapid that paleontologists speak of the Cambrian "explosion." Fossils show that nearly all today's phyla were already present then. There may even have been others that have since disappeared. In contrast, it does not seem that truly new structures appeared afterward. It may be that the relative paucity of the fauna in the preceding period, the Precambrian, made for an environment in which the pressure of selection was less great; immediate die-off may have been less of a risk for the new forms that were appearing then. When biodiversity increased, the nascent species were immediately confronted with a dense network of interspecies relationships, including competitors, predators and parasites. Such an environment no longer permitted major innovations but only diversification within the phyla. This hypothesis is supported by the fact that the great periods of evolutionary "radiation" or proliferation occurred after episodes of mass extinction—that is, in very impoverished environments.

One of the important aspects of Darwinian theory is the pace of evolution. The transformation of species and the appearance of new forms can be very rapid—a few hundred or thousand years. Biologists know of some recent examples, in species isolated in lakes or on islands [see page 260]. Conversely, some animals, like the coelacanth, seem not to have changed over tens or hundreds of millions of years. It is not easy to explain the apparently slow pace of evolution in these "living fossils" [see page 264]. Nor does the evolution of different organs occur at the same speed in each species. So we speak of a "mosaic-style" evolution, as in the case of the platypus, which exhibits characteristics inherited from the earliest mammals, such as its reproduction, which is oviparous (laying eggs), as well as more recent "derived" features such as its famous "duckbill" [see page 266]. Darwin envisaged an accumulation of very small variations that could, over long periods, profoundly transform the species. His detractors said that fossils of intermediate forms should have been found illustrating all the stages of these transformations. This led many naturalists to seek the famous "missing links" that would have stood as evidence of the evolution of species. Some intermediate forms, such as the bird-reptile *Archaeopteryx*, were found, but further examples were still said to be missing. Fossilization is a rare phenomenon, however, and most fossils stay hidden and out of reach, deeply buried in rock. It is unsurprising, then , that we have not found examples of every stage of evolutionary transformation, at least for terrestrial animals whose remains are rarely found in good fossilization conditions. In the case of marine animals, the question was more problematic.

Early in the 1970s Stephen Jay Gould and paleontologist Niles Eldredge proposed that even incomplete fossils constitute suitable archives. To their thinking, fossils show that evolution occurs in bursts and not gradually: species remain stable for long periods because of an optimal adaptation to an environment that is fairly constant, and then change abruptly in the face of a change in their life conditions. Moreover, rapid evolution occurs in populations of small numbers, for whom the possibility of fossilization is extremely unlikely. These two elements thus justify the absence of fossils of intermediate forms. This theory, called "punctuated equilibrium" was the subject of lively debate. Based as it is on the absence of fossils, it is more difficult to verify than a gradual evolution would be. It must also be proven that important mutations can occur abruptly, permitting the quick advent of a new species without at the same time endangering the embryonic development of mutant individuals. The discovery of homeotic genes—essential in the initial construction of the embryo and present in all zoological groups [see page 15]—and the examples of "heterochrony" in the timing of an animal's development [see page 192] have provided examples of such mutations. Paleontologists have found many examples of the two theories, gradual evolution and evolution by leaps, especially in the marine environment, where the sediment sometimes preserves the fossil trace of fauna over long periods and without disruption.

Finally, the two modes complement each other more than they conflict: when one species is transformed, it can also give rise to a daughter species, both then evolving in parallel. In such a case, the fossil archives show that the previous species continues to prosper while a second species suddenly appears.

The contributions to evolutionary theory from paleontology and molecular biology bring into coexistence two very different time scales: the long time of fossils and the extremely brief time of mutations. This confrontation has permitted the emergence of new concepts, like the "molecular clock." Comparing two present-day species, it is possible to estimate the number of mutations separating them in a gene or in a group of genes. Moreover, the methods for the absolute dating of rocks permit us to estimate at what period their last common ancestor lived. From there we can deduce a speed of evolution, for instance by the number of mutations per million years. Once it is calibrated, this clock is used to date the appearance of the various species of the same group, by the number of mutations in their genes. This technique is very appealing in principle, but it has proved difficult to apply, mainly because the rate of mutation varies from one lineage to another. But we can make use of the information from the different zones of the DNA, as we compare species that are close or distant. Some zones accumulate few mutations, probably because they contain important genes for which most mutations have noxious effects, and are therefore eliminated by the selection process. These less-variable genes permit comparison of very distant species. Conversely, the segments of DNA that do mutate a good deal are probably insensitive to selection because their precise sequence is unimportant. These sections are used for comparing very close species.

The molecular clock makes it possible to link a morphological change to a genetic variation. We have an example with the gene that codes for myosine, a protein implicated in muscle contraction, which is different in man and chimpanzee. This gene mainly affects the volume of the muscles of mastication, which are more powerful in the chimpanzee. Fossils show that the hominids had sizeable muscles but that they were smaller in early man. The molecular clock dates the mutation that separated man from the chimpanzee to two million four thousand years ago—that is, shortly before the appearance of these first archaic humans. The information provided by molecular biology, however, is not always in accord with the fossils. Thus, some paleontologists believe that the divergence between man and chimpanzee goes back more than ten or twelve million years, while geneticists think that the two lines separated between five and seven million years ago. The most ancient hominid fossil, nicknamed Toumai, does in fact date from about seven million years ago. Some scientists consider it to be close to the human lineage; others place it with the ancestor of the chimpanzee or the gorilla. So it is probably a very close neighbor of the ancestor common to all three species.

Contemporary man, *Homo sapiens*, appeared around one hundred thousand to one hundred fifty thousand years ago and very quickly took on a disproportionate importance in the history of the earth, given his numbers. Starting from fifty thousand years ago, the dissemination of men on all the continents coincides with the disappearance of many species. The climatic changes at the end of the last ice age certainly played some role, but hunting probably precipitated the end of a good number of the large fauna of the Quaternary era, such as the giant birds of Madagascar and the mastodons of North America. In contrast to the fauna of Africa and Asia, these species had evolved with no contact with men, and were thus confronted with a new situation to which they were not adapted. Ten thousand years ago, the first agriculturists began to modify the landscape in many regions of the world. The replacement of forests by cultivated fields, the hunt, and the competition of domestic animals profoundly transformed most ecosystems [see page 274]. Man also intervened directly in the evolution of the species he domesticated, shaping them to his needs. The transformations obtained by the selection techniques of livestock breeders, in fact, served as a model for Darwin in explicating the notion of natural selection [see page 268].

The evolution of human species has suddenly accelerated, but today it is in culture and not biology. We have gone from natural selection to cultural selection, which is infinitely quicker because it functions according to Lamarckian principles, through direct transmission of an individual's acquired traits to his descendants. Our influence on the environment follows this new rhythm. Our presence does not disrupt the fauna and flora any more than they have been disrupted at some other periods in the earth's history, but the upheavals we have caused have taken just a few dozen years: global warming, the destruction of many ecosystems and the species they supported, contamination of food chains by various pollutants, the dissemination of species imported from one country to another. We are preparing an impoverished world for our descendants, a world that may not offer the minimal necessary conditions for maintaining our own species. That future is very near—a few tens or hundreds of years off—if we persist in overexploiting our environment. In the longer term, with or without the human species, it is probable that the earth will return to its initial biodiversity. A few million years should suffice—just an instant in the history of evolution.

CHAPTER 40
A BRIEF MOMENT FOR THE IBIS

"It is highly important for us to gain some notion, however imperfect, of the lapse of years.... What an infinite number of generations, which the mind cannot grasp, must have succeeded each other in the long roll of years!" (*The Origin of Species*). For Darwin, it was essential to be aware of the oldness of the earth to accept the idea that species can be transformed. The question was not a new one. Half a century earlier, Cuvier and Lamarck had taken sharp issue on the subject over an ibis. The bird was part of a group of mummified animals brought back from Egypt by Geoffroy Saint-Hilaire, who had taken part in Napoleon's scientific expedition during the French occupation of that country (1798-1804). Examined by Cuvier, the embalmed ibis was shown to be identical to contemporary ibises: "It is today the same as it was in the time of the Pharaohs. I know that I am citing only some individuals from two or three thousand years ago, but still this goes back as far as is possible." According to Lamarck, this length of time was too short for the slightest transformation to have occurred, the more so since the animals "were not forced to change their habits," as their life conditions had remained the same.

Darwin did not only seek to demonstrate by what mechanism new species appear; he also wanted to prove that this mechanism takes time to work. To convince his audience, he needed to invoke the hundreds of millions of years that geologists were beginning to envisage for the history of the Earth, but in themselves those long periods rendered impossible any direct observation of evolution. The discovery of the genes, and of mutations, gave biologists access to much shorter periods. The consequences of mutations in bacteria or in fruit flies can also be observed in a few days or weeks. But laboratory experiments are not enough. What was needed was to demonstrate that the same mechanisms are at work in nature, and that they actually lead to new species, morphologically different from the species they come from. For that, biologists seek related species whose phylogenetic history can be reconstructed. They must also be able to date the events in that history, and determine what genes are implicated in their evolution. Isolated environments were revealed to be especially interesting, for they foster rapid evolution of the animals there. The most astonishing examples were found in the great lakes of East Africa, where small fish lived a history at once brief and profuse, ideal for the study of "real-time" evolution.

Lake Malawi, in East Africa, is home to more than five hundred species of fishes, almost all of them cichlids. This family, which is also present in Latin America and India, includes species that are very diverse in size and shape, but with the same anatomical structure. In Lake Malawi, the various cichlids also differ in their ways of life. Certain species live near the lake bottom, preferring either the sand or the rocky areas. Others stay in open water and separate out by different depths. To judge by the geological markers, the lake has existed for only one or two million years. An analysis of the fishes' DNA has shown that they all descend from a single species, which invaded the lake some seven hundred thousand years ago and then gave rise to hundreds of different species. Apparently, three great events occurred in the history of these fishes. The first was a separation into two groups, one originating the species that live on the sand, the other the rock species. Among the latter, a second episode of speciation separated the lines of cichlids according to their feeding habits. These fishes have different jaws, depending on the type of prey they capture—for instance, small crustaceans or worms. Some species are parasitic, and pull off scales and small bits of skin from other fishes. A similar study carried out in Lake Victoria showed that these parasites fall into two groups that differ by the form of the mouth and by which side they choose for attacking their victims. The third major event in the history of the cichlids corresponds to changes in the coloration of the males. Sexual selection became very important, and contributed to the reproductive isolation of the species as they were in the process of differentiation.

Similarly, in Lake Victoria there cohabited hundreds of distinct species of cichlids (whose diversity is, by the way, in grave danger since the introduction of the Nile perch). Their evolution is even more recent, as the fishes are thought to have arrived in the lake only twelve thousand five hundred years ago. The initial species was not the same one as in Lake Malawi, but evolution has brought about species with similar adaptations. In a few tens of thousands of years, these two lakes rather sparse in animal life have experienced extremely rapid evolutionary proliferation, beginning with two pioneer species. Biologists have managed to locate certain genes implicated in this history, such as a dozen genetic factors that affect the shape of the jaw, and a gene whose mutation causes a change in the shape of the teeth.

Thus, the particular mechanisms involved in the evolution of these fishes are gradually being unveiled.

The same phenomenon occurred on volcanic islands, like the Galápagos, that burst violently from the sea and were populated gradually by chance arrivals of species. The succession of glacial and interglacial periods has also provided such examples of speciation. About one hundred thousand years ago, the rise in sea levels resulting from melting glaciers trapped elks in a region newly transformed into an island (which later became the English Channel island of Jersey). As that happened to many mammals isolated by the event, their size diminished markedly. Their average weight went from two hundred kilograms down to thirty-six. The sequence of glaciations is fairly well dated, and allows us to estimate that this transformation took less than six thousand years.

The ibis is no longer considered proof of the impossibility of evolution. The cichlids, the stag, and a good many other species have shown that quantitative and qualitative changes could occur in relatively short times. Opponents of the theory of evolution have sometimes estimated that our brain volume could not have grown by a factor of five in six million years. But the Jersey elk lost that much size over a time span a thousand times shorter. Of course, the human brain has undergone qualitative changes as well, but six million extra years does not, in principle, seem insufficient for an evolution of that magnitude.

—
Sacred ibis, *Threskiornis aethiopicus*. Africa (l. 40 cm)

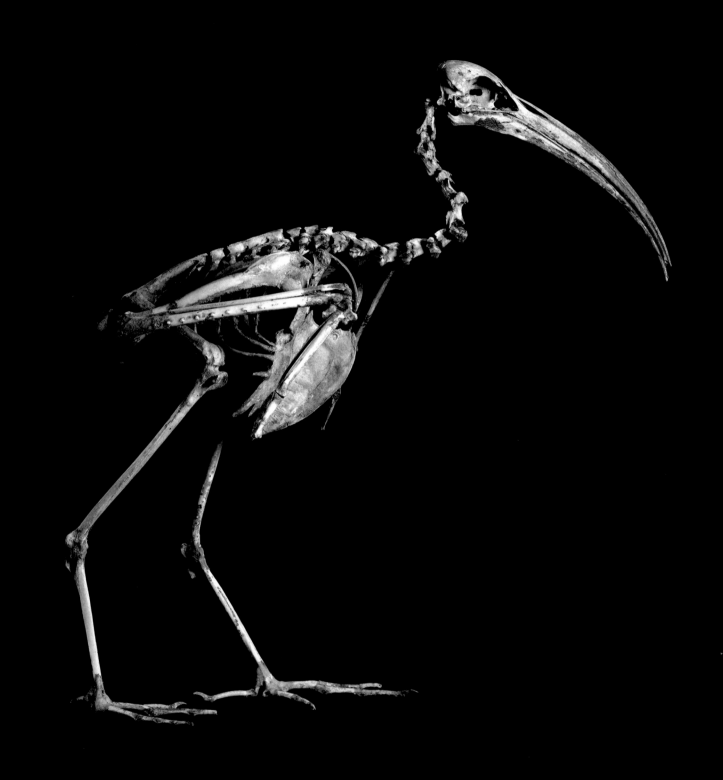

Sacred ibis (mummy)

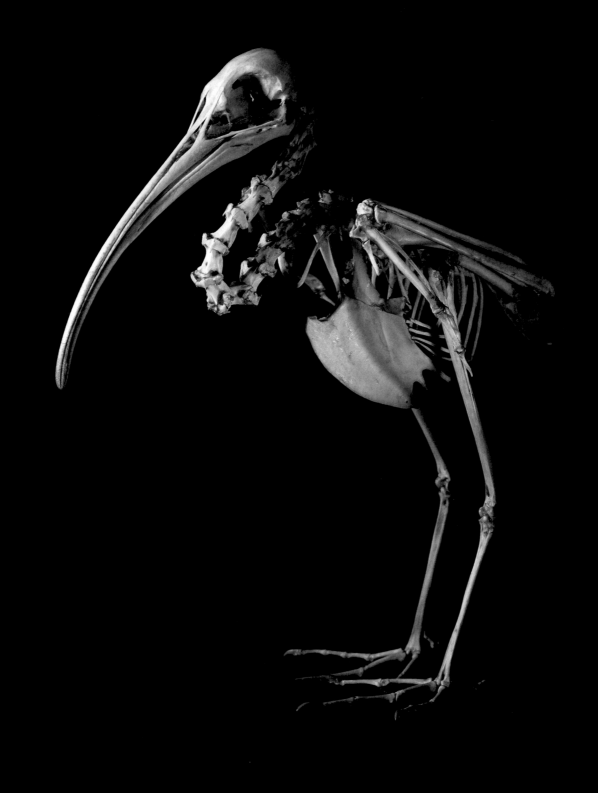

Sacred ibis, *Threskiornis aethiopicus*. Africa (l. 40 cm)

CHAPTER 41
FIGURES FROM THE PAST

In 1938 a fish taken from the Indian Ocean was identified as a coelacanth, an animal that had never before been seen except as a fossil. It was immediately called a "living fossil," not only for its prehistoric look but especially because the paleontologists thought it had disappeared at the end of the Mesozoic era, along with the dinosaurs. There are some seventy different species of fossil coelacanths, dating from three hundred eighty million to seventy million years ago. The living coelacanth looks astonishingly like them, as if it has not changed for several dozen million years. The expression "living fossil," which is scientifically improper, often irritates paleontologists, but it describes animals that are of great interest, apart from their spectacular appearance. On one hand, they offer some clues to the biology of extinct species; on the other, in theory they raise the question of the rhythms of evolution.

Forms known only in the fossil state and then discovered as species very much alive are relatively rare. Most of them are marine animals, like the *Gymnocrinus,* a sea lily thought to have disappeared one hundred forty million years ago. The term "living fossil" is also applied to present-day animals that are nearly identical to prehistoric species. This is the case with a number of arthropods, like cockroaches and scorpions, and vertebrates, such as sharks and crocodiles. On the other hand, the term is never used for bees or ants, although some of them bear a striking resemblance to insects that lived a hundred million years ago. So the criteria for attributing that term are not clearly defined. Furthermore, the expression "living fossil" is misleading, for the coelacanth as well. Even though it resembles fossils in its general form and its skeleton, nothing is known of its ancestors' soft organs or of their behavior. Species similar in appearance, fossil or contemporary, are often very different in their diet, habitat, or physiology. Despite its ambiguities, though, the expression does retain a strong evocative potency. Living and fossil coelacanths are at least as close as might be two contemporary species of the same group. They thus give us some picture, at least approximate, of animals of the past. The amazing motions of the coelacanth's fins, which look like the walk of a quadruped, could not have been deduced from mere observation of the fossils. In the same way, paleontologists draw on living species to try to reconstruct the appearance and environment of extinct species. Marsupials and insectivores are used as models for imagining the small mammals, from the Mesozoic era and the early Tertiary, of which we have only the teeth and a few rare skeletons.

The North American opossum is one of the seventy-five species of sarigue that live on the American continent. These are the only marsupials living outside of Australia and New Guinea. The opossum has a long muzzle, and its narrow skull is topped by a bony crest. It has a total of fifty teeth, a high number, which brings it close to the most ancient mammals. The opossum is an ecological generalist, with a quite varied diet. With opposable thumbs on its feet and with a prehensile tail, it moves about as easily on the ground as in trees. Its internal temperature is lower than that of other mammals, which reduces its energy needs. Thanks to their adaptive capacity, the opossums have succeeded in proliferating despite the competition of other mammals with bigger and more complex brains. Their skeleton has not changed since the Cretaceous, one hundred million years ago. At the same time, there appeared the first placental mammals, which replaced the marsupials on almost every continent. They were rather little differentiated, rarely surpassing the size of a cat. They are often compared to today's insectivores, mammals with primitive characteristics that include, most notably, moles, shrews, and hedgehogs. Among them, one of the largest is the solenodon, which weighs nearly a kilo. It lives only on a few islands in the Caribbean, where it has become quite rare. It digs tunnels underground and feeds on insects and worms. It has a poison gland at the base of the second lower incisor, which makes it one of the rare venomous mammals today. Still, as the insectivores have retained many primitive features, these venomous teeth may have been far more usual in mammals in the Mesozoic era. The insectivores probably offer us a fairly good picture of the mammals in the early Tertiary era, around sixty million years ago.

Beyond the interest of the information they can provide us on the ancestors of present-day species, the very existence of living fossils raises an important question: Why have some species changed so little, as if they had escaped the normal course of evolution? A second species of coelacanth has recently been discovered in Indonesia. The two species live in similar environments—volcanic slopes where hardened lava is pitted with many caves and fissures, several hundreds of meters deep. The deep underwater environment offers great stability, practically on the scale of geologic time. These animals, originally distributed over enormous areas, apparently came to specialize in a narrow ecological niche, with no very insistent predators or competitors, sheltered from natural selection. Similarly, many species considered to be living fossils have been discovered in Australia and Madagascar, large islands long separated from other continents, and whose animals with archaic features were protected from the rivalry of more modern fauna. On the other hand, cockroaches and sharks live throughout the world, in very diverse environments. These species may not have changed much for opposite reasons: because they are generalists, capable of adapting easily to modifications in their environment.

Living fossils, then, are likely to be either well-sheltered hyper-specialists or, on the contrary, generalists capable of adapting to everything. These examples are too divergent to allow a single explanation for them. Other hypotheses have been proposed, but the simplest is statistical in nature: animal species have an average life span estimated at between five million and ten million years, but some of them disappeared soon after they first appeared, and others have lived a very long time. Similarly, in the course of their evolution, some species have changed profoundly, while others have more or less kept their initial form. As to living fossils—whether they are true persisters or forms that approach very ancient species—might they not simply be extreme cases of the vast diversity of the living world?

—
Southern opossum, *Didelphis marsupialis.* Central America, South America (l. 82 cm)

—
Hispaniolan solenodon, *Solenodon paradoxus.* Haiti, Dominican Republic (l. 46 cm)

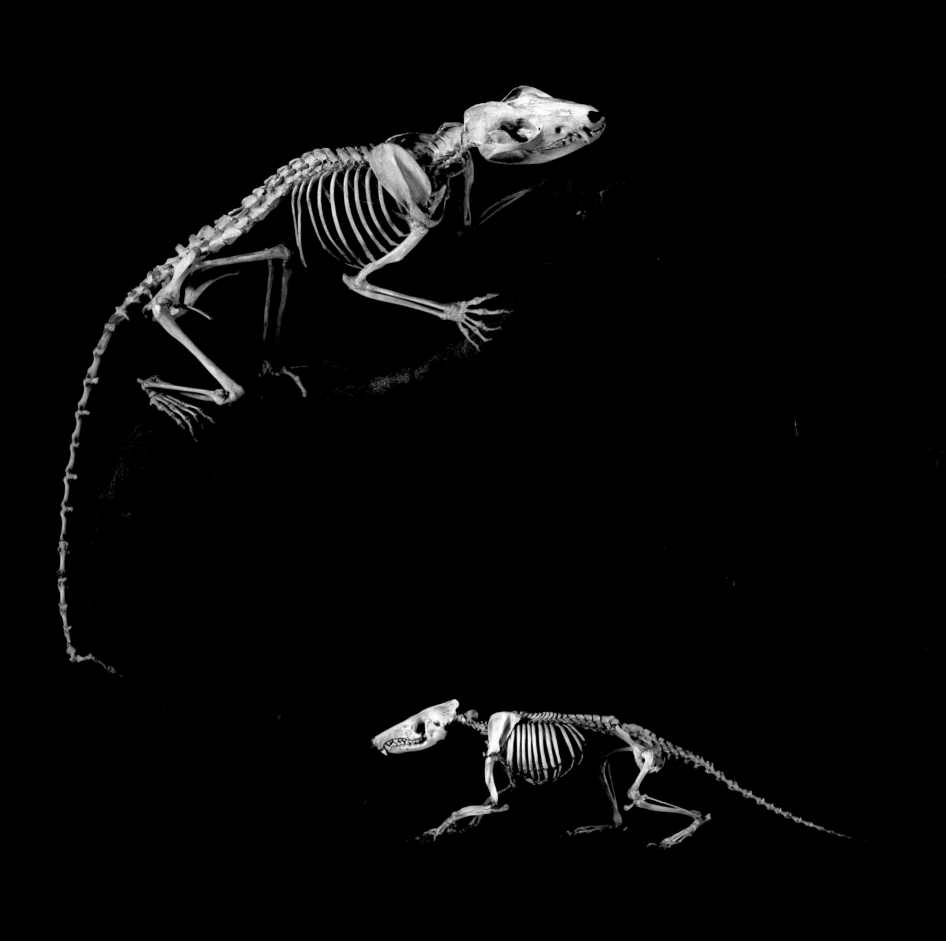

CHAPTER 42
A HIGHLY EVOLVED PUZZLE

The platypus was discovered by Western naturalists in 1798, but one of its major biological characteristics, its mode of reproduction, was not known until a century later. Its first descriptions were a kind of zoological fantasy—a mixture of mammal, reptile, and bird. Evolutionists cited it as a "missing link" between mammals and reptiles; the "fixists" classed it among the mammals and denied any possibility that it might lay eggs. Echidnes, discovered at the same time, were brought into the debate, but not much was known about them either. Today the platypus is not only a surprising puzzle; it is above all a fascinating testimony to the early days of mammals.

The size of a cat, the platypus has brown hair covering its body. On its head is a sort of flattened bill sheathed in thin skin. Its tail, broad and flat like a beaver's, has very little muscle and serves as a reservoir for fat. The feet and hands each have five digits. A slow animal, the platypus moves in a kind of crawl, hoisting itself a bit on its paws when it speeds up. At each step it advances an arm and the opposite leg, but the lateral synchronization is not perfect. It swims very well, however, paddling with its webbed hands, its arms spread horizontally. Its legs and tail help it to maneuver, but not to move forward. It leads a semi-aquatic life, spending a good deal of time digging into the riverbed in search of small animals. Underwater, it closes its eyes, ears, and nostrils. Information comes to it essentially through its bill, which is rich with nerve endings and sensitive to the slightest variations in the magnetic field. The female lays eggs but suckles its infants. As she has no nipples, the milk flows directly onto her fur. The infants have rudimentary teeth that soon fall out, to be replaced in the adult by horny plates.

This animal is certainly a mammal, as indicated by its fur and the fact that it suckles its young. Despite its name, its "bill" is not equivalent to a duck's horny bill. Nor do its webbed feet look like those of a web-footed bird. Its eggs are not protected by a shell but by a tough membrane covered in a gluey substance. To seek some similarities, then, it is more like certain reptiles. The cervical and dorso-lumbar vertebrae of the platypus are prolonged by the ribs, which is common in reptiles and rare in mammals. The pectoral girdle consists of not only the shoulder blades and clavicles, but includes five extra bones, a reptile characteristic. The platypus's

temperature is nearly constant but, at around 30 degrees Celsius, it is markedly lower than that of other mammals. Its reproductive system is more reptilian than mammalian. Notably, it has a cloaca—a single opening for the intestine and the urinary and genital tract—which is typically non-mammalian. The sperm cells look a little like a marsupial's but also like that of birds or reptiles.

The two species of echidnes, which were identified at the same time as the platypus, are also very strange. They are covered with spines, like a hedgehog's, and the head is elongated by a long, narrow muzzle. They have no teeth, and their lower jaw is reduced to thin, bony sticks. The enlarged arm bones serve as anchor points for muscles that are very powerful, given their small size. With their strong claws, they can dig into the soil in search of the ants and termites they feed on. Like the platypus, they lay eggs and suckle their young. These three species have such particular characteristics that they constitute by themselves one of the three groups of mammals—the monotremes—alongside the marsupials (kangaroos, koalas, opossums) and placentals (all the other mammals). The monotremes have retained a number of archaic traits belonging to the earliest mammals, or even to the "mammalian reptiles," those reptiles which are at the origins of the mammal lineage. Their mode of reproduction and their low metabolism are also traits inherited from those still slightly reptilian ancestors. Like the marsupials, they have epipubic bones, which proves that this is an archaic feature and not a novelty that appeared only in the marsupials. The novelty belongs rather to the placental mammals, for they have all lost those bones.

The platypus is one of the few venomous mammals. It injects its poison by horned spurs behind each limb. Many reptiles also produce venom, which they use to capture their prey or for self-protection. But the platypus does not seem to use it except for battles among males, a supposition the more likely as their poison production does increase during the courtship period. The females are born with a very much smaller spur, which they later lose. The horned spurs are supported by special bones. They are also present, though not poisonous, in the echidnes. The few other poisonous mammals belong to the insectivore group, such as the shrews and the solenodons. Like the platypus, they have retained some

archaic characteristics. Still, we do not know whether poison production is a new feature that appeared at the same time in the monotremes and the insectivores, or if, on the contrary it is a feature inherited from their reptilian ancestors and retained by them alone among the mammals.

The platypus is not a "living fossil" that would give us some picture of the early mammals. It too is the result of a long evolution that made of it an animal with a highly specialized way of life. The first monotremes probably did not have the aquatic way of life the platypus had, any more than they had its very unusual "bill." The other monotremes, the echidnes, actually come from a lineage that has undergone a very different evolution. Their adaptations bring them close, morphologically, to the ant-eating animals on other continents. The most ancient monotreme fossil, dating from one hundred sixty million years ago, was discovered in Patagonia. Only its jawbone has been found, but it has teeth, which is different from all present-day monotremes. With three living species and fossils scarcely more numerous, the story of the platypus and of the echidnes certainly holds still further surprises.

—
Platypus, *Ornithorhynchus anatinus*. Australia (l. 37 cm)

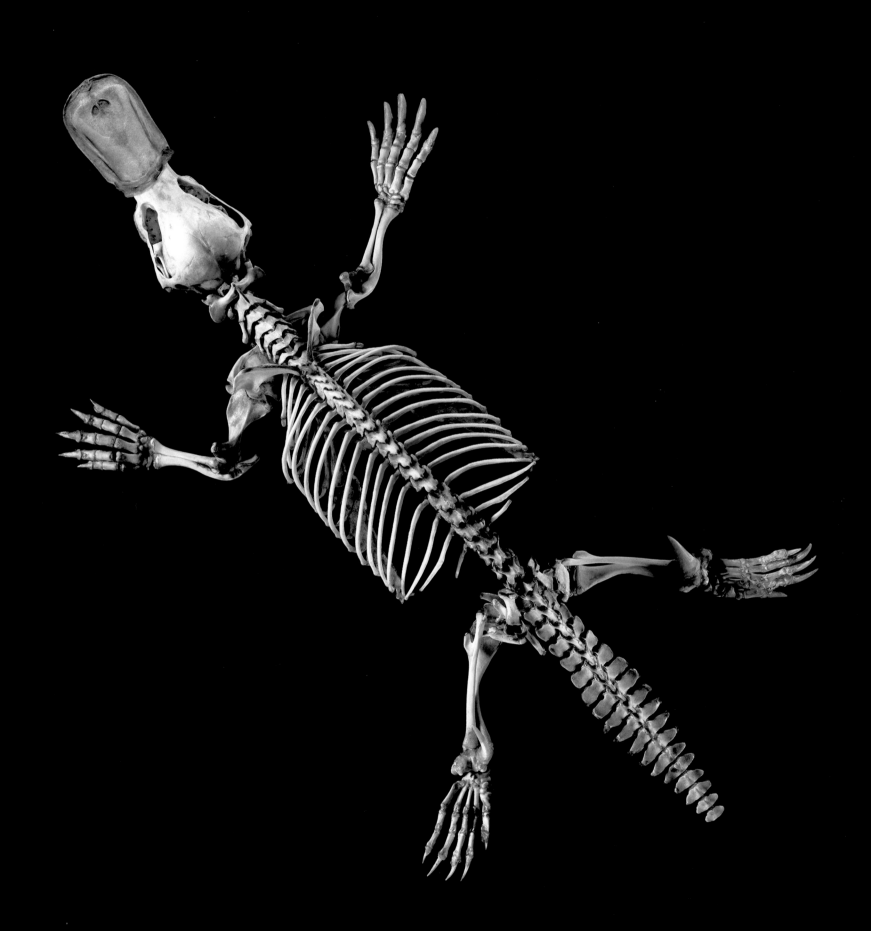

MONITORED EVOLUTION

"The cow…has four udders, even though it bears only one calf and very rarely two, because the two superfluous udders were meant to be the wet-nurses for humans. The sow, in truth, has only twelve of them, and she suckles as many as fifteen offspring. The proportion here seems defective. But if the former has more udders than needed for her family, and if the latter has not enough for hers, this is because the one was meant to give man the surplus of her milk, and the other the surplus of her offspring" (from *Studies in Nature,* 1784). In the late eighteenth century, Jacques-Henri Bernardin de Saint-Pierre was an outspoken advocate of "natural theology," the purpose of which is to find in nature evidence for the existence of God. For him, domestic animals were destined from their creation to provide meat and milk to mankind. Paradoxically, these are the same animals that would provide Darwin with a model for his theory of natural selection, which he described by analogy with the artificial selection of livestock breeders.

The naturalists of the eighteenth century knew that dogs could be crossed with wolves, or pigs with boars, and that their descendants are fully fertile. They also acknowledged the idea that pigs descend from boars modified by domestication, but they debated the origins of dogs, who some thought were wolves, others jackals, or even the issue of some hybridization between two species. Cows, goats, sheep, and cats were all considered to be the descendants of wild species, even though their ancestors were not exactly known. The characteristics they had acquired were attributed to the effects of nutrition or their way of life, and were thought to be transmitted to their descendants.

To impute all their transformations to captivity was an error, as Darwin was to demonstrate. That would also amount to undervaluing the decisive contributions of the first farmers who bred them. From observation of archaeological remains, the first domestic animal was the dog, whose earliest traces go back about fourteen thousand years. Their DNA has also shown unquestionably that the dog's ancestor is the wolf. The changes linked to domestication make it possible to distinguish the two species. Most dogs have a smaller head and a concave profile, which gives them a juvenile look compared with wolves. They bark, and they behave more like wolf cubs than like adult wolves. In morphology and in behavior, the adult dog is a wolf that has remained immature. This chronological lag in development recalls the cases of neoteny in amphibians [see page 192]. In dogs, it is probably linked to humans' selecting the more submissive animals, which accounts for their cub-like behavior.

After wolves, it was the turn of goats and sheep to be domesticated, around ten thousand years ago, followed a few centuries later by cattle and pigs. There again, we see a rapid transformation in the animals. They became markedly smaller, especially the aurochs and the boars, which in the wild state are dangerous animals. Breeders have probably selected the smallest and most docile animals, allowed them to reproduce, and prevented the others from doing so. It is likely, too, that the animals most restive in captivity also became too strained to reproduce and died soon, in a kind of self-selection. That still occurs in our day, with bison that farmers seek to domesticate and that die of a heart attack. Beyond the reduction in size, animals display other bone characteristics that differ from their wild ancestors, such as the form of their cranium or horns. Their living conditions and their nutrition certainly play a role in these individual differences, but the transformation is more profound, since entire domestic populations are affected. Left in the wild state, dogs do not revert to wolves, nor pigs to boars. Selection has changed the genetic heritage of domestic animals, and not only at the individual level.

It has been proven that a very minimal act of selection can have broad consequences. Biologists have tried to domesticate silver foxes, choosing as the sole selection criterion behavior that is less fearful and less aggressive toward man. They have obtained docile, friendly foxes, very different from wild foxes. These domestic foxes also display flopping ears and a dappled coat, with large white patches. These traits have appeared in many domesticated animals: dogs, pigs, cows, horses, goats, sheep, cats, and rabbits. Docility appears to be associated with certain morphological characteristics. The connection might be explained at the genetic level. For instance, melanin is an important pigment in the color of the coat, but after a metabolic transformation, it is also important for nerve reactions. Rat studies show that a similar mutation yields a more docile animal with a dappled coat. Similarly, mutations responsible for diminished thyroid development lead to animals that are smaller, calmer, and flop-eared.

It also happens that "novelties" appear—mutations affecting morphology, color, or behavior that would normally be eliminated by natural selection. It is not domestication that brings on the occurrence of these mutations, but when they occur, they are sustained by the breeders, whose criteria are different from those of natural selection. An anomaly of the face, with a crushed muzzle and a deformed jaw, has often appeared in dogs, giving us Pekinese and bulldogs. Cats and dogs born by chance without hair or with short legs are the basis for new breeds that appeal to buyers, more for the rarity of such mutations than for their usefulness to the animals.

Even though he did not know about genes, Darwin understood that the work of selection in domestic animals was essential. As he was preparing *The Origin of Species*, he interviewed a great many breeders, and he himself raised pigeons: "Man can and does select the variations given to him by nature, and thus accumulates them in any desired manner. He thus adapts animals and plants for his own benefit or pleasure. This unconscious process of selection has been the great agency in the formation of the most distinct and useful domestic breeds. There is no reason why the principles which have acted so efficiently under domestication should not have acted under nature." For Darwin, and for all today's biologists, cows and pigs were created not *for* man but *by* man.

—
Dog, *Canis lupus familiaris*. Domesticated (s.h. 25 cm)

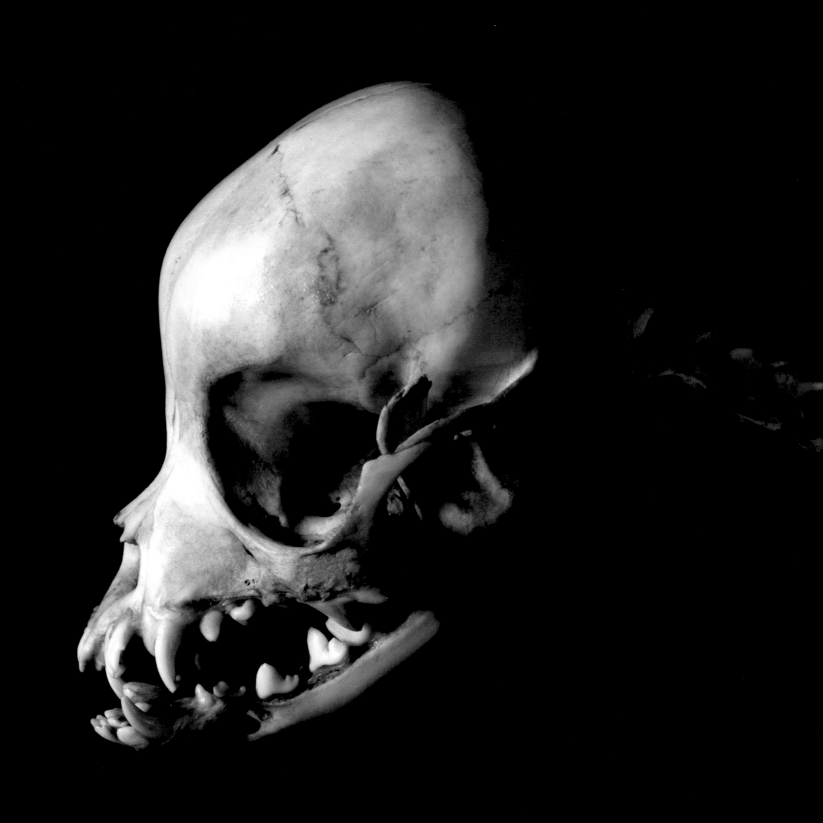

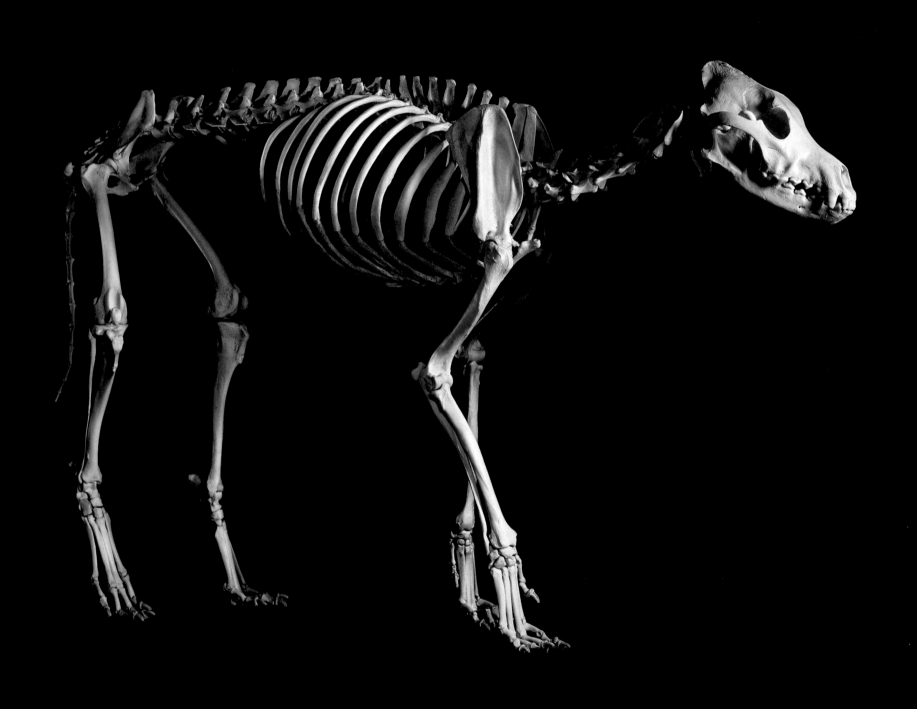

Wolf, *Canis lupus*. Eurasia, North America (s.h. 65 cm)

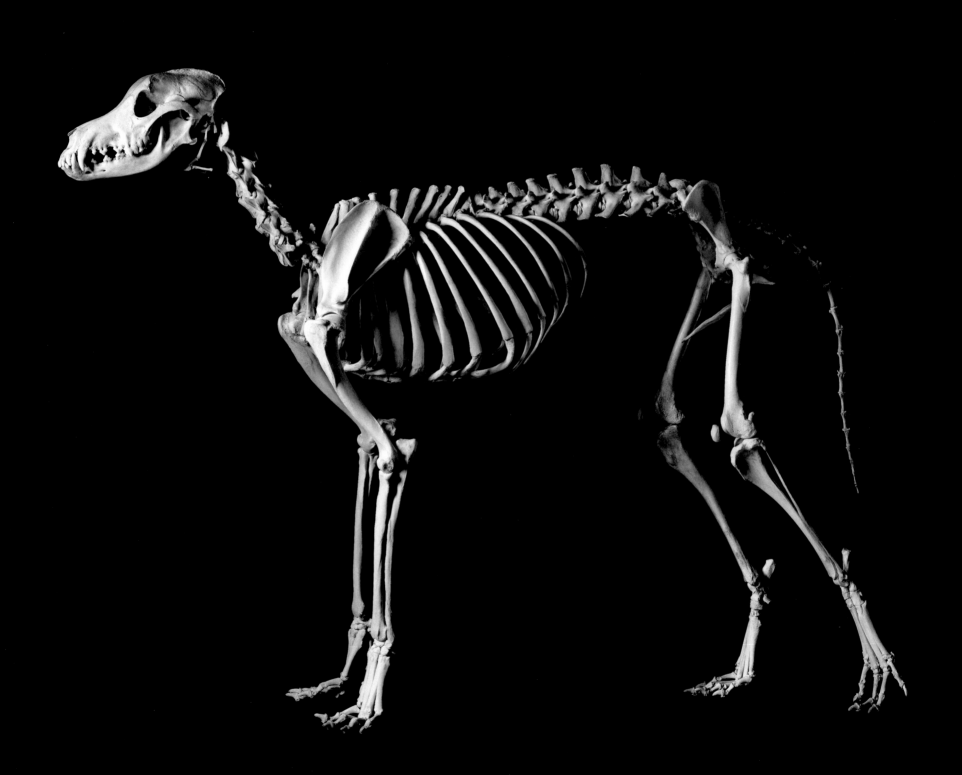

Greyhound, *Canis lupus familiaris*. Domesticated. Worldwide (s.h. 68 cm)

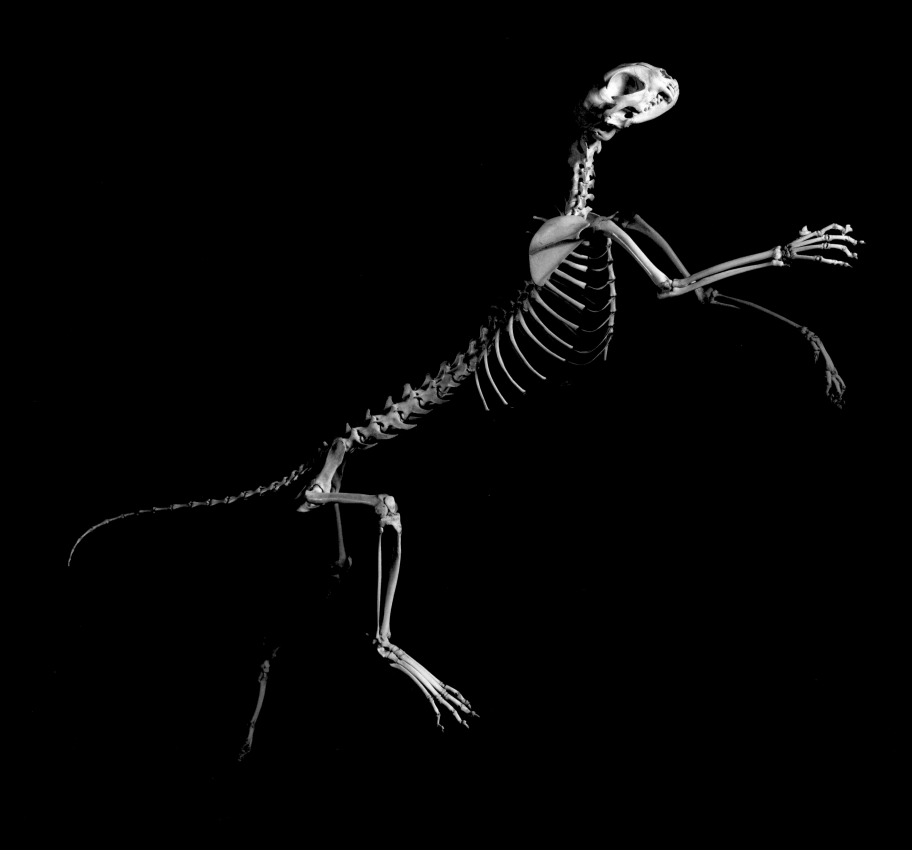

Cat, *Felis catus*. Domesticated. Worldwide (s.h. 30 cm)

Slender-billed crow, *Corvus enca*. South-east Asia (w. span 37 cm)

CHAPTER 44
MAN'S TIME

Only a minute fraction of the hundreds of millions of species that have lived upon the earth since the beginnings of life are still here today. Species disappear because they are transformed or because they are eliminated. Subjected to competition and to predation, as well as to climatic shifts, they have not always had the time to evolve and adapt to changes in their environment. These disappearances constitute a kind of permanent "background noise" for which the fossil archives provide us with only a very incomplete sampling. Most species of worms and insects have lived and vanished without leaving the smallest trace, except for their possible descendants. The vertebrate species have always been less numerous, but their bony skeletons have more often been fossilized.

Detailed observation of fossils has shown that the basic rate of extinctions sometimes rose sharply. "Peaks of extinction" visible in the fossil record are evidence that several serious biological crises have occurred in the course of prehistory. The most important occurred some two hundred fifty million years ago, and caused the disappearance of ninety six percent of marine species and seventy percent of land species. The most famous crisis, sixty five million years ago, saw the end of the dinosaurs and of many other marine and land species. The causes of these mass extinctions are many: worldwide climate changes accompanied by significant variations in sea levels, enormous volcanic eruptions, giant meteorite showers. The end of the last ice age coincided with man's ever-greater mastery over his environment. The climatic changes and hunting both contributed, with little chance of distinguishing between the two factors, to the disappearance of a great many species, including the mammoth, the giant sloth of South America, and the running birds of Oceania and Madagascar. More recently, the rate of extinctions has accelerated: three hundred to three hundred fifty vertebrate species have disappeared in the past four centuries, which comes to more than a hundred times the previous rate. Some species have become the symbols of these extinctions, such as the dodo, the Steller's sea cow and the thylacine, described below.

The dodo was a large land bird that lived on the island of Mauritius before the arrival of the first great ships. It appears to have descended from the Nicobar pigeon, a bird that arrived from Asia. Having lived for millions of years on an island with no predators, it had grown much bigger and had lost any ability to fly. It had no fear of men, and no possibility to escape them. It was hunted for its meat, and its eggs were destroyed by dogs and rats that arrived on the ships. The dodo died out in the middle of the eighteenth century.

The Steller's sea cow was a giant manatee, the size of an elephant, that lived in the North Pacific Ocean. Discovered in 1741 by a Russian expedition, the sea cow immediately became the target of intense hunting, for its meat and its thick skin. The species was not very abundant, and its distribution quite limited; it was extinct twenty seven years after it was first discovered. Because recent fossils of the animal have been found all along the Pacific coasts, from Japan to California, it is believed that this was a last population of a species once much more widespread and that had already been hunted to extinction in most of its regions of origin.

The thylacine was also called the Tasmanian tiger or the marsupial wolf. From the tiger it had a few stripes on its back, but it had neither the tiger's size, morphology, or behavior. Its skeleton, however, shows some astonishing similarities to that of the wolf. It is, however, a marsupial, thus phylogenetically closer to kangaroos than to wolves (although it has lost the marsupial's bones at the pubis). The Australian aborigines often showed it in their rock art. It was eliminated by hunting and by competition from dingos, dogs brought in by the early aborigines. The thylacine survived in Tasmania until it was finally eliminated by the European colonists. The last individual died in a zoo in 1936. It is one of the most recent mammals directly eliminated by man.

Today, some five thousand species of vertebrate are more or less threatened with extinction; a third of the amphibians, half the turtles, one mammal in four, and one bird in eight. Most of the large mammals and the endangered birds are protected by law, at least for the short term. As to the other species, from insects to mollusks to worms, the rate of extinction is reaching a level comparable to the great episodes of mass extinction in prehistory. Hunting and fishing are sometimes to blame, but the major threats come from the destruction of natural environments, from the introduction of alien species, and from the many forms of pollution. To these factors are now added the present warming of the climate. This massive extinction will mean not only the loss of part of the world's richness and beauty; it will also be a major threat to the billions of human beings who use many wild species for food, for health, or for their habitat. We are more dependent than we think on the activity of the countless animals that populate the lands, seas, and forests.

The disappearance of species is an integral part of the story of life. Despite their catastrophic effects, it seems that the great extinctions of the past played a major role in evolution, for instance in "reshuffling the cards" of the various zoological groups. After each biological crisis, biodiversity has once again risen, thanks to the rapid evolution of certain groups, like the mammals which profited by the disappearance of the dinosaurs. But evolutionary time is not human time. It is counted in millions of years and not in centuries. When the tiger, the rhinoceros, and all the other species produced by a long evolution have disappeared, all that will be left to man are the animals that are most tolerant, capable of prospering in any conditions—flies, cockroaches, rats.

"Drawn by the treasures that victory over the cetaceans could afford him, man disrupted the peace of their immense solitudes, violated their retreat, immolated all those whom the icy and polar deserts did not shield from his blows.... They will not cease to be victim to his interest until these enormous species have ceased to exist. In vain do they flee before him: his art can carry him to the ends of the earth; no longer have they any asylum but in nothingness." Lacépède: *The Natural History of the Cetaceans,* 1804.

Steller's sea cow, *Hydrodamalis gigas.* Northern Pacific. Extinct (l. 6.60 m)

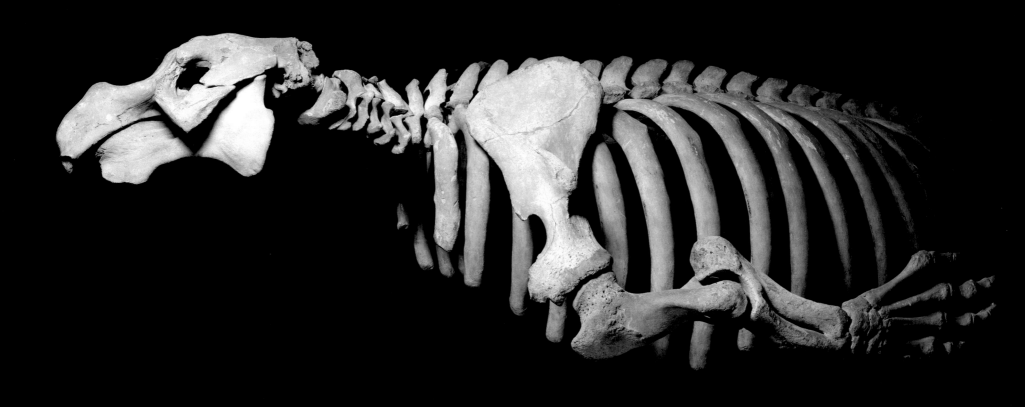

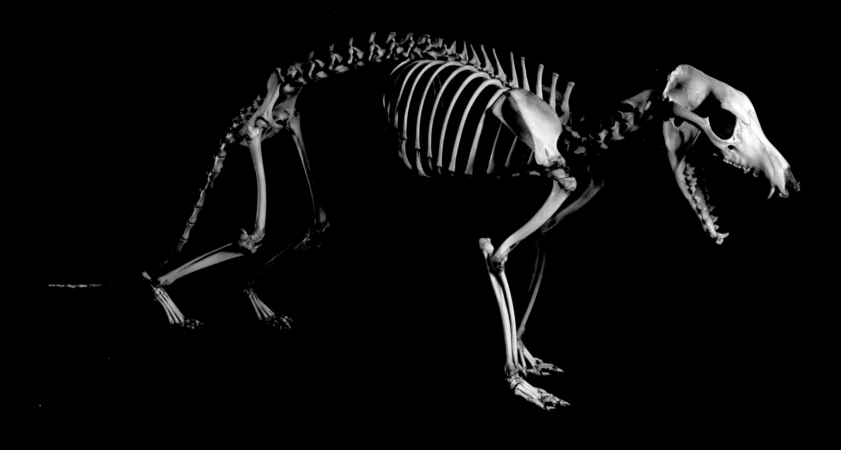

Tasmanian tiger, *Thylacinus cynocephalus*. Australia. Extinct (l. 1.24 m)

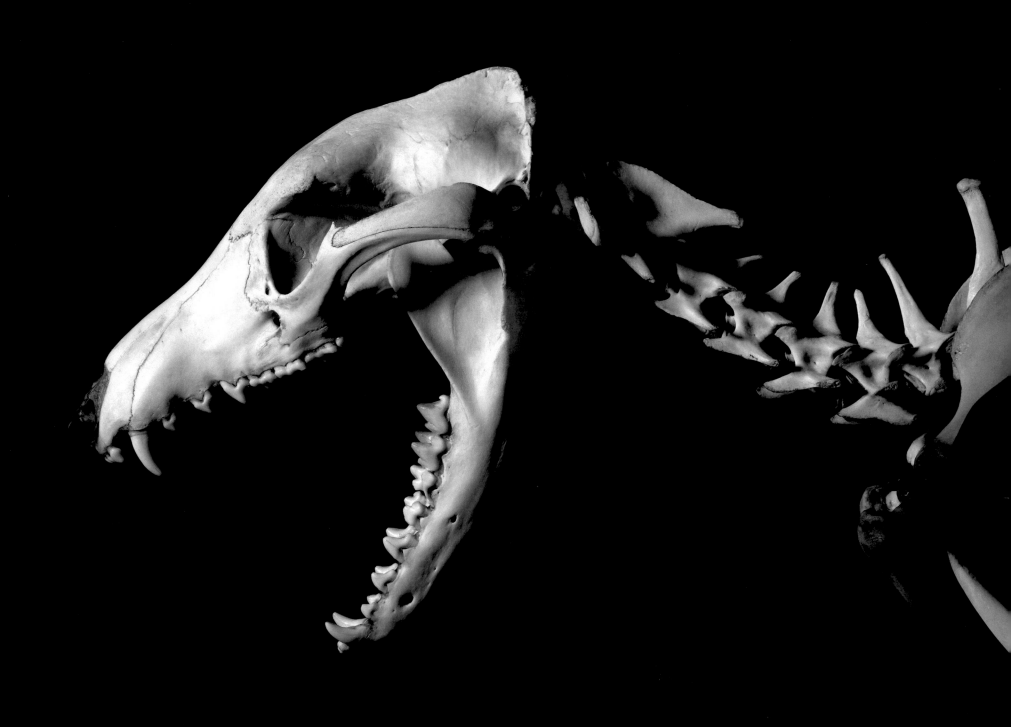

APPENDICES

CLASSIFICATION

Since the 16th century, Western naturalists have been building a systematic inventory of living beings, in order to cut away the tangle of local names for edible, medicinal, and dye plants. Depending on the various authors, the criteria for assignment to zoological classes were morphological, geographical—even alphabetical—for the essential goal at the time was to identify species. A further objective gradually gained importance: to make some sense of nature's profusion. Classifying living beings was meant to provide insight into the hidden order of Nature such as God had created it, and thereby to aid in understanding His intentions. Sorting out the animals, then, required choosing characteristics leading to a classification scheme that would be "natural," stable, and acknowledged by all.

In traditional classification, the zoological groups, or taxons, such as "night raptors," "birds," and "vertebrates" represent different hierarchical levels. The basic level is the *species*, which includes animals that can interbreed; next above, the *genus* [page 70] groups species that are very similar, such as the lion, panther, and tiger; the genera are collected into *families*, and families into ever broader categories: *order, class, phylum*. Thus, the lion belongs to the Felid family, which belongs to the Carnivore order, which belongs to the Mammals class, which in turn belongs to the Chordates phylum. The phylum is the largest category, containing all animals having the same fundamental structure [page 62].

In the early 19th century, classification was based on the anatomy of animals (or plants) but did not presume a priori any relation among the species. With the development of evolutionary ideas, it became tempting to establish a parallel between the hierarchy of the groups and their possible relatives. Darwin proposed, for instance, that classification should be founded entirely on phylogeny—the connections among species and groups. Choosing the characteristics upon which to base classification would take that evolutionary dimension into account—for example, by distinguishing resemblances due to a common heritage from those that arose from parallel but independent evolutions. Thus, tuna and dolphins have the same general form, but the resemblance is due to their adaptations to the same environment, not to kinship. Since the 1960s, the systematists have gradually adopted "cladistic" classification, which considers only "shared derived traits"—characteristics displayed by all the members of a zoological group and only by them. These characteristics would signal that the group's members all descend from a common ancestral species.

The old classes of birds and reptiles show clearly the differences in consequence of this new approach. Birds form one homogeneous taxon, all of them characterized by an evolutionary novelty: feathers. They are the only animals to have feathers (at least among current species) and are considered to all descend from an ancestor in which that innovation appeared. On this point, traditional and cladistic classification are in accord. But for reptiles, the situation is different under the cladistic system: indeed, crocodiles are more closely related to birds than to turtles [see the tree on the facing page]. From a cladistics standpoint, if the reptile class includes all today's reptiles, it should then also include birds. So the "sauropsid" taxon does include both reptiles and birds, with distinctions made for the archosaurians (crocodiles, dinosaurs, and birds), the lepidosaurians (lizards and snakes), and the chelonians (turtles).

The "trees" constructed by cladistic methods do not show the ancestors of contemporary animals. Fossils are noted in the classification, but as "sister groups" to the current groups rather than as their ancestors. The fossils may possibly resemble the ancestors, but they often have some characteristics that prevent their being considered true ancestors. This new way of thinking on fossils makes it possible to abandon any reference to "missing links," a notion that implies uncertainty about the reality of evolution because some intermediary forms are still lacking in the record that would connect fossils to current species. Actually, the absence of such intermediary forms is readily explained by the fact that fossilization is a rare phenomenon, and that a great many species probably have no fossil representative at all, found or unfound. Moreover, it appears that evolutionary transformations more often affect small isolated groups, which further reduces the possibility of fossil formation from among them. The true ancestors of present-day animals therefore remain unknown, even though some fossils may be quite similar to them.

To establish phylogenetic trees, systematists consider a great many anatomical and physiological characteristics, as well as findings from molecular biology. Biologists have compared animals' molecules, first the proteins and then their DNA. Overall, the number of differences between two proteins that govern the same function in two different species depends on the time elapsed since the species separated in their descent from a common ancestor. The same is true for the genes that code for these proteins, such data being even more precise. In practice, the genes must first be sequenced—that is, their exact makeup established and then compared with one another to find the differences between the sequences. Next, by complex mathematical methods, a tree-diagram is constructed to lay out in graphic form the whole array of resemblances and differences between the genes. These techniques, which could only be widely used since the development of computers, have confirmed the common origin of all living things, for they share certain fundamental molecules, such as the proteins necessary for replication of DNA, or for cell respiration. The phylogenetic trees based on molecular biology have often confirmed earlier trees based on anatomy, and have sometimes solved old problems. The molecular information, however, is sometimes as ambiguous as the anatomical information.

Classification is of interest not only to zoologists; the work has other practical uses as well—for instance, in formulating laws to protect species [page 70] or in determining suitable animal models for medical research. Classification has philosophical implications as well—establishing man's identity as a primate, a species that comes from the same original stock as all other animals. And cladistic classification has shifted our position in the species tree: the closest cousin of the chimpanzee is no longer the gorilla, as in the traditional classification, but man.

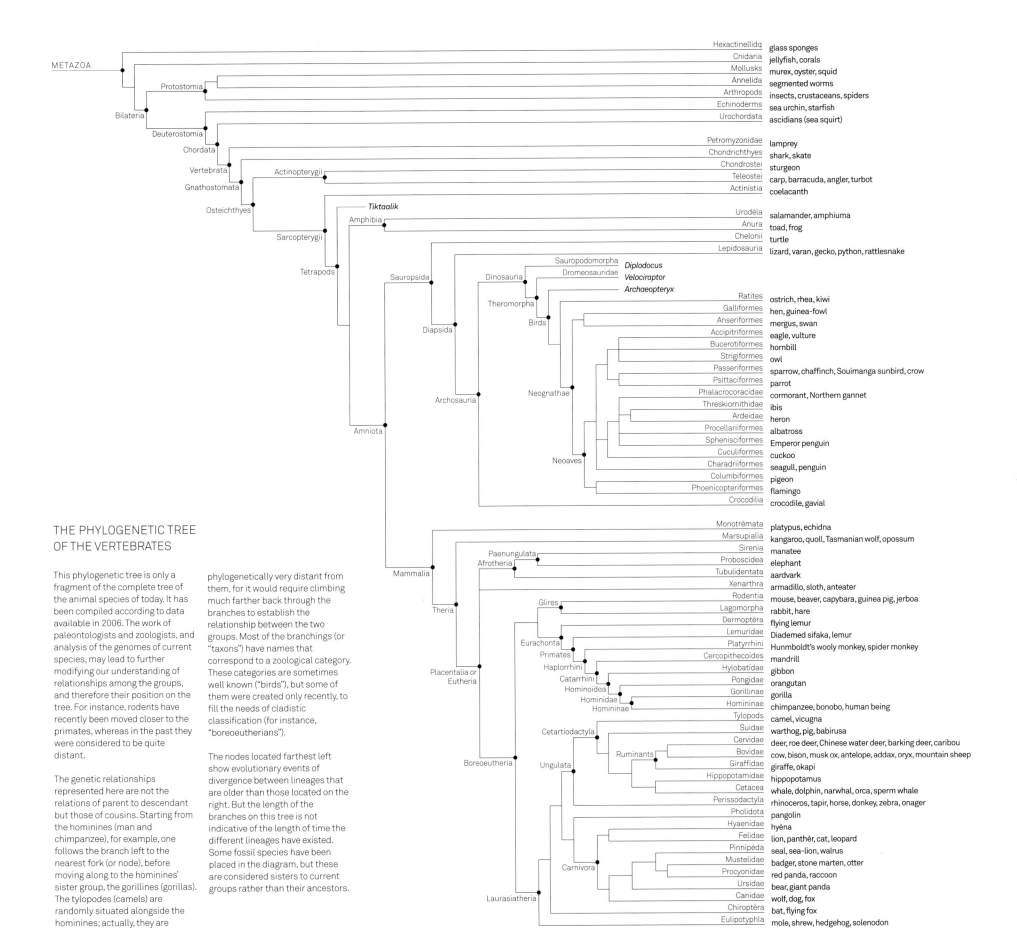

THE PHYLOGENETIC TREE OF THE VERTEBRATES

This phylogenetic tree is only a fragment of the complete tree of the animal species of today. It has been compiled according to data available in 2006. The work of paleontologists and zoologists, and analysis of the genomes of current species, may lead to further modifying our understanding of relationships among the groups, and therefore their position on the tree. For instance, rodents have recently been moved closer to the primates, whereas in the past they were considered to be quite distant.

The genetic relationships represented here are not the relations of parent to descendant but those of cousins. Starting from the hominines (man and chimpanzee), for example, one follows the branch left to the nearest fork (or node), before moving along to the hominines' sister group, the gorillines (gorillas). The tylopodes (camels) are randomly situated alongside the hominines; actually, they are

phylogenetically very distant from them, for it would require climbing much farther back through the branches to establish the relationship between the two groups. Most of the branchings (or "taxons") have names that correspond to a zoological category. These categories are sometimes well known ("birds"), but some of them were created only recently, to fill the needs of cladistic classification (for instance, "boreoeutherians").

The nodes located farthest left show evolutionary events of divergence between lineages that are older than those located on the right. But the length of the branches on this tree is not indicative of the length of time the different lineages have existed. Some fossil species have been placed in the diagram, but these are considered sisters to current groups rather than their ancestors.

GLOSSARY

adaptation: The adjustment of an animal or plant species to the conditions of its environment (climate, soil composition, other species) through anatomical, physiological, or behavioral changes over several generations.

biodiversity: Diversity of living things. Term may apply to diversity among individuals within a species (polymorphism), the variety of living species in a given environment, or the variety of ecosystems.

cell: Base unit of living things, which all are constituted from a single cell or a cluster of cells. In multicellular animals, cells have specialized functions: in nerves, muscle, bones, blood, etc.

chromosomes: Cell elements made up of DNA and proteins, visible under a microscope. The DNA thread in each chromosome carries a series of genes. In most animals and plants, half of an individual's chromosomes come from the father, half from the mother.

classification: Grouping of living things according to anatomical or genetic criteria. Cladistics is a phylogenetic mode of classification that takes evolutionary relationships into account.

co-evolution: Evolutionary history in which two species (or groups of species) mutually influence each other's transformations.

competition: Relationship between species or individuals looking to make use of the same resources. It could be over prey for two predatory species, groundwater for plants, or females for males of the same species.

convergence: Similarity between two species (or two classes) that has appeared independently over the course of evolution: the shape of dolphins and sharks, for example, or the eyes of octopuses and vertebrates.

development: All the phenomena that occur between the formation of an egg cell and the death of the individual that comes from it. Synonym of **ontogenesis**.

differentiation: Progressive cellular specialization over the course of embryonic development; anatomical or behavioral divergence between two species during the speciation process.

DNA (deoxyribonucleic acid): Chemical substance containing all the information necessary for cell function and the development of an animal from an initial egg cell (resulting from fertilization). This information is coded as a chain of four chemical elements (nucleotides A, T, G, and C) aligned in a sequence unique to each individual. Inside each cell, the DNA is distributed into several threads, called **chromosomes.**

ecological niche: The position of a species in an **ecosystem**, including its habitat, dietary regime, relationship to other species, etc. Two species cannot occupy the same niche in the same environment; competition will eliminate one.

ecosystem: A physical environment and the living things that inhabit it. The description of an ecosystem also includes the interaction between these two components.

fertilization: Fusion between a male element (such as a spermatozoid) and a female element (such as an ovule), which then constitute a single cell, the egg.

fixism: Doctrine of the immutability of species, considering them not to have changed since God created them.

gene: Chromosome fragment, made of DNA, containing the information necessary to one or more cell functions. Genes are particularly vital to the synthesis of cellular proteins but also ensure that these cells function as they should.

genome: Set of genes belonging to a species or an individual.

heterochrony: Evolutionary mode characterized by a discrepancy in timing in a species' development—for example, between overall bodily growth and sexual maturation of individuals. See also **neoteny**.

homology: Structural similarities in two organs due to their evolution from the same original organ. Genes too may be termed "homologous" if they derive from the same ancestral gene.

hybridization: The crossbreeding of two different species.

interfecundity: The ability of individuals from two distinct populations to reproduce between themselves.

metabolism: Set of chemical reactions produced in the cells of an organism linked to the production of energy and to molecular synthesis or elimination.

metamorphosis: Set of transformations experienced by a larva until it reaches adulthood, at which time it has a very different form (from caterpillar to butterfly, for example, or tadpole to frog).

microevolution: Evolution within a species due to low-level mutations. Opposite of macroevolution, which describes the differentiation of major zoological categories and is effected through modifications in the deep structure of species.

monophyletic: Said of a zoological group whose members all descend from the same ancestral species and which includes all the descendants of this species. The group "aves" is monophyletic, whereas the class "reptilia" is not; the latter does not include birds, themselves the descendants of some reptiles.

mutation: Change in a gene or chromosome (or the result of this change). A mutation can take the form of a small or large physiological, anatomical, or behavioral change in the animal. Mutations in the sexual cells can be passed on to future generations.

natural selection: Sorting of individuals within a particular species by their ability to survive or reproduce. In order for selection to exist, individuals must differ from one another, these differences must be hereditary, and they must have an effect on rates of survival or reproduction.

neoteny: A form of **heterochrony** characterized by precocious sexual maturity relative to the development of the rest of the body. The adult then retains juvenile characteristics.

ontogeny or **ontogenesis:** See **development**.

parasitism: Said of the lifestyle of an animal or plant benefiting from another living being, disrupting its development or activity to a greater or lesser degree but without causing its immediate death.

phylogeny: Evolutionary history of living things. A phylogenetic tree is a diagrammatic representation of the relationships among species, reconstituted through a comparison of their genes or their anatomical or physiological characteristics.

placental: Said of a mammal whose fetus relies specifically on the placenta for development. Within the mammal class, only marsupials (such as kangaroos) and monotremes (such as duck-billed platypuses) are non-placental.

polymorphism: Individual anatomical, physiological, or genetic variability within a species.

radiation, evolutionary (or adaptive): Rapid and major diversification of a zoological group following the colonization of a new region or the disappearance of other groups, to fill many vacant ecological niches.

sequence: Succession or linking of elements that makes up DNA or a protein (the nucleotides A, T, G, and C for DNA, amino acids for proteins).

sequencing: Mapping of a DNA or protein sequence. Sequencing the genes of two individuals or species allows for the evaluation of the degree to which they differ in evolutionary terms.

sexual dimorphism: Set of anatomical differences between males and females of the same species, apart from differences in the sexual organs themselves.

speciation: Emergence of one or more new species from an ancestral species.

systematics: The science of classifying living things. The phylogenetic system is based on genetic relationships among species.

tarsus: Group name for the small bones that make up the part of the foot next to the tibia.

taxon (or taxonomic unit): Group of organisms sharing a characteristic or set of characteristics. Each taxonomic unit specifies a zoological category with a specific level in the classification hierarchy: phylum, class, order, family, genus, and species. For example, the phylum "mollusca," the class "aves," and the family "hominid" are all taxons.

tetrapod: Vertebrate animal having four limbs, or descendant of an animal with this characteristic, such as snakes and cetaceans.

vestigial organ: Organ found in a rudimentary state, in a particular species or group of species, compared to its development in related zoological species. It can have a completely different function than it would have if developed.

BIBLIOGRAPHY

GENERAL WORKS

Beaumont André, and Pierre Cassier. *Biologie animale. Les Cordés: anatomie comparée des Vertébrés*. Paris: Dunod, 2005.

Buffetaut, Éric. *Cuvier*. Pour la science. Paris: Belin, 2002.

Buffon, Georges Louis Leclerc, Comte de, and Louis-Jean-Marie Daubenton. *Discours sur la nature des animaux, suivi de De la description des animaux*. Paris: Rivages, 2003

Nouveau dictionnaire d'histoire naturelle. Ed. J.F. Deterville. Paris, 1816

Coppens, Yves, and Pascal Picq. *Aux origines de l'humanité*. Vol. 1. Paris: Fayard, 2001.

Cuvier, Georges. *Discourse on the Revolutionary Upheavals on the Surface of the Earth*. Trans. Ian Johnston, Liberal Studies Department, Malaspina University College, Nanaimo, British Columbia, May 1998. <http://www.mala.bc.ca/~johnstoi/cuvier/ cuvier.htm>.

Darwin, Charles. *The Descent of Man, and Selection in Relation to Sex*. London, 1871.

——*The Origin of Species*. London, 1859.

Dawkins, Richard. *The Selfish Gene*. Oxford: Oxford University Press, 1976.

Gasc, Jean-Pierre. *Histoire naturelle de la tête. Leçons d'anatomie comparée*. Paris: Vuibert, 2004.

Goldschmidt, Tijs. *Darwin's Dreampond: Drama in Lake Victoria*. Trans. Sherry Marx-MacDonald. Boston: MIT Press, 1998.

Gould, Stephen Jay. *Ever Since Darwin*. New York: W.W. Norton & Company, 1977.

——*Full House: The Spread of Excellence From Plato to Darwin*. New York: Harmony, 1996.

——*Wonderful Life: The Burgess Shale and the Nature of History*. New York: W.W. Norton & Company, 1989

——*The Panda's Thumb*. New York: W.W. Norton & Company, 1980.

——*Hen's Teeth and Horse's Toes*. New York: W.W. Norton & Company, 1983.

Grassé, Pierre Paul. *Traité de zoologie*. Paris: Masson.

Hartenberger, Jean-Louis. *Une brève histoire des mammifères*. Paris: Belin, 2001.

Jacob, François. *Le jeu des possibles. Essai sur la diversité du vivant*. Paris: LGF—Livre de Poche, 1986.

Jouventin, Pierre. *Les confessions d'un primate*. Pour la science. Paris: Belin, 2001.

Lamarck, J.B. *Zoological Philosophy*. Trans. Hugh Elliot. Rosamond, CA: Bill Huth Publishing, 2006.

Le Guyader, Hervé. *Geoffroy Saint-Hilaire. Un savant, une époque*. Paris: Belin, 1998.

——*L'Évolution*. Pour la science. Paris: Belin, 1998.

Lecointre, Guillaume, and Hervé Le Guyader. *Classification phylogénétique du vivant*. Paris: Belin, 2006.

Mayr, Ernst. *One Long Argument: Charles Darwin and the Genesis of Modern Evolutionary Thought*. Cambridge, Massachusetts : Harvard University Press, 1991.

Monod, Jacques. *Chance and Necessity: An Essay on the Natural Philosophy of Modern Biology*. New York: Alfred A. Knopf, 1971 .

Tassy, Pascal. *Le Paléontologue et l'évolution*. Paris, Le Pommier: 2000.

Tillier, Simon (Ed.) *Encyclopédie du règne animal*. Paris, Bordas: 2003.

Tort, Patrick (Ed.) *Dictionnaire du darwinisme et de l'évolution*. Paris, PUF: 1996.

–*Darwin and the Science of Evolution*. Discoveries. New York: Harry N. Abrams, 1991.

Waal, Frans de. *Quand les singes prennent le thé*. Trans. Jean-Paul Mourlon. Paris: Fayard, 2001.

SPECIFIC ARTICLES

Abzhanov, A., M. Protas, *et al.* "Bmp4 and Morphological Variation of Beaks in Darwin's Finches." *Science* 305 (2004): 1462-1465.

Albertson, R.C., J.A. Markert, *et al.* "Phylogeny of a Rapidly Evolving Clade: The Cichlid Fishes of Lake Malawi, East Africa." *Proceedings of the National Academy of Sciences of the United States of America* 96-9 (1999): 5107-5110.

Bejder, L., and B.K. Brook. "Limbs in Whales and Limblessness in Other Vertebrates: Mechanisms of Evolutionary and Developmental Transformation and Loss." *Evolution & Development* 4-6 (2002): 445-458.

Berglund, A., A. Bisazza, and A. Pilastro. "Armaments and Ornaments: An Evolutionary Explanation of Traits of Dual Utility", *Biological Journal of the Linnean Society* 58 (1996) :385-399.

Boursot, P., J-C Auffray, *et al.* "The Evolution of House Mice." *Annual Review of Ecology and Systematics* 24 (1993): 119-152.

Bramble, D. M., and D. E. Leiberman. "Endurance Running and the Evolution of *Homo*", *Nature* 432 (2004): 345-352.

Chatti, N., J. Britton-Davidian, *et al.* "Reproductive Trait Divergence and Hybrid Fertility Patterns between Chromosomal Races of the House Mouse in Tunisia: Analysis of Wild and Laboratory-bred Males and Females", *Biological Journal of the Linnean Society* 84 (2005): 407-416.

Chen, Y., Y. Zhang, *et al.* "Conservation of Early Odontogenic signaling Pathways in Aves," *Proceedings of the National Academy of Sciences of the United States of America* 97-18 (2000): 10044-10049.

Clutton-Brock, T. H., S. D. Albon, and P. H. Harvey. "Antlers, Body Size and Breeding Group Size in the Cervidae." *Nature* 285 (1980): 565-567

Danley, P. D., and T.D. Kocher. "Speciation in Rapidly Diverging Systems: Lessons from Lake Malawi." *Molecular Ecology* 10: 1075-1086.

Delsuc, F., J.-F. Mauffrey, and E. Douzery. "Une nouvelle classification des mammifères." *Pour la science* 303: 62-66.

Dobney, K., and G. Larson. "Genetics and Animal Domestication: New Windows on an Elusive Process." *Journal of Zoology* 269-2 (2006): 261-271.

Ericson, P. G., C.L. Anderson, *et al.* "Diversification of Neoaves: Integration of Molecular Sequence Data and Fossils." *Biology Letters* 2-4 (2006): 543-547.

Grant, P. R., and B.R. Grant. "Unpredictable Evolution in a 30-Year Study of Darwin's Finches." *Science* 296 (2002): 707-711.

Irwin, D. E., S.Bensch, *et al.* "Speciation by Distance in a Ring Species." *Science* 307: 414-416.

Jouventin, P., R. J. Cuthbert, and R. Ottval. "Genetic Isolation and Divergence in Sexual Traits: Evidence for the Northern Rockhopper Penguin *Eudyptes moseleyi* being a Sibling Species." *Molecular Ecology* 15 11 (2006): 3413-3423.

Liebers, D, P. de Knijff, and A.J. Helbig. "The Herring Gull Complex is not a Ring Species." *Proceedings of the Royal Society of London. Series B, Biological sciences* 7-271-1542 (2004): 893-901.

Lindberg, J., Björnefleldt, S., *et al.* "Selection for Tameness has changed Brain Gene Expression in Silver Foxes." *Current Biology* 15-22 (2005): 915-916.

Lindenfors, P., and B. S. Tullberg. "Phylogenetic Analyses of Primate Size Evolution: The Consequences of Sexual Selection." *Biological Journal of the Linnean Society* 64-4 (1998): 413-447

Lisle Gibbs, H., M. D. Sorenson, *et al.* "Genetic Evidence for Female Host-specific Races of the Common Cuckoo." *Nature* 407 (2000): 183-186.

Loison, A., and J. M. Gaillard. "What Factors Shape Sexual Size Dimorphism in Ungulates?" *Evolutionary Ecology Research* 1 (1999): 611-633.

Mitsiadis, T. A., J. Caton, and M. Cobourne. "Waking-up the Sleeping Beauty: Recovery of the Ancestral Bird Odontogenic Program." *Journal of Experimental Zoology. Part B. Molecular and Developmental Evolution* 306-3 (2006): 227-233.

Olaf, R., P. Bininda-Emonds, *et al.* "Building Large Trees by Combining Phylogenetic Information: A Complete Phylogeny of the Extant (*Carnivora Mammalia*)." *Biological Reviews of the Cambridge Philosophical Society* 74 (1999): 143-175.

Pérez-Barbería, F. J., I.J. Gordon, and M. Pagel. "The Origins of Sexual Dimorphism in Body Size in Ungulates." *Evolution* 56-6 (2002): 1276-1285.

Pouyaud, L., S. Wirjoatmodjo, *et al.* "Une nouvelle espèce de cœlacanthe:preuves génétiques et morphologiques." *Comptes rendus de l'Académie des sciences, Série III:Sciences de la vie* 322 (1999): 261-267.

Robert, M., and G. Sorci. "The Evolution of Obligate Interspecific Brood Parasitism in Birds." *Behavioral Ecology* 12-2 (2001): 128-133.

Ruckstuhl, K. E., and P. Neuhaus. "Sexual Segregation in Ungulates: A Comparative Test of Three Hypotheses." *Biological Reviews of the Cambridge Philosophical Society* 77-1 (2002): 77-96

J. Rutila, R. Latja, and K. Koskela. "The Common Cuckoo Cuculus Canorus and its Cavity Nesting Host, the Redstart *Phoenicurus phoenicurus*: A Peculiar Cuckoo-host System?" *Journal of Avian Biology* 33 (2002): 414-419.

Sato, A., C. O'Huigin *et al.* "Phylogeny of Darwin's Finches as revealed by mtDNA Sequences." *Evolution* 96-9 (1999): 5101-5106.

Simmons, R., and L. Scheepers, 1996. "Winning by a Neck: Sexual Selection in the Evolution of Giraffe", *The American Naturalist*, 148: 772-786.

Tassy, P. "Et la trompe vint aux elephants;" *La Recherche* 305 (1998):54.

Talbot, S. L. and G. F. Shields. "Phylogeography of Brown Bears (*Ursus arctos*) of Alaska and Paraphyly within the Ursidae." *Molecular Phylogenetics and Evolution* 5-3 (1996): 477-94.

Thewissen, J. G. M., E. M. Williams, *et al.* "Skeletons of Terrestrial Cetaceans and the Relationship of Whales to Artiodactyls." *Nature* 413 (2001): 277-281

Tougard, C., T. Delefosse, *et al.* "Phylogenetic Relationships of the Five Extant Rhinoceros Species (Rhinocerotidae, Perissodactyla based on Mitochondrial Cytochrome b and 12S rRNA Genes)." *Molecular Phylogenetics and Evolution* 19-1(2001): 34-44.

Waal, F. B. M. de. "Bonobo Sex and Society." *Scientific American* 272-3 (1995): 82-88.

Wiens, J. J., and J. L. Slingluff. "How Lizards turn into Snakes: A Phylogenetic Analysis of Body-form Evolution in Anguid Lizards." *Evolution* 55-11 (2001): 2303-2318.

GENERAL INDEX

ZOOLOGICAL INDEX

SOURCE OF SPECIMENS

MUSEUM OF NATURAL HISTORY, PARIS

Aardvark
African elephant
Algerian mouse
American bison
Amphiuma
Anteater
Babirusa
Badger
Barbary sheep
Barking deer
Beaver
Black-crowned night heron
Blind snake
Brown bear
Brown gull
Cane toad
Capybara
Caribou, male and female
Carp
Chaffinch
Cheetah
Chimpanzee
Chimpanzee, young
Chinese water deer
Coelacanth
Common merganser
Common redstart
Common Scops owl
Common woodpigeon
Crocodile
Cuckoo
Dasyure
Diademed sifaka
Dromedary
Eagle owl
Flying lemur
Flying lizard
Flying squirrel
Garden hedgehog
Gharial
Giant panda
Giant skink
Giraffe
Glass sponge
Gold finch
Gorilla, female
Gorilla, male
Greater horseshoe bat
Greater kudu
Greater rhea
Green turtle
Griffon Vulture
Grizzly
Guinea-pig
Hare
Hermann's tortoise
Hippopotamus
Hispaniolan Solenodon
Horned lizard
Horse
House mouse
House sparrow

Human being
Hyena
Indian rhinoceros
Indian tapir
Japanese giant salamander
Kiwi
Large ground-finch
Lesser Egyptian jerboa
Lion
Little owl
Long-eared owl
Magellanic Penguin
Malaysian pangolin
Manatee
Mandrill
Maned sloth
Marsupial mole
Mole
Mountain Hare
Murex
Musk ox
Narrow-headed soft-shelled turtle
Northern fur seal
Okapi
Onager
Opossum
Orangutan
Oribi
Ostrich
Père David's deer and doe
Pink flamingo
Platypus
Pocillopora
Polar bear
Python
Raccoon
Rattlesnake
Red crossbill
Red deer
Red panda
Red-footed tortoise
Rhinoceros hornbill
Roe deer
Rough-spined urchin
Sacred ibis
Sacred ibis (mummy)
Scarlet macaw
Scimitar-horned oryx
Sea otter
Sea spider
Seagull
Seven-banded armadillo
Snowy albatross
Snowy owl
Souimanga sunbird
Southern right whale
Southern sea lion
Steller's sea cow
Stone marten
Tasmanian wolf
Vicugna
Walrus
Warthog
Water buffalo

Water monitor
White rhinoceros
White-cheeked gibbon
Wolf
Zebra

OCEANOGRAPHIC MUSEUM, MONACO

Beaked whale
Narwhal
Orca
Pilot whale
Shortfin mako
Sperm whale
Striped dolphin

MUSEUM OF NATURAL HISTORY, MARSEILLE

African elephant

MUSEUM OF NATURAL HISTORY, TOULOUSE

Addax
Alligator
Cat
Chimpanzee
Common skate
Golden eagle
Harbor seal
Horse
Human being
Humboldt's wooly monkey
Leopard
Northern gannet
Rabbit
Red fox
Red-necked wallaby

Ring-tailed lemur
Slender-billed crow
Vanuatu flying fox

NATIONAL VETERINARY SCHOOL FRAGONARD MUSEUM

Cow
Dog
Donkey
Pig

JECO

Angler
Barracuda
Black swan
Common vole
Gopher snake
Helmeted guineafowl
Hen
Nurse shark
Opah
Piranha
Sailfish
Turbot
Wood mouse

ACKNOWLEDGMENTS

THE EDITOR IS GRATEFUL TO THE FOLLOWING PEOPLE FOR THEIR INVALUABLE CONTRIBUTIONS AND THEIR GRACIOUS ASSISTANCE :

FOR THE MUSEUM OF NATURAL HISTORY, PARIS
André Ménez
Bertrand-Pierre Galley
Michel Van Praët
Jean-Pierre Gasc
Philippe Pénicaud
Anne Roussel Versini
Jean-Guy Michard
Anick Abourachid
Christine Lefèvre
Thomas Cucchi
Annie Orth
Marie-Dominique Gouvion Saint-Cyr
Cyril Roguet
Régis Cléva
Patrice Pruvost
Philippe Maestrati
Laure Pierre
Isabelle Domart-Coulon
Luc Vivès
Alain Carré
Eric Pellé

FOR THE MUSÉE DE L'HOMME, PARIS
Philippe Mennecier

FOR THE OCEANOGRAPHIC MUSEUM, MONACO
Jean Jaubert
Didier Théron
Patrick Piguet
Eric Bonnal
Georges Cotton
Michel Dagnino

FOR THE MUSEUM OF NATURAL HISTORY, TOULOUSE
Jean-François Lapeyre
Pierre Dalous
Henri Cap

FOR THE NATIONAL SCHOOL OF VETERINARY SCIENCE AND THE FRAGONARD MUSEUM
Christophe Degueurce

FOR THE MUSEUM OF NATURAL HISTORY, MARSEILLE
Anne Médard-Blondel

FOR LYCÉE HENRY IV
Eric Périlleux

AT NEUNG-SUR-BEUVRON,
Michel Legourd
Collette et Christian Cornette

FOR CLAUDE NATURE (NATURAL HISTORY SHOP)
Claude Misandeau

FOR ANALOGUE
Serge Lestimé

FOR ATALANTE/PARIS
Mathilde Altenhoven
Stéphanie Brissiaud
Stéphane Crémer
Franck Davisseau
Aminatou Diallo
Amélie Doistau
Annette Lucas
Stéphane Trapier

AND WOULD PARTICULARLY LIKE TO THANK
Catherine Alestchenkoff
France et Oscar Bourguoin
Sylviane de Decker
Christian de Pange
Philippe Delmas
Diane Duffour
Hervé Dolant
Clément Durand
Patrizia Facci
Nathalie Feldman
Julien Frydman
Jean Gaumy
Eric Hazan
Anne-Marie Heugas
Marion Jablonski
Christiane et Marc Kopylov
Francis Lacloche
Roland Pilloni
Eric Reinhardt
Agnès Sire
Cristiano Tedeschi
Monica Viola
Luigi Zanetti

AND MY TWO ACCOMPLICES,
Jean-Baptiste de Panafieu
Patrick Gries

THIS BOOK IS DEDICATED TO
Annette, Lola et Margo

CO-EDITOR
Jean-Baptiste de Panafieu

PHOTOGRAPHER
Patrick Gries

ASSISTANTS
Alexandra Taupiac
Eric Genévrier

EDITORIAL DIRECTOR
Roland Pilloni

EDITORIAL ASSISTANT
Pierre Vorméringer

INTERNATIONAL RIGHTS
Sylvia Leuthenmayr

CREATION, GRAPHIC DESIGN AND PRODUCTION
Atalante-Paris

COPYEDITING
Foliotine

DIGITAL RETOUCHING
Hervé Dolant
Clément Durand

PHOTO-ENGRAVING
Analogue

PAPER
Fedrigoni, Tatami ivory

PRINTING
Blanchard

PRINTED
June 2007

NATIONAL MUSEUM OF NATURAL HISTORY

SCIENTIFIC ADVISORS
Anick Abourachid
Christine Lefèvre

EDITORIAL DIRECTION
Anne Roussel-Versini

RESTORATION AND MOUNTING OF SPECIMENS
Luc Vivès
Alain Carré
Eric Pellé